NOW SEE HEAR!

NOW SEE HEAR!

Art, language and translation

Edited by Ian Wedde
and Gregory Burke

VICTORIA UNIVERSITY PRESS
for the
WELLINGTON CITY ART GALLERY

VICTORIA UNIVERSITY PRESS
Victoria University of Wellington
PO Box 600, Wellington

for the

WELLINGTON CITY ART GALLERY
PO Box 2199, Wellington

First published 1990

ISBN 0 86473 096 9

The publishers gratefully
acknowledge the assistance of grants from the
Visual Arts Publications Committee and the Literary Fund
of the Queen Elizabeth II Arts Council
of New Zealand

Cover designed by Leon van den Eijkel and Philip Kelly,
from Augustus Earle, *The Meeting of the Artist with the
Wounded Chief Hongi, Bay of Islands, 1827.*
Oil on canvas, 610 x 962mm.
Courtesy Alexander Turnbull Library, Wellington.
(See also p.26)

Book designed by Leon van den Eijkel
Production by Philip Kelly, Wellington Media Collective
Printed in Hong Kong through Bookprint
Consultants Ltd, Wellington

Contents

Pageworks

Colour illustrations

Foreword and Acknowledgements

The Wellington City Art Gallery is pleased to be able to offer in 1990 this collection of essays and artists' page works by New Zealand and Australian artists and writers. On the launch of this book it will be three years since Ian Wedde and I began discussions toward what has become the *Now See Hear!* project. Our initial talks proposed an exhibition that examined the inter-connections, cooperations and translations of art, language and popular culture within a contemporary New Zealand and Australian context. The proposal grew to include, as a co-project, this book, which will be launched as a major feature of the exhibition *Now See Hear! Art, Language and Translation* scheduled to run from 15 July — 30 September 1990 at the Wellington City Art Gallery.

Now See Hear! has been assembled around the central rubric of translation, and essays address translations between art, language, advertising, television, graphic design, comics, video, film, history, art-history, signs and symbols, landscape and architecture within the context of the current conditions of the market place.

This is the sesquicentennial year of the signing of the Treaty of Waitangi. In any contemporary discussion of translation in New Zealand one must acknowledge the significance of the Treaty and the translations and mistranslations that surround it. Maarire Goodall has provided an essay that addresses the area of translation and the Treaty in particular, and this essay may be read as a prologue to the book's investigation of the production of culture in New Zealand in 1990.

The Wellington City Art Gallery maintains an active publishing schedule to document areas addressed within its programme. This has been pursued vigorously in recent years and the publication of this book continues a policy of the gallery to work in partnership with a publisher on major productions. My thanks to Fergus Barrowman, Editor of Victoria University Press, for his enthusiastic endorsement of the project throughout.

A production of this scale requires the goodwill and assistance of a great many people and I would like to thank all those who have assisted in its realisation. In particular, I would like to thank John Leuthart, Director, and the staff of the gallery for their commitment to and hands-on support of the project. I would also like to thank John McCormack, former Visual Arts Manager of the Queen Elizabeth II Arts Council for his advice and support of the project, and the Literary Fund of the Arts Council for their assistance.

The following individuals and institutions have given invaluable assistance and support:

Joan McCracken and Marian Minsen of the Alexander Turnbull Library, Wellington; Ron Radford of the Art Gallery of South Australia; Christina Barton, Roger Blackley, Andrew Bogle, Ronald Brownson and Alexa Johnson

of the Auckland City Art Gallery; The Australian National Library, Canberra; The Govett Brewster Art Gallery, New Plymouth; Tim Garrity of the Hocken Library, Dunedin; Fritha Marriage, Raewyn Smith, Jane Vial and Nicola Woodhouse of the National Art Gallery, Wellington.

I would also like to express my gratitude to Ian Wedde for his work on developing the proposal for *Now See Hear!* and the substantial energy and time he has contributed to editing this publication; also to Leon van den Eijkel and Philip Kelly for their design and production work, and to Neil Price for his photography of artworks for reproduction.

Lastly, our thanks to the artists and writers who are this book.

Gregory Burke
Wellington City Art Gallery
March 1990

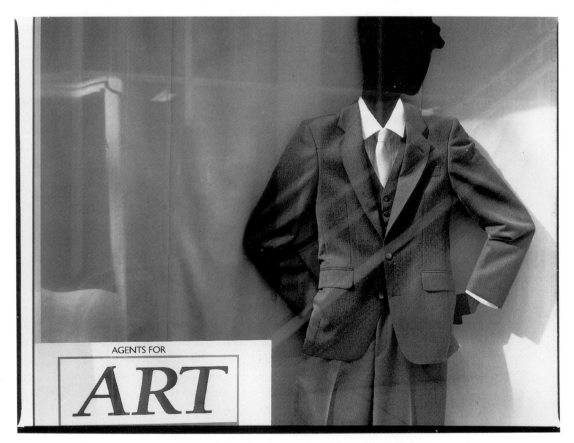

Peter Black, *Dry Cleaning Agents* 1990. Black and white photograph, 110 x 150 mm. Courtesy the artist.

Introduction

1

The occasion of this book and of its sloganeering title NOW SEE HEAR! is also the occasion of an exhibition. When I was invited by the Wellington City Art Gallery to organise an exhibition dealing with art and language in 1990, it seemed an ideal opportunity to extend the range of a catalogue into a book that would itself be a major component in that exhibition, would extend the range of the exhibition, would comment on it, and would have a life beyond the necessarily provisional one of an exhibition documentation.

Art has long had a special relationship with language; but particularly since developments in the early Modern period, when a range of strategies developed for incorporating words or their components in art.

Art strategies for the deployment of language have flourished recently under the stimulation of semiotic theories, on the principle summarised in Laurie Anderson's paraphrase of Ludwig Wittgenstein: 'If you can't talk about it, point to it' (*United States 1979-83*). In the United States artists as various as Joseph Kosuth, John Knight, Jenny Holzer, and Barbara Kruger, have benefitted from the reissue of language in art. In the U.K. the Art and Language team of Michael Baldwin and Mel Ramsden has continued to extend the art/language possibilities opened up also by Terry Atkinson, Ian Burn, Graham Howard, and others.

In the 1970s New Zealand experienced a flurry of interest in the Art and Language movement, particularly in the work of Nicholas Spill, Bruce Barber, and the visiting Australian artist Terry Smith.

More recently, the field has been conspicuously occupied by women: texts or their erasures have been important to the ironic arsenals of Merylyn Tweedie, Mary-Louise Brown, Julia Morison, Ruth Watson, and others. These artists recognise the power of language, and particularly the power of commandingly visual language, to write gender-privileged culture.

The theoretical and critical positions represented by such art are closely tracked by an alert media: the intertextuality of art and the popular expressions of television, film, advertising and magazines, has seldom been more problematic than at present.

In addition, New Zealand art has a singular history of the expressive involvement of language in art: the examples of Colin McCahon, Ralph Hotere, Emare Karaka, and numerous others, indicate a desire to incorporate the rhetorical potentials of language among the expressive signs of painting. The involvement of Maori artists in this context indicates another dimension: the effects of imprinting one language upon another; of imprinting a colonising language upon a land already made particular in another language; of the encounter of one language with another indigenous one whose relationship with its *own* art was seamless.

2

Art/Language strategies have flowed out into a delta of resources tapped by a wide range of agencies: by artists, by advertising, by varieties of media including particularly the electronic ones; by didactic or directional devices such as roadsigns and signwriting; and so on.

We now recognise that writing itself may be invisible where language remains implied. History paintings, for example, do not exist without their implied text — their language component is a commentary we must 'hear' while we scan their pictorial signs.

An issue of *translation* becomes vital here.

For example, in the Augustus Earle painting *The Meeting of the Artist with the Wounded Chief Hongi, Bay of Islands, 1827*, the artist and the Maori rangatira are depicted in conversation across the plane of the painting. An exchange is proposed, one we scan from side to side of the framed material, imagining as we do so the intercession of a translator 'inside' the painting's narrative. In addition, the artist himself stood outside the painting when he made it. He, too, was involved as a translator — he was interpreting this historical moment for an audience that would also stand outside the painting's moment, that would reproduce his own representational viewpoint.

Within the painting, Earle has dramatically displayed certain emblems that are co-opted to language: they are visual words. They include books, muskets, carved figures and other objects appropriated to the ethnological gaze; and a landscape that demands to be read within a tradition governed by conventions of the Romantic Sublime.

Language, although nominally silent in this painting, is involved in promoting yet another silence within the painting's frame — a silence on Hongi's side of the 'translation'. This may not have been Augustus Earl's intention in painting the encounter between himself and the rangatira; but it is an outcome of the exceptional power of the implied commentary within the painting, to direct our responses to its signs.

It was language, and particularly the language of naming, of writing upon the landscape as upon a map, of representing the land in language, of *translating* the land into English, that resulted in that land's alienation to a system of signs the indigenous people could neither see nor hear. The land they had once understood in their own language became a palimpsest overwritten by *an other* language, by systems of signs that represented the land in names, in maps, in landscape paintings, in photographs, in surveyors' codes; and ultimately in the 'stiffening' (as Paul Carter describes it) of such marks as city-grids, dams, telegraph poles, radar corridors, and other overwhelming signs of translation prefigured in Augustus Earle's painting of 1827. Of course such signs have themselves been written and rewritten — translated — by the 'Wounded Chief's' descendants. It is no longer a matter of hearing, of seeing, simple registers of privilege.

3

What is required of us, as we scan *all* such signs, is the ability to read them critically.

The delta from which art and advertising draw off their techniques for the visual display of language is, as noted above, very broad. Equally broad —

coterminous — is the capital base or ground upon which these techniques are exercised.

In viewing language — in 'seeing hear' — an important feature of critical translation, of the bringing of value and intonation to signs, involves an understanding of the economy involved. At what point, and for what reasons, do we make decisions about the values of different registers of image-making relative to their relationships to a shared economy? How is language involved with commodity-value, with aesthetic, spiritual, or art-historical values, and how do the differentiations in these values speak to us? With what kinds of attention do we listen to them, and to what extent are the values we ascribe to their discourses determined by ourselves, by the wider culture, by such forces as those at work in the painting by Augustus Earle?

These are issues of paramount interest and importance in culture drenched in visual language; 'a culture', furthermore, whose singularity as implicitly framed in Augustus Earle's historical 'meeting', has never been under greater critical scrutiny than at present.

4

This project has drawn in a wide range of writers, artists and editors; its excitement has been a result of their enthusiasm. This enthusiasm must be counted as the project's major success: during the hard work involved, Gregory Burke and I have been immensely grateful for it.

There are of course disappointments to record: our failure to complete interviews with Emare Karaka and Robyn Kahukiwa; the need to allocate exhibition — rather than book — space to a range of topics such as design and layout, magazine production, writing for film and television, and others.

We hope, however, that such omissions and suppressions will rise troublesomely from this book, as the conversation of Hongi and Earle continues to rise from the image that both wraps the book and haunts its interior.

Ian Wedde
March 1990

Alex Kotsky, from *Apartment 3–G*. Field Enterprises Inc. 1968.

The Frame

Damien Wilkins

What, after all, is the pleasurable purpose of this calling if it isn't music? What we agree to call voice? I can't remember why I read comic books, but I suspect it was for the noise that racketed in my inner ear . . .
Geoffrey Wolff, 'An Apprentice', in *Best American Essays 1989*

Who is it here who says 'Enough!'? Or who is it that thinks it? Those little bubbles trailing off the frame signal that the word is clouding inside someone's head, don't they? We're no boobies, we know the conventions in comic-land, we're conventioneers: thoughts puff like smoke from a blanket. We read like red Indians. But whose head? The head of the person who owns the lacquered nails and the sharp pencil perhaps? The woman named Helen Cross who did the drawings — is that her bold black wish, her leading on the balloon, the sharp tip of her pencil which has somehow cast its own shadow over its own drawing? Look at that wrecking our view of the frame. Or does the word belong inside the head of the man named Laurence Clark who wrote the comic? Did he write this ending, give Helen Cross that one-word thought? Did she agree to it? Is her hand really so slender or did she draw it like that as an act of vanity? ('Helen, your hands are so beautiful,' says the Art Director at the interview.) Or did Laurence Clark script a hand like that — a perfectly-formed hand, showing the sheen off a painted fingernail. There is a drawing of a glamorous woman with a gun on the page over which the drawing of a hand hovers. Maybe Laurence Clark wrote that there should rightly be a certain correspondence between the drawing of the hand holding the pencil and the hand we might imagine of the drawing of the glamorous woman pointing the drawing of the barrel of the gun in our faces. Why? Is the drawing of the pencil really a gun? ('The woman has drawn a gun on me,' the Art Director says, clamping a hand [his own] over his mouth so that the woman named Helen Cross will be forced to read the words, floss on a candy of a breeze, a quarter inch above his head if she is to get his drift, buying the Art Director some precious time.) When Laurence Clark wrote this about his idea for the drawing of the hand holding the artist's pencil, the artist, Helen Cross, with her real pencil, on which such a drawing was to be based, in her real hand, on which such a drawing could only be based if it had that certain correspondence which Laurence Clark had written about, pointed it at Laurence Clark as a bold black word began to form inside her head, not as an idea but as a picture of that word followed by an exclamation mark inside a balloon inside her head. ('A fucking compliment and she draws a gun,' thinks the Art Director. He has withdrawn his other hand from on top of the hand of Helen Cross ['Cross?' he thinks in the next bubble, 'Fucking M-A-D more like' fills the next] which he had been compliment-

ing and stroking.) Laurence Clark does not lack prescience. He has been around cartoons long enough to be able to read the signs, the asthma in the air, check quickly on the balloons leaking soundlessly

but not wordlessly from the heads of people he has excited or upset. It is like feeling a flat in the back left of the Holden. But wait! Has not Helen Cross the perfect hand holding the perfect pencil after all? Why yes! We breathe relief. Or rather a pictogram breathes it for us across a simple few frames: we mop our brows, we wring our hankies and little drops of something fall towards whatever it is we are standing on. We imagine the drops being collected by a woman such as Helen Cross for future use in comics where perhaps a dash of aftershave has been thrown towards a cheek, a splash of urine suspended over a bowl, or a snowflake melts just so from the crossbar of a soccer goal in a comic strip such as the famous 'Billy's Boots' about which I still dream. Yet on the knuckle of Helen's hand there is a small triangular moment of white skin, a scar from an accident in childhood about which Helen Cross can now recover few details, except that perhaps it happened in Spain, in straw, while she had been jumping, though all these words are very faintly written and largely obscured by the dark weather of other words. The tiny scar is not a worry to Laurence Clark anyway. It is a white blemish and will be invisible on the white paper. ('I hate it when I read in books that so-and-so's face went as white as paper,' the Art Director muses heatedly [though he figures his own has maybe gone a shade nearer woodchip A5]. 'Paper means pictures. Everyone knows that. Lines, type, boxes, inserts, ink. It isn't some dumb window. Look at the shape, the frame that won't let your line wander like a child but is choked with return keys, has our pudgy infant arms in a harness. It's thinking it's a page already!' Helen, meanwhile, is busy reading all these little thought-bubbles — it's like being in a big-game boat trailing a school of sprat. Above her own head, above the gun she holds on the Art Director, are the words 'This creep is hyperventilating.') At the exact time that Laurence Clark is saying to Helen Cross that he has no more story-line in him, Helen Cross is saying to Laurence Clark that she has no more drawing in her. You will have to find another job, they tell each other simultaneously. Snap! Coffee? they chime. Absolutely, they chorus. Did you remember to put the milk bottles out? ('Name your s.s.salary,' says the Art Director to Helen whose lips part a little, for this is his last overhead bloom: his mind is now a blank. She pumps him full of lead. He turns grey. Hey! The grey of paper from which a smudge of carbon has recently been erased.)

Laurence Clark, from The Frame. In Strips No.20 1983. Pencil, ink, letratone on white card. Courtesy Laurence Clark.

DAMIEN WILKINS

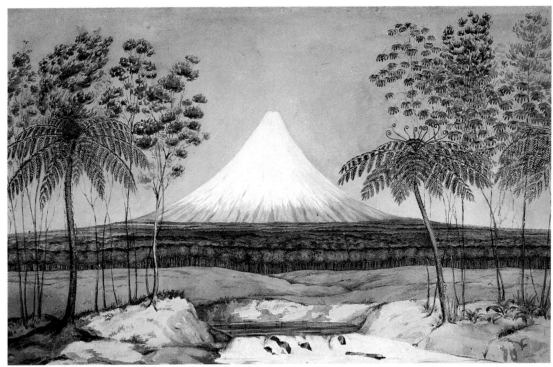

Charles Heaphy, *Mount Egmont from the Southward* 1840.
Watercolour, 460 x 660 mm. Courtesy Alexander Turnbull
Library, Wellington.

Framing Taranaki

Gregory Burke

Ralph Paine, *Matrix, Reference, Index* 1988 (detail). Gouche, ink,
coloured pencil, conte crayon, collage. Photograph Neil Price.

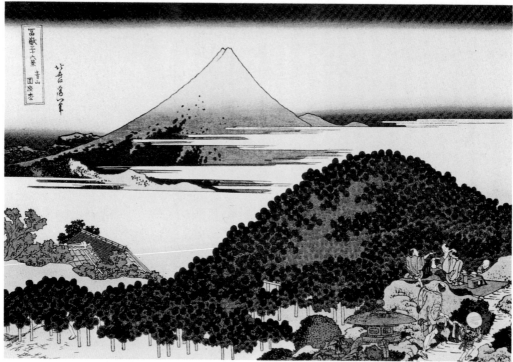

Katsushika Hokusai, *View from Enza Pines at Aoyama* c. 1825.
Woodblock print. Published by Haikusha Publishing Co. Ltd.,
Osaka, Japan.

Mainly I was led to them, the casinos of aluminium,

by the gift of eyebright, whose hollow core contained

a vision of the coast and on it the cone shape,

like a pile of drenched wheat, of Mount Taranaki.

Christopher Perkins, *Taranaki* 1931. Oil on canvas, 690 x 610
mm. Courtesy Auckland City Art Gallery.

David Eggleton, 'Painting Mount Taranaki' in *South Pacific
Sunrise*. Penguin Books (N.Z.) Ltd., 1986, p.75.

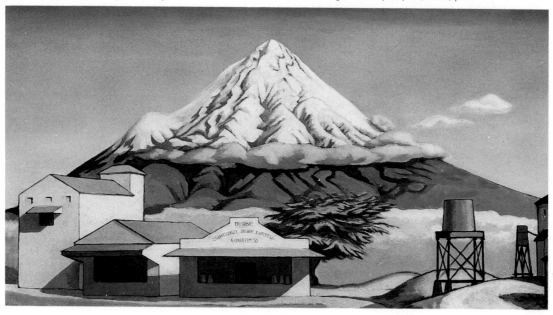

Colin McCahon, *A Painting for Uncle Frank* 1980. Acrylic on canvas, 2330 x 3000 mm. Private Collection. Photograph: Neil Pardington.

Laurence Aberhart, *Taranaki (The Heavens Declare the Glory of God) 14 May 1986*. Silver contact print, gold and selenium toned, 195 x 245 mm. Photograph: Neil Price.

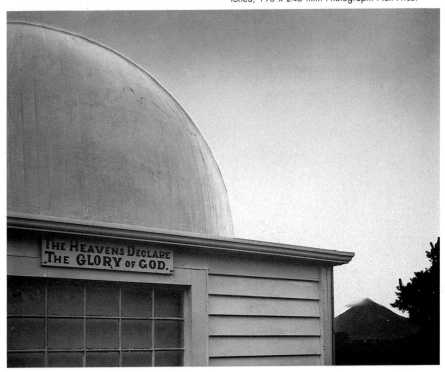

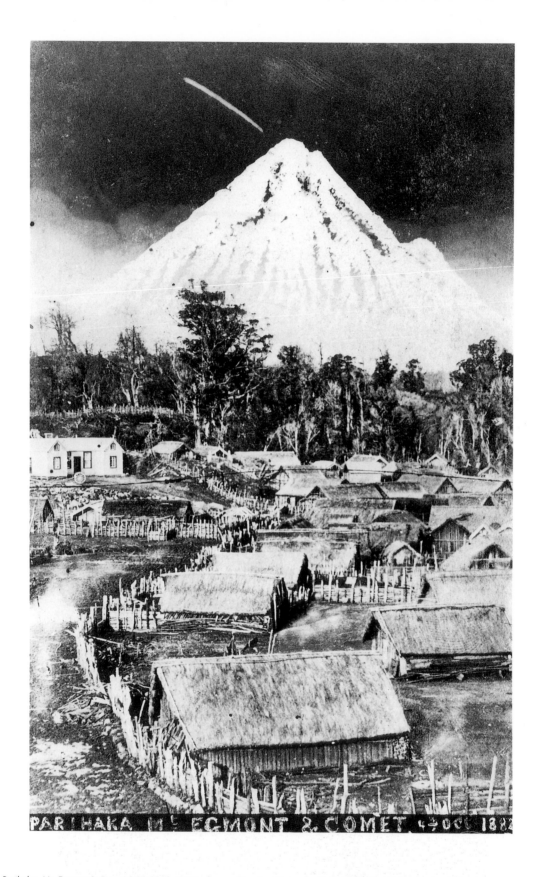

Parihaka, Mt. Egmont & Comet 4.10.1882. Artist unknown. Courtesy Alexander Turnbull Library, Wellington.

Mt Egmont, n.d., artist unknown. Courtesy Alexander Turnbull
Library, Wellington.

National Publicity Studios, *MOUNT EGMONT, Taranaki*
c. 1940s. Black and white photograph. Courtesy Alexander
Turnbull Library, Wellington.

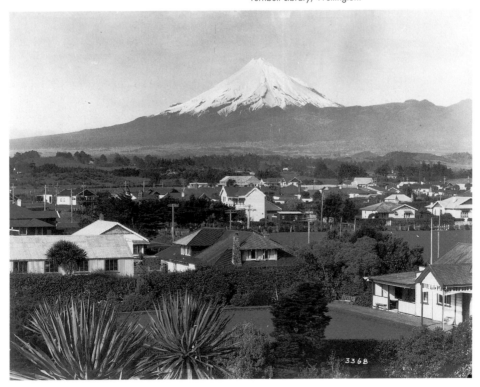

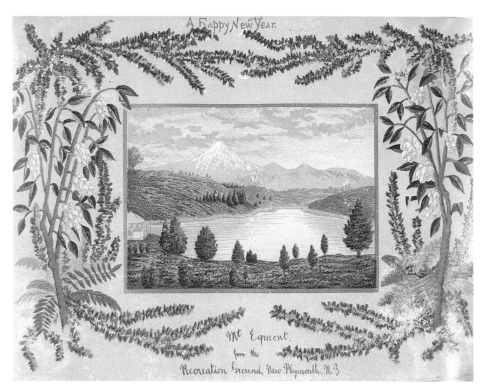

Archibald Duddington Willis. *Mt. Egmont from the Recreation Ground, New Plymouth*, 1886. Chromolithograph 104 x 144 mm. Courtesy Alexander Turnbull Library.

Scenic View n.d., artist unknown. Painted and scalloped whalebone. Collection Jim and Mary Barr. Photograph Gregory Burke.

AUSTRALASIAN UNIVERSITIES LANGUAGE AND LITERATURE ASSOCIATION

VICTORIA UNIVERSITY, WELLINGTON

EXAMINATION FOR ENGLISH ACADEMICS

IDEOLOGY A

January 27-February 2, 1977 ANSWER ALL QUESTIONS

1. 'Comment is free but facts are sacred' (C.P. Scott, editor
 Manchester Guardian, 1926).
 In which ways is this remark
 (a) a lie, and
 (b) a statement in bourgeois ideology?
 In which ways has belief in this statement made newspapers
 ideal forms for propagandising bourgeois ideology?

2. The word/image interplay of newspaper 'art' is free from the
 specialist restrictions of literature and visual art, but is
 equally ineffective at promoting social freedom.
 What does this tell us about the bourgeois/bureaucratic
 capacity to annex creative form and, thereby, annex creative
 content? How should this annexation be fought?

3. William Blake would have despised the profession of Eng. Lit.
 and you for participating in it.
 Does this disturb you? If so, how? If not, why not?

4. Given that you are demonstrably failing to project 'moral
 health', and given that you in fact embody and project a
 limited form of high cultural exegesis which is anti-democratic
 and distortive of the creative capacities of your students,
 why do you go on?

5. Are not Maori, Islander and Aboriginal languages languages?
 Are not Maori, Islander and Aboriginal creative expressions
 literature (or equivalent)?
 Why, then, are they not addressed at this Congress?

6. List your contributions to New Zealand and/or Australian
 culture since your appointment, and demonstrate without
 ambiguity how they contributed to the material wellbeing
 of the New Zealand and/or Australian working classes.

RAISE THESE QUESTIONS THROUGHOUT THE CONGRESS. SUBMIT YOUR
ANSWERS TO YOUR STUDENTS DURING THE FIRST WEEK OF FIRST TERM 1977.

Terry Smith, *Australian Universities Language and Literature
Association* 1976. Black and white photopanel, 595 x 425 mm.
Courtesy National Art Gallery, Wellington, and the artist.

Translation and The Treaty

Maarire Goodall *Ngai Tahu, Ngati Mamoe*

I

The Treaty of Waitangi is an active prism, taking two light beams of different colour, merging them internally to be again emitted brighter than either incident light. The combined beam is more complex, more interesting, carries new possibilities and strengths. But there the analogy is lost. Each first light from the dawning is still there on analysis, but the Treaty prism has done something irreversible.[1]

Any agreement arising from two cultures and binding their members to set out upon a joint venture that embodies them both, must raise questions of 'translation'. The Treaty does that.

I have not embarked on yet another translation of the Treaty from Maori into English, or vice versa. More formidable scholars have scoured the language for possible meanings for 'translation' of the Treaty.[2]

But, a linguistic approach is no longer the most relevant.

The more important thing is *the translating power of the Treaty itself*. It translates Pakeha people into a new bicultural country,[3] and at the same time it translates old Maori society into a new joint venture which we expected to be beneficial. By the Treaty we admitted outsiders to this land, and by *consent* (not by conquest) the rules which were to govern that new society were stated and implied. Our two ancient cultural streams, Polynesian and European, are translated by the Treaty into a new society in Aotearoa/ New Zealand. Now Maori and Pakeha, the Treaty is our translator.

The Maori text is primary in certain respects, and is the text signed by most Chiefs.[4] (See page 33) The Waitangi Tribunal is required to have regard to *both* texts, and to resolve any differences between the two, before reaching conclusions as to any breach of Treaty principles alleged in a claim before them. 'Official' versions of the Treaty for legal purposes are given in the Tribunal's legislation.[5] The first drafts of the Treaty were in English (now lost[6]) and were 'translated' into Maori. The discrepancies[7] in this fundamental process in our Nation's history have been analysed by others already,[8] and are not repeated here.

What is more, we know well that some important *acts of translation* remain incomplete. That must mean, and does, that despite progress so far there are serious defects in our joint society.

The Ngai Tahu meeting house on the Arowhenua marae is named *Te Hapa-o-Niu-Tireni*, as a standing indictment of unfulfilled promises in the Treaty of Waitangi and in Kemp's and other deeds alienating our land. The earlier Wharenui on Otakou Marae, Otago Peninsula, was named with similar intent. The house's name *Te Mahi Tamariki* (originally *Te Mahi-a-Nga-Tamariki*), reminds us that the claims and grievances which were unresolved in our elders' lifetimes, became our responsibility in following generations. The strength of Taangata Whenua is that they *are* the people of the land; Governments come and go, other citizens may emigrate, but Taangata Whenua continue. *Whatungarongaro he tangata, toituu te whenua, he kaainga.*

Sooner or later responsible Government must come to terms with the requirements of Justice. Society is impelled to do that for its *own* good, not for the favour of the disadvantaged at all. Maori victims of injustice are in a sense only catalysts, who give an unjust society the opportunity to heal itself. Too much delay induces crisis. At this time, I believe, we have reached this stage in New Zealand.

Courts can administer only Law, not Justice. If good law and justice cannot be obtained through Parliament, eventually someone will ask, Why do we need it? Civil disorder may supervene. Parliament must be permitted to respond meaningfully to what the country needs, or it perishes. Ironically, 'democracy' could yet destroy Parliament.

Teeraa te uira te waahi rua i runga o Pooneke,
I te whare miiere, Whare pou i te ture,
Pou tinihanga,
E hara ia nei he tohu no te mate ?
Kia miiere ko Ngaati Maaori, uri tangata.
Whare waawaahii i te Wairua o te Tiriti,
Kawenata tapu i herea e ngaa Maatua,
Ki te remu o te kahu o Wikitoria.[9]

So now Maori, and our Pakeha friends, are listening again to the guiding calls of our tohunga, looking back at the wake of our great canoe, to see how we should swing our paddles to correct our course for

ordered past, from which useful information is available to help guide us further.

On a voyaging canoe, the navigating tohunga would sit through the night (or overcast weather) facing the stern, studying the wake and its interaction with current and wave patterns, to estimate course changes needed to obtain desired heading corrections. Before our Euro cousins dismiss our methods, they might recall that Polynesians were traversing at will vast open oceans far out of sight of small islands, at a time when Europeans were able only to tentatively sail around continental coasts, close enough to permit a scramble back to safety.

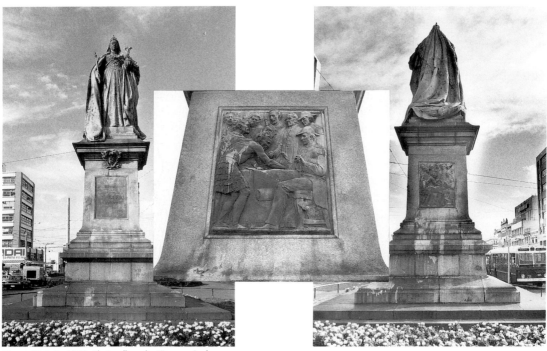

Queen Victoria 1990. Photocollage by Gregory Burke

tomorrow and beyond. A tohunga is an expert person. To Maori the imagery of past and future is clear, but in a way that confuses our Pakeha mates. We refer to past events as *ki mua i ahau*, 'in front of me', while . . . *ki muri* . . . means 'behind (me)' and refers to the future. Pakeha have a contrary image in their minds, and perhaps misinterpret our high regard for the past as a guide to the future. I can see and know the past, it is spread out before me, I can see what consequences flowed from which causes. Events of the future are behind me, still unseen, until my arrow of personal time carries me further to see those things unfold before me to join the past and the known. So, we observe an inchoate future translated into an

While Taangata Whenua society was established many centuries before 1840, the constitutional venture upon which we agreed with the British has run for only 150 years. There is still considerable doubt how it is going to turn out.

II

Translocation is only one aspect of a translation, and translocations can be reversed. Some Maori have been tempted to suggest current problems might be solved if the more arrogant migrants here would just translocate themselves right back again and good riddance. This ignoble thought seemed especially attractive when it emerged that one of the loudest

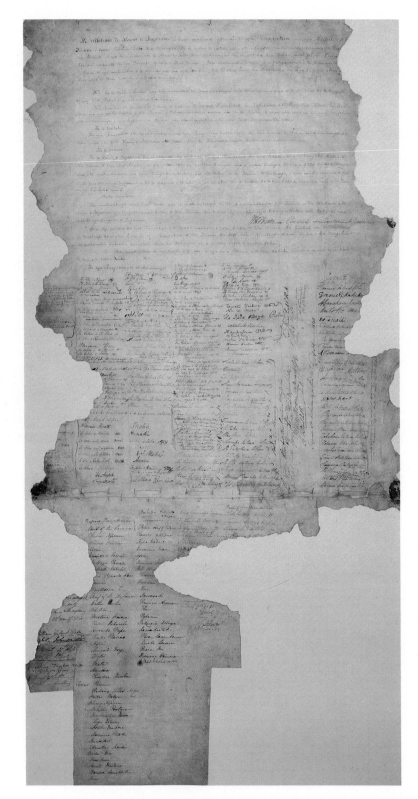

Te Tiriti o Waitangi: The Treaty of Waitangi 1840. No. 1. Waitangi Sheet. Courtesy National Archives, Wellington.

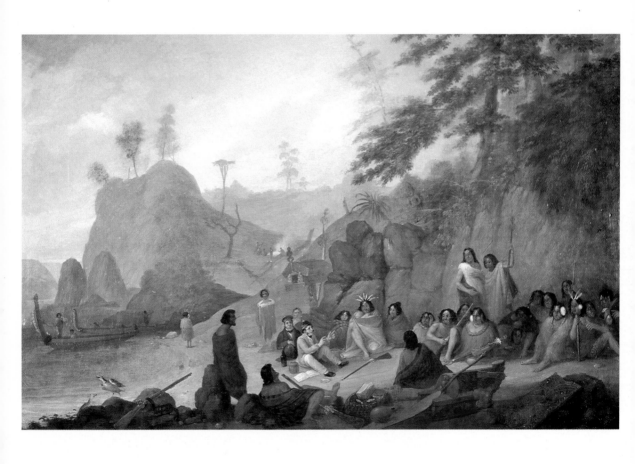

Augustus Earle, *The Meeting of the Artist with the Wounded Chief Hongi, Bay of Islands, November 1827*. Oil on canvas, 610 x 962 mm. Courtesy Alexander Turnbull Library.

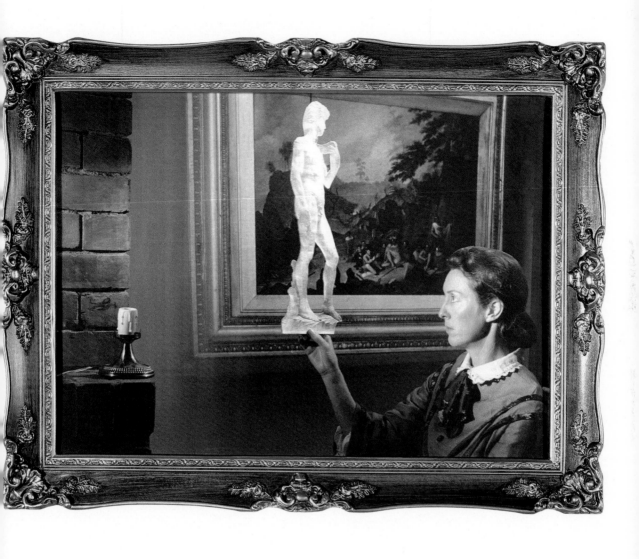

Margaret Dawson, *Colonial Vision* 1987. Colour negative print,
gold frame, 627 x 830 mm. Julia Morison and John Hurrell,
Christchurch. Courtesy the artist.

Robyn Kahukiwa (Ngati Porou Te Aitanga – a – Hauiti), *Mo Irihapeti tenei karanga* (This karanga is for Irihapeti) 1988. Diptych of alkyd oil, paper collage and oil stick on canvas, 1985 x 2635 mm. Courtesy the artist.

voices of the 'One New Zealand Foundation' (especially on the anti-Maori fishery campaign) was no more than an overstayer who hadn't even bothered to apply for citizenship after nearly two decades in NZ.[10] But he had not hesitated to accept valuable fishery Quota handed out (wrongly we say[11]) by the Government (which he then sold for cash). The *emigré* freely lectured us on what we must do in our own country about fishery, race relations and the Treaty of Waitangi. A monocultural TV news system largely ignored knowledgeable and factual contributors on this major controversy, gave prominence to prejudiced presumptions about our fisheries and the Treaty and insisted on broadcasting a stream of ignorance and bigotry from selfish interests seeking their own profit from exploiting resources guaranteed by the Treaty to the Taangata Whenua. If the original owners dare to criticise this broadcasting setup, they are dismissed as querulous ungrateful stirrers. Something lost in the translation here also?

Maori have again become sufficiently numerous in their own land to say, as we do now, that we cannot much longer tolerate political, social, legal and economic disadvantage of the sort we have suffered during most of the past 150 years. It cannot be all-Maori, most can see. What worries is that so many still fail to realise that it cannot much longer be all-Pakeha either.

But the view (of a small minority of Maori) that the pre-Treaty Maori regime should resume dominance, and the intruding British culture be suppressed, is also a mistake. We're definitely in this one together. There no longer is any choice of either Maori or Pakeha dominating.[12]

The Treaty of Waitangi is not a Guilt-Edged Investment for those holding wealth and power, nor is it merely a Rat-Nibbled Nullity.

The Treaty of Waitangi was an exchange of promises and duties by which we are committed to finding accommodation for each other within a new dyadic society which would include a major part (not all) of the cultures of the two partners. These parties in 1840 were Maori Tribal society and the British system of government represented by the British Crown.

It might be helpful to regard Article Three as the part of the Treaty especially concerned with relations between individuals and the State, with Crown guarantees of individual liberties, and between citizens. The remainder of the Treaty deals with the much larger *prior* question of relations between sovereignties, between Tribes or Tribal Nations and the Crown, between mutually recognising sovereign entities. Much as current Red Neckery likes to ridicule the idea, the fact is undisputable that the British Crown did recognise Maori New Zealand long before 1840 as a sovereign entity, with which Britain could, indeed must, deal by solemn Treaty.[13]

I am taking a differing tack, but essays like this usually concentrate on Article Two which specifically reserves to Maori Tribes their Tino Rangatiratanga, and their tribal property rights. In Article Two also, for one type of property *only*, land, Maori granted the Crown the first option to purchase. That 'pre-emptive right' was designed to prevent differing types of land titles for British subjects arising. Many Maori considered that if the Crown failed to purchase at a price and on terms agreed by themselves (as guaranteed in the Treaty), they could then sell to another. Pakeha Governors set their own very low prices (resale at vast profit was to finance colonisation) and denied any Maori right to sell elsewhere. It quickly became clear many Chiefs would have refused assent to the Treaty if this interpretation had been put before them. There was serious mistranslation here, which caused much conflict.

The most important problem with mis-translation of Article Two is that many Maori believed, and still do, that *they* were not 'subjects' of the Crown, *Britons* were, and that Maori 'sovereignty' (for which in fact 'Tino Rangatiratanga' would be the best translation) was preserved, while the Kawanatanga was merely authority for the Crown to control its own immigrant subjects in New Zealand. Dispassionate study of both Maori and English versions of the Treaty has not dispelled this interpretation, despite abrupt political dismissals so far. Good reason for this belief is found in Hobson's own words during debate at Waitangi before the Treaty was accepted. He told the Chiefs that British laws could not be enforced outside British territory, and their only hope of protection against unscrupulous Europeans was to sign the Treaty: '. . . you will be stripped of all your lands by a worthless class of British subject, who will consult no interest but their own, and who care not how much they will trample upon your rights. I am sent here to control such people, and to ask from you the authority to do so.' This speech

persuaded many of the Chiefs to accede to the Treaty.[14]

In the First Article, it is usually assumed, Maori agreed to cede their sovereignty to the British Crown. The Waitangi Tribunal avoided challenging this unqualified assertion openly in its recent Reports (e.g. on the *Orakei* and *Muriwhenua Fishing* and *Mangonui* Claims), and the Court of Appeal (in the landmark case *NZ Maori Council* v *Attorney General* 1987) has clearly confirmed this cession as now being the law of New Zealand.

However this may be an interim conclusion, because Article One ceded sovereignty only upon stringent conditions, expressed in Article Two particularly, which are now under vigorous litigation. Of course no Courts or Tribunals can undermine the sovereign authority that gives them existence, but they may be able to point out equitable restraints on power.

'Sovereignty' of the British (now New Zealand) Crown in New Zealand is very different from the corresponding sovereignty the Crown enjoys in Britain itself. Since it is held that sovereignty resides in Parliament in New Zealand,[15] it must be that the constitutional role of our unicameral Parliament also differs significantly. Also, the Sovereign in New Zealand has a proxy Governor-General, whose powers (at least potentially[16]) seem to exceed what the Queen could herself do at home in England! I've heard Parliamentarians themselves say both 'Parliament is supreme and sovereign', and that Parliament and the Crown are quite separate entities, on the grounds that 'We [Parliament] have killed the Crown, during history, so we obviously must be quite separate' (this remark was made in the Select Committee hearings for the Maori Fisheries Bill, 1989). If Parliamentarians really believe both these things at once, it must mean they see no powers of sovereignty now remaining with the Sovereign, her Crown or her proxy Governor-General!

But recall, those acts of regicide all occurred in Britain, and we are somewhere else. In New Zealand Parliament has never killed the Crown, but soldiers paid by the Crown (suborned by the Settler Parliaments) have killed us! *Despite the assurances of Article Three.*

I believe that powers of the Crown in New Zealand, and of Parliament, are constrained by requirements of the Treaty of Waitangi. It must follow, I think, that many actions taken in the name of the Crown in New Zealand during the past 140 years or so, and given sanction or a false veneer of legality by Parliament, have been quite unconstitutional and illegal. In due time (I doubt I shall live long enough to see my words proved right) the Courts will recognise these mistakes and so declare, as cases are progressively brought to trial. I think Parliament eventually will recognise a mixed sovereignty originating from both Maori and Crown.

The Treaty is not, as racist propaganda claims, fixed in 1840, nor does it bind us in an irrelevant time-warp of the past. As Mr Justice Somers said in the Court of Appeal, 'Everything then was in the future'.[17] The Treaty defined a beginning and set rules for developing our conjoint society. It is not a simple contract of fixed terms, but instead states principles to guide new development, and those principles evolve with us as we progress, becoming important to us *more*, not less, as time passes. As the Chief Judge of the Maori Land Court has said, 'The principles of the Treaty are not diminished by time, *rather it takes time to perfect them*'.[18]

In all these respects the Treaty is always speaking. Past grievances will in time be cleared up and settled fairly, we hope, but it is a mistake to think you can then forget about the Treaty. New problems continually arise, and we shall have to appeal to the Treaty for guidance in solving them. This requires that there be a continuing series of efforts at intercultural translation, by which we can draw upon the content of our own culture as Taangata Whenua, and also upon the culture *translocated* here by the British part of the partnership, and increasingly also from the cultures of the many other peoples now entitled to become New Zealanders. From these disparate sources we infuse our society with life. That partnership between Taangata Whenua and Taangata Tiriti invests New Zealand with meaning and substance. Modern Aotearoa grows from that vision and good intent, not from any miserable treachery to supplant one culture by another.

III

Looking at the Treaty, there is difficulty right at the beginning. The fact is, 'The Crown' and 'Maori Tribes' have both evolved (to differing degrees) since 1840, and so has the Treaty of Waitangi.

The Treaty partners are complex, not yet fully

defined. 'Maori' really denotes the *Taangata Whenua Tribal Nations* who treated with the Crown. On the other side, lawyers and other highly educated Pakeha friends struggle to say something meaningful about the 'Crown' and what it might mean. Most simply don't know what the Crown *is* in New Zealand, and usually overlook that the 1840 British Crown signing the Treaty is quite different from the descendant New Zealand Crown today.

Hence many are quite sure the Crown 'owns' the land and natural resources of New Zealand, and the sea fisheries. They think 'sovereignty' means 'proprietary ownership' of all natural resources, land, seas, rivers, forests, even the electromagnetic spectrum! (Bill Sutton MP Hawkes Bay, Letter to the Editor, *Airwaves owned by the Govt, not Maori*, Evening Post, 20.12.89, Wellington.) He bases that assertion on the electro-magnetic spectrum not being a material substance and so, he thinks, it can't be a property, and so it can't be protected by the Treaty. (Wonderful ironies! He's achieved a position better than his Maori Fisheries Bill efforts, now it's even less than one-eyed.) The point is missed that Maori had no objection, until Goverment created a new 'property right' in one of the natural resources that we hitherto had all shared in the public domain, and then started flogging off the new 'property' to private bidders, the Treasury pocketing the profits unilaterally. Maori had shared the natural resources of this country, without strife. We object when the present Government converts public ('Crown' perhaps) properties which were held in trust for the benefit of us all, into private properties sold for profit, excluding forever the public interest in common that Maori believe the Crown was charged to hold for all New Zealanders in trust. The problem with fisheries being converted to ITQ properties privately held is of the same character in major respects. The Government has subverted Crown trustee into Avaricious Huckster. It is astonishing that, after four years of constitutional violation by the Treasury and Cabinet, Maori still seem to be alone as objectors to what the Government has been doing. Are Pakeha really not caring, or do they still fail to understand what is being done to their country (as well as ours)?

We have experienced a Treasury and Government who think they totally possess these things and can dispose of them, without mandate from the electorate or the original owners, all on authority they think resides in a Crown Warrant to exercise 'Kawanatanga'. Surely there has been some large error of translation there!

Maori still see authority in the Crown. Ironically, Pakeha do not. 'The Crown' is a term not yet fully defined in New Zealand, in my view. Lately Government MPs have taken to regarding themselves and the Caucus Majority as 'The Crown' at Select Committee hearings. Perhaps they hope to follow a prominent example of their predecessors and award themselves Knighthoods. Cabinet Ministers also like to assume *they* are 'the Crown', because they hold Crown warrants.

The NZ Crown cannot be just the Executive, in my view. New Zealand is quite different from Britain. Our Treaty is in similar tradition to Magna Carta in restraining the Sovereign's prerogative, but historical parallels are misleading and by definition *parallels never converge* to get to the point. I think the 'NZ Crown' must include several elements, including both the Executive Council (Cabinet Ministers plus Governor General), and the Courts (definitely not part of the Crown in England). It should perhaps[19] also include the unicameral New Zealand Parliament, the supposed seat of sovereignty in this country.[20] I reach these conclusions quite pragmatically, since without the Courts in NZ there can be no restraint upon the unbridled power of the Executive.

The dogma of Parliamentary supremacy and sovereignty does not translate correctly from England to New Zealand. The doctrine's justification in England was to restrain the Executive (Crown), but in New Zealand it has been perverted to instead permit unbridled power in governance by the Executive Council. In its worst manifestation in the Muldoon years it was obvious that the NZ system *in extremis* permits all power to be exercised by one man, without effective restraint. The doctrine in NZ is overdue for revision, which must mean a sharing of power with other branches of government, especially the Courts and Parliament.

The British Crown bound itself as 'The Crown in New Zealand' by committing the honour of the Crown in the Treaty of Waitangi, which itself requires restraint of the prerogative Crown powers. So: *'Executive restraint by Treaty principles'* must be a necessary attribute of the New Zealand Crown.

MAARIRE GOODALL

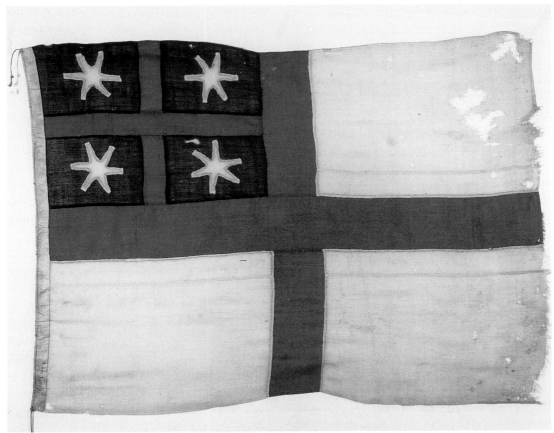

New Zealand Company Flag, sewn on board *Tory* 1839; variant on design by Rev. W.H. Williams for United Tribes of New Zealand 1833. Aquired by National Museum of New Zealand in 1967. Courtesy National Museum of New Zealand, Wellington.

Anything less would demean the honour of the Crown. Maori rely upon that honour, and so do Pakeha who understand their own homeland. Without honour, the Crown cannot be respected. If honour is to be abandoned, it is my hope that I do not live to contemplate the consequences.

To identify 'the Crown' in New Zealand we must look to who exercises effective power of government. This means we must sweep aside English pretences such as the mysterious non-existence of Cabinet, despite the fact that everyone knows Cabinet Ministers in Executive Council, using the Governor-General's signature, are currently exercising all the governing power there is, *de facto*. Since our Parliament is unicameral and totally dominated by the executive Ministers within the ruling party caucus, Parliament is only rarely allowed to rationally amend controversial legislation, and is almost a nullity at present in New Zealand. Mr D. Lange, Attorney General and recently retired Prime Minister, himself confirmed on an Australian TV program recently the completely unbridled power (as he saw

it) of the Executive in Cabinet to exercise the powers of government. The program was not broadcast in NZ, but videotapes are circulating.

IV

Our 'One New Zealand' critics deride us for our living evocations of the past, of our cherished ancestors; they tell us we are locked in an 1840s time-warp irrelevant to the future, and denounce our memories of unfinished business and wrongs still to be righted. Maori have too much past, some think.

But, *Pastlessness* is the curse of Pakeha.

Pakeha are the result, the beneficiaries (sometimes perhaps also victims), of genetic translation. I refer to those men, women and children who lack Maori heritage but know they should nonetheless in every way belong here, in the land of their birth. From the actions of their ancestors, their antecedent chromosomes — books of inherited European experience — were transported here, and translated themselves into New Zealanders.

The Treaty itself is Translator. If it were not for

the Treaty, Pakeha would be something else.

The meaning of 'Pakeha' is defined by contrast with 'Maori', and by actual usage amongst themselves, changing with time. The meaning is I believe unstable just now. Many Pakeha consider the term now belongs to those born here, as distinct from those born elsewhere, and I support that.

Originally 'Pakeha' referred to Europeans sealing, whale fishing, trading, preaching or settling on our shores. Most were British persons, but long before the Treaty we were in close contact also with many other Euro foreigners from Norway, Portugal, Denmark, Spain, America, and elsewhere. There were Asian and Melanesian contacts as well. In the far south, at least, we have a few American Negroes, Australian Aborigines, and American Indians who came here and, like the Europeans, intermarried and translated their genetic contributions into our Ngaai Tahu whakapapa books.

Recently a major (but ostentatiously ignored) Report sought to popularise the idea that we could call all these people 'Tauiwi'. The aim was to distinguish them from Taangata Whenua, without using that contentious word 'Pakeha' and upsetting those who have convinced themselves it is insulting and derogatory. I disagreed because it seemed a cultural cringe, a *mis-translation*. 'Pakeha' is not derogatory at all. We should not give in to the 'One New Zealand' school of arrogance when it sets out to redefine our language. Besides, tauiwi is good Maori which already has meaning and it doesn't help us to have that word hijacked from our language and diverted to mean something else. That just diminishes our Reo, a sacred taonga, for the appeasement of self-misguided Pakehas. Tauiwi to me means 'a person visiting (my home or marae) from another place', and I don't know another strict equivalent. Tauiwi applies to any race, including Maoris of another Tribe, not just to Pakehas, or to 'white people'.[21] Tauiwi means 'strangers', and Pakeha are *not* strangers. To most of us they are relatives.

It is required in any translation to arrive at a new understanding by reference to the original. So it is that 'Other People' cannot simply arrive in New Zealand and define themselves. 'Pakeha' can only have meaning in New

Ralph Hotere, *This is a Black Union, Jack* 1988. Lithograph and crayon, 533x380mm. Courtesy Janne Land Gallery and the artist. Photo: Neil Price.

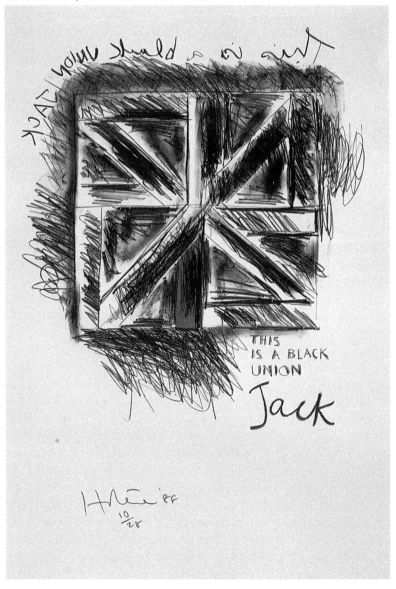

MAARIRE GOODALL

Zealand by contrast with, and by reference to, the Taangata Whenua. As Dame Joan Metge noted (*Dominion*, April 1989), 'Pakeha' is a word that both distinguishes and bonds together our two peoples in partnership. It simply is not possible, as claimed by Counsel for the Fishing Industry before the Waitangi Tribunal,[22] for the newcomers to *redefine themselves* as 'tangata whenua'. The Fishing Industry lawyers and 'One New Zealand Foundation' apologists alleged that they had acquired status as old settlers, became entitled to call themselves 'tangata whenua', and so had the same rights under the Treaty as Maori! They implied the term is only relative or quantitative, rather than signifying a difference in kind. Surprisingly, even a respectable professor of political science commits the same error.[23] On similar lines, we have the 'blood fraction' arguments, which so fascinate Pakehas, but entirely miss the Maori point.[24]

Some commercial interests will put forward *any* argument to avoid the plain meaning, or true translation, of the Treaty of Waitangi. The Treaty is altogether too plain for them to stand up to, much too clear in its language; it cannot be dodged.

Thank God the Treaty was not written by lawyers![25]

Taangata Whenua in fact, are the only people here who *have the right to define themselves*. Theirs is the priority in this land. They alone need make no reference to other peoples now here, before describing themselves and defining who they are. *All* later arrivals after the Treaty, are here legally only because of permission granted in the Treaty and they can define themselves properly only by reference to the Treaty itself, and by referring to the people with whom that Treaty was made.

When the basic translating role of the Treaty is acknowledged, the best description for people other than the Taangata Whenua, that is non-Maori (of all races), might reasonably be *Ngaa Taangata Tiriti, People of the Treaty*. It is only because of the Treaty that non-Maori people have any right to be here on a permanent basis. The Treaty provides their tuurangawaewae, signifying a place where a person *has a right to stand*, to be himself or herself, to take a proper place in society. A precious thing indeed, not something to be granted lightly. Only Taangata Whenua can possibly grant tuurangawaewae to anyone else, you cannot award it to yourself. We consider all immigrants should be required to sign a

declaration of acceptance of the Treaty of Waitangi before entry. They would then know where they were, and know their proper place next to both Maori and our indigenous Pakeha! *Submissions by the New Zealand Catholic EJD Commission to the Select Committee on the Immigration Bill, 1986* (Manuka Henare, 12 November 1986, p. 13), recommended as one of the Bill's 'Principles of Immigration policy': '…that immigrants to Aotearoa (New Zealand) have an understanding of the bicultural partnership embodied in the Treaty of Waitangi'. The strident disruptions indulged in during the Fisheries debate, particularly, have persuaded me that something more definite is required. The United States, for example, makes much more stringent demands of immigrants before admitting them.

V

All valid Government depends for its legitimacy upon consent of the governed. The English have not, historically, been great fans of this simple dictum, preferring the pretences of absolute monarchy or superior force of the State. In their own country the consequences of baronial revolt and Magna Carta, and persistence of their representative bicameral Parliaments over some centuries have ensured the British themselves enjoy a fairly well balanced constitution, with arbitrary 'prerogatives' of the Crown (or State) well controlled. But when the Crown went voyaging to impose itself on other peoples it often left such good behaviour at home. In America it took a bloody Revolution to correct the position; in many other British Colonies there has been greater or less strife to acheive that fundamental Assent of the People.

New Zealand had an unusually sound beginning embedded in the Treaty of Waitangi, which explicitly bound the Crown. And like it or not, we say the Treaty made sovereignty of the British Crown *conditional* upon certain requirements being properly observed, especially those detailed in Article Two.

But twenty years or so after the Treaty things went rapidly wrong once the settler Governments got free of the constitutional restraints held in London. They called it 'responsible' government, but it was constitutionally irresponsible. Under the Constitution Act[26] white settler minority governments, acting without assent of the governed (and therefore quite illegally), set about entrenching monocultural

'legal' powers. They systematically stripped natural resources from Maori Tribes, and transferred all economic power to the immigrants.[27] That is the source of much bitterness today, and will remain so if wrongs are not redressed. One and a half centuries is long enough, 150 years too long in fact!

Too many politicians lately have been talking about overriding the Treaty by 'Government power', about 'changing the Treaty', 're-negotiating the Treaty', 'making a new Treaty' (with no real rights for Maori), putting about (without negotiation or consent) lists of 'principles' which can be taken *in place of the Treaty* (so Government might hope). Is this just evidence that these people have 'mis-translated' themselves, that they really belong, and ought to be, somewhere else ? Go, then, *haere atu*.

Since we have been to Court and properly informed, fair-minded Judges *found on the evidence* that Maori property rights guaranteed by the Treaty have been violated by Government actions, there has been a new outbreak of constitutional horror amongst our political masters. A torrent of vituperation[28] came from politicians who suddenly see the writing on the wall: 'Waitangi Day — A Day at the Races!' Some think politicians hoped the Waitangi Tribunal might with luck be a tame device to 'amuse the Natives'[29] which would defuse grievances with charmingly wrought Reports ('advisory' only). The Tribunal could be relied upon to make New Zealand look good at the United Nations (and is doing so) while at home the quasi-judicial determinations would produce Recommendations which, given time, a benevolent Government would grant in as small a measure as they could get away with, consistent with not upsetting the electorate and real property interests who fix the fate of the nation in the long run.

There was some miscalculation in that expectation. Given a full jurisdiction at last in 1985, the Waitangi Tribunal laid bare our history and went straight to the heart of the New Zealand constitution. But the hearts of our racists (who all claim they aren't) got dysrhythmic and threatened revolt. One might think from virulent things said on television and in nearly all of the metropolitan newspapers the Waitangi Tribunal had violated every sacrosanct canon of decency. The Tribunal has been slandered and denounced as allegedly ruining New Zealand's 'race relations' and spoiling any hope for a future in peace with ourselves.[30]

In fact the Waitangi Tribunal has done more good in race relations than all the politicians of the past 150 years laid end to end (and that's impossible, they wriggle about so much). Parliament gave specific jurisdiction which makes the Tribunal the major *translator and interpretor* of the Treaty in practical applications, going far beyond a mere linguistic analysis of what was written in 1840. Statute law requires the *principles* of the Treaty, not just its words, to be applied by the Tribunal to each case. That simple clear insight, thanks to the Hon. Matiu Rata, releases the Treaty from a linguistic prison and ensures it can live in the real world. The Courts, in turn, have put the Treaty into legal effect. It is a pity so much clever Pakeha legal effort is being devoted to undermining what is fair and obvious to sensible Judges and ordinary Kiwis.

Even our legally sophisticated Prime Minister (and earlier guardian of constitutional principle as Attorney General and Minister of Justice) seems to have got anxious, we notice about the time he got a seductive Crown Warrant telling him he was now Prime Minister. In New Zealand that particular warrant tells a man (it has always been) that he can do almost anything he likes and it will be 'legally valid', and never mind the Treaty, or the constitution if there actually *is* one! This is just a blunt way of saying New Zealand has an alarmingly crude constitution, virtually useless when it comes to settling any serious issue of civil or legal rights.

Our Prime Minister himself earlier described New Zealand's constitution as 'primitive'. Obviously he was quite right. There is almost no real guarantee of civil liberties in this country. That outburst from the PM (then Minister of Justice) was in justification of a Bill of Rights proposal he was urging upon us. Some Maori thought the Bill totally useless in protecting our Treaty-based property and cultural rights because it failed to entrench and protect the Treaty itself from meddling by future Parliaments.[31] Recently,[32] the Prime Minister tried to turn our reluctance to agree with his inadequate[33] Bill of Rights against us. He reckoned we did not want the Treaty protected as Superior Law in such a Bill. He suggested our Treaty claims should not be determined in the Courts (or Tribunal), but rather that we preferred to trust in the politicians to 'do the right thing'. Fat chance. Just look at history (and you don't need to go further back than the Maori Fisheries Act

1989!). This inference of naive faith in paternalistic politicians is about as far away from the reality of Maori wishes and understandings as one could get. It shows the 'Maori advisory' process simply does not work. Politicians hear only what they want somebody to say; and appoint selected 'advisors' to tell it to them. Government simply did not want to accept Maori views put to them on the central place of the Treaty in our constitution, and the need to give real effect to that. Pakeha lawyers would rather keep the Treaty in legal limbo, they don't want it to be *translated into effect*, as we do. So we have still much further to travel than even our most illumined legal scholars seem to realise, before we reach any constitutional safe haven.

VI

As mass religions evolved, those postulating a single god became ascendant over more complex systems of religion accommodating multiple gods, and other arrangements between gods and mankind. So also with political systems. Taangata Whenua society before 1840 was well enough organised to gain recognition as a sovereign entity by Britain, but internally many Tribal chiefs each held a high degree of autonomy in their own regions, none of them able to command the entire country as the Queen did in Britain. While the Kawanatanga which the Treaty ceded was represented by a single Crown, Rangatiratanga reserved to Taangata Whenua was embodied in many independent chiefs. The force of Rangatiratanga was diffused amongst a large number of smaller 'Crowns' collectively set in balance against the unity of British authority. They were prone to division by later settler governments. This obvious point has not been discussed recently, but must be a major part of the explanation of the severe imbalance that within a couple of decades emerged in the new State established under the Treaty. This was a translation defect inherent right at the beginning. If only time was available to develop a representative Council small enough to be able to effectively exert the undoubted powers of Rangatiratanga, as fiduciaries for Maori of all tribes,[34] our history would have been less painful.

Pakeha legal scholars like to cite a sequence of Proclamations[35] as the ultimate 'legal' (they think) authority for British Law and the Crown to take power of government in New Zealand. To Maori, that is legalistic nonsense. Who cares what Britishers might 'declare or proclaim' to themselves? To ourselves, this is still our country.

We say, the doctrine of 'Consent of the governed' as basis for the legitimacy of any Government in New Zealand must eventually take precedence over historical procedural pretensions of the British so far away from home. And our consents are very plainly conditional upon the *requirement that the Treaty of Waitangi be honoured*. Nothing else will do. If Government fails to honour the Treaty, New Zealand will fall down. Even at this late stage.[36] **Now see, hear, translate that!**

VII

Legislation, through Acts of Parliament or Regulations, does not become effective Law in New Zealand until 'validated' by the assent and signature of the Governor-General representing the Crown of New Zealand. Actions of the Governor-General are required to be in accordance with his instructions contained in Letters Patent.[37] This could be where we make another important translation of the Treaty into practical effect.

The Prime Minister has made it clear[38] there will be no Bill of Rights or Constitution embodying the Treaty as superior law, in the politically foreseeable future. My own advice that in the meantime we require *every* new Act of Parliament to incorporate the leading clause 'Nothing in this Act shall permit the Crown to do anything contrary to the principles of the Treaty of Waitangi',[39] is however unpopular in political circles.

A right without a remedy evidences injustice, 'And it is indefensible . . . to enter into treaties without providing for their proper execution.'[40] I believe it is necessary, and in 1990 has become urgent, that the Letters Patent be amended specifically and positively to instruct the Governor-General that he is not to assent to or approve any legislation if there is reason to believe it would be contrary to the principles of the Treaty of Waitangi.

A proposal consistent with my argument could be:

We affirm that honour of the Crown in New Zealand requires that no legislation be permitted if it would detract from or be contrary to the principles of the Treaty of Waitangi. Nothing in these Letters Patent shall empower you to assent to or approve any

measure or law which is or might reasonably be supposed to be contrary to the Treaty of Waitangi, and further if any new Act of Parliament or proposed Regulation or Order is placed before you which, after consulting the Waitangi Tribunal, the Court of Appeal and High Court, and others also as seems advisable to you, should seem to be contrary to the Principles of the Treaty of Waitangi, you are instructed to refuse the Royal Assent and to make public immediately your reasons for doing so.

This modest proposal and *tuumanako* for 1990 would at last remove the conflict and colonial hypocrisy still built into our constitution. We are publicly committed to a fine concept of mutual respect, justice, equity, and partnership according to Principles of the Treaty of Waitangi, but at the same time, all real power is arrogated behind closed doors of a formally non-existent Cabinet[41] where Ministers conceive themselves 'authorised' by Crown warrant to do anything they like! Enough of that cant. Let's get honest.

And then . . . **Onward!** [42]

Notes

1 A similar image struck Donna Awatere, who wrote: '. . . to be joined to our tipuna's beam of light. At last, at one with the pain of the land.' D. Awatere, *Maori Sovereignty.* Auckland: Broadsheet, 1984, p. 90.

2 See particularly the Waitangi Tribunal, Wai-9 *Orakei Report* (Wellington, The Tribunal, 1987) and Wai-22 *Muriwhenua Fishing Report* (1988); also articles by Bruce Biggs, (Sir) Hugh Kawharu and others in I.H. Kawharu (ed.), *Waitangi: Maori and Pakeha Perspectives.* Auckland: Oxford University Press, 1989; and the Court of Appeal, *New Zealand Maori Council v Attorney General,* [1987] 1 NZLR 641-719. Wellington, 29 June 1987.

3 See Raj Vasil, *Biculturalism: Reconciling Aotearoa with New Zealand.* Wellington: Institute of Policy Studies, Victoria University Press, 1988; Joan Metge & Patricia Kinloch, *Talking Past Each Other.* Wellington: Victoria University Press, 1978.

4 Between 530 and 540 in all, see Claudia Orange, *The Treaty of Waitangi.* Wellington: Allen & Unwin and Port Nicholson Press, 1987, p. 260. The English text was signed by 39 Chiefs in the Waikato and Manukau Heads.

5 Treaty of Waitangi Act 1975 (No. 114, including Treaty in English), and Treaty of Waitangi Amendment Acts of 1977 (No. 178), 1985 (No. 148, including corrected form of Treaty in Maori), 1988 (No. 233); also the related legislation in other Acts such as State Owned Enterprises Act 1986 (No. 124), Treaty of Waitangi (State Enterprises) Act 1988 (No. 105), Fisheries Act 1983 and Fisheries Amendment Act 1986, Commissions of Inquiry Act 1908 (No. 25), Legal Aid Act 1969. As well, Acts concerned with Environment, Planning, Conservation etc, which make specific or implied reference to the Treaty or its principles.

6 Return to L.C. Order of 5th August 1869: 'The original draft (if any) is not on record in the Native Office or Colonial Secretary's Office.', W. Gisborne, Legislative Council, Wellington, 1869. See *Appendices to the Journals of the Legislative Council,*

1869, pp. 69-71, for (then) new kawharu ordered by the Council.

7 Especially see Bruce Biggs, *op.cit.* kawharu in note 2, for close to the last word in linguistic analysis. For an interesting political analysis from a Pakeha viewpoint, see Jane Kelsey, 'The Treaty of Waitangi and Pakeha responsibility — directions for the future', *Race Gender Class,* No.5, 1987, pp. 42-50; also 'Free market "Rogernomics" and Maori rights under the Treaty of Waitangi — an irresolvable contradiction ?', *Race Gender Class,* No.8, 1989, pp. 1-19. Also see Paul McHugh, 'Monetarism versus Maoris: aboriginal title diminishes Treaty of Waitangi's status', *National Business Review,* 19 May 1989, pp. W1-W2. McHugh's important book *The legal status of the Treaty of Waitangi* is expected from Allen & Unwin in 1990.

8 See T.L.Buick, *The Treaty of Waitangi: how New Zealand became a British Colony.* New Plymouth: Thos. Avery & Sons, 1936; D.F.McKenzie, *Oral Culture, Literacy and Print in early New Zealand: the Treaty of Waitangi.* Wellington: Victoria University Press, 1985; and Claudia Orange (note 4). Most authoritative are the Reports of the Waitangi Tribunal, and decisions of the Court of Appeal, *op.cit.*

9 'Forked lightning flashing over Poneke (Wellington), arcing above the Beehive, House of honey, House of Laws, House of Honeyed Deceit. Is this not a portent of Doom? Signal of Maoridom and her descendants eclipsed? This House undermining (breaking apart) the Treaty, Sacred Covenant bound by our forefathers to the royal robes of Victoria.' Opening of poem by Reverend Maori Marsden, *He Pepeha mo Enei Ra: Reflections on our Times,* Te Puutaatara, No. 8, 1989, pp. 7-8.

10 We hear that after an infamous TV debate hasty amends were made for this oversight. Mr. Martin later acknowledged the One NZ Foundation he founded had become 'a stronghold of extreme opinion' and because of their 'unrelenting anti-Maori propaganda' he resigned as patron *(Evening Post 19.1.90).*

11 Currently we are in the Courts on this matter, thanks to s.88(2) of the Fisheries Act, so the wish to say more must be resisted.

12 Reasons are given by Sir James Henare, note 36 *infra.*

13 See discussions in Waitangi Tribunal *Reports,* e.g. on the *Orakei* Claim, and the *Muriwhenua Fishing* Claim; also the excellent articles in Hugh Kawharu ed., op.cit., note 2.

14 T.L. Buick, *The Treaty of Waitangi: How New Zealand became a British colony.* New Plymouth: Thos. Avery & Sons, 1914 (3rd ed. 1936), p. 172.

15 e.g. Somers, J. NZMC v Atty. Gen. 1987, note 2.

16 And actually in Australia, if we recall the dismissal of the Whitlam Government.

17 Somers, J. at p. 692, [1987] 1 NZLR 641 - 719, *New Zealand Maori Council v Attorney General* (Court of Appeal, Wellington, 29 June 1987).

18 Chief Judge Edward Taihakurei Durie, Chairman of the Waitangi Tribunal, in *Without the Treaty of Waitangi there would be no New Zealand,* publ. by 1990 Commission, Dominion, 6.12.89, p. 15.

19 I say 'perhaps' because of the recent development of Select Committees with powers to overturn completely the legislation sent to them for report, substituting essentially new legislation of their own which owes most to lobbying by special interest groups. The Bill of Rights itself is an outstanding victim, and the Maori Fisheries Bill which resulted from long and vigorous negotiations with Maori leaders, was gutted by the Select Committee and emerged as 'a Bill to comfort commercial fishing interests', devoid of Treaty principle, and finally provided almost nothing of what was negotiated by the Treaty partners.

20 See also G. Taylor, 'Sovereignty/Self-determination: Fine ringing words', *The Capital Letter.* Wellington, vol.12 no.19, 1989, p.1; and 'Appeal Court row with PM raises important law issues', *National Business Review,* 8th December 1989, p. W24. A very helpful discussion of these issues in context of a proposed Bill of Rights is given by J. Hodder & N. Sallee, 'The right to rights — do we need to legislate?', *National Business Review,* 31 October 1986, pp. 17-27.

MAARIRE GOODALL

21 It was apparently intended by the Royal Commission on Social Policy (*The Treaty of Waitangi and Social Policy*, Discussion Booklet No.1, 2nd ed. publ. Office of the Race Relations Conciliator, 1988), that 'tauiwi' should cover Indians, Sri Lankans or Vietnamese immigrants, and everyone else 'non-Maori', but I think most are applying the term to 'white people'.

22 Hearing at Wellington, 2nd August 1989, Waitangi Tribunal Record of evidence item Wai-27 doc # V 1.

23 Richard Mulgan, *Maori, Pakeha and Democracy*. Oxford University Press: Auckland, 1989. See p. 21 for an attack on the term *Taangata whenua*.

24 See speech by Sir James Henare, note 36 *infra*.

25 I think I first heard a remark to this effect from Chief Judge Durie during debate at a 1987 public sitting of the Waitangi Tribunal in Muriwhenua.

26 New Zealand Constitution Act 1864, *et seq.*

27 See Dr Ranginui Walker in his interesting articles on a wide range of subjects, all germane to this debate, in *Nga Tau Tohetohe*. Auckland: Penguin Books, 1987, and weekly essays in *NZ Listener*.

28 For deliberately provocative paranoia try some of these: 'Race relations fear', R. Muldoon, National MP Tamaki, 6.1.88 *NZ Herald*; 'Crisis could ignite race riots', W.Peters, National MP Tauranga, 12.2.88, *NZ Herald*; 'Town on a time bomb', 5.6.88, *Auckland Star*; 'Army guns for gangs', 23.6.87, *Truth* (as they say, sic!!); 'Society facing breakdown from racism', 9.6.88, *NZ Herald*; 'Race tension in the North was close to flashpoint', J. Carter National MP Bay of Islands, 6.1.88, *NZ Herald*; 'Tribunal law blamed for racial disharmony', R.Muldoon, *Dominion* 26.4.89.

 Unhappily it would be easy, given space, to provide a much longer list of such quotes, without going far outside Parliament or bothering to quote the more extreme racialists hanging out with the One-NZers etc. Shouting 'Fire!' in a crowded theatre is recognised as so obviously unacceptable that even liberal societies are willing to constrain the principle of free speech to prevent it causing havoc. When politicians do the same thing to panic us into giving them political advantage at the next election, we must denounce their speeches as worse than irresponsible — they are contemptible.

29 As said of the Treaty itself by the New Zealand Company. 'Wakefield . . . described the Treaty as a fraud on ignorant savages, and Justice Somes, in a letter to Lord Stanley, described it as a praiseworthy device for amusing and pacifying savages for the moment.' (Sir James Henare, note 36 *infra*).

30 The 'One New Zealand Foundation' and the likes of Hilda Phillips' paper *Let the Truth* (sic!) *be known* have spread about some of the most irresponsible rubbish in this bitter vein. For a scholarly dismemberment of their propaganda based on documentary evidence see: Harry Evison, *The Treaty of Waitangi and the Waitangi Tribunal: fact and fiction*. Christchurch: Ngai Tahu Maori Trust Board, 1989. (Available from the publishers, Box 13-042, ChCh, or from Project Waitangi, Box 825, Wellington).

31 See also Graham Taylor, *National Business Review*, 1989.

32 Speech to the Wellington District Law Society, *The Treaty of Waitangi: Constitutional and procedural issues*, 14 December 1989.

33 A critique of the Bill and White Paper, and proposal for improvements, is in J.B. Elkind & A. Shaw, *A Standard for Justice: a critical commentary on the proposed Bill of Rights for New Zealand*. Auckland: Oxford University Press, 1986.

34 Consider also later developments such as the Waikato Kingitanga (supported now by about a third of all Maori), current efforts to organise an administration for 'Maori' fisheries, the recent Kotahitanga Hui convened by Sir Hepi Te Heu Heu, so-called Devolution policies of the Government, and the current 'Runanga a Iwi' Bill which would give recognition for the first time to Maori Tribes as legal collective persons.

35 See Claudia Orange's excellent book, op.cit. note 4, for the details.

36 'The choice for the crown — the Government — is quite clear, to honour or dishonour, between treachery and good faith, and that we have at last reached the dividing line which makes or mars a nation worthy of the name.' Sir James Henare, last of the Rangatira of the Ngapuhi Council of Chiefs of the Treaty of Waitangi, in a speech to Members of Parliament, published in full in the *Northern Advocate*, Tuesday 4th October 1988, pp. 7-8.

37 The current Letters Patent constituting the office of Governor-General are dated 28th October 1983 and are recorded in Statutory Regulations 1983/225. Read, and wonder.

38 Geoffrey Palmer, Speech 14 December 1989 to Law Society, note 32 *supra*.

39 As in section 9 of the State Owned Enterprises Act 1986. Better than nothing, I thought. Legally qualified Maori friends objected that such law can easily be repealed; in principle true, but when Courts have interpreted the law so strongly, would Parliament dare now to go back? The sword of Justice has two edges.

40 Sir James Henare, note 36 *supra*.

41 'The Cabinet is not a formally constituted body; its existence depends largely upon convention. It is a decision-making body. It meets and deliberates in secret.' R.D. Mulholland, *Introduction to the New Zealand Legal System*. Wellington: Butterworths, 1985, p. 27.

 It may seem strange that no Statute enacted by Parliament, I believe, has ever referred to Cabinet. Probably this is to avoid any possibility of Judicial review in the Courts, and to preserve unbridled 'prerogative' powers!

42 As the NZ Coat of Arms says, Onward! We hope also Upward! I like the poutama design in tukutuku in our Houses. Now that we have given up street marches and taken to sitting in the Courts to observe proceedings, we notice anomalies. What about redecorating our Courts appropriately with kowhaiwhai and tukutuku during 1990? And dare we hope to see Maori, or Women, sitting up there on the Bench soon? Perhaps yet another Treaty interpretation could shed light on this. When we sat for days through legal argument in the Court of Appeal for that famous 1987 watershed case, the only sign of Maori visible to us was our Toa, his taiaha at the rest, in the Coat of Arms above the Judges' Bench. In the High Court room for the fishing case preliminaries, there wasn't even a New Zealand Coat of Arms. *Are these our Courts too?*

Talking to the 'Wounded Chief'

Augustus Earle and Gordon Walters

Ian Wedde

Augustus Earle was born in Marylebone parish, London, on 1 June 1793. His father, James Earle, who died in 1796, had been an artist — the less famous of two brothers who had exercised their talents in Massachusetts until the conclusion of the American War of Independence.

Augustus was a precociously young student at the Royal Academy in London, where he trained under Benjamin West (1738-1820), another American colonial artist, and a pioneer in the 'new Augustanism', the revival of European neo-classical figure compositions. Augustus's name is no coincidence but reflects his father's loyalist and Toryish nostalgia for the example of the first Roman Emperor, Augustus Caesar, under whose rule the Roman empire expanded and the 'civilised arts' flourished. The name 'Augustus', like many names, is itself allegorical, the product of an imperial cast of vision.

The young Augustus exhibited at Benjamin West's Royal Academy from 1806 until 1817. His juvenile works had such titles as *The Judgement of Midas* (1806) and *The Battle of Poictiers* (1808) — historical and allegorical set pieces, whose whiff of Toryism owed as much to academic convention as to his uncle's and West's influence; not to mention to the belief still prevalent in Britain that the eighteenth century was a new Augustan age. It was a belief with imperial consequences, certainly; an allegorisation of the British Imperial project, for example the colonisation of Australia.

This historical and allegorical convention, a neo-classicism that Victorians such as Earle's exact contemporary Francis Danby would later trundle merrily into melodrama, provided Earle with a basic rhetoric within which the exotic acted sometimes as an intervention, and sometimes as a complement.

It would be a mistake to underestimate the tenacity of this convention, and of the imperial milieu in which it flourished, as it passes from illustrations of antique themes, via allegory, into melodrama —

from Poussin (1594-1665), via Turner (1775-1851), to Danby (1793-1861), so to speak. In fact, Turner studied Poussin's paintings in 1802, including the latter's *Winter: the Deluge*, which certainly affected the production of Turner's *The Deluge* of 1805, not to mention Francis Danby's extravagant *Deluge* of 1840. Other early works of Turner's, for example *The Fall of an Avalanche in the Grisons* of 1810, employ a rhetoric of the Sublime inherited from Salvator Rosa via Philip James de Loutherbourg (1740-1812), whose paintings Turner would have seen in the collection of his own patrons Lord Egremont and Sir John Leicester.

It has been customary[1] to see Augustus Earle's subsequent work, the products of his travels and observations in many different parts of the world including New Zealand and Australia, as being freely expressive and even maverick departures from the academicism and neo-classicism of his youthful set pieces. The polarisation implicit in this view, with its phantom of a cult of originality, misrepresents the scope offered by the combined grammars of history painting and the Sublime, with their shared proclivity for allegory, and their combined appetite for the exotic.

In addition to their use of the allegorical and exotic scopes of history painting and of the Sublime, Earle's travelogues and topographical paintings and sketches all repeat a fundamental tenet of both history painting after Poussin, and the Sublime after Rosa, namely, that landscape is always the site of intervention by an event — in the case of history painting, an event that releases allegory as the source of its true object; in the case of the Sublime, an event that emphasises the diminution of the human scale before Nature.

In summary, then, Augustus Earle's training provided him with a hospitably dramatic contemporary grammar for the articulation of the 'exotic' themes his travels would set before him. And, con-

trapuntally, they provided many occasions for the clash of their rhetorical forms with the objectivity of his observations. In his art, Earle never repudiated Augustanism, nor did he ever enter into a critique of its underlying allegorisation of imperialism. However, around 1827 in Sydney he painted *Trajan inconsolable after the Battle of Ctesiphon.*[2] This painting, despite its full-on neo-classical academicism, with references to the Apollo Belvedere and the melodramatic George Stubbs painting *Horse frightened by a lion* (1763), may be an allegory for the exhaustion of the far-flung imperial project.[3] Earle himself had very little sympathy for the colonisers, particularly the missionaries;[4] which did not prevent this charming, plausible, and, when it suited him, entrepreneurial artist from producing, in New South Wales, numerous portraits in the grand classical manner whose allegorising effect had, haplessly, to be an endorsement of the Course of Empire.

What we need to look for, then, is how Earle's Augustanism, his combined inheritance of historical allegory and of the Sublime, provided him with a site and a grammar for the articulation of the maverick observations which his own Narrative tends to supply. How is the play of ambiguity worked out between that Augustanism, so apt for the allegorisation of the imperial Course of Empire theme, and the artist's own sceptical objectivity? How do we read this imperial framing of regional information? And what consequences can such a reading have for us in 1990?

Augustus Earle was often drawn to the panoramic, to a painting axis that encourages us to scan *across*. These landscapes, in the conventions of history painting and of the Sublime, are invariably the sites of interventions by events. Because groups of figures are usually involved in such events, a *conversational* axis is nearly always implied as well as, or in conjunction with, the panoramic one. It is clear that Earle was accustomed to listening to his scenes: to re-hearing them as well as representing them.

At one level, this may simply confirm what we already intuit from his art and know from his travel narratives: that Augustus Earle was an amiable and gregarious man.

At another level, however, it may be (I think it was) that he intuited the interventionist function of 'audibility' in history painting and the travelogue,

and worked to construct his representation as verbal, not just pictorial, discourse. Given that his New Zealand works usually featured Maori subjects, this makes him at once, in 1827, an artist of extraordinary interest, given our contemporary investigations of the role of language in the cultural production of place.

Even where Earle has been careful to pay his dues to the travelogue's demands for a catalogue of interesting ethnological items, the inclusion of such items often seems dutiful; their representations are by turns astonishingly accurate, and dismayingly inaccurate and exoticist.

For example, in *Crying Over the Bones of a Dead Chief. N. Zealand* (1828)[5] a central group of women is involved in tangi rites, and Earle's familiar horizontal axis of discourse is maintained. As well as this event, he has included, in a theatrically posed right-foreground group, a couple of warriors with muskets, a gourd hanging from a tree, and a bunch of fish drying on a pole. We enjoy, in other words, the bonus of Earle's cheerfully dutiful inclusiveness, his willingness (not discounting his own obvious curiosity) to do his job as a travel artist.

But the consequent effect of this inclusiveness is now, in fact, to focus our attention on the work's suppressed discourse, particularly where — as not in the work cited above — the travelogue inventory is glaringly inaccurate. And in a large proportion of his paintings, Earle puts himself in this picture. He pictures himself in conversation. He is himself a subject in the discourse. It is his own conversation he re-hears. It is his own intervention as a talker that he represents as an artist. What are made marginal, are the foregrounded trappings of the travelogue. Central, is the record of *translation*: translation between Maori and English, for example, *within* the painting, translated conversations in which Earle had participated; translations of the regional into the received, for example of local topography, artefact, or figure, into the rhetoric of history painting, landscape, and the travelogue; but also, translations of those moments into their consequences, outside the rhetoric of their framing culture. The conversational and panoramic axis of discourse across the painting, is turned through 90 degrees: a viewpoint is created for us in much the location Earle occupied to do the painting, to re-hear it.

The Meeting of the Artist with the Wounded Chief

Hongi, Bay of Islands, November 1827[6] (see page 26) is one of the best known of Augustus Earle's major New Zealand paintings. It combines the kind of spectacular exoticism Earle certainly sought to emulate in the paintings of Salvator Rosa, with a Sublime landscape featuring crags, rocks, mist, and several Rosa-ish trees. An animated Earle is depicted addressing Hongi Hika, the latter visiting Earle's protector in the Bay of Islands, Te Uru-ti. Hongi was then dying from a bullet wound (his death came 14 months after the meeting with Earle, in March 1828), and he was, due to the tapu nature of his wound, seated aside from his company, with the exception of his wife and daughter.

Earle, with characteristic enthusiasm, had obtained 'an interpreter' and rushed to the scene;[7] the account in his *Narrative* is a catalogue of items represented in the painting: the scene 'surrounded by high rocks and overhanging trees', the 'arms piled up in regular order upon the beach', the 'richly ornamented war canoes . . . drawn up on the strand', 'the chiefs . . . in mute contemplation', not to mention the bottle of wine provided by the artist.

What is also striking in Earle's narrative account of the occasion, is his framing of it in neo-classical terms: 'To me it almost seemed to realise some of the passages of Homer, where he describes the warrior Ulysses and his gallant band of warriors.' And certainly, the location and the event hand Earle a Salva-tor Rosa occasion on a plate; he is able to improvise an approximation of the Antique by means of some improbably located statuary and carving; there is a foreground which is heaped up with objects which manage to serve the portmanteau function of being simultaneously an Antique anthology and a travelogue dossier; and the demeanour and grouping of the chiefs imitate, in some but not all instances, the attitudes of the neo-classical.

But for all the rhetoric of the representation, there is no mistaking the intervention of local fact; in particular, there is no mistaking the centrality of Earle's participation in the painting's discourse; and there is no mistaking his subsequent emphatic realignment of the discourse's axis, to create a point of view (of 'see-hear') from which we can re-hear that moment. Earle has engineered a relocation and translation of the rhetoric of history painting and of the Sublime. The dialogue involved is not just between Augustus Earle and Hongi Hika; *it is also between Augustanism and the local*: a foreshadowing, perhaps, of what Kenneth Frampton in the 1980s will call 'critical regionalism'.[8]

It is the English of Earle, and the Augustanism of his representational rhetoric, that are finally privileged in this discourse. In a sense, what is prefigured is a movement towards nationalism, towards what Bernard Smith has described as an alliance between archaism and chauvinism,[9] in which the Maori must be silenced in order to be appropriated to the nationalist programme. This was not Earle's *intention*, of course — despite his natural inculcation with the rhetorical habits of his own culture, he was, as we have seen, capable of profound sympathy for the culture and language of the Maori.

What is haplessly entrained in *Meeting of the Artist with the Wounded Chief* is, however, encountered well over a century later in the fully-fledged nationalism of, for example, Gordon Walters' koru paintings, the work involving a kowhaiwhai pat-

Gordon Walters, *Painting No. 1*, 1965. PVA on hardboard, 914 x 1219 mm. Courtesy Auckland City Art Gallery and the artist.

IAN WEDDE

tern which occupied Walters from the mid 1950s to the early 1980s — for example, the celebrated *Painting Number 1* of 1965.[10]

This is not to suggest a progression from 1827 to 1966. It is, in fact, a recognition of their *particular* moments in history that makes a comparison of Earle and Walters interesting. Only if we grant them their difference, and especially their historical difference, can the similarities in their work offer us worthwhile information.

On the evidence of work preceding the koru paintings, for example the 1952-5 untitled works in the manner of Vasarely and Herbin, Walters was already interested in a dynamics of transmission — even of translation. His plane is the depthless Modernist one; on it, a grammatical subject-matter emerges. Across this flattened plane, ambiguous transactions occur in which shapes slide into others, in which a debate between containment and penetration (as between figure and ground) takes place. This is very like a debate between the dominant and subdominant terms in translation.

With the discovery and formalising of the interlocking, horizontal koru motif, Walters was able to make this debate approach the suppressed discourse in Augustus Earle's *Wounded Chief*.

Like Earle, Walters comes to favour a horizontal axis — an axis that creates a viewpoint from which we might scan the lateral interchanges of a dialogue. Like Earle, Walters is familiar with, and expert in, the rhetoric of contemporary art — in Walters' case, of Modernist geometric abstraction. Like Earle, Walters encourages the intervention of a discourse, of something very like audibility, in this rhetoric: the interlocking exchanges of the koru motif, its binary colouration, the dynamics of its spring-like clenching and releasing, its canon-like formality, all suggest a grammar, a systematics approaching speech.

And, as in the case of Earle's *Meeting of the Artist with the Wounded Chief*, *Painting Number 1* involves a translation of the local into a received rhetoric: of the koru into the language of Modernist geometric abstraction. It involves a radical relocation and translation of that received rhetoric of Modernism (including Modernism's fascination with 'the primitive', itself an analogue to 'new Augustanism's' fascination with 'the exotic'). It involves a dialogue, mediated by translation of which the painting is a record and representation, between Walters

and the koru: that same koru which we may now allegorise as 'the wounded chief'. Despite the abundant evidence of Walters' sympathy, and despite a recent drive to rewrite the canon and exonerate Gordon Walters from nationalism,[11] it is a dialogue that privileges the rhetoric of Modernist abstraction. It silences the koru in order to appropriate it to a 'nationalist' art.

Notes

1 See, for example, Anthony Murray-Oliver's splendid *Augustus Earle in New Zealand*. Christchurch: Whitcombe and Tombs, 1968.

2 *Trajan inconsolable after the battle of Ctestiphon*, c1827, Sydney. Oil on canvas, 765 x 920 mm. Adelaide: Art Gallery of South Australia.

3 See Ron Radford, 'A Colonial Augustan Age', in *Creating Australia: 200 Years of Art 1788-1988*. Adelaide: Art Gallery of South Australia catalogue, International Cultural Corporation of Australia, 1988.

4 Earle's account of his travels and adventures bristles with denunciations of missionaries and colonisers: Augustus Earle, *A Narrative of Nine Months' Residence in New Zealand in 1827, Together with a Journal of a Residence in Tristan d'Acunha, an Island Situated Between South America and the Cape of Good Hope*. London: Longman etc., 1832. Reprinted as: E. H.McCormick (ed.), *Narrative of a Residence in New Zealand* and *Journal of a Residence in Tristan d'Acunha*. London: Oxford University, 1966.

5 *Crying Over the Bones of a Dead Chief*. Watercolour, 171.4 x 298 mm. Canberra: Australian National Library, Nan Kivell Collection 12/76.

6 *The Meeting of the Artist with the Wounded Chief Hongi, Bay of Islands, November 1827*. Oil on Canvas, 610 x 962 mm. Wellington: Alexander Turnbull Library.

7 McCormick (ed.), *Narrative*, p. 88.

8 Kenneth Frampton, 'Towards a Critical Regionalism: Six Points for an Architecture of Resistance', in Hal Foster (ed.), *The Anti-Aesthetic, Essays on Postmodern Culture*. Washington: Bay Press, 1983.

9 Bernard Smith, *Place, Taste and Tradition: a Study of Australian Art since 1788*. Oxford University Press, reprinted 1988, p. 175.

10 *Painting Number 1*, 1965. PVA on hardboard, 914 x 1219 mm. Auckland: Auckland City Art Gallery.

11 For example, see Francis Pound, 'Walters and the Canon', in James Ross and Laurence Simmons (eds.), *Gordon Walters: Order and Intuition*. Auckland: Walters Publication, 1989.

Reflections, Deflections

from Margaret Dawson's *Colonial Vision*

J. Hurrell

Margaret Dawson's *Colonial Vision* (see page 27) is a peculiar photograph. To anyone familiar with the history of western art and European art in New Zealand, this work conveys an odd lack of interest in the nature of its own medium and seems to celebrate sculpture and painting instead. By its use of Michelangelo's statue *David* and Augustus Earle's painting *The Meeting of the Artist with the Wounded Chief Hongi*, it abnegates the value of the technology behind its production.

This perverse denial of its own status, and the photograph's infatuation with other 'finer' branches of the visual arts, imbues it with an insecurity, a pervading sense of unease, almost of shame.

The frame Dawson has chosen to encase the photograph accentuates this anxiety, this regret. It is an ornate plastic frame, spray painted gold and black, designed to be fitted around domestic mirrors.

We may be at our most vulnerable in front of mirrors. We use them to detect our unattractive physical features so that these can be hidden or modified. Accordingly we scrutinise ourselves and then initiate a remedy.

Dawson's photograph shows a picture inside a picture. Centrally positioned in the background is Augustus Earle's painting of himself, a confident figure as he chats to an admiring group of Maori warriors. Dominating the photograph's foreground is the artist dressed as 'Mrs Victor England', as she calls herself in the work's subtitle.

'Mrs England' does not look comfortable. She and 'Mr Earle' are dressed in clothing of the same period, that of the late 1820s. Together they represent a 'colonial personality', a personality which in Dawson's unusual treatment of Earle's painting now has its darker side exposed. Those aspects which were previously kept at some distance are turned back-to-front and presented 'up front'. The hitherto unacknowledged anxiety within the 'colonial personality' is pulled out, turned 'inside-out'.

The worrying within this work can be examined further. Sometimes when we look into a mirror from a sideways angle we see a double image. Of this duplication, one image is much fainter than the other, separated from it by the thickness of the glass. One ghostly image is reflected off the front face of the glass, and the other bolder version from the quick-silvered surface at the back.

Let us look at these two versions of *Colonial Vision* in greater detail.

The bolder, clearer version of what might be called a *Colonial (double) Vision* can be called *A Colonial in Sight*.

In the foreground of Dawson's coloured print, 'Mrs Victor England' contemplates a replica of *David* she is holding up in her right hand. He is located in the exact middle of the photograph.

The title *Colonial Vision* implies 'Mrs England' is 'holding up' *David* as an icon of the achievements of western civilisation. Michelangelo's marble statue in this context becomes a symbol of white superiority. *David*, a xerox reproduction on a sheet of white cardboard, glows incandescently.

Earle's painting on the wall behind subtly echoes these sentiments. The widely travelled artist, here in the role of raconteur, is surrounded by Hongi Hika, Hongi's family and warriors. Like *David*, Earle shines as if spot-lit by privilege.

A second version of *Colonial Vision* exists that is out of register with the first.

In *A Colonial Insight* we again see 'Mrs England' looking towards *David*. *David* this time is the Biblical figure, the underdog who against all odds defeated Goliath the aggressor, despite the Philistine's superior strength and experience.

Like Donatello's marble *David*, erected ninety years before his, Michelangelo's version was regarded as a symbol of the valiant Florentine Republic when it first appeared. This wiry and supremely confident shepherd boy exemplified moral rightness.

JOHN HURRELL

When *David* was completed in 1504, the Medicis had been expelled from Florence for ten years and the city had withstood many seiges from them and from Cesare Borgia, the son of Pope Alexander VI. Because in 1502 the anti-Medici factions had elected Piero Sodesini to be Gonfaloniere for life, two years later the newly completed statue was placed in front of the seat of government, outside the main entrance to the Palazzo Vecchio.

Fourteen feet tall with elongated arms that compensated for foreshortening when viewed from below, *David* was originally designed to be positioned some fifty feet up, on one of the buttresses that surrounded Brunelleschi's Dome on the Cathedral of Florence.

In *Colonial Vision*, Dawson's replica is, of course, enormously reduced — absurdly so considering that we are looking at a flimsy piece of cardboard.

The Earle painting too, in Dawson's photograph, is slight of substance. It is nothing more than a projected slide of a framed enlarged photographic print, taken of the Earle reproduction in Docking's *Two Hundred Years of New Zealand Painting*.

The interaction between the costumed 'Mrs England' and the cardboard *David* is contained in a kind of intimate mirrored space. 'Mrs England' is very properly attired and much larger than *David*, yet she looks apprehensive. He looks subdued and vulnerable, not nude as Michelangelo made him but undressed, not confident but distracted.

'Mrs England' also has a preoccupied manner. Her eyes are unfocused, as if looking right through *David* towards the half used plastic candle behind him, a light-stand that has an electric cord but no bulb.

David is ignoring 'Mrs England'. Instead he is looking over towards Hongi Hika in the painting on the wall behind her.

Augustus Earle's *The Meeting of the Artist with the Wounded Chief Hongi, Bay of Islands*, was made in 1827, at a time when there were only a few hundred Europeans in Aotearoa. European expansionism had not made a significant impact here yet, although it was clearly about to.

Hongi Hika, whom Earle depicts himself addressing enthusiastically, welcomed that invasion as a means of gaining access to European technology. He valued muskets as a guarantee of victory whenever he attacked tribal enemies of the Ngapuhi. Because of the devastating losses he inflicted, and

the means he used to do so, he can be regarded more as an oppressor of his own race than as a champion of Maori liberty.

At the time of Earle's meeting with Hongi, the chief was slowly dying from a bullet in one of his lungs, received during a skirmish at Whangaroa. Although in his written account Earle describes Hongi's 'frame . . . reduced almost to a skeleton', we see him in the painting looking quite robust. Earle's Hongi is calmly rubbing his chin while he listens attentively, absorbed in the artist's anecdotes.

Dawson's photograph then, has this 'double vision' in which the fainter, off-register meanings of the portrayed characters undermine the intended readings intimated by the title. Skinny 'sensitive' David glares at burly, brutal Hongi, while Mr Earle's elucidations become protestations to be ignored by the agitated Mrs England.

Not only is the viewer's gaze towards Earle's idealised and harmonious scene deflected by Dawson's 'reflections' in the foreground, but the generalised abstractions of this first version of *Colonial Vision* are interrogated in the second by the protagonists' own particular histories.

Kitchen Sink

An Unchastening Tale

Hibiscus Films 1989
Producer Bridget Ikin
Director Alison Maclean
Writer Alison Maclean
Photography Stuart Dryburgh
Art Director Grant Major
Editor David Coulson
Music Headless Chickens
Woman Theresa Healey
Man Peter Tait
Schoolgirl Annagretta Christian
13 mins

A Short Rerun

A young woman emptying the kitchen sink sights the tip of a dark thread emerging from the plug hole. She tweaks it, then tugs harder. It thickens into a fibrous rope. There is a knock at the door and the woman turns away a girl selling mystery envelopes. She hastens back to haul on the rope. Two alien eyes and a mossy head slowly emerge, then a monstrous, hairy 'foetus' hurtles into the room. She is afraid, then curious, but when it does not stir she throws it out. She recovers the creature and places it in a running bath. The phone rings, and she refuses the offer of a visit by a man who seems to be the friend of a departed lover. In the flooding bath the creature has grown to a hairy, comatose man. She drags him into the bedroom by an umbilical cord, or is it a tail? She shaves his entire body — one leg after another, even removing the hair from his face. Now she dresses him, then undresses and beds him. Through the night he doesn't respond to her experimental embrace. In the morning she trashes him again, this time in an outsize rubbish sack. As she baths he stirs and begins breathing through the plastic. She slits the sac with a knife. They wrestle, they kiss. During the embrace her finger catches a long bristle on the back of his neck. As she tweaks, then tugs it, he bites. But she is pulling him inside out, until he is a man, a film

imploding with the yank of a hair.

Stylishly pursuing its own tail, this film passes the rapture on . . . and leaves us somewhere in the middle of our own chase . . . with the riddle of the other's tale . . .

•

Here, a woman is torn between extinguishing and *knowing* the other.

For her ritual-like dance with this other, the unnamed woman is supplied with an immaculate, demonic (mis)conception; a gaze that dominates screen time and space; and a domestic setting.

These three components are fairly conventional to classics of the monster/horror genre. In the latter they are usually predicated and played out along misogynist lines. Feminist film critic Linda Williams has argued, convincingly, that the monster of mainstream horror is often identifiable with, even a cipher for, a hostile, largely unconscious patriarchal perception of female sexuality as deviant, mutilated and mutilating. She also points out that while in this genre the female gaze has unusual prominence, its bearer is invariably violently 'punished' for looking (sometimes the experience of terror embodied in her look serves this end adequately).[1] We must all be familiar with the quality of this gaze — its scope corsetted by terror and victimisation. A look transfixed, and fixing the feminine passivity of its bearer.

The classic function of the domestic in this genre is to signal 'sitting duck' — a function that comes as no surprise given the domestic's largely misogynist identification with the feminine.

Kitchen Sink, however, puts this depressing agenda firmly behind it. Its translation and transformation of these oppressive terms is feminist, but with a stinging wit that is ultimately non-partisan: to be loosed on all parties. Among the latter are the romantic but compelling fiction of the couple and nuclear family; and the equally neat formulas of genre filmaking.

This woman wields a gaze rich with contradiction: one which oscillates between repulsion and desire, and expresses along the way: guilt by association, fear, uncertainty and also tenderness. Moving this gaze, animating her uneasy body, is a deceptively gentle, actually relentless, curiosity. And it is curiosity, coloured but never cancelled by all these other emotions, that gives her often precarious identity a measure of heroism.

The mythological models (and these are also mainstream models) for woman's curiosity, exemplified by Pandora, invariably equate it with the provocation and unleashing of danger and evil. A great deal of the tension in viewing *Kitchen Sink* must swing around our excruciating expectation of this woman experimenting so far that the narrative will respond punitively. In refusing this classic line, *Kitchen Sink* begins to voice a supressed language concerning women and their relationship to danger.

However, the relationship is not conventionally heroicised: this woman's defiance is ambivalent rather than flagrant. Her response to the knock on the door and the telephone ring articulate her sense that her investigative gaze, a gaze that disturbs media norms of gender and sexual relationships, must be private, secretive. She draws the darkened house around herself and the monster. It brings their difference and adversarial positioning — to each other, and also to 'outside', for she is a woman alone and by implication, single — under a roof of complicity, even mutuality. Her relationship to the monster seems to signify and enact, to herself and the viewer, her outlaw status. Hence the disturbing and amusing unconscious logic by which she is anxious to transform this other into 'the norm'.

That logic is best seen at work in the shaving/dressing scene. Here she (almost) translates the monster/man into an icon of outwardly, if zombified,

Peter Tait in *Kitchen Sink*. Director: Alison Maclean. Producer: Bridget Ikin. Courtesy Hibiscus Films Ltd.

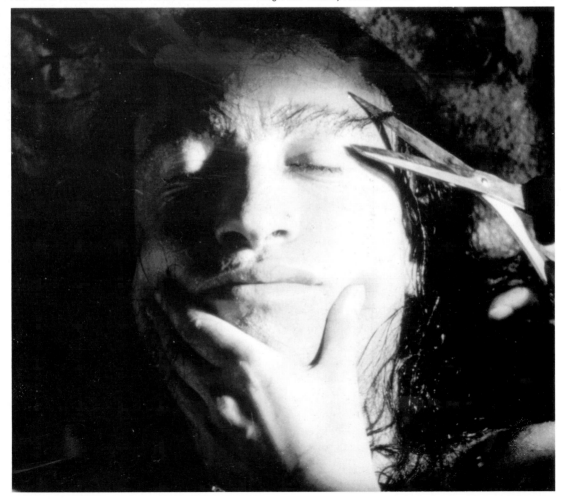

masculinity. This scene, indeed the whole film, presents a humorous and particularly female twist on the great New Zealand tradition of the do-it-yourselfer. A tradition here turned back on its male subject, the handyman.

The close-up shot of body-parts being repackaged into trousers combines the language of an instruction manual with that of advertising. The subliminal text in this woman's mind blends the ancient narratives' penchant for transformation and chrysalis-like identity with the dream of modern advertising in which identity is transformed with a magical and frightening superficiality by the ideal product.

In the preceding bath scene a similar conflation, at once satiric and genuinely horrific, springs a particular memory for me. I identify the foetal-creature's soaking and swelling to hairy-man size with advertisements for 'sea-monkeys' that appeared during my childhood. 'Sea-monkeys' were sold from the pages of comics as a nuclear family of cute freaks that you germinated by soaking some crystal-like substance. Their physical destiny was alluring and obscure. As part of a process that began with my unmasking of the tooth-fairy, my enchantment was nagged into the disenchantment of a consumer. In this instance I didn't subscribe. Even better in *Kitchen Sink*, a woman gets to subscribe for, *and* return, her (deviant) mail-order-man to sender.

For as in all seriously good fantasy every 'norm' in this film is also warped. Each of this woman's attempts at identity with some internalised, fictional, feminine standard is ironically and richly marked by difference. In the age of the artifical womb she tries out a kind of alienated motherhood. Later she is determined to make of this grotesque other her lover. In the grand finale she is his destroyer — but with the deflationary lack of malice with which one would compulsively pop a giant blackhead.

And 'he' in all the different body translations that she helps conjure begins to look like a cipher for all her undiscovered, suppressed or rejected selves. Possibly he *embodies* that which her conscious identity has rejected — in Jungian or alchemical terms, a male self living in the shadows. It is appropriate to this speculation that 'he' emerges from the obviously extremely fertile wasteland of the kitchen wastemaster — an industrial sign for the underworld/unconscious. *Embodied* he is shunted obses-

sively between domestic sites — the wastemaster, kitchen tidy, bath and bed — that take on mythic tones of rejection, regeneration, baptism and consummation.

Finally, he irises out (the image leaves the screen in the shape of a shrinking iris) as a gigantic hair follicle. We arrive at the end to meet the beginning. The symmetry is at once divine and farcical. The serpent of the ancients which swallowed its tail and became the mystical form of the circle is accommodated to the plug-hole and the modish iris-out of early film and seventies TV.

Notes

1 Linda Williams, 'When the Woman Looks', *Re-Vision: Essays in Feminist Film Criticism*, eds. Mary Ann Doanne, Patricia Mellencamp, Linda Williams. Frederick: University Publications of America, 1984.

Theresa Healey in *Kitchen Sink*. Director: Alison Maclean. Producer: Bridget Ikin. Courtesy Hibiscus Films Ltd.

Translating the Body

Men and Make-up

Noel Sanders

What is beautiful must be strong, vivid, and brimming with energy. This is the first principle. The second is that what is moral must be beautiful.
Yukio Mishima[1]

There are two principles in life. The first is that one must strike a pose. I cannot remember the second.
Oscar Wilde[2]

Principle number one in the world of advertising creativity is Ogilvy and Mather's rule that if you have a product with an ingredient likely to cause consumer resistance, highlight it in its negative form. Thus, for example, 'Alpine is fresh'.

The market for male makeup in the late twentieth century, while worth the effort in the deodorant marketing area, is certainly not what it was sixty years ago nor what it was in the last two centuries. Deodorants it is then: but even in this area there is a prime problem with male buying willingness — namely that while men like to wear smellies, smellies cannot be purveyed as such. Like cigarettes, they must be sold as fresh air and as the physical sensation of volatility that masks the fact that the odour of deodorants *stays*.

Of the two such products currently being given TV treatment in New Zealand — Old Spice and Blue Stratos — both feature the liberation whose visual concomitant is windborne movement. Old Spice, the 'nautical mark of a man', uses the old *spruik* of a call to the sea: lots of sails and lashings of the yardarm to mask the outrages of the underarm. Blue Stratos also marks the man: *Stratos* in Greek means 'army'; the product itself has always used the blue of the sky, as Old Spice has used the blue of the sea. Blue Stratos's TV ad images feature a hanglider soaring against peaks, and the voice-over promises the 'alpine feeling of freedom', the 'feeling of freshness'. The prospective buyer is invited to 'Open up your mind to Blue Stratos'.

Standard 'media studies' stuff: nature created as the theatre of the commodity; the crisis of masculinity and male consumerism (deodorants are always a gift, never a purchase); 'personal products' as the commodified parallel of the 'psychic hygiene' performed by dream and ideology. Yet the conspicuously 'textbook' nature of these ads, plus the affront we are allowed to feel in the face of them, before either submitting to them or rejecting them, makes them ad-'chestnuts' of the first order. For, apart from the *bastinado* they are intended to enact on male consumers, a greater question is at stake — the *morality* of advertising and its real-life concomitant, the *morality* of deception, disguise, camouflage; the creation of what Roger Caillois[3] called 'professional resemblances' to a species/class/sexuality to which one does not 'rightfully' belong.

Men do not know why they award fame to one work of art rather than another. Without being in the faintest connoisseurs, they justify the warmth of their commendations by discovering in it a hundred virtues, whereas the real ground of their virtues is inexplicable — it is sympathy.
Thomas Mann[4]

'Allure' is a word most men would qualify with the adjective 'feminine'. Entymologically, as Caillois noted in his 1938 essay 'Mimicry and Legendary Psychasthenia', the adaption of the organism to its surroundings, denying as it does the 'ultimate problem'[5] of *Distinction* (of class, sexuality, life/death, day/night etc.), is nothing less than pathological behaviour. To have this behaviour marginalised as 'feminine' is, in most cases, convenient. To men used to governing the world 'by other means', allure is an offensive concept (and witness the backlash: popular theory that phenomenal attraction is what counts;[6] or that marketed cosmetics are atavistic appeals to a lost *estrus*, marked in all the rest of the animal world, and formerly in the human world, by urinary fragrances, upon whose demise the entire cosmetic is based). Yet, over a larger political and

social spectrum than just the sale of smellies, the aesthetic concept of the *je ne sais quoi* is used to explain sudden shifts in political allegiance and betrayals of social/class position. In place of 'Jeez, you pong', there is 'Jeez, you pong — what'reya WEARING?'

Early in Mann's *Death in Venice*, bound for the 'glorious city', (von) Aschenbach observes a party of clerks from Pola, and particularly one, whom Aschenbach takes to be as young as the others — who 'outcrowded all the rest'. On closer inspection, this rake 'in dandified buff suit . . . a panama with a coloured scarf and a red cravat', is seen by Aschenbach to be in fact 'an old man, beyond a doubt, with wrinkles and crow's feet around eyes and mouth; the dull carmine of the cheeks was rouge, the brown hair a wig, yet totally at ease with younger members of the team'. Aschenbach feels 'not quite canny' (*unheimlich*), as though the world were suffering a dream-like distortion of perspective which he might 'shut out for a few minutes and then look at afresh'. Surprised and initially affronted by this chameleonism and 'morally' disposed to disapprove, Aschenbach later finds himself in the hands of the hotel barber in a scene made memorable in Visconti's movie :

He watched in the mirror and saw his eyebrows grown even more even and arching, the eyes gain in size and brilliance . . . A little delicate carmine glowed on his cheeks where the skin had been so brown and leathery . . . The artist in cosmetic at last professed himself satisfied; after the manner of such people, he thanked his client profusely for what he had done himself.[7]

The 'morality' of the transformation/translation of Aschenbach into the 'young man who looked back at him in the glass' is here absolved, even guaranteed, by the barber's actions, his own demobilised in ironic *desinvolture*. Mann has led up to this: in a simulated dialogue between Socrates and Phaedrus, he gives Socrates the opportunity of ennunciating 'the subtlest thing of all':

that the lover was nearer the divine than the beloved, for the god was in one but not in the other — perhaps the tenderest, most mocking thought that was ever thought . . .[8]

In Caillois' entymology, this mimicry, having as its first 'moment' a quasi-primary narcissism ('how I looked at me', 'how I smelt to me') goes on to set up the other in the place where the self first conceived the place of the other as its *own* place — what Wilde meant by 'pose' (position), or Mishima by the identification of beauty (the property, in theory, of the other) with morality (the property, in theory, of the self). For Caillois, this assumption of the corrupt and devalued beauty of the other, through which the other nevertheless gains a perverse substance of that beauty, is the default of the theory and practice of reproduction itself. This mimicry, for Caillois, is 'an actual photography, but of the form and the relief, a photography on the level of the object and not that of the image . . . sculpture — photography or better *teleplasty* . . .'[9]

Though women must cover their heads in public, a new 'Teheran' look has replaced the voluminous *chador* . . . Lipstick and black eyeliner have returned . . .
Dominion, 26 October 1989

Caillois' point towards the end of his essay is that disguise and simulation are 'a luxury, even a dangerous luxury',[10] — borne out by no more innocent pointer than a dictionary consultation. According to mine which, being dated Blackie and Son 1898 contains no entry at all for, for example, *camouflage*, and is innocent of meanings for words like *stratosphere*, a reading is yet available for *cosmetic* — providing the Greek etymology 'fr. *cosmos*, order, ornament, the world'. To cosmeticise, then, is to ring changes on a notion of disorder, and bring it in line. To cosmeticise is, thus, to bring into order, but the form of the order is left undefined: the derivational power of the word *cosmetic* leaves open the direction in which this operation might happen; or indeed how its outcome might be interpreted. Whatever cosmetic activity might mean for the subject of cosmetic operations (the cosmeticist), the use of the outcome opens up *domains* — whether as prospective luxury playgrounds or sites of (future) oppression.

Cosmetics were and are, amongst males, either a point of absolute departure or a point whereon swung (and do swing) a number of ambiguities that can be *resolved*, or be declared 'unresolved' at a moment's notice. For Carmen, the noted New Zealand entertainer, a courtcase of 1966 hinged on evidence that, in the words of McCarthy S.M., 'His face was made up with cosmetics and his hair was dressed in a feminine way'. The magistrate's decision was that

NOEL SANDERS

the Mark of a Man

Untitled 1990 Neil Pardington. Photo credit: *Vince Gironda, 1951,* by Russ Warner.

Carmen being 'the name by which he is known in his work as a female impersonator . . . of itself does not establish anything!'.[11] Carmen refers to this in her autobiography, as a 'Landmark for the transvestite community in New Zealand . . . From that day I have never worn male clothing.' By contrast, Carmen's trans-Tasman equivalent Dame Edna Everage holds make-up — by which means, amongst others, she announces her fame as yet another ambassador to the rest of the world (as Carmen's axis is Wellington/ Sydney, so Dame Edna's is Sydney/London) — to be a derisory, anyway-but-loose activity.

These never-before-published pickies show me giving my famous face its nightly work-out to music. It's a pity there isn't a talking book or you'd hear the gorgeous strains of Sir Michael Tippett or Horace Heidt in the background as I knead and nourish my nooks and nodules.[12]

Male cosmetics: on the one hand, options, alibis, lines of possible flight; on the other, fatalities, risk and existential danger. In postmodern times, in their reduced form, the smellies purveyed by the cosmetic firms to men barely spell/smell out the larger significance of the role these played for previous generations, in which cosmetics' uses were both more at-hand and more salient. For Carmen, a positive means of demarcation, the setting down of a margin along which dispute could range and ultimately be settled — a state of cosmeticism along which political,

racial, and sexual boundaries could be mapped out. For Dame Edna, drawing upon complex contradictions of class, culture and ethnicity, a lot less so — Dame Edna's use of the word 'spooky' with reference to her own congruence with her *personae* drums up resonances of her phrase 'spooky old me': in my dictionary *spook* is from Danish or Lower German — a 'ghost or apparition; a ghostly or supernatural manifestation; what causes a place to be regarded (Australia?) as haunted'.

Nor is this reading contradicted by other sources: the donning of makeup was ever a sign that a crisis-line had been encountered, met with, overcome or not overcome. John Schlesinger's *The Entertainer*, or *The Dresser*, or Peckinpah's *Dog Day Afternoon* in the previous two decades register the relationship between cosmetics and desperate action. In the Soviet Union in the 20s, the 'mega-star' poet of the times, Sergei Essenin, ambiguated his alliance with the Soviet revolution by his conspicuous use of cosmetics, ordering, in his 1922 visit to Berlin (a much-*bruited* sign of bad faith with the revolution) a 'private bath, a shampoo, eau-de-Cologne, powder, perfume'. Later this use of cosmetics was construed as a betrayal of the revolutionary sympathies that had earlier brought him to prominence as doyen of Soviet poets: 'His face was terrible because of all the violet powder on it.'[13] Later still, in 1925, as one of the editors of the magazine *Hotel for Travellers in the*

Film kindly sponsored by COLOURCRAFT REPROGRAPHICS Wellington.

Beautiful, Essenin is observed by a fellow-editor as being 'in dandyish European clothes and heavily powdered cheeks . . . a duality in the poet'.[14] To observers, this gave out signs of 'Essenin's paradox: contrived love, a contrived biography, a contrived life'.[15]

When in 1977 Bob Jones and Ron Brierley (both since given the monniker 'Sir') backed Carmen for Mayor of Wellington, surely one thing on their minds might well have been a perceived congruency between themselves as (capitalistically) 'self-made' men and the cosmetically triumphant image of Carmen as a 'self-made' woman. 'Self-making' in this respect is what totally and finally makes for Mishima's interpretation of the seventeenth century text *Hakagure* by Jocho Yamamoto. Upsetting all 'stereotyped concepts of the Way of the Samurai', he counsels that:

The morality of not being ashamed before one's enemy requires that one beautify one's appearance just before death, taking precautions to preserve the robustness of life. How much more is it important while one is alive, in a society of externally-orientated morality, to hide the dispirited face of a hungover samurai, even if it must be done by applying rouge . . . This is because aesthetic considerations are always external in nature . . .[16]

For males, costmetics are invidious, then, except to enact and underscore moments of crisis and/or op-

portunity. Manufacturers of these products are just beginning to suggest that such moments are perennially at hand — even congruent with the day-by-day exigencies of male living in the late twentieth century. Translating the body, making-up, touching-up, and disguising the way males go about things, cosmetics yet, and in the ultimate extreme, constitute a male escape-hatch. Finally Mishima:

Rouge used to mask a hangover is directly related to make-up before ritual suicide.[17]

Notes

1. Yukio Mishima, On Hagakure: The Samurai Ethic and Modern Japan. New York: Basic Books, 1977, p. 84.
2. Quoted in Richard Ellman, Oscar Wilde. London: Faber, 1987, p. 273.
3. Roger Caillois, 'Mimicry and Legendary Psychasthenia', October, 1985.
4. Thomas Mann, Death in Venice and Other Stories. London: Heinemann, p. 8.
5. Caillois, op. cit., p. 17.
6. NZ Listener/TV and Radio Times, Nov. 13-19, 1989, p. 91.
7. Mann, op. cit., p. 60.
8. Ibid, p. 39.
9. Caillois, op. cit., p. 23.
10. Caillois, ibid, p. 23.
11. Carmen, My Life, as told to Paul Martin. Auckland: Benton Ross, 1988, p. 113.
12. Dame Edna Everage, Bedside Companion. Corgi, 1983, pp. 83-5.
13. Gordon McVay, Essenin: A Life. London: Hodder and Stoughton, 1976, p. 298.
14. Ibid, p. 220.
15. Ibid, p. 225.
16. Mishima, op. cit., p. 84.
17. Ibid, p. 85.

NOEL SANDERS

The Eye
is
More or Less
Satisfied
With
Seeing

Fiona Pardington, *Sex of Metals I & II* 1989. Gelatin silver prints,
gold toned and mixed media. (I) 354 x 456 mm., (II) 363 x 466
mm. Courtesy the artist.

Sex of Metals

The Art of Transmutation

Elizabeth Knox

Fiona Pardington's *Sex of Metals* I and II show a female and a male torso clutching two constituent pieces of a broken weathervane. Both photographs are framed by a montage of cut-up photocopies of alchemical texts, the 'sense' of the pseudo-scientific shuffled by scalpel and paste, embellished with gold and copper paint and streaks of watery turquoise and pink. The ancient texts lend the photographs their air of dignity and authority, their promises of arcane wisdom. We read for clues, fragments of different languages and scripts — Latin, Hebrew, Arabic, and plain English like plain scone mix sweetened with meaningful dates and dangerous currents. The montage is a droll example of the fashion for the archaic in contemporary art, for models of ritual and magic, charts, maps and reliquaries. (A fashion which, I believe, is symptomatic of an allergic reaction contemporary culture is having to Reason — a prevailing taste that will produce interesting work and other things with a merely acceptably modish flavour, analogous perhaps to late-Victorian engravings of dogs dressed in bowlers and deerstalkers, smoking pipes in country ale houses — Victorian sentimentality being an earlier manifestation of the allergy, the immune system of humanity kicking up against the Industrial Revolution.)

The alchemical texts framing *Sex of Metals* I and II create the right atmosphere, the right look: stars, wheels; figured circles; crenellated towers; six sevenths of the name of God; and tantalisingly partial quotes, '*It is regarded as the mother of metals*', '*. . . to those alchemists metals and minerals were alive.*' But here too are jokes, remarks on what the photographs lack, or lacks the photographs suggest: an amputated leg, a crowing cock. The outer frames also convey more than the right atmosphere, they comment on what they separate from the world (the work and its ideas, separated from the gallery walls, from a collector's home, and from time passing). The frame around the woman is decorated by carved, gilded ribbons and flowers. His frame, despite the gilt, represents rough-hewn, bark-covered branches, complete with knots where limbs have been lopped off. It is an interesting recipe — the correct flavour of mystical or sacred connotations, masking an undertaste, sharp and wicked. We have been slipped a mickey, and the mickey has been taken.

(I) A woman stands against a background of leaves and spiny, upstanding blooms. She holds an iron arrow against her bare flesh, the arrow extended vertically along her body from thighs to throat. Hairs on her arms and sides are erect, due perhaps to body contact with the cold iron — this detail evoking texture, temperature, sensuousness.

(II) The man's body is shown in a tighter shot, but looser focus. He has no gooseflesh, his body hair is more like shading, like cross-hatching on an engraving, than something with a texture, attached to the skin's small responsive muscles. His flexed pecs and nipple look braced and insensitive, the nipple a fleshy stud. He holds the weathervane's decorative metal cock, concealing his own genitals. None of the spiky, phallic flowers are visible in the foliage behind him.

Does the broken cock stand for his fragile sexuality? Is his body braced because his future is so uncertain? After all, he can't know which way the wind is blowing. Perhaps his 'cock' is a stopcock, a closed valve.

While he holds the purely decorative part of the vane the woman has the arrow, the indicative part (yet both are nominal; whether cock, whether vane). Does she have an indication of the direction of the flow of her own desire, or merely the means of knowing? Or has she her own cross to bear? After all, the arrow is a vane, and seeing which way the wind

blows could mean having constantly to monitor the effect her appearance is having on the object of her desire.

The man and woman are faceless, generalised rather than pornographic, each is lacking lower legs and feet, is idle and captive, feet fettered, omitted. Yet, however footless, both figures are fated to stand for the division of difficulties between the genders. *You've got your troubles, I've got mine.*

Still, the sign is in the eye of the beholder. The cut-up alchemical texts and torsos are both nonsense and suggestion. This suggestion: alchemy and sex hold similar enticements. There are secret formulas to be found, the right chemistry; there are conquests,

control over the vagaries of nature (always 'the other'); there are transmutations in the offing, lead cannot be lightened, but it can be enlivened, beautified, made to pay; sense can be made — is on the make — if only enough signs are deciphered.

Fiona Pardington understands that the naked human body is the common currency of late twentieth century monometalism. Flesh is the 'gold-standard' for advertisers, it sells everything. It sells itself — laser therapy, collagen injections, lipo-suction, breast implants, skin care, body-building, macrobiotics and blood products all promise to transmute our lead into gold, provide the elixir of life, pander to our deepest hidden wishes.

make myself light for love. I steam my skin so the air enters me. Small scabs pucker like mouths when my skin dries and are scoured away with a handful of sugar. I pluck each unwanted hair, free its white, bulbous root; evacuated pores seal themselves and my skin sets, opaque and smooth as wax. I wash my hair free of its oils; fill in each feature of this drab hen face, skin an even cream, brows and lashes black as crusted blood, mouth red as fresh. I dress.

All this for a gaze that favours me anyway?

I make myself light for love. My voice lifts, a fish rising to feed on the fly of your attention, which isn't even food, but wire and feather. My sense of speech's duration is disturbed, I feel I'm interrupting you so don't explain myself. I say, 'If you see what I mean.' You are generous, you disagree with me, you give me the benefit of your scholarship.

'Seventy percent of household dust is comprised of human skin.' Powdered seconds, chances, responses. Life coming away at time's touch. The dust that dances where there is no breeze, no cause — like the Brownian motion of pollen dodgems in a still solution, particles butted by molecules. I am in your house, my throat's cilia sifts your skin — discarded the many times you removed your clothes, during caresses, or when you rubbed your eyelids late at night over Foucault or Bataille or St Augustine — sifts your skin out of my system.

In return for your fact I offer a proverb: The rain that falls on skin is made of different water from the rain that falls on cloth, or rock, or ocean, or the vegetable earth. This rain craves a certain kind of heat; it is as greedy and as murderous as love.

History Painting: Paintings of History

Tony Green

Preamble

There is no kind of painting that is not dominated by discourses, namely: social, contextual and material. Even where no narrative is at stake, as in abstract painting, the painter has to have a beholder, a reader, in mind. The familiar social and contextual discourses proceed from this fact. There is a further important discourse that always concerns a painter: the discourse of current knowledge of how to do 'the work'. This has a dual fascination, because it includes the knowledge of craft, in so far as it determines styles of representation, to arrive at something that can be read as allegory, or as narrative.

For the artist, painting may well be — and is sometimes more than anything else — a way of testing out the impinging discourses. These include conversation with family and friends, as much as any contextual or formal requirements, so that painting is, for the painter, inextricably linked with the quotidian as much as with theoretical positions.

However pure-seeming the surfaces of a flat blank-seeming picture of, say, the 70s, such a painting will represent as much of a dialogue with the present as any photograph. It is wide open for allegories based on all the various signs the reader will find there. An artwork is thoroughly dented and scratched from the momentum of the exchanges it bangs about in when changing lanes. It bears the marks of the economics of its dealership, and of the promotional velocities of curators and writers, as well as social or spiritual contexts.

Much current writing about art, some of it claiming that it is renewing art history and criticism, still attempts to recover only one discourse, the discourse concerning what it usually calls *the* text.[1] This regularly excludes discourse to do with what it also calls, in contrast, 'pure visuality'.

The current mode of reading pictures comes down to identifying specific written texts like the *Iliad* as sources; or, if unwritten, something of the order of a social code for manners demonstrated by the posture and predicaments of the characters seen in the figural paintings of the day; or, yet again, a historical-social sub-text, connecting it to the history of the times.

This is akin, in literary criticism, to regarding the text only as the bearer of moral discourse, without acknowledgment of the writing that makes the reading possible. In both painting and literature, criticism is thus restricted to the fictional 'worlds' presented, without regarding the problems of the media. Any writer or painter knows that fictional worlds do not encode themselves in the media without the agency of the artist, with all her knowledge.

A decent critical practice will see all and any painting in relation to a complex of discourses, not just one. These discourses must be seen as necessarily including and encompassing '*the* text', not replacing it or disregarding it. Understanding the way the work is made, must inform the discussion of its other contents.

The counter-move to reading 'content' was also just as exclusionary, valorising as content formal qualities alone. Both sides of the resulting argument oppose 'pure visuality' in painting to 'pure textuality'. This opposition returned in the 1980s by reference to the 'autonomous image', supposedly 'free of discourse'. This is posed as the counterweight to a text seen as invading the art. The autonomous, self-referential image is always conjured up as Modernist painting's purist end, as in the theoretical view credited to Clement Greenberg. Seeing the deficiencies of this 'formalist' reading has been taken as an excuse to return to the equally deficient reading of 'textuality'. Still it has not been seen that both sides are wrong.

The 'autonomous image' is a spook, for both sides of the argument. Criticism can only produce the fiction of the 'autonomous image' or the fiction of 'pure textuality' by closing one eye or the other.

Of the referentiality of abstract painting

What abstract painting lacks is reference in materiality. Its reference is to abstractions: for example, black and white, representing opposites, or poles apart. Or, as a further example, white on white. That asks a question, which is the beginning of a text: 'At what point does figure coalesce with ground?' Isn't such a painting a test case for a generally recognised problem: how to distinguish the indistinguishable, or, where to draw the line? It refers to no thing, no substance; it awakens aporias, calls for ejaculations of hermeneutic discourse, a continual attempt to find answers to 'What makes it tick?' and 'What makes the reader itch?'

These questions arise differently with different readers. The question 'What's the use of that blank thing?' is a serious one. This question should not be taken as dismissing abstract painting from further analysis, since it often leads to an instructive discussion.

Discussion would fasten on the terms 'use' and 'blank' and would consider:

1 is there use for painting?
2 is there a use for a particular painting, in which 'blankness' is a value?
3 how blank is 'blank'?

After a while, it becomes clear that these are only preliminary ground-clearing questions. The answers have to lie in what one says 'happens' in the picture: that is, in the construction in the present by the reader of uses and meanings for the picture, having in mind future action in the culture. In practice, this is never limited to what the figures do, or to such imponderable questions as the unity of the image, or balances about an axis, and so on; but to the difficulty or ease of reading the picture. Often the point at which reading begins is where something jars, where something seems to be wrong or absurd or excessive.

The perspectives within which the picture can be read are discovered in the attempt to read it. They may be eased by knowledge of 'historical context', for example, familiarity with practices of the artist in question, of her contemporaries; of predecessors and successors; of, even, quite remote-seeming work from other times and places.

'What happens' becomes the test of the question of the use of a painting, and also of the question 'Is this really blank?'. For this reason, if something 'happens' when one looks at the picture, then it cannot be a blank, no more blank than one's discourse.

There is also a not unreasonable presumption that a skilled person, who painted it in the first place, would have been super-sensitised to all the effects of making paintings and looking at them from years, weeks, days of thoughtful practice.

An aside

Thoughtful practice covers the old division: theory and practice. In this term the 'thoughtful' is directed at the practice, measuring carefully what is going on while doing it, at every stage, so to speak, even in the swiftest extemporisation.

For extemporisation one is specially prepared, by years of gathering one's material. Extemporisation at speed is a ritual act in most painter's practices, throwing themselves at the mercy of the muse, praying that the preparations have been successful.

'Extemporisation', work done outside of deliberately pre-planned use of time, is an alternative term to 'improvisation' which may imply a dumbness of intention. 'Extemporisation' is, of course, improvisatory, but a purpose is foreseen, and the materials well-organised and practised beforehand. The attitude to time is at least as important as the attitude to chance.

Extemporisation entails giving in to the rhythmic impulse of working, without reflective hesitation and stopping, as if too much complexity of thought hampers pre-planning. Often extemporisation cuts through the complexities of theoretical and moral concerns. Solution to problems A, B, and C, will come while the attention seems to be on D. It is a means of focusing attention on 'one problem at a time', so that other irritations will be happily subordinate for a while.

A note on a particular difficulty

Did the artist mean you to read that? This question arises from the assumption that the business is to biograph the artist, trace everything to her intentions. Not so, though. The purpose I have in mind is quite different: to trace the effects and questions raised in reading the work, not the intention of the artist.

The problem of the 'autonomy' of the work, is the problem of its disjunction, separation, and independence of anything the artist may have 'meant'. In this regard the artist is an interesting, but not a privileged

reader of the work.[2]

The biographical presumption keeps demeaning the work by insisting on our reading its moral text. The habit of doing this is ingrained in a largely fruitless present version of art history, leading to the false assumption that this moral text is the only one to be recuperated.

To say that this essay is provoked by my preoccupation with changing over from teaching seventeenth century to twentieth century art, would serve the purposes of such a discourse. It would enlarge on my need, as a consequence of the change-over, to carry over and adapt discourses I have already developed about the seventeenth century, and in particular its history painting. However, in characteristic fashion, it would be blind to the fact that the seventeenth century material I teach has already been subjected for years to a meditation that rises from thinking in the present and surrounded by contemporary arts. No reader can disassociate present contexts, including those that come from attempting to read contemporary art, from the act of reading seventeenth century art. Nothing of 'the past' can enter a text of 'the present' without the agency of a writer to write it. Historical writing is, in this account, an appropriation, a reading, or, as musicians sometimes say, a realisation.

Development (1)

What I want to ask at this point is about history painting, and I mean very specifically the old master kind, the *istoria*, the *poesia*, and not the painting of historical event; just for the moment, though. A history painting is one that involves the representation of figures who can be identified with those of a classical literary text, for example Homer, or the Bible. Contemporary historical events, as represented by contemporary historical texts in the Renaissance, are chiefly limited to the politico-military acts of rulers. In the seventeenth century these were often constructed in terms of an overt allegory, as in Rubens' *Marie de' Medici* paintings. These make themselves available to a mode of reading that is fundamental to G.-P. Bellori's classical account in his *Lives* of the artists.[3]

Consider the first part of the poem he prefaces to the book. Its concern is Painting, La Pittura, which he treats as a personification.

I don't have life or spirit, yet I live and breathe. I don't move, yet with every action, and every time, I move. I don't have any feelings, and yet I laugh, cry, love and get angry. Miracle of art? My chatter is hushed, I'm born mute, I don't talk and yet I'm very loquacious; I pretend and I'm a liar, and yet I show the truth in every inch. I am shadow, and always diminish the brightness of the canvas to form the light.[4]

The account Painting gives of herself is paradoxical. Her illusions make the beholder see things that are not there, all out of the manipulation of lights and darks. The painter's knowledge is knowledge of the materials of the art, as they are used to arrive at its illusions.

The *poesia* is more likely to consist of a representation of an allegorical text, which the painter may invent, on the basis of classical mythological texts or current poetry. The term relates to such works as Titian's *Sacred and Profane Love* and could be extended to Poussin's *Et in Arcadia Ego*.

The absent signified of the history picture is not actual people or events, primarily or exclusively, but the various texts: Ovid, Homer, the Bible; or later, accounts by survivors of the ordeal of the ship-wrecked on the raft of the Medusa; as well as the discourses that stem from relations to historical context and the way the work is made. And what it engages to do is to supply what is never present in any text, i.e. the *sight* of something. From the outset, the painter is a reader of that text in order to summon up a picture in place of the texts, as representation of event, place, persons, whether in grisaille, or in Kodachrome. This may be called a translation, not from one language to another, but from one medium to another.

This applies to the painting of historical event too, because that also depends on text. As Paul Ricoeur has argued, there is no historical event that is not already symbolically mediated in order to become readable.[5] A historical event can only become text through the necessities of socially acceptable tropes, loosened or tightened to fit the occasion, and according to the reasons of the teller. History is in this sense already a representation.

A painting has to cover for plausible relations to a specific text, by taking up the text as representation of mise-en-scène, actors and appearances. And it needs to do this, so that the reader of the picture can fill it with texts and end with allegorisations.

TONY GREEN

What is specially interesting about the process, is that the painter has to make up the whole thing, with nothing being visible in the first instance other than the letters on the page. Text's apparent bewildering openness to how it is painted is in practice severely limited. A history painter's culture includes models in other paintings. In some cases these are readily applicable to specific subjects, in other cases they have to be transposed. The patterns for an *Adoration of the Golden Calf* may be readily available, but it is also possible to modify the familiar patterns for the *Baptism of Christ* to make an *Anointing of King David*.

Only in the eighteenth century does the painting of historical contemporary event begin to broaden in scope, as in heroic acts, such as Benjamin West's painting of *Penn's Treaty with the Indians*, or Copley's *Brooke Watson and the Shark*, or David's *Death of Marat*. And as the nineteenth century proceeded, the demand on painting for specifics of site, costume and figures grew, disturbing and displacing or reversing completely the rhetorical artifices of the *istoria*, as in Courbet's *Burial at Ornans*. This occurs alongside the presence of photography of historical event and the reproduction in the press of sketches made on the spot.

This is a kind of painting that, more and more, limits the attentions of the reader to its historical content, treating the medium as something to be taken for granted, the mechanics merely of representation. And this was then applied retrospectively to the kind of painting that Bellori had addressed, with a consequent loss of the modes of discourse he had invented for the paintings of Raphael and Poussin. This process corresponds, in literary terms, to the displacement of the long poem by the increasingly 'realist' novel in the nineteenth century.

To make up a scene in painting is to supply a set of figures that do not signify specifiable 'real-life' 'persons' 'in' 'the' 'world', but a twofold intertwined and verbally difficult notion.

The bodily attitude of human figures is at issue. Their meanings can only be construed in the context of the whole figure group and its setting. So one reads back and forth, between one figure and another, in a continuous criss-cross manner.

The painter has to make marks to make bodies, and exactly here the text continues, though it has frequently but wrongly been thought to run out. In fact, 'the text' is here taken up in another way and by the material text, the other crucial but largely ignored text of painting. The main reason why this continuation of 'the text' is ignored is that, from the 1670s onwards, because of the doctrinal influence of the French Academy, the questions of detailed accuracy of mise-en-scène and dramatis personae dominated the theory of history painting.

Before that the classical tradition, as represented by G.-P. Bellori, is deeply concerned with elucidating the artist's invention of the painting, as an act of working with inert materials that creates an illusory presence of the figures themselves, and of the text that they provoke. After Bellori, the materiality of the painting is discounted.

The figure in a history painting is both a representation of a dramatic personage required by the source text, and a representation of the material text that prescribes its drawing, its colouring, its placement within the whole pictorial structure.

A mark is less than a unit of pictorial 'language'. It is unlike a phoneme in that no two marks are alike and they do not appear to belong to a system of differences, or to be part of a code. A figure is much more than a word, a noun, and may be more than a sentence. A figure reads both as an attitude of a person and as a constitution by marks within a representational system. But the representational system is made up of rules for spaces, outlines, shadings, not of systems of marks.

Figures seen as attitudes of persons set up a reading of picture as human interrelations; while figures seen as manipulation of marks and representational prescriptions set up a reading of picture as the thinking in painting that has made the picture possible. Both are clearly present and visible, but commonly only the first is attended to, while the second is omitted with the resulting loss of valuation of something once recognised by critics, and presumably by artists like Bellori's friend Poussin.

A consideration:
The body in the meaning of text

The possibility of voices that belong to quite distinct persons being distinguished for their ethos, through a deeply subjective reading and reaching down of roots into the awkward corners of consciousness — that possibility depends on taking the production of sound as bodying forth a sign of disposition.

One takes the body-movement or posture of figures in painting as significant in a similar way. This is at a quite different level from that of translating posture into allegorical meaning founded on moral and psychological interests.

The movements of another body, or person, are responded to by reciprocation. An attentive reader of a portrait, for instance, will often tilt her own head to mirror that of the head in a picture, much as she might with an actual person. History painting depends for its effectiveness on the knowledge of how to produce postures and directions of gaze of figures that signify affects, interpreted by reciprocation.

Development (2): Some histories

Who has not enjoyed the pleasure of gazing into the eyes of the beloved, lost to absolutely all else in the world, oblivious to danger therefore, completely confident in the security of her being? This is a condition of mutual trust, achieved by promises and vows, by enactments in the bed, which themselves demand a complete trust in the security of the arrangements, because they are otherwise apt to disable the person from adequate physical resources to ward off attackers, an allegory that could be attached to Sampson.

Allegorised, Sampson's loss of his long hair becomes the loss of his virtue, first by seduction then by robbery at the hands of a gentile woman who was his lover, since she could get him to break the promise (a secret she had found out by trickery, to which he was leaving himself wide open, trusting himself where he had been warned he should not, trusting that the promise was unconditional, whereas he had been made to understand it was entirely conditional on his sticking to his side of the bargain), or something of that order in the texts of the seventeenth century. Hence it is a scene readily allegorised for painting in the seventeenth century, for Van Dyck, Rubens and Rembrandt for instance.

The above paragraph is a specimen account, an attempt at constructing a style of reading of history pictures, in which the basis on which each figure is to be painted can be estimated. It is necessary to make a guess how such a process goes on, and try it to see what results it gets.

I make no claims for the correctness of my estimation of what these figures would have to look like. I want to draw attention as much to the blankness of the text, as to the detailed morality that might be spun out from it.

There are texts that seem to engage this species of hermeneutics. It is sufficient for my purpose that I have sketched here a sample of what I would go through if I had to paint a picture of the story of Sampson and Delilah, just to begin with, as I imagine myself faced with a seventeenth century context of reading. To go further, I have to engage with the figures of all the persons, Sampson, Delilah, soldiers, in order to get a semblance of the moral and spiritual character of the piece. How did it feel, how does a figure show that feeling? How would I see the figures as enactments of their passions, in still, silent painting?

No wonder Nicholas Poussin refused a commission to paint a *Christ Carrying the Cross*, in view of his claim that painting the *Crucifixion* in 1646 had made him ill. Going through the process of imagining the plight of the figures, in order to be able to construct them adequately, is precisely what is at stake, for the painter, and therefore for the reader.

It is possible, for comparison, to represent the story of the rape of Lucretia, another famous history figure. She is a figure in what was a well-established type of narrative (stories of virtuous women) for use in a Christian ethical education that could yet take in pagans such as Lucretia.

How can a painting of the story of Lucretia be done with one figure only? Tarquin, rapist tyrant, is not necessary to the painting, as Rembrandt (among others) showed.[6] The artist's treatment of the text is entirely dedicated to pressing everything from this one half-figure, dagger in hand, desolate beyond belief, according to the reading of the face and the gesture. Imagine being so close, face to face with one about to kill herself, from shame, and injured at the hands of a wicked man. She is completely innocent, virtuous to the point of not being able to bear any longer to live after having been sexually taken, even against every endeavour of her will and strength, in case she would thus have become defiled forever (in her husband's eyes). (Gender-wise the moral is lopsided).

Something of this, and perhaps more, including the Dutch Republic's interest in figures who resisted tyranny, would form a probable context for reading Rembrandt's painting as allegorising suffering at the hands of the Holy Roman Empire. The address to the

TONY GREEN

reader is entirely in terms of the affective character of the image, however.

What does it mean: to be face to face with this apparition, which asks all of your sympathy; this figure of a woman that is beyond anyone's forgiveness? You can still halt the act she is about to commit, intervene in the picture, snatch the dagger away, say: 'Please don't do what it seems you mean to do. It is not too late, there is another way out, there must be some power that can extricate you from this fate.' The issue of suicide is reviewed by seventeenth century Christians over the Antique examples, and the tradition of ancient self-sacrifice that is called, loosely, Stoic.

But also at issue is illusion. Here is a reader supposedly rescuing a painted image, not a person. The inert image becomes the agency for an involvement of reader with responses that belong properly to persons. The act of seizing the hand that holds the dagger is deeply in inverted commas. It would be the act of a reader rapt, enraptured by the image.

Rembrandt's answer is to dissolve the certainty of where the picture-plane is, dematerialise the thing into myriad lights and smoky darks, as in a darkened room, where though you are as close as maybe, you cannot touch this insubstantial substance. The sight of Lucretia is predicated on a method of chiaroscuro; of manipulation not of significant patches of meaning — this figure, that limb, this gesture, that heroine — but of the doubt whether this is or is not a substantial being. Yet one wants to save this phantasm from destroying itself, as if it were flesh and blood?

Rembrandt makes a shocking painterly mess to get his effect. Precisely. That mess is the source of all the serious inner reflection; on life and death, on virtue and honour, on dishonour, the dishonour of the tyrant, who is forever remembered as such, and spat upon, or forgiven, as one embraces the virtue of Lucretia. She is the classic suicide, murder with the wrong victim . . .

The old excuse for illusion in painting was that painting was harmless. Here is its payoff: the engagement of the reader with illusion is itself also a subject of painting.

The presence of someone in the paint is also a touch of magic, arising from a magic touch. What is present is light on matter, yet from this nothing we make up a whole universe of spirits and look for the thing that governs all of them. What does govern them: the painter as a biography? the context? or the practice of painting and its context enlarged to include the reader?

Towards some conclusions

Abstraction is no more devoid of intertwining multiple texts than history painting, even though abstraction attempts to eliminate one species of referential text.

What abstraction did was to locate meaning in the thought of how to put paint on, reduced to a point where the absolutely basic unit of painterly means is exposed. What are we really doing when we paint to make a square? Think of doing it, not as a means of starting a picture of a house, but as nothing more than paint on a surface. Thinking of what the reader then has to do should lay bare the significance of this painterly device. The square is not a means to making an illusory image, like a mirage; but to an inescapable materiality.

It is clear that historically there have been different modes of reading painting, and that painting presented itself differently at different times to the then known modes of its readers. The apparently realist concerns of the nineteenth century cover up an earlier reading and painting mode. Modernism opposed the nineteenth century mode of reading of content with a reading of form.

But what was missing was already lost sight of in the eighteenth century. It could not simply be restored, as a correction to a century of scientific rationalism, of journalism, of realist novels, or of painting thought of as transparent representation. The twentieth century Modernist answer to an excess of reading of anecdote and realist content, was to lurch towards its seeming opposite.

One result was an inability to read seventeenth century history painting, leaving it outside the twentieth century system of opposition between form and content. It needs to be read as a duality, in which the paradoxes of illusion are presented for you to unravel them. It is as if the initial doubts of Descartes, brought on by the illusory figures of dreams, and by questions as to the true identity of clothed persons seen passing in the street — were they human beings or automatons? — could be posited and challenged by the illusions of painting.

In Velasquez's *Las Meninas* the figure of a painter is shown in the process of painting the other figures

in the painting. They are, from the point of view of Velazquez painting *Las Meninas*, represented as *not yet represented* in the fictive and unseen painting on the fictive easel of the fictive painter. Therefore, when seen in the painting, they are represented as real, in life, not yet incorporated into an artwork, as they are free yet in the space of the fictive room. But even so, we cannot be deceived for long: they do not move or speak, and we cannot go around them. The conditions of freedom from representation are here represented. If the framework of art were removed, this would reveal real life as Velazquez understood it. The painter has taken up the challenge of representing the figures with a realism soaked in those conditions that signify 'life', so that they would be accounted for as *real* as opposed to *painted*. They are surrounded by framed illusions of all kinds, pictures on the walls of the room, a mirror with figures of the king and queen in it, otherwise not seen in the picture, and a man framed in a doorway, who could also be a painting within a painting. The questions are posed: what makes this *realm* of illusion, and, what is the text of its laws?

Notes

1. As, for instance, in Norman Bryson, *Word and Image*. Cambridge: Cambridge University Press, 1981.
2. See discussion of this in Paul Ricoeur's essay 'The Model of Text: Meaningful Action Considered as a Text' (1971, in Ricoeur (trans. J. Thompson), *Hermeneutics and the Human Sciences*. Cambridge: Cambridge University Press, 1981.
3. G.P. Bellori, *Le Vite de Pittori, Scultori et Architetti Moderni . . .* . Rome: 1672.
4. Bellori, op. cit., p. 31. My translation.
5. Paul Ricoeur, *Temps et Recit*, Vol. I. Paris: Editions du Seuil, 1983, pp. 87-94, esp. p. 91.
6. See Rembrandt's two paintings of this subject, especially the version in the National Gallery of Art, Washington, D.C. No illustration is included here, so that image is evoked solely by text.

Leon van den Eijkel and Ian Wedde. Photo: Neil Price.

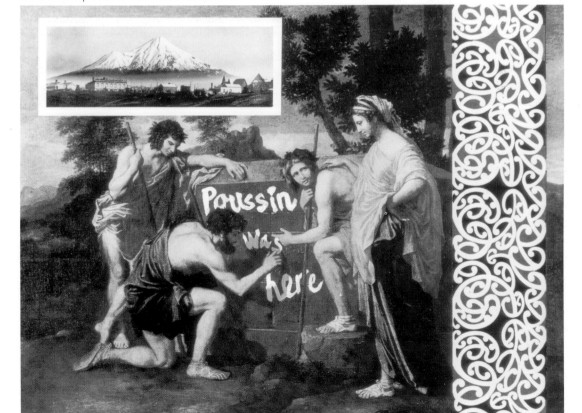

TONY GREEN

Leon van den Eijkel, *D.N. 8 nr. len 2 SA – 1985*, mixed media on paper, 520 x 1440 mm. Courtesy the artist.

What Can I Say? (about Ed Ruscha)

Chris McAuliffe

Ed Ruscha, *Silly* 1977. Pastel on paper, Auckland City Art Gallery. Courtesy Auckland City Art Gallery.

That Ed Ruscha's use of the word in his art has been enigmatic has not made his work difficult to place within the history of Western art. The fragmented, allusive, and poetic qualities of his image-texts place him in the Modernist tradition of Symbolism, Dadaism and Surrealism. The use of fragments of everyday language harks back to the collages of the Cubists. The slogans and brand names in his paintings evoke the Pop strategies of the 60s. His use of found and overheard words in staccato collages is reminiscent of Beat poetry or more contemporary Rap and sampling. The deadpan cool of other works associates Ruscha with Conceptual art.

In broader terms the intrusion of the everyday world into art, and of the verbal into the realm of the visual, might be seen as a critique of Modernism: the autonomy of the visual arts breaks down in the intermedia flow of postmodernism. It is tempting to see the ambiguous allusion to, but ultimate absence of, reference as a symptom of the loss of certainty and stability which is said to characterise post-modernism. Ruscha's work, then, could be made to fit any number of interpretations ranging from the classic Modernism of Mallarmé to the drifting post-

modernism of Derrida's *différance*.

None of these readings would be wrong; Ruscha's work provokes, even demands, multiple interpretations. But none, in isolation, could complete the picture. Ruscha's text-images explore all these possibilities as the artist asks himself 'What can I say?' and 'How can I say it?'. Conscious of the artistic, poetic, and commercial uses of the word throughout the twentieth century, conscious of historical and cultural changes which have affected the stability of language, Ruscha explores the operation and limits (if any) of meaning.

Ruscha's earliest use of text and word in his art drew on the tradition of Cubist collage. In *Dublin* (1959),[1] three collage elements are layered within a neatly drawn rectangle on a small sheet of white paper. At the top is a rectangle of wood, patchily covered with blue paint. Below it are pasted, upside down, some frames torn from a *Little Orphan Annie* comic. Layered over the comic is a pointed strip of green wood. Below the collage the word *Dublin* is lettered in black serif type, spaced evenly across the width of the rectangle. The work draws on many of the tactics of Cubist collage. The use of actual objects — wood and newspaper — disrupts the previously accepted distinction between the real and the illusory. The pairing of painted wood and printed page contrasts the gestural and the mechanical, the natural and the manufactured. The oscillation between the visual and the verbal blurs previously firm boundaries. This ambiguity is also evident in the word *Dublin*. While the precision and formality of the letters suggests certainty, the word is followed by a comma, as if there is more to come, as if it has been excised from a complete, yet unknown, sentence.

Ruscha is aware that letters, as well as words, can speak, that different forms of lettering alter the meaning of the word which they form. Ruscha exploits the way in which typography can generate mood. When choosing the typeface for the artist's books he produced in the 60s and 70s he chose a workaday sans serif type to give it 'a manual look . . . it has that factual kind of army-navy data look to it that I like'.[2] As in *Dublin*, the factual quality of the typeface is at odds with the factual, yet tantalisingly enigmatic, images within the books. Like the Symbolist poet Mallarmé, Ruscha sees that the power of an image or word lies in what it leaves unsaid. Whereas words were conventionally understood to be singular in their meaning, the use of fragmented phrases, allusive typography and evocative placement inject mystery into Ruscha's work: 'I believe it all has to do with tantalising your memory . . . The most that an artist can do is start something and not give the whole story. That's what makes mystery.'[3]

Ruscha argues that words inhabit an unlimited space where scale, logic and causation no longer apply. In *Actual Size* (1962)[4] an actual size copy of a can of Spam is painted in the lower half of a 183cm high canvas. In the top half the word 'Spam' is painted in 60cm letters. The Pop art image brings the mundane world of the supermarket into the domain of high art but, more importantly, Ruscha claims that the canvas is a place of 'no size' where words and meanings are not regulated by being bound to real objects.[5]

This determination to release words into a field of play and mystery is also evident in Ruscha's use of puns and surreal word associations. If the form of letters can be flexible and poetic, so too the content of words is fluid. *Damage* (1964)[6] literally represents the title, the word is painted flatly in a chunky typography with a blazing 'a' and 'g'. *Folded Fats* (1965)[7] is again a literal portrayal of the title, a folded sheet of paper with the word 'fats' written on it. In a tongue in cheek homage to Marcel Duchamp words simultaneously speak properly and improperly.

Like the Symbolists, Surrealists and Dadaists before him, Ruscha demonstrates that language is fluid, that even the material form of a word — the letters that make it up — is part of an unending game of generating meaning, none of which is final. If Ruscha asks 'What can I say?', his work recognises that the fact he can say anything does not guarantee that he controls language, for the viewer can see and hear anything too.

While Ruscha participates in a Modernist tradition of language-oriented art he also uses language to attack other versions of Modernism. He takes issue with the Modernism of heroic abstraction, particularly with the Abstract Expressionists. Ruscha was not convinced that substantial metaphysical or artistic statements could be made using the vocabulary of gesture, splash and drip:

They would say, face the canvas and let it happen, follow your own gestures, let the painting create itself. But I'd always have to think of something first. If I didn't, it wasn't

CHRIS McAULIFFE

art to me. Also, it looked real dumb. They wanted to collapse the whole art process into one act: I wanted to break it into stages.[8]

Sweetwater (1959)[9] maps out the two opposing approaches. At the top of the large white canvas are the slashing strokes typical of Abstract Expressionism, at the bottom the word *Sweetwater* is neatly lettered. Which says more, asks Ruscha, the existential immediacy of brushstrokes or the poetic/cultural phenomenon that is language itself. The existential theatre of Action Painting is an empty gesture in Ruscha's eyes. He finds substance in the enigmatic poetry of typography, in the words he finds in the everyday world. For Ruscha the word is a kind of found object, in the tradition of Surrealism and Dada. It may be empty of any aesthetic worth, as was Duchamp's *Bicycle Wheel*, or, in the Surrealist vein, it may be loaded with fetishistic meaning.

It is clear, then, that while it is possible to locate Ruscha's early work in the context of Modernism — be it in the critique of language, the use of poetic allusion, or of collage — his questioning of language and art is symptomatic of the increasing scepticism towards language and Modernism in the 60s and 70s. During this period American cultural and political movements focused on language in an effort to articulate their dissatisfaction with, and confusion by, the contemporary world. Conceptual artists like Joseph Kosuth and the Art and Language group used linguistic analysis to criticise the structure of formalist art. Artists and writers used a variety of means to demonstrate that language was inherently unstable, that meaning was always tenuous. The Beats dissolved the formality of language in free form hipspeak. William Burroughs and Brion Gysin wrote novels from cut up phrases which were fished out of a hat. Earthworks artist Robert Smithson argued repeatedly that language, rather than being a stable edifice, was a heap of rubble, confused and decaying. Student activists, Hippies and Yippies insisted that all language was ideologically loaded. Language was no longer regarded as a neutral tool, it was a medium that could be manipulated. The age of mass media exaggerated this scepticism. Commentators from the Left through to establishment culture all observed that the 'pseudo-events' of the print and electronic media had revealed that language was a fluid, fragmented entity.

All of this is perhaps more familiar to us now through the filter of postmodernism — a term which made its first tentative appearances in the art world in the late 60s. While it is tempting to apply now-commonplace theoretical models retrospectively — to use Barthes and Foucault to illustrate the nexus of language and power, Baudrillard to describe the media pseudo-event, and Derrida as the analyst of an endlessly mobile language — I suggest that Ruscha's problematisation of language, initially the product of his participation in the Symbolist-Dadaist-Surrealist tradition of Modernism, becomes, in the context of the late 60s and early 70s, part of a questioning of Modernism, of the real and of language, which is a sign of nascent postmodernist practice in the visual arts. From the late 60s, when Ruscha concentrates more and more on the presentation of words and phrases, his work might be characterised as an exploration of the problematic status of language through the alternate presentation of its stability and mobility.

Ruscha's display of language as stable shows how few ways there are of achieving solidity and how flimsy they are. Language appears to be stable when it is used or presented in a literal way. But Ruscha reveals that the literal is but a narrow component of the totality of language and that literal assertions are shallow. The most obvious tactic is Ruscha's 'manual-style' typography and the frontal presentation of words. This no-frills presentation seems to suggest that what you see *is* what you get, but that ultimately you get very little. *I Live Over in Valley View* (1975)[10] spells out the phrase in straightforward frontal lettering. The assertion is literal but empty. *Three Darvons and Two Valiums* (1975)[11] reads like a simple shopping list, suggesting that it is still possible simply to name things. But do the words really point to anything? These are brand names, a shorthand for complex chemicals. In the case of both works the seemingly obvious assertions give rise to a destabilising mystery: what kind of a place is Valley View, who is the 'I', are the drugs for medicinal or recreational use? *I Don't Want No Retro Spective* (1979)[12] pin-points the problem. Taken literally as a denial of professional ambition the statement is clear enough, but an assertion can be a lie.

What Ruscha's lists, names and statements do is indicate that pure denotation is no longer plausible.

Language cannot simply invoke something, there is always an element of connotation which sets the meaning adrift. Even when the word is made of what it refers to, is literally what it says it is, connotation creeps in. *Stews* (1970)13 is a print displaying the single-word title in Gothic type. The print is made by passing baked beans, caviar, strawberries, cherry pie filling, mango chutney, tomato paste, daffodils, tulips and leaves through a stencil. Certainly a stew, if not

Ed Ruscha, *Brews* 1970. Organic silkscreenprint, 584 x 812 mm. Auckland City Art Gallery, presented by the artist 1978. Courtesy Auckland City Art Gallery.

Ed Ruscha, *000*. Lithograph, 508 x 711 mm. Auckland City Art Gallery. Courtesy Auckland City Art Gallery.

an edible one. But there the literal element ends, for Ruscha says of the work, 'Stews is my idea of British cooking, with little rooms, smoky kitchens and fireplaces, warming by fireplaces'.[14] The print is awash with associations — cultural stereotypes, travel brochure clichés, Dickensian vignettes. That the word could ever be solely and precisely what it says, is as ridiculous as its ingredients.

Ruscha catalogues the many responses to language which render it mobile rather than stable. The *News, Mews, Pews, Brews, Stews, Dues*, print folio of 1970 comprises a set of associations evoked by

England: tabloid newspapers, mews houses, churches, pubs, food, and Robin Hood.[15] This associative attitude extends to the material form of words themselves. Ruscha anthropomorphises words, seeing different presentations of language as having emotions and moods in their form rather than their content. With his liquid letters — trompe-l'oeil renderings of letters formed by water — Ruscha claimed, 'I could make an "o" stupid or I could make it hopeless or any way I wanted to and it would still be an "o"'.[16] This registers the extremes of the ambiguity of language: on the one hand, the very look of words can generate extremes of associative reading, while on the other the fundamental operation of a letter remains intact. Language is an incessant oscillation between the extremes of denotation and connotation.

Ruscha's obsession with language is such that he has an almost fetishistic relationship with words:

Words have temperatures to me. When they reach a certain point and become hot words, then they appeal to me. 'Synthetic' is a very hot word. Sometimes I have a dream that if a word gets too hot and too appealing, it will boil apart, and I won't be able to read or think of it.[17]

Here dream and desire cause language to disintegrate, an extreme example of the dissolution of meaning, or rather, of the constant loss and retrieval of meaning which constitutes a postmodern understanding of language.

In a mobile language words drift through a cloudy, uncertain space, detached from the ground of the canvas and the grounding force of semantics. Even the form of the letters becomes mobile. Fluids, ribbons, and paper hold together tenuously to form words of only momentary equilibrium as in the case of *Silly* (1977).[18]

Ruscha's relationship with language is a love-hate one. On the one hand he uses a quotation from Shakespeare to decorate a library, claiming that the words are 'noble . . . timeless . . . profound',[19] yet on the other he mocks the power of language offering such nonsense aphorisms as *Thermometers Should Last Forever* (1976)[20] and *Headlights are Similar to People's Eyes* (1974).[21]

In addition, Ruscha persists throughout the 70s in evoking mystery through language. *Screaming in Spanish* (1974)[22] *Very Angry People* (1973)[23] *Execu-*

CHRIS McAULIFFE

tive Pressures and Loss of Memory (1973)[24] continue to use language to achieve poetic perplexity rather than utilitarian communication. The response Ruscha seeks is similar to the disjunctive jolt of a Surrealist image, what he describes as 'a kind of a "Huh?"'.[25]

For Ruscha words are not so much building blocks with which to construct a message as something that is in the air, to be plucked out at random and presented as meaningfully meaningless phrases. The artist's vocabulary is seemingly acquired by spinning the dial on his radio. A page from one of the artist's note books lists possible paintings: '99FM, Drive to Arrive Alive, Miss Fox, Hey All Right, Rockin Reggae, Hunk Punk, Poll TV, Eddie Murphy, Disco Condo, Star Force 99, Party All the Time . . . Miami'.[26]

What can Ed Ruscha say? How can he say it? He can say plenty but nothing substantial. Like 24 hour radio he can broadcast an endless flow of words with no dead air. But like the dialogue of a character in an Ionesco play the constant prattle is profoundly banal, banally profound. Ruscha's Sisyphean task is to hope for a stable language even as his work points to the mobility of language which makes this unattainable. In answering both questions he finds that the only solution is to keep asking them.

Notes

1 *Dublin*, 1959. Wood, newspaper, and ink on paper, 34.3 x 33 cm. Reproduced in colour in *The Works of Edward Ruscha*. San Francisco Museum of Modern Art, 1982, plate 1.
2 David Bourdon, 'Ruscha as Publisher (Or All Booked Up)', *Artnews*, 71/2, April 1972, p. 33.
3 Fred Fehlen, 'Ed Ruscha: Interview', *Flash Art*, no. 130, January-February 1988, p. 72.
4 *Actual Size*, 1962. Oil on canvas, 182.9 x 170.2 cm. Collection: Los Angeles County Museum of Art. Reproduced in colour in *Edward Ruscha*. Lake Worth, Florida: Lannan Museum, 1988, plate 35.
5 Ruscha quoted in Fehlen, 'Ed Ruscha: Interview', p. 70.
6 *Damage*, 1964. Oil on canvas, 182.9 x 170.2 cm. Collection: Alford House/Anderson Fine Arts Centre, Anderson, Indiana. Reproduced in black and white in *Works*, plate 24.
7 *Folded Fats*, 1965. Pencil drawing on paper, 29.2 x 36.8 cm. Collection: the artist. Reproduced in black and white in *Graphic Works by Edward Ruscha*. Auckland City Art Gallery, 1978, plate 59.
8 *Works*, p. 27.
9 *Sweetwater*, 1959. Oil and ink on canvas, 152.5 x 122 cm. Destroyed. Reproduced in black and white in *Works*, p. 10.
10 *I Live Over in Valley View*, 1975. Pastel on paper, 54 x 73 cm. Collection: the artist. Reproduced in colour in *Works*, plate 103.
11 *Three Darvons and Two Valiums*, 1975. Pastel on paper, 57.3 x 73.7 cm. Reproduced in colour in *Works*, plate 95.
12 *I Don't Want No Retro Spective*, 1979. Pastel on paper, 58.4 x 73.7 cm. Collection: Bud Cort. Reproduced in colour in *Works*, plate 113.
13 *Stews*, 1970. Screenprint; baked beans, caviar, fresh strawberries, cherry pie filling, mango chutney, tomato paste, daffodils, tulips and leaves; 58.6 x 81 cm. Collection: Auckland City Art Gallery.
14 Quoted in *Graphic Works by Edward Ruscha*, p. 15. Statement made, June 1970.
15 'News means that England is a tabloid-minded country. Mews is a little alleyway found in many towns. Pews is Westminster Cathedral. Brews refers to English beverages . . . Stews is my idea of British cooking . . . Dues is . . . the story of Robin Hood.' Ruscha quoted in Ibid., p. 15.
16 Patricia Failing, 'Ed Ruscha, Young Artist: Dead Serious About Being Nonsensical', *Artnews*, 81/4, April 1982, p. 79.
17 Howardena Pindell, 'Words with Ed Ruscha', *Print Collector's Newsletter*, 8/6, Jan-Feb 1973, p. 126.
18 *Silly*, 1977. Pastel on paper, 57.4 x 72.7 cm. Collection: Auckland City Art Gallery.
19 Ed Ruscha, 'A Proposal by Edward Ruscha for the Circular Ring and for the Lunettes of the New Miami-Dade Public Library', *Edward Ruscha*, p. 133.
20 *Thermometers Should Last Forever*, 1976. Pastel on paper, 36.2 x 57.8 cm. Collection: Lauren Hutton, New York. Reproduced in colour in *Works*, plate 102.
21 *Headlights Are Similar to People's Eyes*, 1974. Pastel on paper, 36.2 x 57.8 cm. Collection: Ulrike Kantor, Los Angeles. Reproduced in clolour in *Works*, plate 79.
22 *Screaming in Spanish*, 1974. Shellac on taffeta, 91.4 x 101.6 cm. Collection: John Martin Shea, Newport Beach, California. Reproduced in colour in *Works*, plate 87.
23 *Very Angry People*, 1973. Cherry stain on moire, 50.8 x 61 cm. Collection: William Copley, New York. Reproduced in colour in *Works*, plate 86.
24 *Executive Pressures and Loss of Memory*, 1973. Egg Yolk on moire, 91.4 x 101.6 cm. Collection: Mr and Mrs Barry A. Berkus, Santa Barbara, California. Reproduced in colour in *Works*, plate 73.
25 Willoughby Sharp, '. . . a kind of a 'Huh?': An Interview with Ed Ruscha', *Avalanche*, no. 7, Winter/Spring 1973, p. 36.
26 Reproduced in *Edward Ruscha*, p. 126.

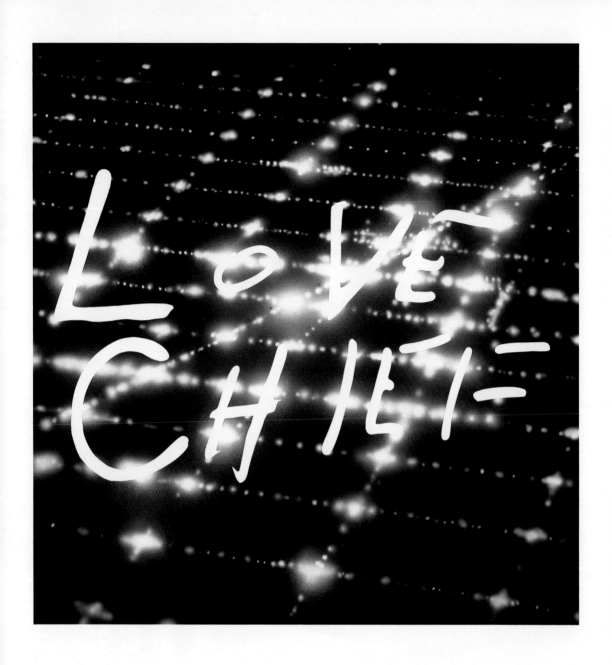

Ed Ruscha *Love Chief* 1986. Acrylic on canvas, 1630 x 1630
mm. Auckland City Art Gallery, purchased 1989. Courtesy
Auckland City Art Gallery.

Aesthetics of Abundance

Ann K.I. Poulsen

It may sound somewhat naive to wax nostalgic about being televisionless, but walking miles along a moonlit bush-verged road in order to watch an episode of American drama on that small glowing screen made a wonderful child's adventure.

The focus of our lives was making ends meet, a form of inconspicuous consumption. Homegrown and handmade weren't counter-culture political statements, they were all we could afford. And because deprivation is relative, judged against the neighbours' standard of living, our neediness didn't make us unhappy.

Eno super for TV commercial, Art Director/Illustrator Martin Hill, for Beechams, New Zealand, 1983. Courtesy Colenso, Auckland.

This was suburban poverty, not some isolated rural slump, shared by most of the people we knew. It was respectable, not slovenly, and perfectly acceptable to our parents, survivors of the Depression and Rationing which didn't disappear in New Zealand with the end of World War Two.

My autobiography is only worth recounting in that it contains the outline of countless others in the 1950s. And it is against this social context that the radical nature of Pop Art's agenda is truly appreciated.

Because we have come to take consumerism for granted as a social right, it is necessary to turn back the clock, to recapture the awe with which washing machines, refrigerators, vacuum cleaners and televisions were regarded in order to reconstruct the polemical nature of an image such as Richard Hamilton's *Just what is it that makes today's homes so different, so appealing?*

The title reads like a headline from an advertisement, and the densely packed visual appropriates its contents from the pages of popular magazines, including advertising. Of course the history of art is filled with similar scenes of domestic interiors. However, this image inverts that tradition by focusing not on the relationship the inhabitants have with each other, but on their relationship with their possessions.

The pose and rapturous expression of the naked woman suggest that there is erotic pleasure in ownership. The aloof gaze with which her mate addresses the viewer assumes that we look on with envy.

But the desire aroused can be fulfilled. Because the people we are observing are not our social superiors, surrounded by priceless antiques or other items of class-conscious distinction. The anonymous couple is us as we could be; we are envious of our future selves.

Hamilton has borrowed far more than advertising's likeness. He has also annexed its intentions.

The clarity of Hamilton's communication, able to be interpreted by any interested member of society, posed a challenge to the prevailing attitude that fine art was for a cultural elite whose upbringing and education trained it to 'read' a work of art.

In depicting the constituents of daily life and in choosing to do so through the selection of familiar, pre-used photographic images, Hamilton underlines the continuity between art and life.

ANN K.I. POULSEN

Another remarkable attribute of this seminal collage is that it was never intended to be hung on a wall and exhibited like a regular painting. It was planned to be reproduced only, as an illustration for an art exhibition catalogue and accompanying poster.

In co-opting the working methods of advertising by designating the collage finished art (the pasting together of type and visual ready for processing for photo-mechanical printing) instead of an exhibitable artwork, Hamilton questioned the accepted precepts of art: authenticity, originality and presence.

Even though art history involves more than merely the chronological succession of art styles, the birth of Pop denotes an historic moment because it heralds the arrival of postmodernism. Art's subject had become the mass media, signifying the social construction of a material culture.

Now language, in the form of brandnames, bodycopy or cartoon captions, was amalgamated into the artist's graphic repertoire. And what animated language! In the Hamilton family portrait we read, 'How do you think my daughter feels, hiding in the back street of your life?'.

If the hyperbole and sensationalism of such wording didn't already seem ironic in its original reductionist setting, the dislocation of these words by Hamilton exposes their innate absurdity, providing a new perspective from which to dissect their significance and their power.

Like the naked couple in the foreground, the caption telegraphs the awareness that the new material culture can foster a new morality and at the same time reveals a deep anxiety about the consequence of such change.

That a 'Young Romance' comicbook should act as an oracle for expressing such anxiety to a mass audience highlights the emergence of new authorities in the social hierarchy.

•

In trying to classify the workings of an invented as opposed to an inherited culture, the British Pop artists drew heavily on Americana-comics, finned cars, Hollywood, Madison Avenue. They wanted to hybridise the vitality and vulgarity of the New World with the introverted intellectualism of old, war-weary Europe.

But if the British were only beginning to come to grips with materialism, the Americans could take it for granted. In fact, many of their emerging artists had worked inside the glamour industries of advertising and movie-making. And so, ultimately, it was the Americans who groomed Pop into a successful, regenerative art movement.

Of the American school, no one enjoyed, exploited and manipulated the mass media better than Andy Warhol.

Whereas Hamilton's collage was intended to be reproduced just twice, Warhol's images were conceived to be printed hundreds of times. Furthermore, they explicitly addressed the impact on our lives of mass media image saturation. And while Hamilton worked with common sights, Warhol commandeered famous ones, already indelibly imprinted in our minds and suffused with connotations.

But Warhol did more than broaden the practice of Pop art: he lived it. Emulating the subjects of his work, Warhol remodelled himself as a star and in so doing was transformed into a Pop icon, a genuine household name. He also acknowledged the sociohistorical location of his work by establishing The Factory in order to implement industrial manufacturing methods for producing art.

Having begun his career as a commercial artist, Warhol did not separate the objectives of advertising from the purpose of art. By creating a unique, distinctive and readily identifiable style for his art, then consistently maintaining this look over a considerable period of time, Warhol imbued his work with a brand image.

The function of a brand image is to give a consumer product a personality, enabling the prospective customer to form an intimate bond with it, so adding value to the product and justifying the purchase price. As the market price of his work attests, Warhol was extremely adept at adding value to well-known, cheaply reproduced images.

Advertising sometimes formed the subject as well as the object of Warhol's work. In 1985 he produced a series of 10 screenprints simply called *Ads*, using these to demonstrate that the enticement to purchase is not the only source of interest in ads, that we sometimes consume them as entities in their own right.(see page 72)

The most striking attribute of *Volkswagen* 1985 is that the original ad (which first appeared around 1959) has been faithfully reproduced, not dismembered and reassembled or overlaid with editorial

asides. Artistic intervention is seen only in the colouration of the image and the use of Warhol's characteristic out-of-register line effect.

This restrained treatment seems to imply that the retired ad has the same importance as Warhol's other celebrity subjects, that it too deserves star status. And among the advertising cognoscenti, this is indeed the case.

The Volkswagen campaign was part of a remarkable body of work produced by a New York advertising agency called Doyle Dane Bernbach. The personnel of this agency are credited with changing both the appearance and work habits of advertising, an innovation that was dubbed 'The Creative Revolution'.

Prior to this revolution, ads were produced by writers working in isolation, composing as many descriptive words as possible. They would then take their copy down to the Visualising Department, where a finished artist arranged it neatly on the page and maybe added photography or illustration to supplement the verbal picture.

Andy Warhol, *Absolut Warhol* 1985. Courtesy Estate and Foundation of Andy Warhol.

Then Bill Bernbach, a copywriter who understood visual ideas, met Paul Rand, a talented and literate graphic designer. Instead of working independently, with the visual component merely supporting the words, these two men worked together as a team creating concepts in which the visual and the verbal were equal.

Ads became intelligent, amusing, unpredictable, fascinating. But even more importantly, it became established that the words and pictures could be married in such a way that it was their juxtaposition which generated the idea being communicated.

It is this synergy of combining an image of a funny-looking foreign car with the headline 'Lemon' which Warhol is celebrating in *Volkswagen* and the reason why he crops out some of the bodycopy, leaving only as much as is necessary to signal the appearance of the original ad.

The stylised reduction of photographic detail to outlines and planes of bold colour emphasises the symbolic function of the car's portrait in relation to the headline. The richly variegated rendering of the word 'lemon' enhances its dominance of the picture space, giving it a weight equal to the immensely larger car. Such treatment makes the creative tension between the headline and the image visually tangible.

It may overwork the joke a bit, but the execution makes any attempt at a literal interpretation impossible.

Warhol does not include within the scope of this work the ramifications for society of the then newfound power of advertising, but in accentuating the mercurial associations central to advertising's functioning he clarifies consumers' inclination to enjoy it.

•

Unlike Warhol, Roy Lichtenstein was already an established artist given to impressionistic drawings. Never having been part of the agency world, Lichtenstein approached advertising from a different perspective, experimenting with its graphic techniques in order to transform his own style.

Lichtenstein's interest in the starkly figurative illustrations of retailers' catalogues and Yellow Pages ads led him to focus his experimentation on another mass media phenomenon, comics. Although the intrigue of comicbook images was not lasting, their quotation was pivotal to the development of Lichtenstein's on-going style.

Lichtenstein's simplification of picture content, representation of his content as stereotypical, use of heavy black outlines, choice of bright primary colours and the dot treatment he utilised to produce tonal gradings of colour, all refer to the illustration genre which developed to cope with the limitations of printing methods and absorbent paper stock used to produce comics.

While the genre may have technical reasons for

ANN K.I. POULSEN

its origination, by emulating it in the different medium of paint Lichtenstein draws attention to the way in which such visual reduction manipulates information. He suggests that the very artificiality of the drawing style begs the question of whether there is also a concomitant ideological bias.

From this point of view, the cameos he reproduces are more than straightforward parodies of the lurid comicstrip method of narration. They signpost the cultural preoccupation with romance, as exemplified by the calculated pairing of youthful passion with wartime daring.

Lichtenstein isolates frames from a story in such a way that the narrative context cannot be accurately reconstructed, merely suggested. This discontinuity precludes becoming involved in any actual sequence of events, with the reclaimed distance being used by the artist to objectify the propaganda function of the words within frame.

Monologues such as 'We rose up slowly . . . as if we didn't belong to the outside world any longer. . . like swimmers in a shadowy dream . . . who didn't need to breathe . . .' or 'I pressed the fire control . . . and ahead of me rockets blazed through the sky . . .' rely on vivid, emotive writing. The use of first person pronouns invites reader participation, enhanced by the appeal of action verbs.

This style mirrors refinements being made to advertising as the 'Unique Selling Proposition', or product description, was superseded by branding. Copy combined immediacy with glamour and excitement to generate a strong emotional appeal, as exemplified by 'Accountancy was my life until I discovered Smirnoff . . . The effect is shattering'.

In rendering the text, Lichtenstein incorporates captions and speechbubbles into the pictorial whole as graphic elements important to the carefully designed balance of the painting. However, they are attached to the action as commentary not incorporated in it. We need the description to interpret the action in lieu of being unified with it and yet are visually reminded that it is a contrived construction of the facts.

The artist sometimes breaks away from this treatment in paintings such as *Wham*, where text is integrated into the picture by being illustrated as part of the subject matter. The care with which the letters are composed to accentuate their visual drama creates an optic onomatopoeia. That Lichtenstein chooses to treat only slangy words with a reduced informational content in this way further alludes to the manipulation of language's expressive capacity.

In exploring comicbook characteristics, Lichtenstein is analysing the power of a seemingly innocuous form of storytelling to generate distortions. The comicbook obsession with romance and its expression in heroic, slightly antiquated imagery suggest the comics were promoting nostalgia, perhaps as a retreat from the confusion of moral choices thrown up in the 60s.

•

Despite Edward Ruscha's dislike of being labelled as a member of any art movement, his continued interest in the depiction of words and his treatment of this motif relate directly to the themes of Pop. The departure Ruscha made from mainstream Pop was to use the techniques he had learned as a graphic artist to invent his own subject matter, instead of quoting directly from existing sources.

Ruscha's background in typography, and his desire to communicate ideas rather than create paintings kowtowing to the precedents of art history, may explain his interest in words. Another influence may be his living on the West Coast, centre of the freeway culture of billboard art.

Whatever the reason, prints such as *Let Me Putty Your Window Panes* make explicit Ruscha's enjoyment of the power of words to convey meaning not apparent in a surface reading (for elaboration of the putty innuendo, refer to the Alberta Hunter song 'Handyman').

His experimentation in having food as an art material enriches the potential for textural ambiguity. Like the television set in Ken Russell's *Tommy*, spewing out baked beans and chocolates for Ann Margret to wallow in, Ruscha may introduce vegetables and cuts of meat into art museums to underline the distinction between the biological need for nourishment and the social drive to consume products as substitutes for status/love/adventure/etc.

Despite the seriousness with which some commentators try to validate Ruscha's use of food as an art material, quoting some of its traditional applications from gum Arabic to egg tempera, its most conspicuous attribute is its sense of playfulness.

While part of this exuberance may be a natural offshoot of the campy, jokey mood perpetuated by

Pop, it can also be interpreted as a high spirited challenge to the stranglehold New York theorists such as Clement Greenberg had achieved over American art.

No doubt familiar with their theories from having worked as art director for *Artforum* magazine, Ruscha appears to be reacting against their suppression of Realism and their insistence that being faithful to the physical flatness of the painted surface was paramount.

As well as using food to give his work real depth, Ruscha employs all the perspective techniques of draughting and mechanical art to simulate an ostensible depth of space. His series of 'wet' words (printed in ordinary ink) contrast the literal flatness of the image with an optical illusion of depth. By approximating the transparency, sparkle and fluid mutability of water, a convincing trompe-l'oeil deception, equal to the best of Disney, is accomplished.

But Ruscha is concerned with more than visual trickery. In *Drops* he extends Lichtenstein's optic onomatopoeia by conveying the meaning of the word in its appearance, each letter having been coalesced from a sprinkling of water. The effect of this coupling of a noun with the substance it encodes is to intensify impact and memorability — hence its popularity as a graphic device in advertising.

Ruscha's exploration of the rendering of words recognises that denotation is arbitrary, that language is a social construction for interpreting rather than recreating reality. His puns and double entendres examine the manipulation of and by language made possible because of its artificial nature.

Whereas Lichtenstein confronted the tactics of the media, Ruscha addresses the influence of the media's model on everyday usage. By fabricating imitation signs referring to daily life and art in the place of brandnames, Ruscha draws attention to the manner in which society packages information as well as to the way we have come to accept this process. By implication, our interpretation of the artwork is modified by our habitual reading of signs.

•

The artists considered so far might be dubbed members of the 'first generation' of Pop. Building on the impetus of their work, a second generation has risen to prominence during the 80s.

Ed Ruscha, *Absolut Ruscha* 1988. Courtesy Carillion Importers Ltd., Teaneck, N.J.

These younger artists grew up in a society dominated by the mass media and radically altered by the advent of Pop itself, in all its guises from fashion to music. What for the older generation was novel and controversial, they have been socialised to take for granted.

However, they have also grown up with the knowledge that America has fallen from grace. In searching for a new heritage, society remains a compelling subject for these artists, but one which they can no longer approach with awe or innocence.

This new generation has consistently tried to find alternatives to the highbrow model of art which would restrict their audience to a privileged elite.

Keith Haring started out defacing the New York subway and has ended up imprinting his images on everything from watches to liquor ads. Mark Kostabi designs shopping bags for Bloomingdales. And Laurie Anderson has transformed performance art into rock concert programmes.

In wanting to communicate with maximum clarity and accessibility, many of these newer Popsters have adopted language as an important leitmotif, making it both the subject and the object of their work. It is the *cri de coeur* rephrased as slogan and publicised as a product of contemporary dissatisfaction.

Jenny Holzer acknowledges that her art most probably grew out of her experiences as a typesetter. While exposing her to the manipulation of language

ANN K.I. POULSEN

for mass consumption, this training also provided her with the expertise to produce her own public announcements.

Holzer's work embraces aphorisms of her own writing as well as mottos derived from the public domain. A poster with the instruction 'Put food out in the same place every day and talk to the people who come to eat it and organise them' uses the same form and tone as 'official' language to deliberately disorient the reader — is this a social service or a subversive message?

Equally perplexing is her compilation of 'truisms', controversial statements purporting to be self-evident laws. Holzer intercuts these dictums, for example 'Freedom is a luxury, not a necessity', 'Murder has its sexual side', 'Romantic love was invented to manipulate women', without any apparent rhyme or reason.

The compound effect is to bewilder the reader by offsetting every laudable maxim with one that is loathsome. Resolution of this confusion does not exist within the framework of the truisms, only occurring when the underlying issues of truth, gullibility and prejudice are confronted.

Holzer's work does deal not with logic but with conviction. Against the social background of politicians and causes being promoted like consumer products, she points out that the plausibility of any belief often seems contingent on its verbal packaging. This has encouraged a rhetoric which resorts to hyperbole at the expense of sound reasoning.

An integral element of Holzer's critique of the media is her utilization of their channels of dominance. In publicity terms, might is right because it provides the muscle to rise above the background static of information overload.

In her use of handbills, Holzer explores the impact of frequent exposure to a message and suggests that repetition has the capacity to engender popular acceptance. Her large electronic billboards situated in locations such as Times Square exhibit the impact of reach, visibility and exposure to a large audience, in begetting an aura of supremacy.

•

Whereas Holzer concentrates solely on language, Barbara Kruger merges her pithy captions with photographic images appropriated from the media. These assertive images are carefully composed to be visually dramatic, although their apparent meaning is often keenly modified by the text.

Much of Kruger's work is manifestly feminist, addressing the media practice of reducing women to mere 'sights', or objects. Drawing on her magazine background, she raids the mindset of advertising to construct her refusal of compliance in a voice equal to that of her transgressors.

Despite Kruger's use of media photographs, her montages look more like reportage than advertising. The graininess of her blow-ups, the lack of production values in her images, the prevalent use of black and white all suggest the surreptitious observations of a candid cameras.

Indeed it is this contrast between the glossy contrivances of ad and the austere candour of her reconstructions which draws attention to the highly politicised nature of Kruger's work. In stripping away the seductive camouflage, her intention is to make it impossible to ever again read an ad as innocuous, unbiased or well-intentioned. But Kruger's work also goes beyond this, insisting that we scrutinise the motives of the social structure which resorts to this type of myth manufacture.

•

Both Holzer and Kruger have also turned their talents to decorating consumer products. Their images have adorned t-shirts, while other Pop artists have experimented with furniture, jewelry, textiles and even advertising.

Discarding the rule of art for art's sake alone could be interpreted as Pop artists trying to break away from art's social function as an acquisition denoting wealth and taste. If this is so, the art audience has mistaken Pop's critique of consumption for the aesthetics of abundance.

Nor has Pop undermined the credibility of its role as the bade of elitism by commodifying itself for mass distribution. Just as all the reproductions of the Mona Lisa publicise the painting and so help to maintain its market value, the fame generated by working within mainstream culture has enhanced the desirability of Pop's art items.

In fact Pop artists seem to have emulated advertising and adopted marketing techniques to promote both themselves and their work. They utilise publicity to generate top-of-mind awareness. They socialise with their target market, creating patrons

out of friends. some particularly entrepreneurial artists have even used sales reps to follow leads and bring in commissions.

While artists such as Holzer and Kruger question the influence that advertising has had on our thought patterns as well as on our purchasing preference, this awareness has not necessarily exempted them from succumbing to the same influence.

Pop plunders the language, imagery and graphic techniques of advertising with great sophistication, but in trying to phrase an alternative out of a system devised to ensure exclusion rather than choice Pop artists are complying with its logic. Advertising may promote a variety of brands, but it does not acknowledge the option not to consume.

Keith Haring, *Absolut Haring* 1986. Courtesy Carillion Importers Ltd., Teaneck, N.J.

ANN K.I. POULSEN

Landscape as Text

The Literacy of Wayne Barrar

Joanna Paul

Science is not devoted to another world; but to our own; in the end it refers to the same things that we experience in living . . . [1]

In a decorated anecdote in *Eiffel Tower* Roland Barthes recounts the pleasure Maupassant took in dining in the Eiffel tower because he could not see it.

Similarly, those who take refuge behind a viewfinder do not see the camera imported to the wilderness; most conventional nature photographs bear no reference to the artifice of the intrusion. Blue skies, green 'native forest', close ups of flowers (leaves in soft focus), humming birds and browsing deer, bear no relation to recalcitrant nature as it is experienced by the eye; nor to the travesty of 'nature' most of us most of the time live.

Wayne Barrar's *Viaduct/Forest, Mohaka river, 1985* articulates a bush covered hill through the grid of an iron bridge. It is part of the singular pleasure of this image that the double girders of the viaduct (a technical accomplishment roughly contemporary with the camera — & la Tour Eiffel) should recall one to the binocular vision of the eye.

To scan a landscape through a bridge introduces a new order of discourse into landscape photography. The photographs of Wayne Barrar need a syntagmatic reading. One might group as sentences his images of technical intervention in the landscape.

bridges — *Viaduct/forest, Mohaka river, 1985*
dams & ponds — *Salt works 1987-89; Dam construction on Motu River, 1985*
roads — *Bruce Rd panorama 1 & 2, Ruapeheu, 1986; Track in field, Kai Iwi, 1985*
storm walls — *Human generated driftwood dam, Motu river, 1989*
fire breaks — *Fire break, Scott Burn, 1988*
plantations — *New Forest, Waitotara, 1986*
(grafitti) — *(Coyotes, Wanganui River mouth, 1985)*

These categories shift from artefacts of engineering, *Viaduct/forest, Mohaka river,* through the artifice of cultivation, *Dune/Marram, Wanganui beach, January 1985,* to the accident of a lone *Cactus, Tangimoana dune rubbish dump.*

The intervention may be obvious but compatible (*Salt works, 1986-1989*); or minimal and insidious (*Young pines near Twizel 1987*).

The intrusion is sometimes organic: willows planted against flooding *New trees, Motu River, 1985; Human generated driftwood dam, Motu River, 1989* yet ambiguous in effect: *Dune/Marram* (dune planting halts erosion at the expense of native *pingao*).[2]

It may be parasitic and destructive as in the meretricious building at National Park where disjunction of place and objects is stated in the scatter of buildings round an empty centre: *Ski chairs, 1 & 2, Whakapapa 1986.*

One is left on perusal of such a series with new awareness of landscape itself as artefact and artifice; as the ground for the inscribing hand of culture and technology; as no clean slate.

A culture is no better than its woods.[3]

Interested though Barrar obviously is in the interface of nature/culture the process and evidence of natural change becomes his subject in the *Mason Bay, Stewart Island* sequence.

This recent series — one hesitates to use the word completed in a *modus operandi* always open — shows the engulfing of dune by sea observed over an interval of four years; 'graphically' recorded in 1988 in the tracks of trickling sand, or in the tops of buried beeches, dead trees in newly trapped bush ponds.

Stewart Island is *prima facie* remote, but plastic bags are washed up on its beaches. There are no acts of God in 1989 unabetted one suspects by irrational

Wayne Barrar, *Viaduct/Forest, Mohaka River* 1985. Black and
white photograph, 175 x 210 mm. Courtesy the artist.

Wayne Barrar, *New Forest, Brasch River, Marlborough* 1987.
Black and white photograph, 165 x 210 mm. Courtesy the artist.

JOANNA PAUL

man. And this category of erosion could be seen as part of the continuum of interest in Wayne Barrar's sentence structure.

Landscape activity was precipitated by Cyclone Bola in 1988. Among many photographs made in its wake occurs a rare passage of Claudian landscape, unusually dark and obscure, offside, in *Silted Farmland (after Bola) Waipaoa River 1986*. Conventional landscape beauty is not of interest to the photographer and nor are the Claudian pictorial conventions — the plain of cracked brine fills the centre of the picture without courtesy of framing devices.

Looking with this detachment at the constructed pastoral landscape one can read a causal relation between arable land, over-fertilised, inappropriately planted, stripped of remnant bush by the clearfell policies of the 60s — and the flooding which swept away trees and bridges poisoning the land with silt. 'Ecologically succinct' (Neil Pardington);[4] linguistically sophisticated, Barrar's photographs are didactic more than documentary, as practice rather than the words' common root defines it. (*Documentary* photographs an object because it is there, leaving the viewer to supply meaning. Thus documentary photographs have a kind of apoplectic expression — suffused with a significance which remains illegible . . . '*message without a code . . .* '.)

Wayne Barrar grew into photography at a time when a minimalist and programmatic school of Americans were displacing the romantic and subjective grand tradition of landscape photography (Edward Weston, Minor White, Ansel Adams) — and turning critical or accepting eyes to the inhabited landscape.

There were precedents in the careful photographs of industrial monuments by the Bechers or the cool statement of Richard Avedon: *I don't want to get below the surface — I don't want to get below anything; I have great faith in surfaces. A good one is full of clues.*[5]

But this moment in photography was novel in its inclusive view; its attention to unmarked and unregarded sites, new housing developments — a tract of emptiness between a telephone box and a Pepsi sign or *Grain Elevators & lightning*. A suburban and subrural semiotics adapted by Wayne Barrar to a study as stringent and directed as any of his older contemporaries.

Like Robert Adams whose skies redeem the trailer parks, Wayne Barrar is interested in beauty. Like Stephen Shore he articulates space with precision and geometry. And as in the *St Helens* photographs of Gohlke the evidence of 'natural disaster' is orderly; its structural elements enabling one to look.

The chance display of *Saltworks* alongside Wystan Curnow's *Putting the land on the map* annexed Wayne Barrar, among local traditions, to the art of the surveyors. Post-modern painters searching for a convention are more remote than he from the simplicity of purpose of the map makers.

It was the surveyor/painters who scored *lines* on the land that later became roads (*Bruce Rd panorama 1 & 2 1986*).

The surveyor's art plots roads, sources of rivers, coastlines. Heaphy's *Coastal Profiles; from Mt Egmont to Queen Charlotte Sound (1842)* — follow the horizon, read like a log from left to right. (The asymmetry of Taranaki/Egmont in Heaphy's log has no parallels in landscape painting. (Where McCahon took up the striated landscape to naturalise words in a painted text he transposed the plain language of the surveyors to a new hieratic.)

Close up, one might compare *Horseshoe curve in road/deep storage pond 1987* (*Saltworks*) with *Lake Wanaka from Wilkins Hill* by Julius von Haast — no 'viewpoint', foreground, framing devices or symmetry; economical in means (pencil and blue) circumstantial in title. The title does not allude to the picture (*Drift II* Gretchen Albrecht), the picture names the place.

In *Wairau Railbridge (13 viewpoints 1988)* Barrar renews the view favoured by von Haast, Fox and Kinder — *Semi Panoramic View taken from the Masters House attached to the Grammar School, Auckland, New Zealand, overlooking Hobson Bay, 1958*. Both pictures use rhythmically repeated fence posts/bridge piers to insist on a reading from left to right. They share: *the iteration which delights us in so many parts of nature, in the reflection of the shore and the trees in water; in Architecture, in the repetition of posts in a fence, or windows or doors . . . or still finer the pillars of a colonnade; in poetry rhymes and better still the iteration of sense . . .*[6] The lovely painting of Kinder is referred to point 48 on a map of Auckland. Unlike von Haast and Buchanan, Kinder uses light, but informatively, and also on his tenderly painted map, an imaginative aerial view as it were — the paintings elevations to the ground plan of the

Wayne Barrar, *Concrete engraving (date 1947), Wanganui River*
1986. Black and white photograph, 175 x 210 mm. Courtesy the
artist.

Wayne Barrar, *Pipes, Kapuni* 1988. Black and white photograph,
155 x 220 mm. Courtesy the artist.

JOANNA PAUL

map.

A Thomist notion of beauty might embrace the work of Kinder, Wayne Barrar, and Stephen Shore's *U.S.1 Arundel, Maine*. They share *claritas*. *'A thing is beautiful if the apprehension of it pleases.'*

In Wayne Barrar's photography beauty is in clarity of intention; precision of detail, lucidity of internal structure; an economy by which thematic motifs are compositional devices.

Open, airy and paradigmatic structures which draw as much attention to the landscape as themselves, the chirography of fence wire and grass contrast with the solemnly closed edifices, the lodges of Aberhart's classic documentary which confidently naturalises and subtly diverts the Romantic and humanist tradition — to utter a culture out loud.[7]

Beauty, for Barrar, has nothing to do with 'subject' but with 'apprehension'. The narrow elegant steel *Pipes, Kapuni* is 'unnatural', sinister, in juxtaposition with the sprayed bindweed which in its turn becomes inchoate, bedraggled. Horrid as the evidence in the photograph is beautiful.

Conversely, the photograph of a glassy sea and sky divided by a spit of land at sunrise *Chrystallizing pond edge at daybreak* is most beautiful when apprehended in syntagmatic relation to other episodes in salt chrystallization (its colour a register in legible weather).

Like maps *grafitti* appeal to those interested in pictorial conventions. Read the grafitti of Wayne Barrar differently, as paradigms for writing of/writing on the landscape. 'Nature' read as sexual energy carved its insignia *Concrete engraving dated 1947*. This is not a picture 'of'. There is no frame. The graph is respectfully treated, surface grain clear and sharp.

You know that happiness
 has to do with yes
 drains & that nature
like a pear tree
 must be served.

Like Ian Wedde, also a poet of process, Barrar uses threads of different discourse (*'Hang Loose'*/ the 'speech of the landscape') to make a satiric point.

Juvenal, satirist, Roman conscience, was angered by the arrogance of the engineering landscape; the demotic spring covered over by marble. One hesitates to imagine Juvenal in a rubbish dump measuring how far 'progress' has taken 'us' from 'nature'. A photographic antipollution crusade might be easy but trying to the emotionally exhausted. Wayne Barrar is also concerned about pollution of the visual language. His modest declensions on a theme impart (*teach*) careful thought, thoughtful care on, of, through the 'landscape'. *The waters would surely possess a deeper sanctity, if they were closed in a green verge of grass, and the native stone were not polluted by marble.*

quanto praesentius esset
numen aquis, viridi si margine cluderat undas
herba nec ingenuum violarent marmora totum[8]

Notes

1. Merleau-Ponty, *The Prose of the World.*
2. Derek Schultz expands on Wayne Barrar and the notion of (lethal) ecological ambivalence in *Art New Zealand*, 55.
3. W.H. Auden, 'Woods'.
4. Catalogue essay in the Sergeant Gallery's 1987 exhibition of Wayne Barrar.
5. *Avedon.* Minneapolis: Minneapolis Institute of Art, 1970.
6. *The Journals of Ralph Waldo Emerson*, vol. VII.
7. Walter Ong pursues a distinction between chirography and orality in *Interfaces of the Word.*
8. Juvenal, *Liber I Satyra III.* English Version by Gilbert Highet from *Poets in a Landscape.*

Through a Long Lens

The 1990 Commission's Treaty of Waitangi Unity Campaign

Alex Calder

Unity has always been used to sell New Zealanders things. A common pride in ourselves and in our country has always been a selling point — until now, unity itself has not had to be sold.

1990 changes that. There are 150 years of being New Zealanders to celebrate, but the point of reference for this anniversary also acts as a focal point of anxiety, tension, and resentment. The Treaty of Waitangi is like a product with a poor image in the market place. The 1990 Commission has tried to change that image, transforming that which divides us into that which brings us together.

I can't recall a more ambitious or more responsible campaign. While comparable efforts in Australia seemed indistinguishable from beer ads, the Commission's strategy has been softer; we are simply invited to consider the Treaty in a certain light, and — through a coordinated progression from TV and radio ads, to full page newspaper spreads, to a free twenty-page brochure — invited to find out more about it. Yet, in attempting to place the Treaty above politics, the campaign highlights new questions, new difficulties, even as it seeks to educate, even as it finds common cause in the aspirations of Maori and the aspirations of us all as a community. I'd like to look closely, then, at what is necessarily the least informative, but most connotatively rich, segment of the campaign: the two ads on TV.

One has a voice-over by Te Arikinui Dame Te Atairangikaahu. She says:

In 1840, a pact was signed with good and true intent. And that was the beginning of a nation called New Zealand. To its shores have come people of every race, colour and creed. Kotahi te koha a te ngira e kuhuna ai te miro ma, te miro whero, me te miro pango. Kia mau i te whakapono, te tumanako me te ture. I believe it is time for our founding document to be set free; for the Treaty of Waitangi to once again be a symbol of unity, trust, understanding and goodwill amongst all the many peoples of Aotearoa.

In the other, His Excellency the Governor General The Most Reverend Sir Paul Reeves, says:

150 years ago, something great happened — the Treaty of Waitangi was signed. From that day, the Treaty has been our founding document; the symbol of our life together as a nation. I rejoice in the unique character the Treaty has given this country. We are so much a part of each other now. This is our New Zealand. So let the spirit of the Treaty move among us powerfully and bring us even closer together.

It is a bit like one of those ceremonies where elderly marriage partners reaffirm youthful vows. Whatever it was that happened in the past is ritually substituted for something at once purer and seemingly more tangible than the mixed motives of so long ago. The Maori Queen and the representative of the Crown re-sign, as it were, the old treaty but, as they speak, it is the 'original spirit' of the treaty that is affirmed and their words have a symbolic, even spiritual, value for the community.

The advertisers needed an image to represent and fill out that value on film. In this respect, it is not so much what we see — two boys, one pakeha, one Maori, meet and play on the beach, gather mussels, make a campfire — but how we see it that is important. The ad is carefully designed to draw on everyone's generic memory of the summer holidays of childhood and a raft of cultural paradigms from *The End of the Golden Weather* through to *Ngati*. All these associations are further filtered — by the music, the quality of the light, the camerawork and editing — to emphasise the twin qualities of timelessness and innocence. But the most telling device, it seems to me, is the use of a long lens.

A long lens brings together near and far, land and sea, 1840 and 1990. It is the middle distance that gets squeezed out: a stretch of beach between the boys and a wave, pulled closer, that crests and breaks; a stretch of time between the signing of a treaty and,

ALEX CALDER

pulled closer, the elevated presence of the Treaty as 'founding document', as 'the symbol of our life together as a nation'.

Suppose we call that middle distance a history — an ongoing history — of colonialism in New Zealand. The ad invites us to transcend all that; to refer the racially marked divisions and inequities of contemporary New Zealand to the warm glow of an originary gesture whose nearest earthly exemplar is the innocent, timeless, carefree play of two boys on a beach. And the invitation does have a great deal of appeal. It not only simplifies and explains the past, it packages the present that way too. Take the gathering of mussels, for instance. We cannot but be reminded of Maori claims — under the Treaty — regarding fisheries. The ad implies that these matters are easily resolved on a human, one-to-one level — all it takes is a little goodwill, the give and take cooperation of, say, two kids, with campfire-lit faces, cooking mussels. This is not only inadequate, it also has the potential to go tragically wrong.

When two parties to a dispute both defer to some common spiritual or mythic founding reference, the persistence of disagreement can only be ascribed to bad faith, to an intrinsically evil betrayal of principle on the part of the other. When a nation constructs an imaginary future on the basis of a founding myth, its history comes to a stop: for a moment, we are redeemed from the worrisome present; there is no middle distance, only the endlessly circling, endlessly repeating dream of what 'was' and might yet come to be. Here, all contraries are resolved, but the price is all too easily a tacit understanding that they remain irresolvable at the socio-economic level.

Heartbreak lies ahead on either of these roads. Perhaps, in our politics, and especially our cultural politics, we should learn to be more wary of appeals to myth, spirituality, and the discourse of origins: these are lean ghosts, they fatten on stereotypes and the simplicities of violence.

Still, there is one other way to read that final, campfire scene. In what seems an unscripted moment, the pakeha boy fiddles with a mussel shell near him, then leans across, right across, to select another from right by his Maori companion. That is true innocence and, with that gesture, we might see all the troublesome secularity of middle distance make its return.

From It *Happened in New Zealand* by Ross Gore, 1958.

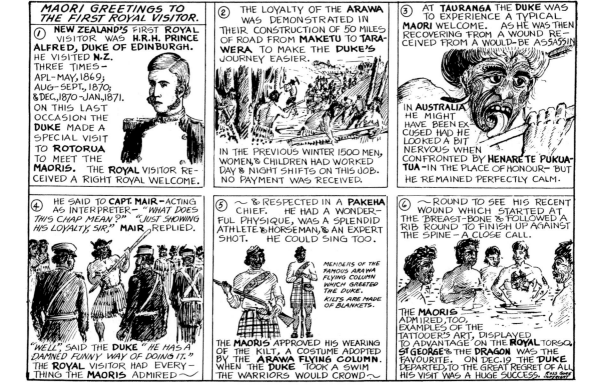

Life and Death at Sea

L. J. Steele and C.F. Goldie's *The Arrival of the Maoris in New Zealand*, 1898

Leonard Bell

The Arrival of the Maori in New Zealand (see page 90) was described by a recent Director of the Auckland City Art Gallery as 'one of the country's most culturally valuable paintings'.[1] Much reproduced, it is probably the best-known indigenous historical painting and the image which evokes most readily for Pakeha New Zealanders Maori migration to New Zealand. Its high status, both as history painting and as cultural artefact, has been longstanding from the time of its first showing in 1899 — for instance the painting was described that year in the *Weekly Graphic and New Zealand Mail* as 'magnificent . . . in conception and treatment decidedly above the level we have been accustomed to in our local exhibitions . . . in its historical interest, in the variety of clever studies of the human form which it embraces, in its terrible suggestiveness . . . nothing of the kind has ever been attempted by any local or New Zealand artist'.[2] These remarks suggest that the painting had several dimensions of meaning for the viewing public. It functioned not only as a representation of a particular event in Maori history but also as a spectacle and as a more generalised emotive and dramatic statement.

Steele and Goldie had produced *The Arrival of the Maori in New Zealand* for a competition (which it won) under the Helen Boyd Bequest for the purchase for the Auckland Art Gallery of an original work on a New Zealand subject by a New Zealand artist.[3] This prescription exemplified a recent development in the Auckland art world of the 1890s, which hitherto had been dominated by landscape and portraiture. Though art reviewers had cited New Zealand history as a rich field waiting to be exploited, it had hardly been touched by painters. For instance in 1894 the art reviewer for the *Auckland Star* remarked that paintings with characteristically New Zealand subject matter represented 'a class of picture of which we have almost no pictures of merit'.[4] He excepted 'Mr Steele . . . the first painter of merit who recognised the interest of the Maori

subject . . . highly characteristic of New Zealand . . . (and of) didactic value'.[5]

The Arrival of the Maori in New Zealand then was one of the first and one of the few genuine history paintings executed in New Zealand. When first exhibited in 1899, first at the French Academy of Art, and later at the annual exhibition of the Auckland Society of Arts, the painting was praised in all the major newspapers and periodicals: 'magnificent',[6] 'splendid' and 'masterly',[7] 'the feature of the exhibition'.[8] As a Maori subject picture and an historical and dramatic piece *The Arrival of the Maori in New Zealand* was acclaimed as of 'such extraordinary national interest (that) it should find a place in our Art Gallery'.[9] It was the enthusiasm of public response, when the painting was first exhibited, that provides the key to the subsequent popularity of the painting. Certainly *The Arrival of the Maori in New Zealand* cannot be brushed off as just a picture the popularity of which 'has been considerably helped through its frequent reproduction in school history books', as claimed in a current secondary school Art History text book.[10]

It is hardly surprising that the subject struck a chord with the viewing public and has continued to do so since. The tale of the migration of Maori to New Zealand has been assimilated into European culture in New Zealand. The journey from a strife-torn 'old world' to a new land rich in possibilities far across the sea was an event with which Europeans (a society largely of emigrants and their children) could readily identify. The long journey of Maori could provide a prototype, a symbolic prefiguration, for the nineteenth century emigrations from Britain. Consider the popular historian, Maori 'expert' and mythmaker James Cowan in a 1908 publication: 'Aotearoa . . . cried Tamatea . . . when the Takitimu made a landfall on the east coast of the North Island . . . It was a new world indeed of hope and plenty for Tamatea and his adventurous brown seamen . . . and a land of equal

promise was it to be for the white pioneer.'[11] *The Arrival of the Maori in New Zealand* was painted in a period when interest among Europeans in the culture and origins of Maori was increasing considerably. The Polynesian Society was founded in 1892 and the first Journal of the Society appeared in the same year. In the late nineteenth century several major historical and ethnographical studies were published: John White's *The Ancient History of the Maori*, 1887-90, Augustus Hamilton's *The Art Workmanship of the Maori Race*, 1896-1900, S.P. Smith's *Hawaiki: The Whence of the Maori, with a Sketch of Polynesian History*, 1898, for example. Nor were accounts of Maori culture and history confined to scholarly publications. There were other books intended for a broader and more popular audience; for instance J.A. Wilson's *Sketches of Ancient Maori Life and History*, 1894, which was originally serialised in the Auckland Star. So with certain features of Maori history and mythology beginning to enter the collective European consciousness the time was opportune for such a painting as Steele and Goldie's *The Arrival of the Maori in New Zealand*.

Professor M.P.K. Sorrenson has documented the attempts by Europeans from the time of Cook to explain Maori origins and migrations to New Zealand.[12] Interest in the 'coming of Maori colonists'[13] increased greatly as European settlement progressed and dominance over Maori was established. For instance, the idea of the Great Fleet, the bulk of Maori migrants arriving on a single voyage, gained wide currency among European writers in the late nineteenth and early twentieth centuries, even though, to cite Sorrenson, it was 'essentially the construct of European collectors and editors of Maori traditions',[14] not of Maori themselves. That is, Europeans invented a history of the coming of the Maori for their own purposes and requirements.

Steele and Goldie treated their subject from Maori history with a fair degree of licence, though the detail with which Maori artefacts were rendered may have given the impression of an authentic record. The painting, though, does not exhibit the 'laborious archaeologising' that various writers have attributed to Steele and Goldie's depictions of Maori.[15] In this respect David Simmons has written:

Ethnologically . . . the picture is a disaster. The crew are shown as Polynesians with no tattoo, wearing tapa cloth, but they are sailing in a mixed-up double Maori canoe of the eighteenth century using a sail form which probably never existed. So we have a presumably fourteenth century Maori arriving in New Zealand and in a canoe with eighteenth carving and notational construction.[16]

Furthermore no one knows in what condition Maori actually arrived in New Zealand. Accounts by Maori of the event, as recorded for instance by John White in *The Ancient History of the Maori* make no mention of the physical suffering and stormy sea horrors that Steele and Goldie concentrate on in their painting. The descriptions in White's book tend to be factual and unsensational, primarily concerned with the names and interrelationships of ancestors and the recording of places visited and at which landings were made.[17] Likewise in S.P. Smith's account of the discovery of New Zealand by Maori in *Hawaiki: The Whence of the Maori*.[18] Indeed Steele and Goldie's treatment of the arrival of Maori in New Zealand does not appear to have its origins in either Maori accounts or the historical and anthropological literature of the period. Only in the popularising tracts like Wilson's *Sketches of Ancient Maori Life and History* was any attempt made to inject 'excitement' or 'adventure' into the narrative, and even then it is only of secondary importance and tame compared with Steele and Goldie's handling of the subject. Rather it is a romantic 'suffering' and 'heroism' of a particular European type that characterises *The Arrival of the Maori in New Zealand*.

Steele and Goldie's treatment of the subject suggests that their intentions were not only to monumentalise or recreate imaginatively an event from Maori history, but also to dramatise certain European feelings and attitudes about struggle and suffering at sea and (sometimes) fortunate survival or miraculous salvation. On this dimension the sea voyage of Maori to New Zealand provided the artists with a suitable vehicle, a pretext for the performance. So *The Arrival of the Maori in New Zealand* can be seen primarily as an action piece, with the Maori historical or legendary event transformed into spectacle. The main emphasis is on extreme physical suffering; men and women in a boat pitted against the vast sea and all its terrors. Commentators at the time of the painting's first exhibition wrote most enthusiastically about this aspect of the work,

The Treaty of Waitangi Campaign, New Zealand 1990
Commission. Courtesy New Zealand 1990 Commission.

C.F. Goldie and L.J. Steele, *The Arrival of the Maoris in New Zealand* 1898.
Oil on canvas 1380 x 2450 mm. Auckland City Art Gallery collection.
Presented by George and Helen Boyd, 1899.

generally according the Maori historical connection secondary acknowledgement and more prosaic treatment. 'Tragic', 'terrible', 'suffering' feature prominently in the commentaries. For instance, the *Auckland Star* reviewer wrote:

In tragic intensity and supreme suffering the picture is a wonderful conception . . . The heavy storm-swept sky, the tattered sail, the broken carvings on the prow, all things suggest and tell of the sufferings endured, just as much as the terrible figures with which the canoe is crammed.[19]

At another exhibition of the painting the *Auckland Star* reviewer had dwelt on the 'emaciation' of the 'sea-worn Polynesian voyagers', and the 'privations of the . . . ocean voyage, the starving men and women', the 'gaunt' limbs, the canoe 'battered' by the sea.[20] The *Weekly Graphic and New Zealand Mail* reviewer too was impressed by the 'starving voyagers . . . helpless and desperate'.[21] For him there was a 'terrible attraction in these naked emaciated figures huddled in all different postures of agony and despair'; there was a 'world of terrible meaning in the contortions of their bodies', 'these scarecrows of human beings', 'their limbs those of skeletons'.[22] All in all for this viewer *The Arrival of the Maori in New Zealand* was 'certainly most gruesome'.[23]

With such primary attributes as suffering and horror *The Arrival of the Maori in New Zealand* fits easily into a longstanding convention of imagery common in European history and narrative painting, literature and book illustration: the imagery of storm-battered boats with human cargoes in extreme states of misery and desperation. Lorenz Eitner has written:

. . . the symbolism of the *storm-tossed* boat is ancient and familiar. Used to dramatise man's struggle against fate or nature, or to point up the need for salvation, it occurs in poetry and painting with the frequency of a popular figure of speech. A typical statement of it is this line from John Webster's *White Devil*, written about 1610: 'My soul, like a ship in a black storm, is driven, I know not whither.'[24]

Of course not every shipwreck or storm-battered boat image was consciously intended as a symbol; and it might be reading too much into the image to attribute such explicit symbolism to *The Arrival of the Maori in New Zealand*. Yet for some contemporary viewers the painting suggested states of feeling analogous to the sort that Eitner discusses. Consider the response of the *Weekly Graphic and New Zea-land Mail* reviewer: 'The lowering sky and the dark weary waste of waters over which the weather-battered canoe is making its way conveys the idea of utter loneliness.'[25] Moreover, in the 1890s for some European commentators on the migration of Maori to New Zealand, Aotearoa and Paradise were synonymous. For example in his *Sketches of Ancient Maori Life and History* Wilson describes the arrival of the Tainui in New Zealand thus:

The wayworn voyagers, turning their eyes from the beautiful land, grasped the situation at a glance, and their hearts fell from the heights of joy and hope to the depths of fear. Were they, after all their suffering and pilgrimage, to be sacrificed at the gates of Paradise on those jagged rocks.[26]

To pursue the analogy: in *The Arrival of the Maori in New Zealand* the voyagers bear the obvious marks of suffering and hardship, but they have endured, and light has appeared on the distant horizon: Aotearoa: Paradise. It is perhaps not uncoincidental that in the 1890s New Zealand was hailed as a potential paradise: 'God's own country'.[27] Associations of this sort could have contributed to the popularity of the painting.

Whether or not such associations were made or intended, it is within the storm-battered boat and suffering at sea convention that the most likely explanation of Steele and Goldie's treatment of their subject is to be found. Related literary pieces like the shipwreck canto in Byron's *Don Juan* and Coleridge's *Ancient Mariner* come readily to mind,[28] especially since such leading nineteenth century painters and book illustrators as Delacroix and Gustave Doré drew on these works for inspiration and subject matter. As a type in painting, storm-battered boats and suffering at sea occurred with such frequency in late eighteenth and early nineteenth century art[29] that it became almost clichéd, though in the hands of practitioners like Géricault, Delacroix and Turner it remained compelling and haunting.

Not surprisingly, the prime inspirational model for Steele and Goldie in painting *The Arrival of the Maori in New Zealand* was one of the most famous examples of the type, Géricault's *The Raft of the Medusa* (1819 Louvre, Paris). The fundamental similarities between the two paintings are obvious: the stormy sea and lowering sky; the placement of the boat, which occupies most of the picture space, diagonally across the canvas, the upward thrust to the

LEONARD BELL

right of the boat and figures counterbalanced by the directional force to the left of the mast and sail; the distressed crew; the glimpse of salvation at the top right; the stress on out-thrust limbs and splayed naked torsoes; in some figures the expressions and gestures of desperation such as sagging half open mouths and hands clutching heads; the positions of various figures on the raft or canoe. For instance there is a figure in the prow of both the Steele-Goldie and the Géricault vessels, arm outstretched in the direction of rescue, head turned back towards his fellows.[30]

Steele and Goldie did not model every feature of their painting on *The Raft of the Medusa*. There are differences between the two paintings, most notably in the scale of the works and in the treatment of the human figure. Steele and Goldie's ugly, skin and bone figures are 'realistic', while Géricault's are handsome, well-built and idealised. But this is merely a difference in formal means. Allowing for the obvious differences in their specific historical and social references, the general narrative and dramatic thrusts of the two paintings are basically the same; evocation of the terror of the sea on which humans suffer, though with salvation at hand if they are fortunate. The close parallels in design, poses, gestures, and themes and sentiments expressed that exist between *The Arrival of the Maori in New Zealand* and *The Raft of the Medusa* are not surprising given the close connections both Steele and Goldie had with the art institutions of Paris. Both had studied at leading academies in the city.[31] They would have been familiar with the famous paintings of the storm-battered boat and sufferings at sea type by Géricault and Delacroix. In fact Goldie had made a copy of *The Raft of the Medusa* in 1896. This would not have been difficult since the painting was on public display in the Louvre, as were Delacroix' *Shipwreck of Don Juan* (1840) and *Dante and Virgil in Hell* (1822), which also feature desper-

ate figures caught on forbidding waters.[32]

Steele and Goldie's treatment of the figures in *The Arrival of the Maori in New Zealand* further points to the French connection that is primary to their work. The crowded arrangement of figures, twisted and tortured with jagged, extravagant gestures, and the overall melodramatic effect, recall strongly the work of the then famous French book illustrator Gustave Doré.[33] Human suffering was Doré's forte: brutal and 'realistic' as, for example in his images of urban poverty and misery in *London:*

Théodore Géricault, *The Raft of the Medusa*: definitive composition c. 1819. Oil on canvas, 650 x 830 mm. Paris, Louvre.

A Pilgrimage (1871), or in his representations of the desperate and the damned in his *Bible* (1866) or his *Paradise Lost* (1866). Interestingly in 1875 Doré illustrated Coleridge's *Ancient Mariner*[34] with all the 'tragic intensity and supreme suffering' in the figures that reviewers were later to ascribe to *The Arrival of the Maori in New Zealand*.

Though causing a sensation in New Zealand in the late 1890s, Steele and Goldie's nautical drama would have looked old fashioned in British and European art milieux, even in conservative institutions. Excepting Doré, Steele and Goldie's primary inspirational models all belonged to the first half of the century. By the 1850s the vogue for paintings of the storm-battered boat and suffering at sea type was on the decline in Britain and Europe. The advent of

steam ships and the corresponding decline in sail during the nineteenth century, together with the increasing safety of sea travel, meant that shipwrecks were no longer such an ever present threat. T.S.R. Boase suggested that these developments may have diminished the resonance of suffering at sea imagery for the European viewing public.[35] Whatever, by the end of the nineteenth century paintings of shipwrecks and hazardous sea voyages were virtually non-existent in the major European art institutions. For instance during the 1890s no such paintings were exhibited at the Royal Academy in London.[36]

That a type of painting out of fashion in Britain and France should have been so successful in Auckland suggests several things about European culture and society in New Zealand. First: it points to the provincialism of colonial culture; provincial in the sense that generally in the visual arts there was a considerable time lag between the occurrence of certain developments and fashions in Europe and their appearance in New Zealand (if they appeared at all). Significantly in the 1890s the suffering at sea type was still alive and well in the United States of America, which at that time in terms of art could still be regarded as a province or colony of Europe. For example Winslow Homer's *The Gulf Stream* (1899 The Metropolitan Museum of Art, New York), which acquired instant fame when exhibited in Philadelphia in 1900, has the same basic narrative structure as *The Arrival of the Maori in New Zealand* or *The Raft of the Medusa*: man alone at the mercy of the sea and associated perils, and so suffering, but with the possibility of salvation (ship or land) on the distant horizon. Interestingly in 1900 a leading American critic, Royal Cortiissoz, called *The Gulf Stream* 'Homer's *Raft of the Medusa* . . . his equivalent for the drama of a Géricault or a Delacroix.'[37]

Second: that the suffering at sea image type was not spent or hackneyed for the viewing public in New Zealand, but still compelling, suggests the nature of the relationship between New Zealand and the sea at that time. New Zealand was extremely isolated and seabound, recognised 'facts' of existence there. As a result life would have seemed much more subject to the ocean's whims than in Europe. The feelings, then, embodied in storm-battered boat and suffering at sea imagery could still have been central to the general emotional climate in New Zealand, even if

they were much less so in Europe. For a country with such a small population shipwrecks still occurred with frightening regularity. Between 1890-99 there were 107 recorded shipwrecks in New Zealand waters.[38]

Steele's 'history pieces' are decribed as 'empty' in a still standard history of New Zealand painting.[39] In fact that is not so. His paintings were, and still are, loaded with meaning, with connotations. That is certainly so with *The Arrival of the Maori in New Zealand*. In 1899, and thereafter, the painting was one with which many New Zealanders could readily empathise. The painting was the stuff of myth; mythmaking by Europeans for Europeans; mythmaking that involved a reshaping of Maori history; a reshaping that can be regarded as a form of incorporation of things Maori into European culture in New Zealand.

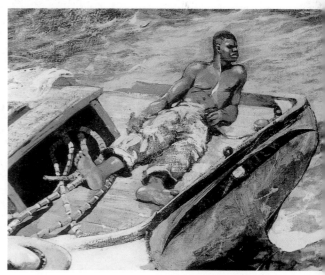

Winslow Homer, *The Gulf Stream* (detail) 1899. Oil on canvas, 714 x 1248 mm. Metropolitan Museum of Art, New York.

Notes
1 T.L.R. Wilson, *Auckland Star*, June 26, 1985.
2 *Weekly Graphic and New Zealand Mail*, November 18, 1899.
3 *New Zealand Herald*, October 28, 1899.
4 *Auckland Star*, March 2, 1894.
5 Ibid. Lindauer had been painting Maori subjects, mainly portraits, since the mid 1870s, but he only rarely exhibited at the Auckland Society of Arts, the major art institution in Auckland at the time. Steele, who arrived in Auckland from England in 1886, first exhibited a Maori subject picture at the Auckland Society of Arts in 1888; a painting entitled *A Maori Legend, from Te Rau*. He exhibited only three other Maori subject pictures at the Society before *The Arrival of the Maori in New Zealand* in 1899: in 1894 *Tattooing in the Olden Times, On the Waikato*, and a painting not listed in the exhibition catalogue, but described in detail in the Auckland Star review.

LEONARD BELL

6 *Weekly Graphic and New Zealand Mail*, op. cit.
7 *Auckland Star*, October 27, 1899.
8 *New Zealand Herald*, op.cit.
9 *Auckland Star*, October 27, 1899.
10 Brown and H. Keith, *New Zealand Painting: An Introduction*. London & Auckland: Collins, 1969, p. 70.
11 Cowan, *New Zealand or Aotearoa: Its Wealth, Resources, Scenery, Travel Routes, Spas and Sports*. Wellington: Government Printer, 1908, p. 1.
12 See M.P.K. Sorrenson, *Maori Origins and Migrations*. Auckland: Auckland University Press and Oxford University Press, 1979.
13 Ibid., p. 35.
14 Ibid., p. 44. See too D. Simmons, *The Great New Zealand Myth*. Wellington: A.H. & A.W. Reed, 1976.
15 McCormick, *Works of Frances Hodgkins in New Zealand*. Auckland: Auckland City Art Gallery, 1954, p. 56. Brown and Keith, op.cit., p. 70. G. Docking, *Two Hundred Years of New Zealand Painting*. Wellington: A.H. & A.W. Reed, 1971, p. 86.
16 Simmons, 'C.F. Goldie — Maori Portraits', *The Art Galleries and Museums Association of New Zealand News*, vol. 5, no. 2, 1974, p. 38.
17 For instance John White, *The Ancient History of the Maori*. Wellington: Government Printer, 1887-90, vol. 4, pp. 28-29: Tainui (Nga-ti-maru). 'This is the history of the migration of the Maori from Hawaiki . . . The Maori came to New Zealand on account of a great war in Hawaiki . . . As peace could not be made one party fled to New Zealand. Before the fleeing party had left Hawaiki they consulted and determined to build canoes in which they could go and discover new lands in which to dwell. First they built the canoe called Tainui then Hotu, with chants and incantations to the Gods, sought to bind the power of wind and waves, so that the track on which he sailed in his voyage might be calm and unbroken by any power. Then entering on his voyage, he sailed across the sea and landed in these islands of New Zealand, where the crew of Tainui saw the red glow of the Pohutukawa . . . '
 And from vol. 2, p. 184:
Ngahue (Arawa). 'They went over the ocean and discovered the land called Aotearoa.'
18 Smith, *Hawaiki, The Whence of the Maori*. Wellington: Whitcombe and Tombs, 1898; the sections 'The Discovery of New Zealand', pp. 216-18, and 'the Migration of Toi-te-huatahi to New Zealand', pp. 229-31.
19 *Auckland Star*, November 9, 1899.
20 *Auckland Star*, October 27, 1899.
21 *Weekly Graphic and New Zealand Mail*, November 4, 1899.
22 Ibid.
23 Ibid.
24 Eitner, 'The Open Window and the Storm Tossed Boat: An Essay in the Iconography of Romanticism', *The Art Bulletin*, December 1955, p.287.
25 *Weekly Graphic and New Zealand Mail*, November 4, 1899.
26 Wilson, *Sketches of Ancient Maori Life and History*. Auckland: H. Brett, 1894, p. 15.
27 Note the popular poet Thomas Bracken's 'God's Own Country' in *Lays and Lyrics: God's Own Country and other poems*. Wellington: Walter Brown, Thomson and Co., 1893. Richard Seddon, Prime Minister, 1893-1906, appropriated the phrase for his own purposes, and it soon became a nationalist slogan.
28 There is an enormous body of European literature on sea voyages, shipwrecks and suffering at sea, which indicates that these themes have held an important place in the European collective imagination. Note, for instance, the literature of this sort listed in John Livingstone Lowes' *The Road to Xanadu: A Study in the Ways of the Imagination*. New York: Houghton Mifflin, 1927 — a study of Coleridge's *Ancient Mariner*.
29 Boase, 'Shipwrecks in English Romantic Painting', *Journal of the Warburg and Courtauld Institutes*, vol. 22, 1959, pp. 332-47.
30 Note Dr Gerda Eichbaum, 'Géricault's *Raft of the Medusa* and Goldie-Steele's *The Arrival of the Maori in New Zealand*: A Comparison', *Arts in New Zealand*, March 1942.
31 Steele studied at the Ecole Des Beaux Arts in Paris in the 1860s and, after a period in Florence in the late 1860s, lived in Paris again in the 1870s. Goldie lived in Paris from 1892-97. He studied at the Académie Julian and at the Ecole Des Beaux Arts.
32 The Louvre acquired *Raft of the Medusa* in 1848, *Dante and Virgil in Hell* in 1874 and *The Shipwreck of Don Juan* in 1883. See L. Hautecour, *La Peinture au Musée du Louvre: Ecole Francaise*. Paris: Picard, n.d. The two Delacroix paintings belong to a series of works featuring people threatened by seas, a theme which preoccupied him throughout his life; *Christ on the Sea of Galilee* (1846 Walters Art Gallery, Baltimore) and *Abandoned Shipwrecked Men* (Salon of 1841) being the most notable examples, besides the two in the Louvre.
33 In the 1850s and 1860s Gustave Doré (1832-83) was one of the most sought after illustrators in Europe; his popularity so widespread that his *Bible* (1866) was published simultaneously in four European countries; and his fame and reputation so great in England that the Doré Gallery, open in London from 1867, exhibited nothing but his work until W.W.I. It would have been difficult for Steele and Goldie not to be familiar with his work. See M. Henderson, *Gustave Doré: Selected Engravings*. London: Academy Editions, 1971.
34 See *The Annotated Ancient Mariner*, Introduction and notes by Martin Gardner, with Doré's illustrations. London: Blond, 1965.
35 Boase, op. cit., p. 345.
36 See *Royal Academy Pictures*. London: Cassell & Co., 1890-1900.
37 Quoted in *Nineteenth Century America: Paintings and Sculptures*. Exhibition catalogue, Metropolitan Museum of Art, New York, 1970, p. 161.
38 Ingram and P.O. Wheatley, *New Zealand Shipwrecks*. Wellington: A.H. & A.W. Reed, 1936, pp. 241-73.
39 Brown and Keith, op. cit., p. 119.

An earlier version of this essay was first published in *The Bulletin of New Zealand Art History*, vol. 3 1975.

Translation and Representation

A History of Ferries

Ian Wedde

1

The title of this essay negotiates the area of New Zealand that the naturalist and writer Ernst Dieffenbach became familiar with in 1839, namely the Cook Strait region, where Arapaoa Island is located at the entrance waterways to the South Island, where the South and the North Islands of New Zealand have between them, as a conjunction or disjunction, depending on your point of view, the waters of Cook Strait.

You will see that we already have here, in a version which fiction might wish to appropriate from geography, a model of *translation*. As well, we have a political model, inasmuch as this geographical fiction contains the contours of disjunction and of privilege, a model made more dramatic by the fact that Cook Strait is crossed several times a day by the *Cook Strait Ferry*.

At this point let me introduce a quotation, not from Ernst Dieffenbach's *Travels in New Zealand*,[1] but from a more recent sceptic.

To name a space, to turn it into a negotiable place, was like constructing a sentence.[2]

That quotation from Paul Carter's book *The Road to Botany Bay — an essay in spatial history* is at the heart of this enquiry into the discourse of translation: for example, a description of the translation process which sees how space is translated into or constituted as *place*; how *that* translation modulates into *transaction*, that is, into a translation with value added; and how that modulation in turn bestows on us a *point of view*, that is, a place from which to look at the 'place' of the initial translation.

Translation occurs in a cultural space, which is a historical, narrative, and visual space; a space which language, in fact, is constantly rewriting as place — not neutral, but deeply coded.

We could imagine that the language translated *from* would be both primary, in the obvious sense of being first; and dominant, in the sense that the language translated *to* will be a derivation. In fact, as we know, the cultural space of translation doesn't admit such equanimity. To the nineteenth century Enlightenment explorers who ventured into the Pacific, including even the sympathetic Ernst Dieffenbach, the transactional, or value-added, modulation of translation was fixed by culture, much as the economy of Late Capitalism fixes exchange rates.

When translating Maori into English, for example, Maori was clearly the *primary* term. But no sooner had translation taken place, than this primary term became sub-dominant. Translation privileged English. The assumption of a majority of those who spoke English was that no matter whether English occupied the primary or the secondary place in translation, it remained dominant at the end of the process. It was assumed to have the right to appropriate, and even rescue, other languages to its own cultural space, its place. It was assumed to have the right to rewrite them, and thereby to rewrite the space which they had, in their own terms, constituted as place.

This has had continuing consequences, for example in the interpretation and implementation of the Treaty of Waitangi; and in the interpretation of images, inasmuch as these constitute a translation of cultural space, of place.

The point of view deriving from this transaction as it follows translation might seem to belong to an exclusively chauvinistic imperial historical sense. This is not quite true. It was certainly *characteristic* of imperial behaviour, and remains so. But the thinking, and the behaviour, of Captain James Cook, or of Ernst Dieffenbach just over half a century later, was not necessarily in itself imperial. The evidence is that Cook's insistence on the importance of *coasting* above territorial speculation makes him an ambiguously un-imperial figure, despite the consequences

IAN WEDDE

of his navigations. And Dieffenbach, certainly, regarded the neo-imperial behaviour of colonists he encountered in New Zealand with a sceptical eye.

What was absolutely imperial, in a sense, was the language itself. The language itself was the vessel that Cook sailed in. Wherever that vessel made a landfall, or was the platform from which a coastal observation was made, it translated the space before it into place. Having translated and revalued space in this way, it then tautologically derived a viewpoint within itself, from which to look at the view it had itself inscribed.

This is not always an entirely unilateral process. The trace of language may often seem imperial — may seem to have proceeded with confidence from the coastal outline of the cartographer, to the interior-seeking track of the explorer, to the trigonometrical enclosure of the surveyor, to the domestication of the settler, to the grids of town-plans, motorway systems, power-lines, hydro-electric schemes, and air-traffic radar corridors. But even within this post-imperial outcome of densely inscribed cultural landscape, the trace of language can appear ambiguous.

This is because translation must occur not just between signifiers of whatever kind; but also between signs or *representations*. To translate the word 'mountain' into another word meaning something equivalent, is one thing, or may seem to be. But to translate what the word 'mountain' represents into something that doesn't look like one at all (as a low salient in the Australian desert does not resemble Mount Snowdon), is to make the word too general to maintain an imperial air of appropriation. The word comes, at first, to wear a strained expression appropriate to its straddle from an ideal representation to a remote deviant of that ideal. In time, its expression may relax, as the remotely deviant representation comes to seem normative and even ideal in itself; 'acclimatised', as we say, which means regionalised.

In addition to words and representations, of course, translation will have had to take place between *values* as inscribed in the cultural landscape. One language's word for 'mountain' may represent, in a particular instance, a heap of valuable ore; another language's word for 'mountain' may represent, quite literally, the body of an ancestor. In such a case, translation does not, in a sense, take place at all, even when the dominant if not primary language tells us that it has. The inscription of one language simply does not register in the cultural space of another.

The tragedy of this procedure, whereby an 'invisible' superscription of space has resulted in the alienation of an entire *primary* culture by the translation's dominant term, has been repeated everywhere the ferryboat of imperial language has made landings. It has been a process at once tragic, and hapless; imperial, and provisional; definitive, and ghostly.

2

As well as the alienation of primary cultures from the representations of dominant ones, the process has caused the alienation of translated terms from their originative ideals. Thus, while a low mound of ore in the Australian desert did not, to those explorers travelling within the conveyance of the English language, resemble the body of an ancestor, nor did it resemble the Romantic Sublime ideal of a mountain — a mountain, say, after Salvator Rosa, with crags, mist, precipices, a ruined castle, shattered trees, and, if possible, some off-the-wall narrative content.

This representation, one ideal among several available, had to struggle to find a stand-in in its newly-inscribed cultural space. In both New Zealand and Australia, though more readily in New Zealand with its abundance of lofty mountains, such substitutes *were* found. In New Zealand, the totem of a ruined tree in a bleak landscape became at once a nationalist emblem, and a means of keeping alive the Salvator Rosa ruined castle or shattered tree. And in Australia, the great gaunt gum tree seems to have served a similar function: it was simultaneously an emblem of nationhood, of reinscribed space, of successful translation; and a portmanteau term which kept smuggling the Romantic Sublime back into the picture.

Despite the strenuous efforts of Nicholas Chevalier and Eugene von Guerard in the 1860s, the Australian landscape had offered less scope for Sublimity than New Zealand's, endowed as the latter is with Mitre Peak, pointy Mount Taranaki, and assorted alps and cascades. The Australian example therefore offered the translation process a tougher acclimatisation.

In 1843, some 20 years before Chevalier and von Guerard, we find an extraordinary painting by Captain E.C. Frome (admittedly in the service of topo-

graphy and surveying, rather than of the salon) called *First view of salt desert, called Lake Torrens*[3] (see page 107). In this modest notation of watercolour on paper, a brown band of land occupies the lower part of the painting, while the upper part consists of a wider band of paler brown sky. A standard European horizon-line has been lowered, forced even below the level of Dutch landscape, so that the utterly blank, flat expanse of the dry salt pan seems to stretch to infinity. Just to the right of centre is a diminutive brown figure, the explorer, surely, on a brown horse. He has dropped the horse's reins and is gazing through a telescope into the middle distance. What can there be for him to see in this utterly featureless space?

Sure enough, in the distance and barely visible, are two ghostly scratches, the merest vestige of a tree.

These two skeletal sticks, a sign almost but not quite erased, are all that remain of Salvator Rosa's lofty mountains and ruined castles. The explorer's act of looking at something that is almost not there, what's more his use of an instrument that will drag that phantom into his foreground — this act tells us that translation *has* occurred. We see that a transaction has also occurred. And the explorer's fixed gaze upon that skeletal sign of revalued Sublimity, tells us also that this translation has created a point of view for *us*. We, too, are told where to stand, and how to understand. Just as surely as is the explorer's, our monocular gaze is fixed for us upon this evidence that originating ideals can survive radical translation.

In addition, we might say that the horizontality of this 'scape has replaced verticality as a repository of the Sublime ideal. While remaining mindful of the distinction between rhetoric and realism discussed by Tony Green,[4] we can with some justification declare that the crag has been overturned and translated into a flat desert. This moment resonates through Australian landscape painting, with a culmination of sorts in the planar flatness of Fred Williams' landscapes, the bird's-eye-viewpoint of William Robinson; and even, ironically, in the conspicuously successful appropriation to mainstream Australian cultural identity of the cartographic flatness of much contemporary Aboriginal painting.

3

What I have said so far has not been a digression, but rather a kind of coasting, James Cook-type navigation towards my destination, Arapaoa Island.

I recently travelled to Australia on a British Airways flight. As we were passing over Taranaki, the skipper of the plane spoke to us on the intercom. He told us we were just passing over a mountain *which did not exist on his maps*. He had called up Wellington flight-control and asked for the mountain's name. They had replied that it was called 'Mount-Egmont-or-Mount-Taranaki'. He appealed to New Zealanders on the plane to solve the mystery for him: which was it? (Which name put the mountain on the map? Which name wrote it into the text of navigable space, which word constituted the mountain as cultural fact, as something that could be represented, that itself represented something, an ideal, perhaps, a locus for the gaze, the body of an ancestor [and so on]?)

Ernst Dieffenbach himself, in his wonderful two-volume account of his travels in New Zealand on the Wakefields' colonising ship *Tory*, speaks of 'Mount Egmont', and describes how he made the first ever ascent of it — as he supposed, since his Maori guides, regarding the place as tapu, refused to accompany him past the snowline to the summit.

Here already we have a clash of representations and of values. Ernst Dieffenbach, for all his sympathy, his powers of observation, and not least his remarkable sensitivity to the Maori language, had no problem with making the ascent, accompanied by James 'Worser' Heberley, a whaler taken on by the *Tory* as pilot. To him, the *value* of the mountain was its function as a salient: it enabled him to make observations, to trigonometrise, and to perform some modest examples of scientific measurement. The tone of his writing at this point is interesting:

The country over which we looked was but slightly elevated; here and there broken, or with irregular ramifications of low hills, towards the snowy group of the Ruapehu in the interior, which bore N.60deg.W. I had just time to look towards Cook's Straits and distinguish Entry Island, when a dense fog enveloped us, and prevented all further view. Whilst waiting in the hope the fog would disperse, I tried the temperature of boiling water with one of Newman's thermometers, and found it to be 197deg., the temperature of the air being 49deg., which, taking 55deg. as the mean of the temperatures at the summit and the base, would give 8839 feet as the height of Mount Egmont; the whole calculated according to the tables given in an article

IAN WEDDE

published in the London 'Geographical Journal', vol. vii, and communicated by Lieutenant-Colonel WH Sykes, FRS.[5]

As poignant as the image of the naturalist on his knees on the mountaintop making fire sufficient to boil water and take measurements, is the fact that chapter VII of his *Travels in New Zealand*, the chapter that deals with his ascent of the mountain, is sub-headed 'Taranaki, or Mount Egmont'.

Which brings us back to the British Airways skipper and the problem he had with his map. As Dieffenbach knew very well, 'Taranaki' was an autochthonous term. It was, and is, the name of one of the tribes living in the region of the mountain; which is to say the mountain Taranaki *lives* as an embodiment of the *living* continuity of the tribe Taranaki, of the tribe's succession of lives.

Once, there was Mount Taranaki, the body of the tribe of that name, whose mountain-relatives stood in the central plateau cluster which Dieffenbach had found bore N.60deg.W. from his little altar of fire, and which he designated 'the Ruapehu'. Before Dieffenbach kindled his altar to science, Taranaki had already been reinscribed as Mount Egmont; in a sense, Dieffenbach's fire represents the transactional aspect of that translation: he has revalued the site as suitable for trigonometrical and other observations. The candour with which he described the picturesque aspects of the place, which is to say its distance from the ideals he had from Europe, was soon replaced in history by the familiarity of an occupying and regionalising culture — a culture for which 'Mount Egmont' would soon become an ideal, a symbol of individuality, even of nationhood, appearing on the wrappers of butter, cheese, knitwear, and other products of the region, as well as in a great deal of art.

'Taranaki', though it still existed, had become invisible, and virtually inaudible as well, because the language in which that mountain was uttered had become the sub-dominant, though once the primary, term in a translation. More recently, however, a reconstitution of those sub-dominant terms has begun to take place. The fourth Labour Government of New Zealand, in its wisdom, decided to settle the sensitive issue of whether the mountain should be called Taranaki or Egmont. In a sense, it put the clock back to Dieffenbach's 'moment' in December 1839. It

decreed that henceforth the mountain would be called, hyphenated as it were, 'Mount-Egmont-or-Mount-Taranaki'.

In a completely hapless fashion, of course, this amenable stroke by the government described and even memorialised exactly the superimposition of terms, the doubling, in which the translation of the mountain had resulted.

What the government did not realise, and what the British Airways skipper found out, mistaking the portmanteau term 'Mount-Egmont-or-Mount-Taranaki' for a binary choice, was that this political chicanery had produced a term *for which there was in fact no map*. This term did not exist on any known map: neither on the 'map' created by the history of the Taranaki people, nor on the map created by those who translated the mountain into Egmont. To that extent, as the British Airways skipper found out, *the mountain itself no longer existed*. It did, of course, as he discovered when he looked out the window. But as constituted in language, it had been erased.

This anecdote brings us within sight of Arapaoa Island.

4

Ernst Dieffenbach, in December 1839 on the summit of 'Mount-Egmont-or-Mount-Taranaki', 'had just time [as he later wrote] to look towards Cook's Straits and distinguish Entry Island'. What Dieffenbach called 'Entry Island' is what is nowadays called by its Maori name, Kapiti. The name 'Entry Island' aptly, however, describes the island's Gibraltaresque situation: it guards the western approaches to Cook Strait, and the approaches also to what are nowadays called the Marlborough Sounds.

And in particular, to the fjord or sound known as Queen Charlotte Sound, or Totaranui to the Maori. Totaranui runs in from the north-west of Arapaoa Island. Captain James Cook anchored there, in the lee of Arapaoa Island, in Ship Cove, in 1770, 1773, and 1777. It was from the summit of Arapaoa Island, at a point called Kaitapeha, that he looked across the body of water that now bears his name, and 'discovered' that this water was in fact a strait: that it separated the north from the south island. This was, and is, an extremely important moment, for reasons I will return to.

At the time Ernst Dieffenbach was kindling his fire on the summit of Mount Taranaki, the other entry

Carte du Détroit de Cook dans la Nle. Zélande. Carte von Cook's – Stasse in Neu–Seeland. Norimber–gae, 1773; Christchurch: Avon Fine Prints, 1969. From a map drawn by Capt. James Cook, 1770. Scale not given. Courtesy Alexander Turnbull Library, Wellington.

and persistent from my childhood, namely, the Cook Strait Ferry, the ship that passes several times a day between the north and the south islands of New Zealand, entering the South Island waterway of Totaranui, or Queen Charlotte Sound, by means of that Tory Channel which memorialises Ernst Dieffenbach's ship of employment, a spectacularly narrow and dramatic entrance to the Sounds, during which the ferryboat seems almost to skid along the south east flank of Arapaoa Island itself.

I'll start with the ferryboat, the Cook Strait Ferry.

This ferryboat has mesmerised us for the better part of a century.

to Totaranui, the one to the south east of Arapaoa Island, had been named, or re-named, Tory Channel. This was, of course, the name of the ship Dieffenbach himself was employed on: the flagship of 'Colonel' Wakefield's ambitions for the translation of this territory into a colony.

What Dieffenbach observed while he was in Totaranui (or Queen Charlotte Sound), in Tory Channel (or Kura-te-au), and on Arapaoa Island itself, was that the whole region was a busy nexus of activity. A whaling economy was in full swing. There was constant military and strategic traffic among the Maori, mostly directed from the fastness of Kapiti Island. Raukawamoana, or Cook Strait as it is now called, was a major shipping highway. For someone wanting to read Arapaoa Island, there was (and is) a lot of text.

I want to focus my attention on two sentences, as it were, of that text: one, the moment when Captain James Cook ascended Arapaoa Island to its high point at Kaitapeha, and from there translated Rauka-wamoana into Cook Strait; the other, a motif familiar

Katherine Mansfield, no less, memorialised the Cook Strait Ferry as that 'little steamer all hung with bright beads'.[6] As a kid I spent a lot of time in Queen Charlotte Sound, and the Cook Strait Ferry was central to my sense of the place.

My memory of the Cook Strait Ferry is, in a real sense, the language-vessel with which I am able to rewrite that past for myself. It is the ferryboat in which I cross the divide of time to my childhood, to my father, to the first educations of my senses. But also, massively looming above the little dinghy in which my father and I rocked, it provides me with my first sense of a scale in culture beyond the domestic proportions of my childhood. The 'little steamer all hung with bright beads' was the language-vessel that conveyed to me my first sense of difference outside my family. Its arrivals and departures, like the arrivals and departures of Captain James Cook in Totaranui from 1770 to 1777, portended Otherness.

At the very centre of my earliest perception of culture, the Cook Strait Ferry installed an awesome model of division.

IAN WEDDE

John Bevan Ford, from *Te Hono (the Connection)* 1987. Coloured ink on paper, 570 x 765 mm. Courtesy 33 1/3 Gallery, Wellington, and the artist.

For this to happen, there had to be a predisposition in the culture, a predisposition endorsed by history, a discourse that emphasised separation even while it wallowed in the jargon of cultural unity with which the 1950s of my childhood was filled.

To discover how this came about, we must return to the image of Captain James Cook on Kaitapeha, the summit of Arapaoa Island, looking out across Raukawamoana, soon to be translated into Cook Strait.

It was vitally important to Captain James Cook to emphasise his discovery of Raukawamoana as a division, a *strait*. The logic by which Cook bestowed names on the salients of his maps was often extremely subtle; but here, on Arapaoa Island's Kaitapeha peak, Cook was moved to give his own name to the body of water before him. This alone should be enough to tell us how important he regarded his discovery as being: Cook was not given to carving his own name on his discoveries.

The consequences of this emphatic naming, and of the cartographic insistence on Cook Strait's divisiveness, have been to reinscribe as binary or divisive what another culture saw quite otherwise; and what even the ecological facts of the area see otherwise.

Cook Strait is a tricky and often dangerous stretch of water. But it is only twenty kilometres wide, and offers a favourite set-piece for marathon swimmers. Both islands are normally in sight of each other. And the Cook Strait area forms a readily identifiable ecological zone which is joined, not divided, by the water in its midst.

Much the same could be said of the region's cultural mapping before Cook. Totaranui was a busy trade nexus. Raukawamoana was a highly convenient waterway, whose vital navigational salients had been preserved in oral record from the time of Kupe, the founding-father navigator and cartographer of Maori settlement. Each of the many names Kupe

bestowed on the region, for example Kura-te-au, subsequently renamed Tory Channel, was surrounded by a quantity of language, of korero. This discourse surrounding the names fixed them culturally. It fixed them as navigational vantages, mapping a coastline in stories as surely as Cook mapped it in charts. And it fixed them as *shared* resources for the tribes of the region who, even at their most fluid in this fluid nexus of interchange, were *joined* by this korero, not divided by it.[7]

The extraordinary fact we now encounter, as we contemplate Cook's translation of Raukawamoana into Cook Strait, of a fluid and unified cultural site into an emphatically divided one, is that he accomplished this momentous feat against all the evidence available to him at the time.

We encounter the fact that Cook's translation, his mapping of Cook Strait and that map's subsequent enshrinement as a cultural icon by Cook devotees such as Faddei Fadeyevich Bellingshausen in 1820 — that this translation, in complete contradiction of its primary term, scored a division across the culture we live in to this day; so that the ferryboat Katherine Mansfield nostalgically miniaturised as a 'little steamer all hung with bright beads' now stands as a national emblem of separation, not of conjunction; so that the marathon swimmers we record as having crossed against the dangerous odds of the place are not, in a sense, remembered for having *swum* the distance (and back) at all, but rather for having not perished in the attempt; so that the familiar profile of Arapaoa Island viewed from the Cook Strait Coast of the North Island, is seen as being *distant* rather than near, when in fact it would often be quicker to cross that gap by boat than to drive from the beach into Wellington in the rush-hour.

I say that Cook accomplished this translation *against the evidence* because his journals, not to mention the range of Maori artefacts collected by him on all three visits,[8] imply one fact above all others about the culture in whose midst he anchored in Ship Cove, Totaranui. This fact is the extraordinary 'throughput' of culture in the region: the rapidity which which news of his arrivals, especially the second and third ones, was widely communicated and widely responded to; and the *trade* evidence of an economy that was moving artefacts and materials the length and breadth of the country. Cook parked his expedition in the middle of Wall Street. Why then did he so emphatically go on to declare the place a communications dead-zone?

The burden of the answer, for our purposes, lies of course in the nature of translation itself: its modulation into transaction, its creation of point of view. Cook cannot have foreseen the consequences of his emphasis. The language, and the translation process it entrains, have seen to the consequences of Cook's uncharacteristic excitement, his 'wild surmise' upon the peak of Arapaoa Island. Translation, in this model, has become endemic within history.

5

The Maori artist John Bevan Ford is of Ngati Raukawa descent, with Rangitane affiliations. That's to say, his tribe shares its name with the waters Cook translated; while his Rangitane affiliations associate him with the Tararua and Ruahine ranges of mountains which offer spectacular viewpoints from which to look at Raukawamoana.

He looks out across the Kapiti Straits to Kapiti Island which, as I said earlier, was known to European settlers and explorers, including Ernst Dieffenbach, as Entry Island. In the distance, in many of his drawings, especially a series called *Te Hono — the connection*, (see also p. 107) you can see the high profile of Arapaoa Island in Raukawamoana, with an entry to Totaranui at either end of it. And in many of these drawings you can also see the mountain Taranaki, in the right-hand side of the frame.

This *represents*, in geographical or accurate cartographic terms, an unrealistic (a rhetorical) enclosure of the terrain. You cannot literally encompass the distance between Taranaki and Arapaoa within a single viewpoint, except perhaps, on a very clear day indeed, and allowing for a panoramic sweep of the eyes, from a lofty viewpoint in, say, the Ruahine ranges.

What John Bevan Ford's *viewpoint* is doing, then, is representing the connections, the affiliations, of the area. It is representing the connections between Ngati Raukawa, Rangitane and Taranaki tribes, in the Cook Strait area. The *scale* of the terrain he represents is accurate as a record of its connectedness in history. This enclosed or contracted viewpoint tells us that the value of the place lies in its connections, in nearness rather than distance — and this despite bitter rivalry among the tribes on this coast.

IAN WEDDE

The insistence on nearness also records the historical convenience as a communications and trade nexus of Raukawamoana. It records what Captain James Cook must have known, on the evidence of his own eyes in Ship Cove in Totaranui: that this waterway and the places it linked were intimately and accessibly connected, and that the connections reached also to more distant parts of the country.

You will notice that the coastal outlines drawn by John Bevan Ford resemble those coastal profiles sketched as adjuncts to cartography by the likes of William Hodges and Sydney Parkinson on Cook's voyages, not to mention their equivalents almost a century earlier by the Dutch artist Victor Victorszoon, who drew the coastline of Western Australia; or by Abel Tasman's artist Isaac Gilsemans in 1642. There is, then, a western art history for such coastal profiles that goes back to at least the mid seventeenth century. But you will also notice that John Bevan Ford's representation of Kapiti Island includes certain formal devices: these derive from motifs of Maori carving, and they cause the island to become, for example, a manaia figure, a beaked and supernatural being; or a taniwha figure; or a whale or wheke, interchangeably a giant squid, whose name, wheke, survives in Kupe stories and place-names, for example Whekenui, a particular rock and bay just inside Tory Channel. The name Whekenui commemorates Kupe's victory over a giant squid at that place; the Maori name for Tory Channel, Kura-te-au, commemorates the creature's blood flushing into Raukawamoana on the tide.

You will also notice, perhaps before anything else, that John Bevan Ford includes kahu or cloaks in his drawings: they are spread as protection above Raukawamoana and its important salients Taranaki, Kapiti, and Arapaoa.

All of the cloaks depicted by John Bevan Ford in these *Te Hono* drawings are copied from actual examples in the Museum of Mankind in London. They are the kahu that were collected by or traded to Captain James Cook or his officers during his visits to Totaranui and Arapaoa Island between 1770 and 1777. John Bevan Ford travelled to London to draw them; in his drawings he is, in a sense, returning them. Their different patterns reveal them as having come from different tribal affiliations. They represent the vigour and mobility of people in the region at the time of Cook. Together with the intimate viewpoint John Bevan Ford establishes, and the

cartographic phantom of coastal outlines, and the references to the oral history of the region, they also represent a re-translation, a rerouting of the sullenly repetitious ferryboat of imperial language, an opening-out of multivalent possibilities for the writing and picturing that might be done in this place.

Notes
1 Ernst Dieffenbach, *Travels in New Zealand*. London: John Murray, 1843; reprinted Christchurch: Capper Press, 1974.
2 Paul Carter, *The Road to Botany Bay*. London: Faber and Faber, 1987, p.137.
3 Captain E.C. Frome, 1802-1890, *First view of salt desert, called Lake Torrens*. 1843, Lake Frome, South Australia. Watercolour on paper, 180 x 278 mm. Adelaide: Art Gallery of South Australia.
4 See Tony Green's essay in this volume, 'History Painting: Paintings of History'.
5 Dieffenbach, p.157.
6 Katherine Mansfield, 'The Voyage'.
7 See Tipene O'Regan, 'Queen Charlotte Sound: Aspects of Maori Traditional History', in Glynn Barratt (ed.),*Queen Charlotte Sound, New Zealand: the Traditional and European Records, 1820*. Ottawa: Carleton University Press, 1987.
8 D.R. Simmons, 'Artefacts and People: Inter-Island Trade through Queen Charlotte Sound'. Op. cit., p.159.

Translating Video

Languages of Space in the Video-work of Peter Callas

Gregory Burke

The video *NEO GEO: An American Purchase*[1] by Peter Callas begins with an (icono)graphic image of a nucleus (a world) gridded into latitudinal and longitudinal sections. In much the same way that an atom's nucleus is popularly depicted as being completed by swirling electrons, this not-so-foreign body is circled by satellites, defining a space, a schema. This breathing schema, this pared down sign, swirls and pulsates, moving to define the limits of its realisation within and on the surface of the screen. The schema draws you in, and from behind it the video's title appears. Alternating between light and dark this schema dances before that opening line of language. The schema begins a circumnavigation before uniting with the title thus cementing their joint status as logo and signature. The title and credit disappear leaving the schema pulsing on the screen. It gains velocity in its revolution as the opening image fades in. This lack of a cut, this seamless transition continues through the duration of the video as spaces of representation mutate and invade each other.

The opening image itself becomes a continuous chain of images repeated as it falls from top right to bottom left of the screen. This at once singular and articulated image network is mapped into its components by pulsating arterial lines suggesting a nervous system. The components however are illustrations transposed from another medium, signs that fall across a flattened plane with a speed that makes their reading difficult other than as signs of popular culture. We do catch glimpses that persist like afterimages: idealised images of the family and images of surveyors in landscapes, suggestive of the cultural mappings of territory. What appears as the central component of the image that in a sense envisions the whole nexus is a cutaway side view of the human head retaining essential organs: ear, eye, nose and mouth. The nervous system of canals that divides the image also traverses and braids the head. Attached to

these threads are words, fragments of language that are pumped into life, fading in and out. The total image is pulsating, moving and transforming at a rate that inhibits a reading of these words. A few may register: ambition, vision, family, liberty. A catalogue of human desire and aspiration.

With these initial moments on the screen Callas establishes a play of references to conceptualisations of space, and further to the techno-cultural projections of territory. The representations shown are polysemic. They resonate in their allusions to, rather than depictions of, a terrain. The elemental schema that introduces the video collapses allusions to the operational space defined by communication and surveillance satellites, and the sub-atomic space deep within matter itself, into one sign. These are

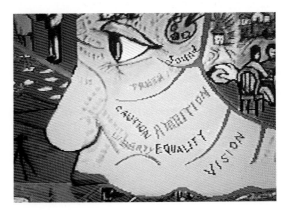

strategic spaces that cannot be seen, only represented in the abstract; spaces not inhabited by the body but existing both within and outside its skin; spaces traversed and inhabited by televisual and telecommunicational networks. Callas relates this operational space of technology, this data-space, to the human condition by materialising out of screen-black an image of a head, fractured and flattened into a field of transposed images. A mapping of the human psyche appears to be enacted; an aerial view of the psyche with its language-constructed projections inclusive within its continuous but repeating frontier.

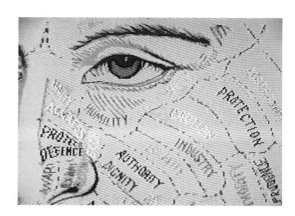

Having established its field of operation, the video continues as the viewer is bombarded with images. The monitor acts to contain a vertiginous space in which samples from the field of popular American iconography are processed as they slide

past and into each other with relentless velocity. Enveloping the senses, the transmission on the screen evokes a state where pasts and futures are collapsed into one moment. This is a timeless moment where images exist in a space of ceaseless recoding and translation. Using the pause frame on the video player does not much aid the reading of the image. The moment paused on the screen shows elements of the image in the process of becoming or disappearing, but this image is not complete. The moment paused on the screen is but a phantom of the unstoppable, irrepressible *now!*

In his videos Callas persists with concerns that have preoccupied many artists working with the televisual media. It is a concern for the power the televisual apparatus has in transmitting and thereby perpetuating dominant ideological discourses. But perhaps more importantly it is a concern for the

nature of the medium itself beyond the content of its transmission; its unremitting and indiscriminate penetration into public and private space, and thereby its assimilation of all space into its realm, a realm that can only be passively engaged by the viewer.

The passive relation of the viewer to the televisual medium was powerfully and ritualistically demonstrated by the late Joseph Beuys in 1966 in his performance *Felt TV*. Here Beuys wrapped a television set in felt disrupting the flow of its transmission while he donned boxing gloves and punched himself repeatedly in the head. Of course the plinky-plonk mood music of the TV (its speech) continued in a non-response to Beuys' self-directed violence (his response) reducing the TV to an absurdity in its refusal to communicate. In its one-way transmission, television fabricates a space that the media theorist Baudrillard has described as one of non-communication. By denying the viewer a response television makes '. . . *all processes of exchange impossible . . . This is the real abstraction of the media. And the system of social control and power is rooted in it'.* [2]

Since the 1960s there has been extensive diversification of the information-processing

technologies, technologies through which the world is structured, pictured and spoken. The television screen now co-exists with video screens, closed circuit monitors, computer terminals, computer-game display screens, cardiac monitors and radar screens. The video camera actively *pictures* the world for a plurality of overt and covert contexts. Satellites record the world from afar while the space within the body itself is entered and imaged via fibre optics. Public and commercial space is monitored and regulated by exposed and concealed cameras, their images not usually surfacing on our screens. Our experience of the world then has become increasingly conditioned by its potential and actual existence as image. Coincident with the combined diversification and proliferation of information technologies, the televisual media in particular and the mass media in general have expanded into both real and abstract space at an exponential rate. Television has further penetrated the home, delivering an ever-burgeoning number of viewing options, options that are highly regulated by the current conditions of the market-place. These same conditions have colluded to transform the fabric of our urban architecture creating a surface display of ever-changing messages.

The experience of the urban-dweller, then, is constructed within a networked world of images that are in themselves spaces of representation. Not only are these spaces infinitely mutable, they compete with and further invade each other through appropriation, assimilation and recontextualisation. Images defined within one medium are processed, their specific meanings altered or subsumed as they resurface within the context of another medium or representational space.

This is the only true response of the media, based in the urgent and competing desire for maximum visibility and recognition. Nor is this process of exchange culturally specific or contained. Cultural boundaries have in effect been collapsed as satellites beam signals and visual messages across cultural borders limited only by their ability to negotiate the contingencies of reception. Within the fictional space defined by the media machine itself, information is exchanged and processed, achieving a feverish pitch in densely populated areas.

It is the combined process, effect and speed of this exchange that interests Callas, informed by his experience of living in Tokyo. Within the vast sprawling cityscape that is Tokyo, the demand for living space is at an optimum. The city is organised within densely networked space. Its population crowds into this space as it exists within the home, the workplace and the street. Callas, who in the 80s spent extended periods living and working in Tokyo, suggests that television there acts as a surrogate for the experience of limitless space. It brings the outside world to Tokyo, but more importantly the screen provides space that can be easily and passively entered, unlike the space outside it. *Television it seems is providing Japan, as it provides no other country, with a psychological space, a dimensionless terrain which can be traversed without physical motion.*[3]

This terrain is not limited to television but includes all the image-based technologies. Concrete and illusionistic spaces inter-narrate with one another as video screens transform the urban environment, replacing billboards and shop window displays and punctuating the interior surfaces of department stores. These screens are more than simply agencies for product promotion; they simulate experience itself. They deliver images taken from a multiplicity of cultural and sub-cultural contexts: from the silence of nature to the noise of Western pop culture. Images can be selected from screens like the items in the stores that house them. Through transposition and unrelenting change the media in Tokyo conspires to absorb all imagery and thereby all culture into its realm.

It is within this context that Callas spent 1986 working as a video artist in residence at the Marui department store in Shibuya, Tokyo. As a feature of its hi-tech hardware, Marui is fitted with a 15 square metre video screen on its exterior facade. While resident, Callas produced a number of works that were programmed into the cable-cast transmissions from this screen. As with his later tapes these works

GREGORY BURKE

were derived in the main from existing imagery including *manga* (comics), television and cinema. Within them he orchestrates an electronic space of sequential images cribbed from the media that are reprocessed and transfigured with the aid of computer hardware.

In one sense the experience of viewing these videos approximates and mimics an experience of the vastness of Tokyo's shifting terrain of image transaction. Images on several planes slide past and fold into one another, flashing (blinking) against mesmerising swirls of electronic patterning. The viewer, unable to identify a coherent narrative structure, is instead confronted with an implosion of discontinuous images severed from their originating contexts. The power and spectacle of this image-exchange overrides specific meanings signified by any one image.

But Callas does not simply seek to reflect the spectacle of the media in Tokyo. By working within

its forms and by infiltrating its channels of exchange, he seeks to address aspects of its affective power. He explores the linguistic nature of his images, playing off the coherence of their original meaning and context against the decontextualising forces inherent in the media.

For example in *The Esthetics of Disappearence*[4] Callas uses images of Japanese actors from the silent era as his visual core. He plays off the ritualised and coherent space of the theatre implied in these images against the fragmentary, decentred space of the Japanese media, a space characterised by speed of image-exchange and translation. Theatrical images flash momentarily onto the screen, intercut with digitally re-ordered images of war and destruction on the one hand, and a flow of electronic patterns on the other. The speed of editing increases to a point

where the content of the images is rendered inert, thereby suppressing emotional reaction and response. At mid-point in the video Callas playfully reminds us of consumer investment in the ownership of images. After alerting us to its copyright status, the tape declares *see it now* against a backdrop of disappearing images. Thus the meaning of any image within the abstract space of the media is defined by its exchange value as object. The video, then, acts as a metaphor for a media construction of vision; a vision transfixed and desensitised by the speed of change and exchange.

Working through the medium of video, Callas suggests that technology, and in particular information-processing technology, establishes a form of territory, a territory where images are fundamentally linked to the transactions of commerce and power. He seeks to explore the politics of the deployment and the resulting manipulation and colonisation of this territory within the cultural context in which he is working. In *NEO GEO*, produced in New York as the result of a 1989 residency at P.S.1 studio, Callas concentrates on the codes through which this territory is projected both from and into the collective American psyche.

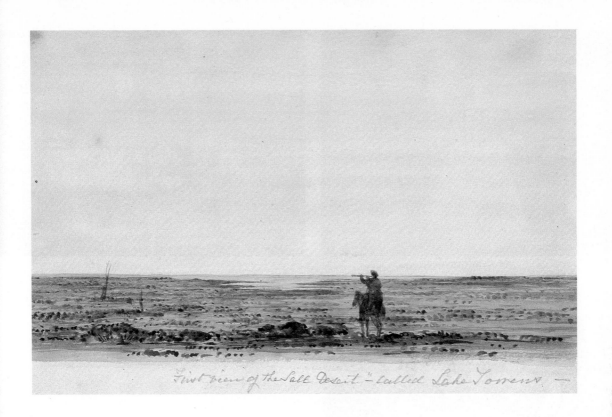

E.C. Frome, *First view of salt desert, called Lake Torrens* 1843. Watercolour on paper, 180 x 278 mm. Art Gallery of South Australia, Adelaide. South Australian Government Grant, Adelaide City Council and public donations 1970.

John Bevan Ford, from *Te Hono (the Connection)* 1987. Coloured ink on paper, 570 x 765 mm. Courtesy 33 1/3 Gallery, Wellington, and the artist.

Peter Callas, *NEO GEO: An American Purchase* 1989. 1 inch video, 9.17 mins. Courtesy Peter Callas.

Peter Callas, *The Esthetics of Disappearance* 1986. 1 inch video, 5.55 mins. Courtesy Peter Callas.

The majority of images used in *NEO GEO* are icons redrawn from American popular culture. They include many emblems, historical and contemporary, that relate to the language and condition of war (the Pentagon, warheads, Uncle Sam, soldiers and war slogans). Also used are functioning signs of America's capitalist economy (the dollar sign), as well as signs and images of the American entertainment industry, religion, technology and the mass media. By collapsing these images into a protean space of signification set against a landscape of language fragments, Callas implies a functional relationsip between, and intertextuality of, these cultural forms. However this relationship is far from being coherent or stable. The sense of reality achieved through the unifying single-point perspective of the camera is abandoned in favour of a fragmented and temporally unrelated sequence of images appearing to materialise from within the medium. The lack of groundedness and the disorientation that are engendered suggest

that the current pace of image consumption, and resulting reordering of meaning, are a powerful pacifying mechanism integrated in the structures of Late Capitalism.

Callas has stated that his intention in the video is to 'portray the processes of endocolonisation',[5] a term coined by war theorist Paul Virilio to describe a condition where the psychology of war is directed by a state against its own population.[6] According to Virilio this reversal has resulted from the dramatically altered nature of war in the nuclear era, an era where the world powers base their economies in the build-up of arms and deployment of increasingly sophisticated military technologies for a war which is finally futile. The threat of total annihilation through war leads to the teleology of war turning inward. The umbrella of deterrence becomes a means of social control and manipulation. For Callas, this umbrella defines a boundary for a psychological terrain that is the object of endocolonisation; a terrain established and controlled through the media. This terrain is not so much the mind of the individual: by co-opting and manipulating the very icons that establish identity in the individual, the forces of Late Capitalism irrupt into and derange the collective American psyche.

While *NEO GEO* alludes to the fragmentary nature of the media landscape as a whole, it also bears a partial correspondence to specific media forms and types of programmes. Images that slide out of register resemble scanning and surveillance procedures, while the use of texts placed in front of an image correlates with the strategies of advertising. The use of graphics that simulate war machines, explosions and generic figures etc., draws an analogy with video war games. Video games are an interesting form in that they do allow a simulated response; on the other hand, the response is programmed into the game in order to keep the troops playing. As with other Callas videos *NEO GEO* establishes a particular assonance with the music video form, especially contemporary rock video. Much rock video, in its adoption of pastiche, collapses geographically and temporally unrelated moments into the present,

GREGORY BURKE

divesting them of meaning, thereby invoking a fixation in the viewer by and on the image as object and commodity.

However Callas does not recreate these forms. He both articulates and works within an organic space projected through the contemporary media: a space that interpenetrates memory and time. He suggests that there is no state of being, or speaking position, outside this space. By using the language of this space and reordering its syntax, he seeks to speak from within it.

Notes

1 *NEO GEO: An American Purchase*. Colour, 9:17 mins., Peter Callas, 1989. Music: Stephen Vitiello, John Zorn.
2 Jean Baudrillard, 'Requiem for the Media', trans. Charles Levin, in *Video Culture, A Critical Investigation*. New York: Visual Studies Workshop Press, 1986, p. 129.
3 'Technology as Territory, Video and Desire in Japan', ex. cat..Sydney: Artspace, 1987.
4 *The Esthetics of Disappearance*. Colour, 5:55 mins., Peter Callas, 1986. Music: Jun Togawa, Gernica.
5 Unpublished synopsis, 1989.
6 Cf. Paul Virilio, *Pure War*. New York: Semiotext(e), 1983.

Illustrations pp. 103-105 and 109-110: Peter Callas, *Neo Geo: An American Purchase* 1989. 1 inch video, 9.17 mins. Courtesy Peter Callas.
Illustrations p. 106: Peter Callas, *The Esthetics of Disappearance* 1986. 1 inch video, 5.55 mins. Courtesy Peter Callas.

"E koe ano!"

John Bevan Ford (Ngati Raukawa ki Kapiti)

One of the hobby horses that I have in talking to people about Maori art is that it is not a matter of hieroglyphics. I can remember Pine Taiapa telling me of a kowhaiwhai pattern called ngutukura, that's the beak of the kura. If this group of people had this pattern, it more or less recorded that not too far away they had the type of bush that attracted this parrot to it, this kura, which they could capture and kill and feed people with. So you might say they were complimenting themselves on this great supply of kura and also saying to the guests, don't worry, we are very proud of our ability to look after you well, and feed you well. So they had this pattern, but they did a few little things to it, and between themselves the artists called it 'the hidden faces'. Now the building had been put up to commemorate the people who had died overseas during the Second World War. You know, it was a major cultural problem, that all these deaths occurred and the tangi couldn't be actually done with the papa tuupapaku itself. And so the hidden faces partly related to those. But they had put it in this ngutukura pattern so that the uninitiated would say, 'Look at that lovely pattern, yes ngutukura, oh yes, we'll get a good kai afterwards,' and things would be left at that level. But if they stayed there any length of time, then they'd say, 'Oh, but it's a bit this way and a bit that way,' and then their minds would get engaged in this problem — and if it was felt appropriate then some of this idea of the commemoration would come forward. And then out

Courtesy John Bevan Ford

of that came the emotional problem that lay in those warriors being over there and by themselves, and lonely, and that sort of thing, and these people who had come in and wondered about this, they might have some of the same problems, like that. And then that widens out into other areas of death, and life, of movements about, those people went for a heke over there, to the other side and died, there were the ancestors who died before us, that died before they ever came here. But for us, living here and dying here, perhaps there is the same grief back there at Hawaiiki for those of us that have gone on. And it gets into the emotional and spiritual world of where you have come from and the consequences of moving, and the consequences of dying.

So that the pattern — it is as though it recedes. At its most surface level it is a pattern. Behind that it has a narrative meaning to do with the supply of food. Behind that again obviously what I am beginning to talk about now is genealogy. In whakapapa, we go back through the families to the gods, and through the gods to the states of being before there were gods — because whakapapa starts with very, very abstract concepts that are pre-material and that really is one of the areas where the arts come from, that allows you to say, oh, arts have a spiritual meaning for Maori. There is a direct line that you can trace to see where that spiritual meaning comes from, and the answer generally is in the whakapapa. The whakapapa in its abstract sense. And so you have an abstract art which beautifully mirrors the abstract

concepts of whakapapa.

•

The late Pakaka Tawhai who used to lecture at the University about tapu, and mana, and things like that, put a lot of weight on the myth being the spiritual guideline, and one of the areas where the layers of meaning can begin to be approached. He would say, for instance, that the myth belongs to the storyteller. This is saying that knowledge doesn't come from a vague nowhere, it comes from a specific place and person. But the myth is told at a series of different levels. So there is the myth as we tell it to little kids, so that they can come to grips with some of these cultural ideas in a way that they can cope with, and learn through in a play-like way. Then we retell the myth again to the young adults. It is the same myth, and it has the same cultural meaning, but it is told at a different level. Then there is the myth as the old people talk to one another about it, in the whare waananga. In the deepest part of winter, and the deepest part of the night, you might say. And there they are really getting as close as they can to the truths, but even then the words are designed so that the truths are still only hinted at and not openly revealed so that they become dangerous to human beings. So you create in this case a verbal structure, in the case of the visual arts a visual structure, that acknowledges that these problems are so deep that they don't reveal themselves, and will never possibly be revealed but at the same time by keeping on searching for them you are restructuring yourself to meet the changing world. Because you are trying to bring those thoughts into the present. And you can't bring them into the present from yesterday's symbols, but you can use some of yesterday's symbols and restructure them to get a cutting edge that gets you a little bit closer to it.

So that you can begin not only to create the new symbol but to create the structure for the new symbol. So that the integrity remains there. And the integrity isn't a matter of little specifics. It is the large concepts. It could be a concept such as sharing, for instance. If you jump back into the myth and look at Tane, one of the children of Rangi and Papa, and all those children of Rangi and Papa were male. And so there was the thing that is learned from whakapapa, that there is the capacity for change. Well here were all these children, and they were becoming human-oid, as it were, human-like. And they didn't have the

capacity for change, all these bloody males. So Tane goes to Papatuanuku, where the first change had taken place, and models this thing and breathes life into it and you have Hineahuone — Hine of the Stone, you see. And he mates with her, and they have Hinetitama. He then mates with Hinetitama, goes and lives with her. She eventually asks, 'Who is my father?' And he said, 'Ask these walls.' Now the walls were made of timber, of course. That was another aspect of him. Tanemahuta. And she immediately realised that he was not only her husband but her father. So deeply ashamed, she left and became Hinenuitepo. She went to the underworld. He rushed down and tried to get her to go back. She said, 'No, I'll stay down here and look after what comes when life finishes, you stay up there and make sure life continues' — more or less. The message there of that myth is, why did she flee? Now when you bring a pakeha point of view, you say, oh well, he committed incest. But they weren't concerned with him committing incest. What happened is that he wouldn't share his progeny. He had a child. He had grabbed her again. So there's that concept of sharing that you hear about in Maori terms, and it lies in this myth. And they are the big things. You can see what a lovely great story evolved around this concept of sharing.

And it begins to take a material form too, in that it already involves the making of life in timber, in rock, and so on. So that it starts to represent itself even in the telling.

And it goes right back into the beginnings of whakapapa. One of the initial concepts was te kore — this is before te po which most people might have heard of, and te ao marama, that's the darkness and the light in all the various stages. Te kore, the nothing — but the nothing is called *te* kore, the 'te', the definite article, has the implication that there is *the* nothing and therefore the not-the-nothing. So you have that two-way thing right at the beginning. Look at work like Ralph Hotere's and you see this duality is basic to his underlying structures. If you think of his Cross series, it is a beautiful statement of that concept of te kore, his work has the commemorative aspect about it — almost all of the time — and so even in this innovative work we see the underlying concepts of the nothing and the not-the-nothing, of

light and dark, of commemoration, of coming and going, of responsibility toward land, responsibility toward one another. And that's what makes his work Maori. It is not that he is using lots of korus, but it is absolutely Maori thought. I tell you, a young chap that I met at the last Ngapuna Waihanga hui at Ratana, he said that he was busy trying to figure out a definition for Maori art, you see. What is Maori art? A desperate question! So I said, 'Oh that's easy, it is just the materialisation of Maori thought!' Okay, that's too pat and smart, but yes, it does go back to major concepts, and that's where you'll find the new symbol.

•

In the Cook's Voyages — there are lists of what things were traded in those first three voyages — the thing with the highest profile at the beginning was nails. And then very quickly as they became available, tomahawks; things of that nature. Now, as soon as that tomahawk was available, that stone adz was dropped on to the ground. You will find stone adzes littering the ground as it were, not necessarily around ovens, not necessarily around places of work, but just as if people threw that thing away wherever they were — hell, this doesn't matter — and quicker. It was the same, the whatu, that symbol that I use so much, the kahu. The technology of that — now I'm sticking my head out — was really you could say fully developed in New Zealand. It's a New Zealand art form, in that clothing was done with those great big pandanus leaves. Pandanus was brought over but only barely survived in the north, so it wasn't very useful; and so there was the flax, the harakeke — the harakeke when it was plaited was a pretty stiff sort of thing and not very bloody comfortable. But then the inside was found and the knotting technique which would have come over here, was adapted to what we call weaving, you see, or whatu; knotting. And that very quickly developed. You know, that was found quickly and developed very, very quickly and it looked as if, when you get some of the very old stories, people tore about this country when they first got here, looking for types of stone and they didn't, when they found greenstone, say, 'Oh, this is much harder than that old rock we used to use, oh, no, we shouldn't use that, it makes things too easy; we'll stick with this bloody old soft rock here.' No, you stopped using that, and if you could lay your hands

on greenstone you'd go for miles and miles in this wild, bloody southern sea down here, to get the stuff.

Any looking back at the material culture in New Zealand shows you how adaptive the people were, and smartly. The important things were the cultural *ideas*. The material things were just the way of exploring those cultural ideas and making them more apt. They did get values in themselves, but in general it was a very immediate type of culture. For instance, a building would be put up and when you moved away you just let it fall down. In later times when carving was associated with buildings, if the people moved away the carving stayed with the buildings and they just fell down.

Yes well to stay with that particular one on the kahu, let's go back to the Cook time. The principal kahu then to show mana of a very high caste would be patterned or decorated with dog skin. And then the next most important one, I think — to create a hierarchy may or may not be a correct thing to do — was the kaitaka cloak. That is the cloak that has the taaniko border. Then there was the kahuhuruhuru, the feathered cloak. When, in the nineteenth century, you had this wool, that was a quick way of getting some of the colours of the feathers: you could put them into the kaitaka cloak without compromising the kaitaka, you could add either the wool to the taaniko, to increase its colour range, or you put the wool up in the kaupapa of the cloak. You know, you have the little tufts of wool and so forth in there, and that was gorgeous, but Europeans were greatly taken with the kiwi feather cloak. It was exotic, yes, sure. And so kiwi feather cloaks were the ones that were done to give away to the pakeha. But then it turned around and it became the principal cloak for the Maori. So you had that shift very, very quickly taking place right within the nineteenth century itself. So the kahu kiwi has become *the* clothing symbol of Maori people. In some measure it started because it was so valued by the pakeha.

The other thing that took place is that another cloak, the korowai, you know, with the tags on it, also gained a tremendous popularity. It was just one of the many cloaks in earlier time. But with the advent of the modern action song as a statement of the resurgence of Maori identity that was often shown by marae protocol which got extremely elaborate in the early twentieth century and later on — the korowai with its tags which move when people move — in

JOHN BEVAN FORD

fact, you know some people call cloaks korowai — it has become a standard term. And people like Ralph and Para [Matchitt] and company are not really more innovative than those people in history, they are just part of that line. You know, it is unfortunate to say it, but the people who are merely working strictly within the tradition are not really as innovative as their ancestors were. I mean, any culture always has that. You have your most innovative and most conservative people operating together at any given time in the culture, but it was the Maui Tikitiki a Tarangas of this world who saw themselves as, you know, needing to venture out and find things, and test things, test the realities, test places and things: 'Where does this bloody fire come from? Let's put it all out and see what we can do about it!' Why did those myths of someone like Maui, who broke the rules ... why did young Hatupatu, his myth ... and he was the younger brother, you should have been talking about the older brother, he was the Chief — why do we remember these fellows? . . . to reconfirm the basic cultural symbols, not to knock them down; but in fact to modify them and build them up, I think. Perhaps! E koe ano. The first bit of writing I had to do as an academic was for the Polynesian Society Journal. And it was about a Taranaki carving that had just come up out of the swamp. And I'd go to my old uncle. Anything about things Maori and so forth I'd go to my Uncle Val, and talk to him about the project. And he said, 'Now, that's good you are writing that thing, it is better to have a Maori like you writing it than some other bugger that doesn't know anything,' he says, 'but one thing you must do; put down e koe ano — is that so!' I am writing these things down, but I am reminded e koe ano — is that so!

•

That kaokao pattern in tukutuku panels. Okay, off the top of my head. I think that because it is first of all a materialisation of a particular thought it allows the thought to stay around for a while, it allows the thought to be shared not only across the family but across time and it allows the thought, because of its abstract nature, to grow and change. But the kaokao symbol nevertheless is still abstract enough to allow new thoughts to occur and also to sustain being put into new forms. Now what I am getting at there is that in Pine's [Taiapa] writing he points out how it refers to a mat that warriors once stood on when they were

blessed, before they went to war. And here it is on a tukutuku panel. Now he is talking here, without actually saying it, of how material symbols can get transferred from one area to another.

Another one like this is the patterns that were placed on paddles that were used in the wakataua, the Chief's war canoe. They became a basis for, and you find them transferred to, the kowhaiwhai patterns in meeting houses. So that when the wakataua itself became outdated as a statement of chiefly mana by the growth of the wharewhakairo, the carved meeting house, some of the mana of the past got transferred into this new environment. And the same thing had happened with some of the patterns that were in areas of raranga and weaving and of taaniko — they got transferred into the meeting house, too. I think it was not just a matter of kaokao still holding on and referring to messages over a long period of time. I think there were a lot of other patterns that would have too.

I do have a problem with this concept and that is that these patterns aren't necessarily hieroglyphics. I think I have gone over this before. So that their meaning can also change as they come from one environment to another. And I have certainly heard some stories around some of those patterns that are very different even from his [Taiapa's] stories; people have appropriated the patterns that reconstructed a story which is much more meaningful to them. You can see there that Pine had verbalised a particular significance into this pattern and to that extent, of course, any of those things are like writing. It is like the carvings of the tupuna on the outside of the house — that speakers on the marae might refer to. Just as you might refer in a speech to someone saying, or to writing in a book, or whatever in European terms, then you might refer to an ancestor on that house. But there are other levels. The other thing that I suppose is a problem to me even talking to you at any stage, is that I believe that visual symbols say the sorts of things — I have to use the word 'say' since I'm doing this verbalisation — that the normal words don't quite cope with. It is its own language. We are talking about different forms of language. But I think that we must agree that there are both forms of language, and that they tend to meet the requirements of languages, that they materialise internal thoughts, they make them available to share, and they fit them into a pattern so that time, although it might modify them,

nevertheless doesn't destroy them.

They are a language. They are concerned with thought. Because that is something I hadn't got round to saying. I usually carefully use the word 'pattern' rather than 'decoration'. In no way do I think the patterns on carvings or any other Maori artwork are decoration. I think that is very much a nineteenth century European idea, where at that time many European critics thought of art as decoration.

To what extent can this language, let's call it, of the tukutuku pattern, to what extent can that be separated from the speaking that it elicits? You say that just as the figure emerges from the body of the timber, so does the korero emerge from the body of the carving. Now this seems to me to be an absolutely essential point, that these patterns should not only utter themselves, but should be the occasion about which speaking continues to happen.

Yes. For instance, we have been talking about tukutuku panels at this stage, and about carvings and so we are obviously talking about the wharewhakairo. In itself, wharewhakairo attempts to be a holistic statement about the Maori sense of reality, sense of life. The commemorative house is part of the whakapapa. Its poupou carvings and other things deal with part of the whakapapa but it's designed in such a way as to make sure that the rest of the whakapapa is acknowledged. For instance, the taahuhu, the ridge pole of the house, usually has a pattern down it that is a continuing type of pattern. Maybe it's a sinuous line with pattern on either side of it, or it might be a series of panels that repeat themselves, but you get this concept of continuity in there. In the actual structure of the house you first of all put up the pous at either end of the house and then you brought down the — and I use the word brought down rather than put up — you bring down as it were from up there that great long whakapapa section of it, as the taahuhu; but the pattern that you put on makes you realise that it started away before this taahuhu itself and it will go on away beyond. So even when you are constructing, you see, it is people thinking about where they are at in time.

And to get it there, the Chief would have caused the people to sit round and think about what it was that they wanted to commemorate. So it would have started with a great deal of discussion in the first case and then, after hearing all that discussion, the rangatira would decide what he would do. So he said, 'Well, we'll have a poupou 80 foot long and we'll have a pou inside the porchway and then we'll have the pane (that's that part that sticks out beyond the porchway), we'll have another potahuhu here and we'll have a potokomanawa in the finish because we have quite a few things that we need to symbolise in this statement of ours, you see.'

And then, all right now, we have all these other people to acknowledge here, as part of our story. Now we are hoping that the people over the hill over there and those other relations of ours will feel at home there, so we will have to put their tupuna in as well. And then there are their relations as well. And now there's those people who are instrumental in helping us come here. Those ancestors. Now they'll have to go somewhere. And there's all this korero and, all right, so we'll need thirteen, fourteen, fifteen down this side and fifteen down this side and then along the poutuorongo at the back if we can get three epa on either side we should be able to get most of our ancestors of the past into that area there. Now we have to link all these things. Now we'll need these kowhaiwhais coming down here to link those ancestors with the sense of whakapapa. Now we have got those links but I think we'll need some horizontal links as well, so we'll also use some kowhaiwhais around here. It might be better if we use something based on those taaniko ideas. You know, at the bottom of our cloak that taaniko encircles the cloak. Now let us encircle all these people here. So we'll use this taaniko here, up at the top here, and then of course the other thing is we'll have these moana between each poupou, that's the tukutuku pattern. That was an old name for tukutuku, the sea. Buck mentions it, and it is a lovely concept because it is the sea that brought us together and it is the sea that holds us apart. So that you put the tukutuku there and it distances each ancestor from each other but it also joins them, you see. And so on. Now the other thing is that our role in this house of supporting all of these people is based mainly on our fish culture here. We're down by the coast — kaimoana is an important part of our diet. Now our tukutukus can perhaps support that concept. So we'll have some patterns that do that and our linking patterns, our kowhaiwhais can also support that concept, but we'll have some other things it will be necessary to do.

JOHN BEVAN FORD

And so there's a tremendous amount of korero that has gone into the formation, the shaping, the structure and then finally the patterns themselves. And then exactly the reverse happens. The house is built and it is in use, and so you come into this house after all that carry-on outside, then you're lying back there and you look at the ceiling and, 'What the heck's all that scrawling around there, what's all that about?' And as you say, there's a verbal response.

The other day I had this talk — going back to another aspect of the abstraction involved here — we were doing some paintings for a house that's just been put up. It's a normal house house, not a carved house, but it is to be used as a meeting house, up the Waitara River, at Otaraua. We didn't want to go through the carved meeting house process, but we wanted to carry some basic ideas that are concerned with Otaraua and its identity, so we did a whole series of paintings that were based on tukutuku concepts, because they were going to go on the walls. But we weren't going to make them mistaken for tukutukus, so we put a frame round them so that they would be thought of as pictures. But it was still Maori thought. The kuia was talking to me, because I said we'd take these ideas and then we'll think of some naturalistic forms and we'll abstract them and we'll hide our ideas in there. And she said, 'But what happens when people say to me, why did you make it as difficult as that? I can't work out what these things are about, you see.' I listened to this and explained it as best I could, and then while we were doing it, because we had a weekend and everybody came together, I pencil drew them out and we did the painting by numbers, you see, put those colours in there and so forth and they were painting them. So there will be times when visitors come, when they would say, 'Oh, Hone's come along and he's brought all these patterns for us here,' and I'd take the opportunity then to do a bit of indoctrination. I had to point out that I hadn't brought the patterns, the patterns were about Otaraua. And that we were doing it like this so people didn't trivialise them and people really thought about Otaraua. Because I said they'll come in, and they'll say, 'What's all that about?' And they'll sit down and for the next two hours you and they will discuss how those things might mean something about Otoraua. Now if I've just put in a few fancy trees and some little waves going along — they say, 'Look at the fancy trees and the waves, isn't that nice.

Now what did you do last Thursday?' And so on, and so on. So it's not just that korero arrives from it, but korero that really works on the identity of the place and the significance of the place, and the significance of the people tends to arise from it. So there's that aspect, and it happens not only during the protocol outside the marae where someone will point up to the tekoteko and say, 'Because of that tekoteko there, you are I are related in this particular instance, because so-and-so and so-and-so and so-and-so and here stand I, and I know that that's your tekoteko there, so there you are.' Now, it is happening out there in that confrontational situation. But inside, when people are talking about the things that bind them and the state of the world and what they are going to do about it, again it arises because of the even more abstract ideas that the kowhaiwhai and the tukutuku have embedded in them. You know, not just the particular ones of the line of names.

The question that occurs to me now comes out of the way you have described the movement from a complex narrative or a moment in history into abstraction, and then a movement from that abstraction back out again into speech — that process leads me to wonder how we read the paintings of an artist like Gordon Walters who, on the one hand, is completely straightforward in saying that he never intended to take anything more than the formal properties of the koru motif that he worked with for so many years. But at the same time, to any person who looks at a lot of his paintings of that type, it is obvious that he saw a dynamic at work in what that form could do, or was doing, that also approaches very closely the process that you've described: the endless variation that was available, the collision of ground with figure, the sense in which you can't tell which is behind and which is before, and the sense of a language being there, and the rhythms of it. It would seem to me that although for reasons of propriety Gordon never wished to claim to be doing any more than borrow a pattern, there was more happening in the work than that. Now do you think that that is in the nature of the motif itself? That somehow the dynamic of that form is irresistible? That its function, having once been to do this business with speech, it can't be prevented from doing so?

Yes, I think there is no doubt that the dynamics of the materialisation can remain in there long after the major particular thoughts that drove it out have left. Especially the kowhaiwhai-like nature of positive and negative being intermixed, in fact there's no such thing as foreground and background. That dynamic, that potential for message-making stays with it and so therefore, in retrospect, or in a different environment, it still carries on its dynamics.

I've often quoted, and I've seen it quoted, Api-rana Ngata's statement that words themselves are charged particles, just the individual word is a charged particle. You know, some words in Maori were so tapu that you only used them in certain circumstances. There might be an ancestor who was so tapu that only in times of a really important cultural event would you name this name. Now, I've used this particular thought to help some people understand the process that if you, in a museum or an art gallery, you take a patu, a greenstone patu, and you put it up high, throw a light on it, and possibly gradually let it revolve, and so forth, it can act as a charged particle, emotionally stating something that is relative to the power it had when it was in the hand of the chief and was held down here. In fact, you might be able to get into a sense of mystery and power greater than if you got a plastic model of the bloody chief and stuck it in his hand. In fact I am sure you would. And you see some of our ethnographers, when they talk about context and think about the material context, stop at that level. So you have lots of plastic figures holding lots of real Maori works and that has diminished it, as we are inclined to think when Gordon at times took a charged particle and didn't look at the charges but just looked at the particle. We at times might have felt that it was trivialised.

But for Gordon and for another group of people, they would pick up the charges that come purely from the visual interplay of the thing. And I suppose that that just leads us to another thing which you didn't ask me, and that is that perceptions can at times be racial as well as universal. That's perhaps another matter altogether. So, to go back to the Maori side and that patu up there, some Maori people have said, that when the patu is shown in that way it's been the appropriation of the art gallery that gives them the message, the appropriation of the art gallery, because it is shown like a pakeha sculpture. So that's the other side of the coin. Although in my opinion it

can capture the wehi of the thing, with this light glittering on it as the sunlight once glittered on it. Now hell, we don't have to see the chief and his hand any more, all that wehi is in there. Just the same as when we look at this carving here, in no way did that tupuna look like that. When the bugger walked down the street he didn't have paua glittering at you and all these patterns . . .

•

I could stand back from the content of my work, but I find it difficult to rationalise how the patterns emerged. And I have attempted to do it before, as you know, in a TV interview, and I often wonder whether I am purely rationalising rather than did it really happen that way. And I wonder how the viewer can come to this. I mean, I really wonder that. Because you have been talking about Te Maori and the very interesting thing was that for cultures who had no ethnographical or any other context to put it in, those charged particles were really perceived as charged particles. There's no doubt about that. And they didn't need a book of writings, or museum writings, to tell them what the hell it meant. And at times, although perhaps particularly in New Zealand where

John Bevan Ford, *Ancestor Figure with Cloak* (in Te Kahu o Maungakiekie project) 1990. Mount Summers stone, 2700 mm. high. Courtesy John Bevan Ford.

JOHN BEVAN FORD

we had guides and so forth, I think that the effect of the guides was just showing that it was a relationship between the people and those things. Some people, of course, enjoyed it at a storytale level, but I am not certain that those stories helped them begin to work through the patterns and therefore learn to be able to enjoy and read the patterns and therefore to come in contact with the idea of the patterns, because you become mindfully enabled through the patterns. And yet this obviously does occur.

All of this explanation etc. was not necessary in the old days when the patterns that were being made were the only patterns that were being made. You had no alternative cultural statements, you see. You had all sorts of alternative regional statements but most of the work was done on the spot and although you didn't see it being done you saw the work that had been done beforehand, you saw it when it was finished and you might have seen some new work, and then when you visited you saw other work, and although it varied from place to place you still more or less knew where it was coming from and going to, even if you couldn't read its particularities. Just the same as you could enjoy a waiata being sung from some other area. Although you might not have picked up the place names and the resonances that come from those place names because, you know, none of your people lived and died around that rock, or whatever it was. Nevertheless you know the sorts of feelings that are being evoked and you translate them into your similar feelings.

Now, in this day and age, especially for those of us who are referring to patterns that had their first light in the older culture, I suppose that it is only in doing what you might call an academic study of that, and by academic I don't necessarily mean going to university, but putting your mind to it and living with those things and asking questions of the creators of those things, that you can come to grips with them. I think that is the way it has to be done. And I think it actually has to be the way it needs to be done in the Maori world as well. And this has been a little bit of a hobby horse of mine because in the old days you could see things, you could observe things, you could let them go down into the subconscious and then when you're working you can just rely on the subconscious to bring out the things that you need to do and therefore your thought would be Maori. In this day and age you have to be somewhat more

analytical because we have all grown up in a bicultural situation and Maoris all have to go to pakeha schools. So, especially these days, everybody hears a radio from time to time and can read the paper and of course these days watch TV — so what goes down into the subconscious — there's a whole mixture of things. Now if you just leave it open — the subconscious open, and accept anything that comes through — and think because you are bloody Maori that that is a typical Maori statement — if you are trying to be, you know, if you're really trying for it to be an essentially Maori thought, then you are as likely to come up with Donald Duck as anything else!

How do you gauge what is trivial thought and what is deep thought? And that's open to every race, isn't it? So you have a very special activity happening that I think needs a little bit of specialist thought if you are going to get in touch with it — you've got to begin to learn the language. Although there's an area in which it works, at a quite common level, to get a really enriched view of it I think that you have to make some sort of study.

It was interesting to consider how important art was to the old culture. A lady, making a cloak, and it is a very, very slow process, handweaving, especially if there was going to be a taaniko on it, especially if you are adding strips of dog skin or feathers to it, it all slows the process up — that person could be put aside from the business of gathering kai, of cooking, of everything else. And to me that means, when you look at the structure of Maori art, just look past these little patterns and things and look at the structure, you don't have to be wondrous of the fact that the structure is a reflection of the life.

And because it is a reflection, you see, you look at the symmetry, for instance. Now that symmetry is a message of the Maori understanding of life, and there seems to be some sort of a balance. There's night and there's day time, and the tide comes in and the tide comes out. Also there is a structural significance in the way society was put together, with this rangatiratanga, and this looking in towards a leadership for survival purposes. And so this looking in, if you think of the central line down the carving, or the notional central line, or along a taaniko pattern, the centre line that things alternate across, you see this centralised form of control. It is a mirror of that. But within that, especially in the old works, you see the variation on either side of that because not every-

thing balances out. And not everything is the same. And you see it, you see old taaniko patterns with all sorts of variations within new — some people try to say that oh, you know, they must have forgotten what they are doing. It happened far too often, and it was obviously this asymmetry which was a statement of life as it really was. And again you pick this up in Ralph's work, where he has this basic symmetry and then, look how he . . .

Coming back to Ralph's work for a moment. It has intrigued me that he's very often made use of texts not just as adornments but starting points; and has produced whole series of works out of a single text, or out of small texts. Writing appears also on work by, for example Emare Karaka, someone like Para [Matchitt] used forms of symbol which very often approach writing and he's included writing on some of his larger, more free standing works lately. And so on. Selwyn Muru does. Now, I have wondered if this isn't a way of describing the close relationship between the artefact, and language. It seems to be too persistent to be just accidental.

Well there is certainly, when you mention people like that, there is very little that they do that is accidental. I don't think there's anything accidental other than that creative accidentalism in there. You can see it in the way that Ralph repeats the word so it's no longer a word, but he's repeated a word so that it becomes a sentence, and it becomes a paragraph, and so it becomes a novel, so that it becomes a myth.

And so it becomes a pattern. But you see, I mean the pattern grew so that it could relate to the myth anyway. And then you see Selwyn at work, you see him working on the letters with the same technique and development as he's doing on the other parts of the work. So that he's turning the verbal statements into visual statements. I think all of them are saying that the material of life is what I need to use, and this piece of art work is a resolvement of the material of my living; and if words become important to the material of their living, then the bloody words are in there. That might be too simplistic a way to look at it, but it's a start. What else can I make art about, other than the material of my life? And there's Ralph, now, has made sure that Hone's [Tuwhare] got a koha from people that have bought his work, where Ralph has quoted his poems. And the thing is there,

that Ralph was so close because they used to live together, and have supported one another over the years, that Hone's work is the material of Ralph's life. For Para, the sayings of Te Kooti have been a part of the material of his life. So he uses these words.

Once you have turned that word into writing, you have turned it into a material statement. And that material statement can have all sorts of styles and manners of itself. For instance, we can use italics, and we can use all sorts of different scripts, lower case and upper case; and those little visual shifts alter the ideas and the meanings. And just in the same way if I use a line and I thicken it, and I curve it, and I thin it, and I straighten it — I'm affecting the way in which the idea that lies behind it is being read. And I think those are important, so important. You know I make all the fuss that women's work was straight-edged, whereas men's work tends to be curvilinear, and was left right out of the Te Maori exhibition. So that there is no way that you could call Te Maori a statement about Maori art. It was a statement of 50 per cent of Maori art only. That that important straight-edged thing and the sorts of messages that it promotes was missing from that whole exhibition, I thought not much less than horrific. I have done the same thing myself when I was talking before, I lumped verbal art and writing under the one heading.

The title of this exhibition is Now See Hear, the idea being that it should sound like a slogan, like a command, like an invitation. What you see and what you hear. You look at a word. In looking, you are also hearing. I mean we are now used to this interchange to such an extent that we should be able to do it the other way round as well. We should be able to see the heard sound.

Yes, sure.

Note.
Illustration used on pp.111, 114 and 117: Kaokao (armpit) pattern (detail). From a kete by Wairua Toka nee Kawharu, (Ngai Tai), Torere, 1900-1962. Kete, kiekie, black and white, 260 x 380 mm., c. 1930. Reme Mio Collection, Torere. Illustrated in Mick Pendergrast, Raranga Whakairo: Maori Plaiting Patterns. Coromandel Press, 1984. Courtesy Mick Prendergrast.

JOHN BEVAN FORD

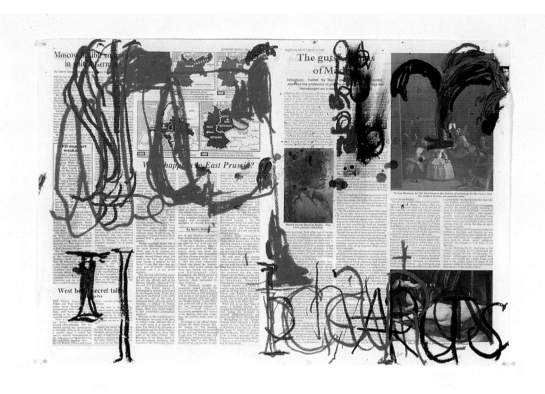

John Reynolds, *The Head of Apollo* 1990. Oil pastel and wax on
newsprint, 380 x 570 mm. Courtesy the artist.

Unlit Story

Nostalgia, Text and Picturing

Patrick Pound bɴυoꟼ ʞɔiɿɟɒꟼ

Nostalgia. Nostalgia for what? For an important text.
For painting in a garden.

Text. A garden. A garden of letters.

The sliver of writing the fragment of code.[1]

The letter. In many of Reynolds' works letters or letter parts are planted. It is as if those gestural marks which surround them were only fits and starts of language and here we find a truly recognisable shard. Part of the real thing. A fragment of code amidst the architect's doodles. The letter is separated by our recognition of it as a type. It is staged, and its worn-out functions outplayed like some levelled historiated initial, fissured, particled, decayed, dealt to.

The text is broken. The arms of a 'T', the flying buttress of an 'A', the wash of an 'I'. Language or the marks of language are reduced to decor.

These letters do not stand in for the hole in some violin. This garden of letters is siteless.

•

Anatomy of a letter/Tatlin's tower.

The letter is constructed around the bones of its conventional shape. Limbs may be added or subtracted. Filled in, crossed out. Moved. We may be left with only some tiny fragment, the severed foot of some letter. The old bones of a letter become the armature for the construction of a drawing. The letter is built into something else, Meccano fashion, something like a doodle, tracing Tatlin's tower.

•

The letter may be grafted.

To write means to graft. It's the same word.[2]

Everything other than meaning may be attached.

In those days I took the alphabet and signed it, confining myself to adding a title to it. This must be considered as collage.[3]

•

The inclusion of a fragmented text, a sprinkling of letters throughout Reynolds' pictures, can be seen as a nostalgic performance. The very ruins of narrative loiter like the broken columns littering the 'repoussoir' wedges of a good old picturesque landscape. The remains of a text, the letters left behind, form a sort of linguistic sublime. Here a text implied, only in part supplied, is erased or altered or damaged or disguised, leaving only the much quoted 'tissue of past citations', half the story which may have the look of being more important than the whole story.

•

Picturing.

Gesture should frequently inscribe itself (s'écrire) in the place of discourse.[4]

Reynolds' pictures are a construct of mark making. Their gesture salad has the look of 'pentimento' or a sort of drawing out loud. Those gestural marks are elegant deceits. They are images clearly out on good behaviour. Signs of self under surveillance.

Gesture. The unicorn in the museum. Towards the gesture being rendered matte.

One can't take up a past form as if nothing had happened in the meantime.[5]

It is of course hard to undo that which by its very use is significative.

The subject who says 'I' . . . is thus individualized on the level of utterance, but the discourse is nevertheless a composed, feigned, or if you prefer, 'a pieced together' discourse (the result of montage).[6]

•

Where does the writing begin. Where does the painting begin.[7]

In this 'situation of writing'[8] we can't see the crocodile tears of expressionism. Instead we find, amongst other things, a sort of 'language on stage'[9] made up of a jumble of its 'waste products',[10] fragmented, grafted, hinted at, rubbed out. The smudges of the text alone remain. What we see are the ruins of a text. The 'ribbon of language'[11] fraying in these feigned fragments.

A tissue of hieroglyphs[12]

•

the situation of writing[13]

When Reynolds' inclusion of letters is confined to smaller works it is as if these letters are a piece of handwriting rather than a large scale letter which would be more akin to the look of the commercial hoarding or the 'sign'.

•

There is nothing here below that lasts forever. The colosseums crumble, the 'terme' crumble, the worlds are dust, their pomps a nothing, and human pride a smoke, a worm . . . the cradle is for us the prologue to tragedy.[14]

A vanitas of language. A memento mori.

It is as if these letters replace the skeletons and skulls, the helmets, the crumpled books and the tattered papers, the dead pigs, eagles and hippos, the fish, the sea-shells, the owls in their broken trees, the cypresses and the broken stones which littered the vanitas/memento mori tradition. (See Salvator Rosa's *Democritus* etching for an example which contains all of the above and more.)

It is as if the letters left behind in Reynolds' pictures are a memento mori/vanitas not of the individual, not of us directly, but for the language which supposedly speaks us. Reynolds' letters seem not so much symbols of human actions — practical, theoretical and artistic — as they are the litter of the 'vicious infinity of language',[15] litter from 'a world that arrogantly opposes 'realities' to 'words' as if

language were only the 'futile decor of a man's more substantial interests.'[16]

Whereas in Rosa's *Democritus*, on a stone plaque next to the philosopher we see the Greek letter Omega, the last of the alphabet and a symbol of death, or the ten 'M's alluded to on the same plaque, the symbol of 'Finis' (the ten 'M's represented 10,000, the perfect finished number, the product of the multiplication of the dimensions of the pyramid of Egypt which Valeriano describes as 100 on each side. Ripa's *Iconologia* too, shows 'Fine' as a seated old man holding a pyramid with ten 'M's and a rectangle with an Omega in his left hand), in Reynolds' pictures the letters do not perform such literal and readable references. Reynolds' letters seem to be the ruins of a text. Each letter a block taken from language's handsome edifice.

•

I will not need words.

Traditionally the hierarchy of the genres of painting was determined by subject. History, religious and allegorical were tops, and at a lower level were the portrait and the landscape and so on down to the dishcloths of still life. As these top subjects' import began to nod off, a complex adjustment in the rationale of the pyramid of practices emerged. (Amusingly, the rise in the role of the artist as 'creative genius' can be loosely mapped in inverse proportion to the decay of the primacy of the important-text base of large scale serious high art).

An early 'shifting' can be seen with the Romantics' paintings of Baudelaire's 'modern life'.[17] With the advent, and hierarchical elevation, of modern subject painting we often see a sort of 'covering letter' of exotic remove. The subject while contemporary takes place in an exotic 'other' place as in Delacroix's *Scenes from the Massacre at Scios*. Courbet too kept modernity at one remove in the timeless countryside of his peasants.

With Manet, as the first painter to fully 'answer' Baudelaire's call and to recognise 'how great and poetic we are in our cravats and patent leather boots',[18] the 'trivial kitchenry of doing'[19] is 'finally' elevated to the place or positioning atop the pyramid of practices and, it is here we see perhaps, a sort of 'replacement' of the important subject, of the

important-text base, deemed necessary for the important artwork.

The important-text base has gone. (Although some oddly continue to attempt resuscitation or, as in Reynolds' case, elevation of a picture's 'importance' by allusion to the once essential important texts of religion and the classics.) The 'sense of importance' has however to be largely found elsewhere for large scale, serious and high art. How modern paintings are made to look important is, of course, another story.

•

Read the story with the painting in order to know if each thing is appropriate to the subject.[19]

What would we read now. Here there is no story left. No important text on which the picture is hinged in its pregnant moment. Only a sprinkling of letters remains, as if the ruins of a narrative. An *unlit story*. We are left without words, a 'delicious protection'.[20]

Notes

1 Roland Barthes, *Empire of Signs*, translated by Richard Howard. New York: HIll and Wang, 1982, p. 55.

2 Jacques Derrida, *Dissemination*, translated by Barbara Johnson. Chicago: University of Chicago Press, 1981, p. 355.
3 Louis Aragon, 'Collages dans le roman et dans le film', 1965. Quoted by Gaeton Picon, *Surrealism 1919-1939*, translated by James Emmons. London: Macmillan, 1977, p. 34.
4 Denis Diderot, quoted by Victor Burgin, *The End of Art Theory. Criticism and Post Modernity*. Atlantic Highlands, N.J.: Humanities Press International Inc., 1986, p. 115.
5 Roland Barthes, *The Grain of the Voice. Interviews 1962-1980*, translated by Linda Coverdale. London: Macmillan, 1985, p. 328.
6 Ibid., p. 285, re *A Lovers Discourse*.
7 *Empire of Signs*, op. cit., p. 21.
8 Ibid., p. 4.
9 Umberto Eco, *Travels in Hyper-Reality*, translated by William Weaver. London: Picador, 1987, p. 242.
10 Walter Benjamin, *Illuminations*. New York: Shocken, 1969, p. 34.
11 Roland Barthes, *The Pleasure of the Text*, translated by Richard Miller. New York: Farrar, Straus and Giroux, 1975, p. 7. Barthes actually speaks of a 'ribbon of meta-language'.
12 Denis Diderot, *Oeuvres Complètes*, 22 vols, J. Assèzat and M. Tourneaux (eds.). Vol. III, p. 190.
13 *Empire of Signs*, op. cit., p. 4.
14 Salvator Rosa, from his satire 'Tirreno', quoted in Wallace, *The etchings of Salvator Rosa*. Princeton, N.J.: Princeton University Press, 1979, p. 43.
15 *Empire of Signs*, op. cit., p. 175.
16 *The Grain of the Voice*, op. cit., p. 197.
17 Charles Baudelaire, *The Mirror of Art*. Salon Review, 1845.
18 Roland Barthes, quoted by Nochlin, *Realism: Style and Civilisation*. London: Penguin, 1971, p. 16.
19 Nicolas Poussin, in a letter to Chantelou, April 28, 1639.
20 *Empire of Signs*, op. cit., p. 9.

Restricted Vision

Images of Australia in New Zealand Television Commercials

Nick Perry

The playwright Oscar Wilde once suggested that the British and the Americans had everything in common except language. This was both a very aristocratic and a very British thing to say. It's the kind of sardonic remark one might expect when a threatened sensibility tries to combat — with words as weapons — the ever more manifest material superiority and technical virtuosity of another culture. Conversely there seems something characteristically American about the M.I.T. engineer who summarised the most famous dramatic work in the English language by suggesting that the trouble with Hamlet was that he had too much feedback on his circuits. Furthermore what was tragic about the play was that its hero operated at only 16.67% efficiency (ie. about that of an internal combustion engine) because he had one person to kill but actually got rid of six.[1]

It is the disparity between the linguistic conventions appropriate to the very different disciplines of literary criticism and engineering which makes this latter interpretation appear so exotic. The coexistence of a variety of different approaches *within* a single discipline is, of course, the chronic condition of sociology.[2] It is therefore one of the conditions for engaging in the sociological craft that its practitioners become worldly wise about the undermining effects of different modes of discourse. Their presence can be expected to lead to an undercutting of the presumptively unifying combination of an agreed agenda, a shared lexicon and a purportedly common subject matter.

The subject of this paper[3] is one such subversive device. I want to try and make more explicit that pattern of half-hidden assumptions, codes and conventions which govern the imagery and interpretations through which New Zealanders construct — or rather invent — Australia. My route into this territory is via three television advertisements. All of them were made by New Zealand agencies, and all of them have recently — and, of course, repeatedly —

been shown on prime time television throughout New Zealand. [This essay was first published in December 1987.] The emphasis is on trying to reconstruct the kind of cultural milieu in which such ads are not only possible, but also come to be regarded as exemplary, as managing both to summarise and to articulate the sentiments of the audience to which they appeal. The focus is thus not on the semiotic details of the texts, nor on the context of their production, but rather *between* text and context. More particularly, this methodology involves probing into those aspects of the ads which might account for their being not merely tolerated by viewers, but actually enjoyed, even cherished, by them.

Two of the ads make use of rural settings. It's important to note that the pervasiveness of rural imagery and themes is evident not only in adverts but in the locally made programmes which they punctuate, not only in television but in New Zealand films and literature. To cite just two cases from many possible examples; the country's favourite cartoon series (*Footrot Flats*) is set on a farmlet; and what was the country's favourite police programme (*Mortimer's Patch*) was set in a rural police station. And yet more than four out of every five New Zealanders live in towns or cities. That statistic makes New Zealand, along with Australia, one of the most urbanised countries in the world. It is an overwhelmingly urban society with a predominantly rural mythology. I propose to argue that what that mythology incidentally reveals are the tensions associated with managing the contradiction between the statistical dominance of the urban population and the (declining) structural power of the rural sector. The idea of Australia is not only a topic *sui generis* but a resource in this specifically local struggle.

The first rural ad was made for an I.C.I. subsidiary called Coopers to sell a sheep drench called Nilverm. The manifest target audience for this ad was, of course, New Zealand farmers. That an urban

"We may live without books

— what is knowledge but grieving?

We may live without hope — what is hope but deceiving?

We may live without

— what is passion but pining?

But where is the man that can live without dining?"

John Reynolds, *Unlit Story* 1989. Oil stick on panel and canvas
board, 280 x 560 mm. Courtesy Patrick Pound and Juliet Frizzell,
and the artist.

audience was exposed to it at all is because achieving an adequate coverage of rural areas necessarily involves transmitting to all the urban centres. Thus not only did farmers have no part in producing it but they were not the only people to have watched it. It was, in fact, voted one of the top three TV ads of 1985 by the overwhelmingly urban and middle class readership of Auckland's *Metro* magazine in 1986. It is this anomolous configuration which provides a point of entry for my reading.

The opening shot of a somewhat ramshackle farm is not only identified by subtitles as being Cullengoral, Australia, but is accompanied on the sound track by the raucous 'laughter' of kookaburras. Nonetheless the opening visuals, with their echoes of a Russell Drysdale painting, and the authentic sound of Australian wildlife, might just admit of a lyrical or affirmative reading, a down-under version of a chocolate box aesthetic. The sound of distant conversation prefigures the cut to the farm verandah: a newly arrived visitor is introduced by the farmer to the local vet (and one other man) as 'My brother-in-law, over from Kiwiland'. The locals are bedecked in the uniform of Ockerdom, grimy shorts, singlets and working shirts, whereas the new arrival is clothed in sober shirt and tie and is carrying an equally sober suit jacket.

These visual signals of authority are reinforced when the conversation is turned to veterinary matters, and the group moves round to the back of the farmhouse. The visitor alternately interrogates and instructs. The instruction depends upon an invidious contrast (for Australians) between Australian and New Zealand performance both with respect to sheep production and in the realm of sporting achievement. These two arenas are linked through the colour of the sheep drench. 'Gold?' says the farmer. 'Same colour as those medals we won in L.A.', responds the visitor, 'but then you wouldn't have seen too many of that colour, would you?'

The pack shot is followed by a brief coda. Like the ad's opening sequence it might just be read as picturesque. In the background is an ancient, rusting and immobile farm truck; in the foreground two young boys are playing cricket. The bowler, clad in Australia's national colours (and gumboots) sends down an underarm delivery. 'Oh, Trevor', shouts the other boy in exasperation. Cut to a shot of the New Zealander together with one of the women at the farm

(and who might just be intended to be his sister). He laconically observes, 'He could play for Aussie one day, that little fella.' The woman half smiles, and then glances at the visitor. She, unlike the viewer, cannot see the self-satisfied look on his face. The mocking sound of kookaburras is heard once more. Fade out.

All such ads presuppose visual literacy. Perhaps one reason why small children lock into them is that they are particularly instructive in this respect. A crucial point about the Nilverm ad, however, is that it is not only and not simply premised upon a knowing audience. It also flatters them, grants them recognition for being insiders. It presumes that they are: familiar with, and care about, sport as an expression of national identity; cosmopolitan enough to know what L.A. means; aware of the relative gold medal tallies of Australia and New Zealand at the 1984 Olympics; acquainted with, and were exasperated by, Trevor Chappell's underarm ball at the end of a tightly contested cricket match between the two countries.

The audience is presumed to be knowing in a more general sense. They are expected to be aware of the disparity between frontal facade and operational practice, and to relish the unmasking of the former. Thus the call of the kookaburra gives way to the sound of flies, and the possibly picturesque — or at least 'authentic' — gives way to the manifestly shoddy. This is not only clearly signalled verbally ('Keeps it hidden, does he?') but also visually in the movement from the front of the farmhouse to the back. It's an exposure that is almost indecent. Indeed the ad was the subject of formal complaints to the Race Relations Conciliator, on the grounds that it discriminated against Australians. The judgement of the Conciliator's Office was a publicist's delight. Their conclusion was that there was no case to answer. After all, the ad *was* filmed at Cullengoral, there *are* farms like the one depicted, and they *do* get three sheep to the acre. Furthermore all of the actors involved, including the visitor, were Australians.

This is a judgement which attends only to what might be called the surface of the ad as a text; it is both too literal and too literary an interpretation for our purposes. I have already pointed out the way in which the content of this ad moves and works in the contrast between front and back, between facade and substance. These distinctions also apply to its *form*.

NICK PERRY

Its effects are achieved through the interaction of spoken word and visual image, of what is said, the way it's said, and how it's shown. This is most explicit in the coda, in which only the camera is privy to both the visitor's look of self satisfaction and to the woman's querulous half smile. It is this combination, together with the local cultural knowledge which the viewer must bring to bear, which gives the spoken words their meaning, and allows for the encoded message to be understood. Throughout the ad the viewer is drawn into such conspiracies, thus the visitor's laconic one-liners are always for the camera rather than for his hosts. It's therefore in an aesthetic, rather than a judicial sense, that the charge of indecent exposure might be made to stick. This is an ad which publically plays with itself; it's not surprising that the farm wife didn't know whether to laugh or not.

The Office of the Race Relations Conciliator was also silent about the ad's ideology, the way in which it strives to embody a more general cultural statement about Australia and Australians in and through its specificities. A central theme of the ad is trans-Tasman competition; the terrain on which it is purportedly played out is sport and farming, locations in which New Zealand is indeed competitive. But in this microcosm it is conversation itself which is the locus of competition, and in this contest the visitor enjoys not just a sporting chance but a monopoly of winning lines. From the beginning both green and gold are set to come under the control of the New Zealander, as in the lush green pasture that is evident from the photograph of New Zealand sheep which he shows to his hosts. It's left to the Australian farmer to verbalise what is visually apparent, i.e. New Zealand superiority ('Now that's what I call a sheep') and then to be mocked for saying so ('You don't miss much do you'). The correlate of monopoly is, of course, appropriation — no wonder that in thirty seconds the visitor partakes of a beer, a sausage, and a sandwich — all without a word of thanks. In the popular culture of New Zealand males such boorishness is half-admired, both as an expression of that famous Aussie maxim 'No bullshit' and as a sign of strength. It's seen as characteristic of home grown property millionaires and — as a recent McNair survey (1986) indicates — of Australian visitors. The ad therefore deliberately inverts what is perceived to be the conventional pattern of hospitality.

In this ad the women are also 'round the back'. They have little presence and no voice; we glimpse the performance of domestic tasks — the rest is silence. But one of those women is the visitor's sister, and it is this status which can be made to speak. For it is what makes the provision of hospitality an obligation and all that verbal competition a possibility. The women have the obligations and the men have the possibilities.

I've argued that this ad articulates the typical concerns and sense of resentment felt by the inhabitants of a small country about their relations with a much larger and more powerful neighbour. What is also typical is that the attendant nationalist sentiment is orchestrated for the commercial benefit of a transnational corporation. But this seems to me insufficient to account for its appeal to an urban audience. My suggestion is that what the Australian location both sanctions and conceals is the antipathy of city dwellers for the farm sector. This is an implicit meaning rather than a manifest intention. For what the idea of 'Australia' is most likely to invoke for most New Zealanders is not the outback or the sheep station but the city.

As a necessary preamble to that claim I want to talk about another popular New Zealand ad which has a rural setting, this time a wholly indigenous one. This provides an opportunity to examine the cultural effects which flow from the city/country distinction when they are unmediated by the kind of nationalist feelings to which the Nilverm ad appeals. This second ad was made by Colenso for Apple Computers, and the analysis which follows extends and amends an earlier one by Ian Carter and myself.

The opening shots are of the bar of a country hotel. Apart from a barmaid and one table of women sitting together, the clientele is exclusively male. The men are wearing working clothes. The encoded mood is of weariness, of lives used up. Apart from the sound of a racetrack commentary in the background, the only animation comes from a Tom Selleck lookalike; an All Black lock in his gardening gear. He tries to start a conversation with a fellow drinker, throwing out laconic one liners while munching fistfuls of peanuts. 'Had to put the dog down.' No response. 'The missus shot through with the bloke down the road.' Still no response. In keeping with the conventions of Kiwi masculinity, he keeps his motives out of his speech. For the camera's benefit,

however, they are conspicuously displayed on his face. More intense facial anticipation. 'Bought a computer.' Pandemonium in the pub. Cut to the pub car park, where his mate disparages the farmer's purchase with a single word 'Computer!' Cut to a long focus, head on shot, as the entire male clientele rides assorted machinery in an anarchic charge to the farm to view this new marvel. It looks like a chase scene from the Keystone Kops or Bonnie and Clyde or, to bring it closer to home, *Goodbye Pork Pie*. Cut to the poorly-lit farm barn, where (incongruously) the Apple PC is kept. The men edge towards the machine. 'It looks harmless enough,' says an un-identified voice. 'Have you got *Deep Throat*?', asks another, clearly identified as the farmer's best mate. Appreciative male guffaws. Initial fear is dissipated as the proud owner shows the computer's marvel-lous abilities. Quick cuts between shots of the VDU screen and admiring faces lead to the scene's climax. The best mate leans forward and stares intently at the screen display. 'Great subsidy!' he breathes. The farmer looks pleased then claps his hands over his mate's mouth: 'Oh, you're not supposed to see (say?) that.' Cut to a coda as the inspecting party breaks up. 'Hydatids, was it?' asks the mate. 'Tractor,' comes the farmer's reply. We have returned to the opening sequence both in content (how the dog died) and in style (laconic understatement). The prevailing rules of conduct, briefly disturbed by the men's unwontedly animated admiration for the new purchase, have been re-established.

When this ad was first shown in the second half of 1984, it shared advertising time with another one, made for the same company by the same agency, but having an office setting and an urban location. This suggests that it may have been intended, either in whole or in part, to be a 'farming-as-a-business' ad. But whereas it endured well into the second half of 1985, its urban counterpart was taken off New Zea-land TV screens much earlier. Yet if the prime target audience was indeed farmers, then from the outset they were unlikely to see that climactic crack about subsidies as either endearing or funny. And by the time the ad dropped from sight it had become bitterly ironic as New Zealand farmers, like their Australian counterparts, began to take to the streets in order to advertise their problems in a very different way.

Whatever the intention, what the ad shows is that it was produced by urbanites and appeals to city-based audiences. It also appeals to men. The ad talks to business owners and executives threatened by competition, by doubts about their competence in the face of new technology, by novel challenges to patriarchal attitudes. They are reassured on all three counts. For if the hero's combination of terse speech and a boyish animated expression signals a good Kiwi joker, it also suggests that he may not be *quite* as bright as the potential purchaser of an Apple PC. But if *he* can hack it . . . And although there may be women in the public bar, there are none in the barn. The penetration of some traditional male enclaves is balanced by the creation of new bastions of male power where boys can do anything, including show pornographic videos. The traditional hardware of patriarchy is seen in the race to the farm, and once there its new software is revealed. Perhaps the reason why the computer is kept in the barn is so that the house can remain the locale for women's work. No wonder the missus shot through.

The way in which this is accomplished is very subtle. Partly it has to do with lighting, which bounces off European painterly canons. Everything is muted with brown the dominant tone. The pub scene is chiaroscuro, Rembrandt with gumboots, backlit by the late afternoon sun. The light is fading as the men race to the farm. Once there, light is needed in the barn. The new machine is illuminated by a single light bulb (McLuhan's pure information); the screen's etherial green glow lights up the admiring faces in an update of conventional representations of the Nativ-ity in which technological shepherds watch their flicks by night — the adoration of the cagey.

The coda takes place late in the evening. It points up a motif as central to this ad as the front/back distinction was to the Nilverm ad. Here the contrast is between the onset of darkness and the possibility of light; between defeat and exhaustion in which death (of a dog) and dissolution (of a marriage) are routine, and a technological promise of enlighten-ment. But that enlightenment is user-friendly: it reinforces existing social relations.

The Apple ad offers a conventional rural setting but not a conventional rural iconography. There is no celebration of free landscape, no pastoral lyricism, not even much in the way of daylight. Instead what we are shown are dimly lit interiors, a vehicular free-for-all, and the night. It is by way of this rather distinctive ambience that the ad gives expression to

NICK PERRY

a form of dark comedy for which there are precedents not only in New Zealand literature, but more recently in New Zealand films.

I suggested earlier that the race to the barn echoed scenes in a locally made film called *Goodbye Pork Pie*. In referring to it as 'road movie with menaces' what I sought to convey is the way in which what begins as the film's near slapstick style is progressively undercut by a growing feeling of desperation and a heightened sense of threat. Although this conception of the comic was not based on a pre-existing story, it is represented in New Zealand literature, particularly in the work of Ronald Hugh Morrieson, and is routinely referred to as 'Taranaki gothic'. New Zealand film makers — and audiences — seem particularly drawn to his work; three of his four books have been made into full length features. As critics have noted, Morrieson uses both the western (*Came a Hot Friday*) and the thriller (*The Scarecrow*) as models for his fiction. The film version of *The Scarecrow* came out before the Apple ad and may well have influenced it. In cinematic terms, the thriller is the city's genre. *The Scarecrow*, however is actually set in a small New Zealand town in the 1950s. Thus the film was not a genre movie in the sense of being responsive to the disciplines associated with that term. Nonetheless it depended, like the Apple ad, on the selective appropriation of some of the conventions of genre. That film and ad share the same look is because each edges towards an urban iconography in a rural setting.

The final ad that I'm going to discuss is again about Australia. It was made for Air New Zealand by Dobbs-Wiggins-McCann-Erikson.

In this ad a veritable smorgasbord of images is presented in rapid succession; in its thirty seconds of running time there are more than forty cuts. The ad begins with images of water sports and beach life, cutting quickly between shots of men and women, adults and children, individuals and groups. These give way to city scapes and urban night life, which in turn are punctuated by somewhat different beach shots, a couple of outback and rural images and a view of an Air New Zealand 747 in flight. The ad concludes with a lingering shot of an aircraft's cabin complete with smiling air hostess.

The accompanying sound track is a jingle whose opening lines are 'Australia's gotta lotta go, whatta lotta go it's got' and which closes with the suggestion that 'Australia's got the lot.' It is this jingle which integrates the ad and provides its narrative line. The cutting is so fast that, without cues from the sound track, a linear reading of the visual imagery would require several viewings. As it is the most easily recalled scenes are those which contain little internal movement such as a view of Sydney's skyline, a bikini clad torso and a glimpse of a drag show. A hint of prurience combines with that process of commodification which is a defining characteristic of ads. And like all ads this one both orchestrates desire and points to how it can be be met. The ad targets a general sense of incompleteness, that chronic psychological condition which a market society strives to induce. It is premised upon an absence and it offers consumerism's utopian promise. But because it constructs Australia as a country of the New Zealand mind, it also speaks to the specificities of New Zealand as a post-colonial society. Thus the general psychological concerns which a market society promotes are fused with specifically local anxieties deriving from semi-peripheral status. The ad not only posits the universal experience of relative deprivation — the sense that some*one* else is better off — but also implies marginality — that the centre is some*where* else. It's not simply that Australia's 'gotta lotta go'. In the course of the ad it becomes the definite article — It's 'got the lot'.

Just as the sheer number of images signals choice, diversity and opportunity, so too do the pace and rhythm of the ad carry a message of their own. They serve as a formal analogy for the tempo of modernity and city life. This interacts with the diverse content so as to collapse locations dispersed in space into the allocation of time. Thus as a definition of Australia, the very form of the ad signals not the distances and the emptiness of the interior but the density of the cities.

The social range of this ad's opening shots reveals that women are part of the target audience. But with the transition from the diversity of the potential clientele to the diversity of Australia the commodification becomes more manifest, and the 'strine' begins to show. Consider, for example, that image of a bikini clad young woman lying on an air-bed. It's a pin-up style shot of a peculiarly modern type which a blanket criticism of all such images cannot isolate. The blanket objection to pin-ups is that they construe women as sex objects; considered semiotically the

point is that their meaning is not just denotative but connotative. As such, they stand in for, but have a determinate connection with, the pleasure that men everywhere take in looking at women's bodies. The problem is not the pleasure but its relation to consent and its mediation under modern conditions. The traditional pin-up is at one remove from the complexities — and the chance of shared pleasure — associated with the actual relationships between men and women. But what the traditional pin-up does leave open is the possibility of movement from a subject/object to a subject/subject relation. What distinguishes the body shot under discussion is that it goes much further in attenuating the relation between male desire and the mutuality of pleasure. First of all, we see the woman as if she does not see us; erotic appeal is conceptually divorced from consent *within* the image itself. Second, when first we see her, she is faceless by design; the shot cuts the woman up, objectifying desire in terms of the parts of her body. By the standards of some magazine ads it is of course, a modest, even a conservative image.[4] Nonetheless we can say that in the selling of Australia, fetishism becomes a commodity. In such a context the lingering image of a smiling air hostess seems to belong to another, earlier time and place — namely, New Zealand. It might even be read as a working woman making the best of a bad job — domestic service in a changed context. It seems churlish to see it as a metaphor for inauthenticity, when the deceit lies in the imputation of glamour.

In focusing on the details of each ad, my concern has been to establish what each can be made to reveal. I want to conclude by commenting briefly on the uniformities of gender, class and nation which underpin and condition the differences between them. The images of women as models of domestic virtue, as threats to mateship, and as toys for the boys, represent different points along the axis of patriarchy in a market society, whereas the celebration of the urban and the critique of the rural moves at the intersection of class and nation. The social grouping which this combination of ads is produced by, and selects for, consists of *compradors*;[5] male, urban, middle class New Zealanders oriented towards overseas metropolitan centres and antipathetic to agrarian petty commodity producers. The more of those social categories one occupies, and the more of those attitudes one shares, the greater the appeal of these ads. The ads themselves are a kind of peripheral vision, refracted images of New Zealand's changing web of dependencies. The view from the centre looks rather different of course, as in the American tendency to filter their perception of Australia through the metaphor and mythology of the frontier. Or at least, that's how how they interpret Australian movies. For New Zealanders by contrast, Australia is only 'way out West' geographically. Structurally and culturally it is as much 'back East' as the United States itself.

My suggestion, then, is that these ads are both inadvertent signals of the economic and social location of *comprador* strategies and necessary measures of the ideology which justifies them. This ideology works to restrict the imagery through which both Australia and New Zealand are invented. It is with some style and imagination that both countries are sold to us — but both are necessarily sold short.

Notes

1 Cited in Morison (1962, 17).
2 Here too, national differences play an important role, in ways that Galtung (1977, passim) has sought to map and which international conferences sometimes serve to demonstrate. A characteristic illustration of their effects was given at the Heidelberg conference on the centenary of Max Weber's birth as, for example, in the exchange between Aron (1971) and Deutsche (1971).
3 First presented as a presidential address to the annual conference of the Sociological Association of Australia and New Zealand, University of New England, Armidale, N.S.W., Australia, July 9-12, 1986, under the title 'Inadvertent Signals or Necessary Measures?'
4 Since this was written this strategy has been deployed in other locally made television commercials.
5 *Comprador* is a term widely employed in development studies to refer to that indigenous section of the middle class in an economically dependent country whose activities serve to consolidate the interest of overseas metropolitan centres.

References

R. Aron, 'Discussion on Max Weber and Power Politics' in O. Stammer (ed.), *Max Weber and Sociology Today*. Oxford: Basil Blackwell, 1971, pp. 131-2.
I. Carter and N. Perry, 'Rembrandt with Gumboots' in J. Phillips (ed.), *Te Whenua, Te Iwi; The Land and the People*. Wellington: Allen and Unwin/Port Nicholson Press, 1987.
K.W. Deutsche, 'Discussion on Max Weber and Power Politics' in Stammer, op. cit.,.pp. 116-22.
J. Galtung, *Methodology and Ideology: Essays in Methodology*, Vol. I. Copenhagen: Christian Ejlers, 1977.
McNair Surveys Ltd, *Trans Tasman Attitudes Survey*, prepared for Australia and New Zealand Foundation, 1986.
Metro (Jan. 1986), pp. 77-88.
E.E. Morison, 'Scientists in Decision Making' in M. Greenberger (ed.), *Computers and the World of the Future*. Cambridge: M.I.T. Press, 1962.

This essay was first published in *Landfall*, December 1987.

121 Feb '78
Dunedin

Dear Colin, This is a rather beautiful
song which my father* gave me last
year and which came to mind when
I helped Rodney hang your latest Muriwai
paintings. It's called the Song of the Shining Cuckoo
and refers to the spirits en-route to
Te Reinga & resting for a bit on a
sand bank in the Hokianga harbour.

Te Tangi o Te PIPIWHARARUA
TUIA TUI
TAHIA TAHIA.
KOTAHI TE MANU I TAU KI TE TAHUNA.
TAU MAI
TAU MAI
TAU MAI.

A rather inadequate translation goes thus.

The song of the Shining Cuckoo
TUIA TUI
TAHIA TAHIA
One bird has landed on the sandbank.
It has landed
It has landed
It has landed -
I hope you can use it somewhere
Greetings
Ralph

TE TANGI O TE PIPI—
WHARARUA

TUIA TUI
TAHIA TAHIA.

KOTAHI TE MANU T
TAU KI TE TAHUNA

TAU MAI
TAU MAI
TAU MAI

The Song of the shining cuckoo.
Glance and tell us, Glance
, his voice and penis
eggs ...

Bird, alight on the beach
alighting, alight,
alighting, alight,

The song of the shining cuckoo.
The Song of the
shining cuckoo ...
Glance Glance & tell us

Te Tui: hiare mai and
join us together,
Bird: alight on the beach
alighting, joint
alight, my voice
alight, and...

hettie

You read handbills, catalogues, posters that shout
out loud:
Here's this mornings poetry, and for prose you've
got the newspapers,
Sixpenny detective novels full of cop stories,
Biographies of big shots, a thousand different
titles,
Lettering on billboards and walls,
Doorplates and posters squawk like parrots.

1. Guillaume Apollinaire, extract from *Zone* (1909)

Listing a few of his favourite things, such as 'handbills, catalogues, posters . . . Lettering on billboards and walls, Doorplates and posters', Apollinaire's poem *Zone* (1909) erupts with the quintessentially Modernist jubilation: 'I love the gracefulness of this factory street'. Visual Poetry and the 'visual' literary sensibility derive at least in part from this sense of delight before the monumental geometrical typography and the dynamic 'grace' of the industrial city. Writing in his essay 'The New Spirits and the Poets' (1918), Apollinaire prophetically called upon the poetic imagination 'to mechanize poetry as the world has been mechanized'.

Visual Poesis at Twenty Paces

Nicholas Zurbrugg

2. Pierre Albert-Birot, *Paradis* (1922)

Discussing his picture-poems — or *calligrammes* in a letter of 1918, Apollinaire describes them as 'an idealized form of free verse poetry and a typographic precision made in a period when typography is winding up its career brilliantly, at the dawn of the new means of representation, cinema and the phonograph'. Apollinaire's friend and publisher, Pierre Albert-Birot, the editor of *SIC*, synthesizes this 'typographic precision' in humourous *poèmes pancartes* — or poster poems — such as his road sign *Paradise This Way* (1922). As Albert-Birot suggests, such texts offer an immediate verbal-visual message to be 'read with one's eyes', like a picture.

fmsbwtözäu
pggiv-..?mü

The Berlin Dadaist Raoul Hausmann's poster-poem *f m s b w t* (1918) explores more abstract verbal relations. Firstly, it functions as a graphic and typographic visual poem; secondly, it is a score for 'phonetic' performance. At the same time, Hausmann's other collages evoked more topical issues within mixtures of abstract typography and referential photo-collage. In this respect, Hausmann's experiments typify the ways in which visual poetry and its sonic and photographic adjuncts variously refine and combine language's abstract and denotative energies, both as familiar signs and sounds, and in conjunction with what Apollinaire terms 'the new means of representation'.

3. Raoul Hausmann, *fmsbw* (1918)

4. Isidore Isou, extract from *Les Journeau des Dieux* (1950)

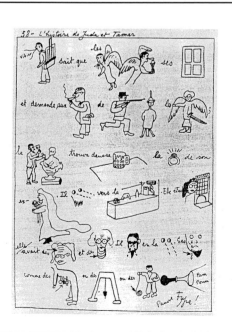

Founded in Paris in 1945 by the Roumanian poet Isidore Isou, Lettrism is one of the first substantial avant-garde movements to follow the second world war. As this extract from Isou's 'hyper-graphic' novel, *The Gods' Diaries* (1950) indicates, Lettrist research fuses graphic and typographic materials in what Jean-Paul Curtay calls 'a merry jungle of signs'. The rather naive, hand-written quality of Isou's work typifies the expressionist impulse in visual poetry, and can be traced through Situationist and Fluxus graphics to the more recent graffiti-art of New Yorkers like Keith Haring. Concrete poetry, by contrast, employs far more austere, impersonal typography.

NICHOLAS ZURBRUGG

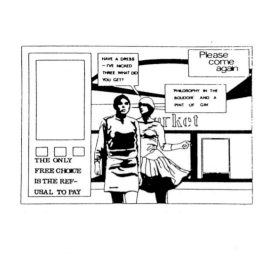

5. Anon, extract from Situationist comic strip

Launched by Guy Debord in 1957, as a splinter-group from Isou's Lettrist Movement, the Situationist International redeployed Lettrist graphic techniques to satirise 'the society of the spectacle'. Prosaic rather than poetic, Situationist graphics tend to deconstruct the clichés of advertising and pulp fiction, juxtaposing aphoristic slogans ('The only free choice is the refusal to pay') against subversive speech bubbles ('Have a dress — I've nicked three'). Situationist fusions of ideology and fiction anticipate the still more prosaic writings of post-Structuralist gurus like Baudrillard, and the condensed public signboards of artists like Jenny Holzer.

6. Ben Vautier, *l'absence d'Art* (1963)

Je soussigné Ben Vautier, déclare authentique œuvre d'art

l'absence d'art

le 1/10/63

Ever since the early sixties, the French artist Ben Vautier has written, painted and signed assorted paradoxes, such as his declaration that 'the absence of art' is 'an authentic work of art' (1963). Looking like overgrown market-stall price-tags, Ben's works function both as textual jokes and performance scores, acting out conceptual rituals like Ben's 'authentication' of non-art, and inviting the reader to perform such instructions as 'Think of something else'. Like the Situationists' political slogans, Ben's witty inscriptions anticipate later language-art maxims, such as Jenny Holzer's imperative: 'Laugh hard at the absurdly evil' (1983).

Hassan i Sabbah: "Last round over — Remember i was the ship gives no flesh identity — Lips fading — Silence to say good-bye —

7. Brion Gysin, *Silence to say good-bye* (1962)

First introduced in his 'Statement on the Cut-Up Method and Permutated Poems' (1958), the calligraphic poem-drawings of the Paris-based American artist Brion Gysin attempted to 'liberate the words' by employing random methods 'as simple and immediate as collage or montage'. As his drawing for the final page of William Burrough's novel *The Ticket That Exploded* (1962) indicates, Gysin's permutated words and images stand mid-way between the graphics of the Lettrists and Ben Vautier, and the more formal and impersonal typographic compositions of the concrete poets. Like Hausmann's poem-posters, they are also scores for sound-poetry performance.

8. Eugen Gomringer, *ping pong* (1952)

ping pong
 ping pong ping
 pong ping pong
 ping pong

While Brion Gysin's permutation poems interwove semantic and sonic values according to random structures, the Swiss concrete poet Eugen Gomringer attempted to compose more orderly 'play areas' of 'fixed dimensions'. First outlined in his manifesto 'From Line to Constellation' (1954) as 'a reality in itself', rather than 'a poem about something or other', Gomringer's concept of the concrete poem offered a direct literary equivalent to the Swiss 'concrete artist' Max Bill's equally geometric analyses of the 'fundamental elements of painting'. Gomringer's poem, *ping pong* (1952) characteristically encourages exploration of the semiotic, sonic and semantic facets of two 'elementary' words.

NICHOLAS ZURBRUGG

9. Décio Pignatari, *beba babe coca cola* (1962)

As Gomringer remarks in 'The Poem as Functional Object' (1960), concrete poetry's 'reduced language' aspires to 'greater flexibility and freedom of communication'. Accordingly, 'poems should be . . . as easily understood as . . . traffic signs'. The Brazilian 'Noigrandes' poets similarly argued that concrete poetry should attain a 'Dynamic structure' communicating a 'multiplicity of concomitant movements'. While their 'Pilot Plan for Concrete Poetry' (1958) also initially rejected the 'poetry of expression', their subsequent work often expresses considerable satirical irony. Haraldo de Campos associates this with such 'anti-advertisements' as Décio Pignatari's poem *drink/dribble coca cola* (1962).

10. Ian Hamilton Finlay, *Le Circus* (1964)

Whereas Pignatari's *coca-cola* poem typifies the subversive impulse in early concrete poetry, the Scottish concrete poet Ian Hamilton Finlay tried to refine concrete poetry's capacity to create utopian rather than dystopian variants of advertising. Like the amusing road-sign poems by Albert-Birot, Finlay's *Le Circus* (1964) is primarily reconstructive rather than deconstructive. Adopting the circus poster format, and evoking a series of metaphors, such as his suggestion that fishing boats sailing through reflected rainbows resemble circus ponies jumping through hoops, Finlay's poem-poster offers what one might think of as *poeticised* publicity, as opposed to *politicised* anti-advertising.

11. Ian Hamilton Finlay, *Pebble Rocks Pond* (1969)

Throughout the 60s and 70s, concrete poets frequently collaborated with artists and with typographers in order to extend typewritten texts into other media. Ian Hamilton Finlay's portfolio *Headlines — Pondlines* (1969), combining Finlay's 'headline' poems with drawings by John Furnival and artwork by Frankie Partridge, typifies this process. At the same time, Finlay's pseudo-journalistic poems such as 'Pebble Rocks Pond' indicate the close proximity between much early concrete poetry and the compressed, contemplative register of the haiku — a genre to which Finlay fondly alludes in a reference to the 'largely uncorrupted' tradition of 'describing ponds'.

12. Ian Hamilton Finlay, from *The Metamorphoses of 'Fishing News'(2)* (1970)

FROM 'THE METAMORPHOSES OF <u>FISHING NEWS</u>' (2)

'FISHERMEN TURN
TO MACKEREL'

Finlay's 'headline' poems subsequently extended into collections like '*Fishing News* News' (1970); a series of found poems taken from the weekly newspaper *Fishing News*. These are not so much visual or concrete poems, as conjunctions of elaborate titles and minimal texts. The pseudo-classical seven-word title 'From "The Metamorphoses of *Fishing News*" (2)', leads, for example, to the four-word statement: 'Fishermen Turn to Mackerel'. In a sense, this text performs a double metamorphosis, as the seemingly factual content and the seemingly prosaic register of *Fishing News* gradually reveal unexpected poetic connotations.

NICHOLAS ZURBRUGG

13. Sarenco, *La religione e l'oppio dei popoli* (1972)

Writing to the French poet Pierre Garnier, on September 17th 1963, Finlay defended concrete poetry as 'a model of order, even if set in a space which is full of doubt'. Unlike Finlay, the Italian poet Sarenco and the Belgian poet Paul de Vree — co-editors of the review *Lotta Poetica* — insisted that visual poetry should re-emphasise questions of existential 'doubt'. Condemning the pioneer concrete poets for neglecting social and political unrest, Sarenco's works of the seventies revived Situationist tactics in order to denigrate aesthetic and metaphysical ideals, annotating reproductions of religious paintings with slogans condemning 'the opium of the people'.

14. Ian Hamilton Finlay, *After Giovanni Francesco Guercino's 'Et in Arcadia Ego'* (1977)

Inv. Ian Hamilton Finlay *Del.* Gary Hincks

Like Sarenco, Finlay turned from purely verbal poetry to annotated images of classical art. But whereas Sarenco's annotations deride the values evoked by the works upon which he comments, Finlay's annotations and adaptions attempt to translate past values into more accessible twentieth-century terms. Elaborating variations upon Giovanni Francesco Guercino's theme of *Death in Arcady* — in which two shepherds muse upon a Death's Head placed upon mouldering masonry — Finlay presents two Arcadian shepherds contemplating more modern intimations of terror and mortality, as they consider an abandoned tank bearing the Death's Head insignia of the German SS-Panzer division.

EQUALITY DOES NOT CONSIST
IN EVERYONE BEING ARROGANT
BUT IN EVERYONE BEING MODEST

LOUIS-ANTOINE SAINT-JUST 1767-1794

DEATH TO STRATHCLYDE REGION

While Finlay's variations upon Guercino's iconography offer pictorial homage to Arcadian values, his gardens at his home — 'Little Sparta' — typify his attempt to evoke an environmental dialectic between past and present ethics and aesthetics. Whereas the Strathclyde Regional Council classify 'Little Sparta' as an art gallery, liable to commercial rates, Finlay argues that it should be a tax-exempt 'garden temple'. Distracting Finlay from his usual pastoral themes, subsequent disputes precipitated a series of distinctly polemical posters condemning contemporary secular logic, and reaffirming the maxims of another ethical role-model: the French revolutionary, Saint-Just.

15. Ian Hamilton Finlay, *Equality does not consist...* (1982)

16. Ian Hamilton Finlay, *Bicentenary Tricolour* (1989)

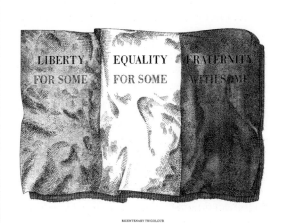

LIBERTY FOR SOME EQUALITY FOR SOME FRATERNITY WITH SOME

BICENTENARY TRICOLOUR

Finlay's imaginative garden proposals have included a commission to design a monumental garden at Versailles as part of the 1789 Bicentennial celebrations. This project was cancelled when a section of the French press crudely denounced Finlay's earlier metaphorical use of the SS emblem as evidence of Nazi sympathies. Finlay's subsequent *Bicentenary Tricolour* (1989) evokes precisely the kind of social and ethical 'doubt' that his idealistic early work had hoped to transcend. Speaking from painful personal experience in a work that is both public and private, and both contemporary and historical, Finlay suggests that revolutions seldom offer more than 'Liberty . . . for some'.

NICHOLAS ZURBRUGG

17. Jenny Holzer, extract from *Truisms* (1977-79)

While Finlay's texts and images beg prolonged contemplation, and seem very much the consequence of his private poetics, the more public language art of the American artist Jenny Holzer seems substantially dependent upon the advertising dictum that 'you only have one or two seconds to catch someone'. Holzer's early *Truisms* (1977-79) displayed columns of alphabetically ordered one-liners such as the prophetic: 'A little wisdom can go a long way'. As Holzer admits, there is a 'real danger' that such snappy content may become 'inane'; a hazard which she attempts to sidestep by placing simplistic individual statements within the quantitatively complex context of elaborate lists.

18. Jenny Holzer, *Expiring for love is beautiful but stupid* (1982)

Jenny Holzer's subsequent electronic signs, such as her Times Square piece: 'Expiring for love is beautiful but stupid' (1982) impressively assume — and compete with — the vast scale of commercial advertising. Holzer interestingly notes that these works are usually deliberately prosaic and pragmatic responses to the 'emergency' of New York life. Accordingly, she is drawn more to '"real world" concerns', rather than to 'mysticism or poetics'. Despite their frequently monodimensional content, Holzer's variously static and variously dynamic electronic texts — and her rather more subtle multi-media installations — magnificently realise Apollinaire's dream of mechanising language, 'as the world has been mechanized'.

19. Nicholas Zurbrugg, *Intuition...* (1989)

If I immodestly reproduce my computer-generated piece *Intuition . . .* (1989) — a collaborative work made with the artist Adam Wolter — then this is primarily to illustrate and record first-hand enthusiasm for the astonishing virtuosity of computer technology. Whereas visual poets of the sixties worked independently or collaboratively with hand-drawn lettering, typography, typewriter, letraset, silkscreen and duplicator, language artists of the eighties are more likely to work independently or collaboratively with the computer's unprecedentedly immediate array of colour, scale, typeface and affiliated modes of mechanical reproduction, be these computer print-out, xerox copy, laser copy, slide, photograph or cibachrome enlargement.

20. Adam Wolter, *Work Place 2* (1989)

Computerised language-art permits poets, artists and polemicists to orchestrate and re-orchestrate their materials with maximum rapidity and precision. The work of the Brisbane computer artist Adam Wolter epitomises the cutting edge of this new creativity. As Wolter remarks, 'The use of text in a computer is as near as damn it to unavoidable', so that 'a reluctance to employ visual text in visual art would seem to derive motivation from a fear of fact'. Wolter's composition *Work Place 2* (1989) typifies the computer's capacity to recycle language and image into rich, Rothko-like textures, glowing with a luminosity and an aura all of their own.

NICHOLAS ZURBRUGG

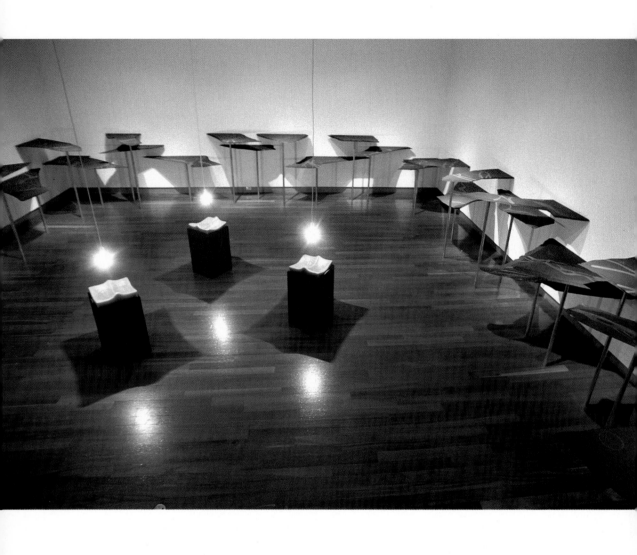

Andrew Drummond, *Repository for Dreams and Journeys* 1989.
Slate, beeswax, gold leaf and pigment. Detail from *Images from
Another Archaeology*, Auckland City Art Gallery Artist's Project,
December 1989 – January 1990. Courtesy Auckland City Art
Gallery and the artist. Photograph: John McIver.

Calling the Strokes

The language fragment in the modern period

Elizabeth Wilson

Confess to me a quick saying.
Gertrude Stein 1925

...the question of the being of language, which, as we have seen, is so intimately linked with the fundamental problems of our culture, reappears in all its enigmatic insistence.[1]

That literature of our day is fascinated by the being of language is neither the sign of an imminent end nor proof of a radicalisation: it is a phenomenon whose necessity has its roots in a vast configuration in which the whole structure of our thought and our knowledge is traced.[2]

From within language experienced and traversed as language, in the play of its possibilities extended to their furthest point, what emerges is that man has 'come to an end', and that, by reaching the summit of all possible speech, he arrives not at the very heart of himself but at the brink of that which limits him; in that region where death prowls, where thought is extinguished, where the promise of the origin interminably recedes.[3]

Three issues are all but inextricable here: the use and effect of language as 'fragment' in the art project; fragmentation as part of the 'crisis mentality' of Modernism; and the relation of fragmentation to the repudiation of representation in art.

We have long lived with words tied to our images. On the whole, words have been orderly. Legitimised by context they have always been explicable in terms of their relationship to a representational schema. Language, tied to representation in art, sat at the right hand. It named: God high in the Byzantine mosaic, grounding us; *fuit hic* on the Van Eyckian mirror; at the foot of the image itself as title.[4]

Stepping outside of representation with its myth of truth to a natural world, the Modernists stepped outside of permanence and of continuity. Time no longer had to do with coherence but, estranged from the 'natural', became a violently disruptive medium which sundered objects from each other and the perceiver from the world. In the fragmentation of language there is a denial of temporality, sequentiality. The appearance of the language fragment in the art-object signals the re-appraisal of temporality and its relation to concepts of a unified space. The use of language in art seemingly proffers language as a plastic, spatial rather than temporal entity. Removed from syntactical patterns and structures, which of their nature are sequential, linear, the language fragment must operate within a spatial continuum rather than a temporal one.

Language appears in art at that moment when mimesis, that 'empty centre of content', is no longer a sustaining value. At the point where the work is seen to have no truth value, no absolute relation to the world of appearances, the pictorial surface becomes opened to language which can make no pretence at having an unproblematic relationship with the thing it 'represents'. The language fragment insists (by its presence in the work) that representation has been doubly divorced from the art object. Furthermore, a work which includes language as one of its elements also signals that indeterminacy which is the condition of the fragment. The work is both the site and the demonstration of indeterminacy. Together the fragmentation of language and the eschewing of representation are like the undoing that Foucault speaks of: his 'being spun backwards'[5] which brings about an end rather than asserts a beginning. A fragmented language after all should cease to speak, no longer 'speaks of'.

The displacement of subject matter, of 'the figure of man', also sees the displacement of the ways in which a picture 'means': by displacing meaning as it is allied to representation, by displacing content to the point where language does not speak of 'man' but of language. Moholy Nagy's *Construction with 'h'* foregrounds the letter 'h' with a trenchant obduracy; nothing is subordinate to it.[6]

The emergence of an insistent 'calligraphy' in art beside the disavowal of 'the image of "man"' is already familiar from the art of Islam.[7] 'Excluded from figural depiction [Moslem calligraphy] turned upon its medium — the grapheme — to test its own plasticity: cursive swirls were its autoerotic music, a libidinal drive diverted towards rituals of inscription.' This same play between plastic representation and linguistic reference

. . . emerges [again] with the medieval belief in the world as a book, to be read; the picture-power of letters. It takes up concrete poets, Apollinaire's calligrams, the *peinture-poesie* of Breton and Ernst — and the mix of poetry and gestural plasticity of the Frank O'Hara/Jim Dine collaborations.[8]

In Islam 'man' will not be 'represented', as too in the mediaeval world his place was circumscribed. Indeed in the Modernists' radical disavowal of representation there is something of iconoclastic intensity. A reading of violence is never far from the discourse of fragmentation, a violence for which the body is often the site.[9]

If art in the early modern period is described in terms of 'abrupt discontinuities' and 'rupture with the past', then praxis mirrors cultural perception. That rupture or breaking with the past becomes a metaphor literalised in the art-object, from the Cubists' insistence on 'seeing all sides of the story at once' to the Futurist's synergistic fragmentation, to Dada's apocalyptic refusal to perpetuate the condition of art as they perceived it.

The rhetoric of fragmentation is often also that of 'the new' and concomitantly of liberation or freedom. The disruption of continuity and the rejection of dominant art canons are part of an assertion of freedom which is also a 'freeing' of language from its 'imprisonment'. Liberation was to be achieved in part by an idea of speed in the work — often signalled by a fast execution. Marinetti's style had, he said, to do with making the art statement 'brief and declarative', the words in the works 'make themselves felt' by the impression of intensity in the execution[10] — as if speed itself could free the artist from cultural constraints or could 'unlock unfettered' levels of consciousness.

The conceit of freedom or breaking-away/out from the constraints of language, of which fragmentation invariably partakes, ties both to the affirmation of primitivism and to the utopian urge found so frequently in avant-garde thinking in the early twentieth century. (Even Nietzsche's predilection for the fragmentary and the aphoristic can be linked to his desire for an aesthetic revolution.) At the same time, the disavowal of representation characterises 'breaking free' as a 'purging' and a 'breaking of taboos'.[11] The artist breaks the bounds of the acceptable in an act of defiance against a society whose ways are perceived to be those of cultural exhaustion and depletion. The artist inhabits the role of rebellious son at odds with the father, though both of course retain their places in this scenario. The viewer too is implicated in this pattern in that the breaking of the conceptual frame can also be characterised as transgressive.

Much of the force of Dadaist and surrealist literature and film lies in the breaking of the reader's or perceiver's conceptual frames. At the same time the outlines of the frame are respected since the breaks would not otherwise be noted. Dadaist and surrealist works are privileged areas of investigation in that they allow us to establish the minimal conditions for the recognition of frames while enabling us to observe at the same time the effects of frame transgressions.[12]

Such disruption carries with it the agenda of alienation, of defamiliarisation, of *verfremdung*, of *ostranenie*. The processes of fragmentation in art are part and parcel of defamiliarisation and its belief in the possibility of a perceptual and conceptual revolution, in the ability of art to change modes of perception, 'to experience . . . new levels of consciousness and verbal meaning'.[13]

Against the overt utopian impulses of much Modernist thought, Dada combined a deliberate repudiation of the future with an 'atavistic ennui', and elevated boredom to an art form. Yet if we accept the relation between boredom and anxiety, a different move proffers itself. 'Boredom masks uneasiness, and intense boredom exhibits the signs of the most basic of modern anxieties, the anxiey of nothingness, or absence.'[14] Read this way defamiliarisation becomes a manoeuvre whereby terminal boredom is relieved, and anxiety assuaged. Countering the schizophrenia of anxiety, it moves to restore the world to itself through seeing-afresh 'those things

which a daily and vulgar use have brought into a stale unaffecting familiarity'[15] — which might also offer the balm of restitution.

Marinetti's rhetoric of words freed from bondage and servitude, included a disavowal of the logic of syntax. His 'words-in-freedom'[16] were released to create unexpected 'non-rational' analogies which 'seized the simultaneity of the heightened moment of awareness'.[17] Tristan Tzara said of logic:

We needed works that were strong, precise, forever incomprehensible. Logic is a complication. Logic is always wrong. It draws the threads of notions, words, in their formal exterior, towards illusory ends and centres. Its chains kill; it is an enormous centipede stifling independance [sic]. Married to logic, art would live in incest, swallowing, engulfing its own tail . . . [18]

Similarly, Marcel Duchamp's deliberate effort to erase 'useful significance'[19] from an object is a repudiation of the established logic of objects and of ideas. The move away from 'reason' is signalled by much art utilising language. Setting aside the rational, setting aside logic, one moves ('logically') to their alternatives, the irrational, dreams, a 'landscape of the mind'. And to the repudiation of meaning.

Pope's description of bathos provides an apt comparison. Bathos is an 'anti-natural way of thinking' where one can 'mingle bits of the most various, or discordant kinds . . . and connect them with a great deal of flourishing . . . as it shall please his imagination . . . His design ought to be like a labyrinth, out of which nobody can get clear but himself.'[20]

Of Rendez-vous du Dimanche 6 Février 1916, a typewritten text on four postcards taped together, Duchamp said 'meaning in these sentences was a thing I had to avoid'.

The construction was very painful in a way, because the minute I did think of a verb to add to the subject, I would very often see a meaning and immediately I saw a meaning I would cross out the verb and change it, until . . . the text finally read without any echo of the physical world . . . [21]

Fragmentation by its very partialness thwarts any move to read a work for the closure of meaning. Fragmentation's first challenge is to syntax. No one word can of itself complete its relationship in/with the syntactical system. Fragmentation's second challenge is to causality. The artist working with the language fragment — with any system that resists representation or the norms of communication — is flouting all but one of the Gricean maxims, that of quantity. The other three, truth-value, perspicuity, relevance, are deliberately resisted. And where the Gricean maxims outline the means whereby ambiguity is limited, resistance to them results in a rapid increase in ambiguity. The language fragment in an art-work is first and foremost a decontextualised language event. If context serves to limit meaning, then the placing of a linguistic sign in a visual system results in a proliferation of the possibilities of meaning, all of which are refuted by the flouting of the Gricean maxims. Having the option either to limit or to encourage ambiguity, the art-object using language chooses to maximise ambiguity.

The move to thwart coherence exists, then, in tension with the equivalent move to reinstate it. No matter what the degree of fragmentation, the pieces pull back to the system to which they owe allegiance. The chicken perpetually runs about after its head has been severed. Or the Hydra multiplies heads for each one detached.

In *RIGHT HERE* Ruscha's X marks the spot where meaning is cancelled out or conversely begins to be located (WRITE HEAR); like McCahon's jets over Muriwai, significance seems unavoidable, the angle of flight directly overhead, the X underscoring the insistence of the 'sky's' emptiness.

The 'viewer' whose urge-to-meaning is ingrained with the achievement of linguistic fluency, perpetually struggles to 'read' a piecemeal language that refuses to make itself intelligible.

The imperative 'need to find regularities' . . . coupled with [the] 'effort after meaning', constitute a powerful expectation in human beings that what is said or written will make sense in the context in which it appears. Even in the most unpropitious circumstances, the natural reaction of man [sic] appears to be to make sense of any sign resembling language, resembling an effort to communicate . . . The natural effort of hearers and readers alike is to attribute relevance and coherence to the text they encounter until they are forced not to.[22]

Our urge is always to try to combine disparate elements so that they make sense. Caught in the discourse of parts and wholes, the open-ended work of art is shadowed by closure. However, the 'causing to think' that the indeterminate work engenders in

the viewer is often seen as the means whereby the work completes itself. Closure becomes simply a matter of deferral whereby resolution is lodged in the auto-erotic ability of the viewers to bring themselves to fulfilment. The loss of meaning becomes the meaning.

And so the transgressive repudiation of norms epitomised in the fragmentation of language itself, comes to signify loss, pain, a scattering of identities, all the arsenal of the Modernist vision of dislocation. This play between the literal and the metaphoric is the very play of the language fragment itself, that can neither 'be itself' (having no being-in-itself it is doomed to partialness) nor escape from being read (even as phoneme it will signal the possibility of reading).

Language fragments, then, signify the absence of meaning in any conventional sense while at a deeper level they still adhere to the principles of relevance. However you come at it the discourse of fragmentation is framed by the discourse of restitution.

Yet neither is the word free to exist as a pure visual sign, as a 'formal iconographical element in the composition'.[23] The insistence that the word or the fragment of the word can stand as a formal device, as 'pure entity', is as problematic as the insistence that the language fragment severed from its linguistic context becomes 'inert'.

Each is per se an image denoting, at first sight anyhow, nothing except itself . . . The big capital letters . . . are stripped of their phonetic values, while Arabic numerals are similarly transmuted into pure visual entities.[24]

Nevertheless, the premise that much concrete poetry was built on, that 'the old grammatical-syntactical structures are no longer adequate to advanced processes of thought and communication in our time', holds true also for much Modernist work with language. Again however we encounter the utopian in the insistence that the language object can exist 'in its own right, for its own sake', something of the formalists' vision of an unsullied virginal purity that refuses to acknowledge the deep implication of all things with all other things.[25]

Malevich said of Cubism:

Art was freed by Cubism from dealing with ideological content and it began to build up its own character. It had served its ideological master for many centuries; it had cleaned, powdered, coloured its cheeks, its lips and made up its eyes. Today it has refused to do this to the advantage of its own culture. This is the same for the cinema, which, for the moment, is another maid which needs to be liberated and made to understand. As the Cubist painters understood, paintings can exist without imagery, without everyday references and without obvious ideology.[26]

Ideology is the master for whom Art tarts itself up. Cubism is the liberator who brings understanding, cinema the virgin art in need of similar forceful instruction ('*qui doit se liberer et comprendre*') from the austere cleanser of cultural sordidness, he whose role will be to engender a purity beyond image, beyond mundane representation, beyond the 'investments' of ideology. Divested thus of the garments of the trade, art is released to transcend its past, to embrace in austere joy its new tomorrow.

In all of these assertions of purity a sexual agenda makes itself felt, as it does also in talk of the passivity of the inert fragment. But the language fragment cannot exist in a state of inert passivity: it must remain in a condition of tension wherein two systems, the linguistic and the visual, are thrown together, both asserting their difference even as they interact.

The binary opposition is therefore at the outset a heuristic principle, that instrument of analysis on which the . . . hermeneutic is founded. We would ourselves be tempted to describe it as a technique for stimulating perception . . . a way of forcing ourselves to perceive difference and identity in a wholly new language the very sounds of which we cannot yet distinguish from each other. It is a decoding or a deciphering device, or alternately, a technique of language learning.[27]

Obviously the need to destroy difference is as rampant as ever. Nevertheless, I think a number of new games have been put into place: games fitted with prized plenitudes and horizontal grids as opposed to the usual ladders, and relentless verticalities of refinement and challenge.[28]

Jakobson's 'mutation' comes to mind, where the role of the mutation is finally to re-establish equilibrium — the 'whole series of stabilising mutations' which have to do with bringing the system 'back into line'.[29] The fragment, partaking of disorder, sits down at the feast of the prodigal whose return to the fold was always assumed. Do we remake even as we mourn? Is the urge to complete greater even than the thrill with which we contemplate the sundered?

Voyez, il vient de comparer l'éponge à l'orange, deux choses en ge, deux ob-ge, leurs deux rapports à l'impression aspirante et à l'expression. «Comme dans l'éponge il y a dans l'orange une aspiration à reprendre contenance après avoir subi l'épreuve de l'expression. Mais où l'éponge réussit toujours, l'orange jamais: car ses cellules ont éclaté, ses tissus se sont déchirés. (. . .) Faut-il prendre parti entre deux manières de mal supporter l'oppression?»[30]

Inaccessible to any one reading, signalling absence and indeterminacy, the language fragment takes on the characteristics of a private language. Torn/taken from its 'initial tissue' it is now part of a *'langue'* which has its explanation, if any, in the mind only of its maker, the artist; and of which, in the Freudian sense, the dream-state is the *'parole'*. The act of fragmentation asserts the power of artifice even as it signals defiance and rupture. Unable to complete its conventional syntactical function the language fragment must find a raison d'être in systems no longer generally explicable in terms of a shared knowledge. It must become part of that 'profound unintelligibility' of dreams, of mystic apprehension, which haunts even as it mocks.[31]

Thus to view the work of art where language exists in a fragmented state is to stand at the door of dreams. Free from determination the language fragment frees us also from our determination as viewers, as readers. Encountering the fragment we substitute in our attempts at interpretation, at reading, *langue* for *langue* and affirm thereby our radical disparity of experience.

Picabia's *Portrait d'André Breton /* André Breton's *Poème-Objet*

Picabia's portrait of André Breton[32] is such by virtue of the words *'Portrait d'André Breton'* which edge round two sides of the work. Words and names are scrawled alongside four outlined blots which randomly threaten to spread amoeba-like towards the words. The language alternates between names and statements which have about them the sense of exhortation. The largest of the inscriptions, drawn collage-like in label form with typographically precise block capitals, reads LA LOGIQUE DU SYSTEME. Here that *logique* (the logic of relevance) is that each of the names becomes part of the Breton 'portrait' or repertoire — Charlie Chaplin, Apolli-

naire, Tristan Tzara, Rimbaud, Lautréament. Yet these in turn work against the statements with which they are surrounded or surround themselves: TOUT DE MEME, TOUT DE MEME, EVASIONS, PUISSANCE, ENTREE LIBRE SOURIRE, ECORCHE INCOMPLET, VOLONTE DE PUISSANCE.

So the 'portrait' is formed by locating one name in the context of many others, each of which signals its own set of significances and its own resistances — the resistance especially to any straightforward grasping of 'identity'. Stray letters float, given direction by arrows which indicate nothing — the work becomes noisy with its barrage of language, its sense of pace, its arbitrariness.

The irony of the interactions in the Picabia lies in the way that, with one phrase, *Tout de même*, and by way of the logic of syntax, the concept of 'the portrait' is called into question. With one word, 'all', the accusation of sameness is levelled at all of the words and all their meanings. They all have the status of evasions, all partake of the oscillation between *puissance* and *impuissance*.

Breton's *Poem-Object*,[33] inscribed in pieces, *'ces terrains vagues / où j'erre / vaincu par l'ombre / et la lune / accrochée à la maison de mon coeur'*[34] also demonstrates the pull of language, its urge to coherence. The work has the components of a complete sentence, quickly sequenced. The conventions of reading, top to bottom, left to right, chart a journey encompassing stopping places, places of engagement, yet all the points of the journey remain on view like a mediaeval multiple perspective. Beyond the structure of the sentence the words function as labels, delineating a ground and locating the figures upon it. But *'ces'* gestures towards everything, much like Picabia's *'tout'*; the whole space as much as any one part. The work, emptied at the outset, comes to house the objects which themselves are always under the pressure of eviction. The words float in a space of multiple significations. The assembled sentence satisfies at the very moment that it opens itself to any number of dissatisfactions, each of which is answered by a further reading. First coherence, then its wry undoing, while the readings proliferate to the point of exhaustion, of laughter.

What is held in common in the face of the labyrinthine complexities of works which resist or multiply readings is the knowledge of the impossibilities of communication and coherence.

ELIZABETH WILSON

Anxiety remains as a prime response to the fragment, its incomprehensibility, its partialness, its ability to alienate. 'The experience of a discontinuity produces a momentary conflict or anxiety in the mind . . . the moment of discontinuity will reveal a frightening vacancy . . . It cannot control the making of meaning.'[35]

To confound words was to confound reality and to disturb nature as well as the social order . . . There are two ways to tamper with the received 'natural' meanings of signs which have constituted the heart of order. The first is to open a gap between word and thing . . . The second is to use words out of their accustomed 'natural' order, to violate decorum.[36]

Think of Pope's 'increasingly violent irony' by which he attempted to avoid implication with the sublime and its manifest anxieties. Irony remains the very thing that disengages the humanistic avowal of the sublime from the bathetic — the means to appropriate the responses of the sublime without being ensnared in its humanistic agenda — its yearnings after unity, its longing for a lost centre, its delight in the terror of the void which justifies, fills and domesticates that void most effectively.

Irony, then, is the means whereby the modern agenda resists its own urge to complete itself.[37] 'Only irony, not any alternative semiotic, separates bathos and the true sublime.'[38] So in Duchamp, so in Picabia, so in Breton, and so on; it is their irony that matters most and is often most under-read.

. . . our experience remains riddled by discontinuities, and the sublime or something like it, as well as the bathetic, or something like it, will always be found in the ill-defined zones of anxiety between discrete orders of meaning. In the sublime moment we are on the verge of or in passage to a 'higher' meaning; in bathos, our laughter is a defence against the anxiety of losing or falling out of what meaning we've got.[39]

These two possible sublimes — one which signals a utopian yearning, the acknowledgement of void, and the second which ironises that urge, which brings 'laughter in the face of death', offer two ways of reading the discourse of fragmentation. Works which utilise 'fragmented language' can by their indeterminacy waver between readings, between the anxieties of the dismembered body and a 'wild laughter'; they will continue to 'facilitate': not that there is a statement to be made but that the making of statements

opens up the possibility for further thought and further different kinds of thought.[40]

Duchamp's *Green Box*, constructed to be a companion 'album' for the *Large Glass*, contained notes, sketches and studies mainly to do with *Glass*. The facsimile papers were randomly put into their boxes. Sequencing was the role of the reader:

I wanted that album to go with the 'Glass' and to be consulted when seeing the 'Glass' because, as I see it, it must not be 'looked at' in the aesthetic sense of the word. One must consult the book, and see the two together. The conjunction of the two things entirely removes the retinal aspect that I don't like.[41]

The reading of the art-object can only be properly achieved by the reading also of the random notes and fragments in the box, while Duchamp explicitly scores out the idea of a simple retinal viewing. The activity is conjunctive, synthetic, against the monocular insistence of vision.

There is of course no settling of the issues. The idea of fragmentation still occupies critical and artistic endeavour. Jeremy Graham's broken glass fragments with their pieces of gold lettering from old shop windows and their eye-icons — one eye per piece — are ciphers for the empty space that is 'human'. The window, the vessel, the glassy surface of the eye itself is broken over and over, yet leaves its subject intact, urging all the time to further violence, further disintegration, which even so would result only in proliferations of the one, the eye, the I, since each fragment has already sustained its image completely.

Andrew Drummond's *Images from Another Archaeology*: where the traveller moves through a landscape of rooms, through the door of dreams, into a realm of fragmentation, fragments of inscribed slate, remnants of topographical sites, archaeological sites which offer no explanation, where the 'illumination' has come down to what it always was in the comic books, the lightbulb dangling down. Not Rodin's thinker but the place where once he sat, next to a room 'dedicated to broken humanity, at rest and inert'. 'Yet it is also about recuperation.'[42] So it goes — recouping the losses.

The rooms interrelate as analogues for the human body, for the heart, the head and its fractured substance. A complex dialogue is set up suggesting both a splitting of the elements

but also — when viewed as a whole — their unity. This overcoming of separation becomes a transcendent moment in the appreciation of his installation . . . A response to Drummond's work always involves an element of anxiety.[43]

'This is art's redemptive function.' / This is 'the explosion of man's face in laughter'.

Duchamp and Man Ray met on a Sunday afternoon. Duchamp spoke no English. Man Ray spoke no French. Man Ray brought out racquets and they played tennis on the grass. 'I called the strokes to make conversation: fifteen, thirty, forty, love, to which he replied each time with the same word: Yes.'[44]

7 proliferation of manifestoes in the early modern period. There seems to be some sense of inevitability in the way that language spilled out from the manifesto onto the surface of the art-object itself as an 'integral' part of the 'work'.

7 Liliane Touraine also talks of the art of Islam in her contribution to the image/text debate. See 'Des Mots et des Images/ Images de Mots', *Colóquio Artes* 2nd Series 72, March 1987.

8 George Alexander, 'Slipzones: Text and Art', *Art and Text* 26, Sept-Nov 1987, pp. 44-5. W.J.T. Mitchell 'draws' a similar analogy between our experience of the contemporary world and the mediaeval belief in the world as a book to be read. See W.J.T. Mitchell (ed.), *The Language of Images*. Chicago: University of Chicago Press, 1980, p. 1.

9 Derek Cowie's *First, we are cut*, for example, or Duchomp's study (1948-9) for *Etant donnés le gaz d'eclairage et la chute d'eau*.

10 Cf. Kruger's insistence on the speed of execution which is 'crucial to convey the urgency and feeling of the moment'.

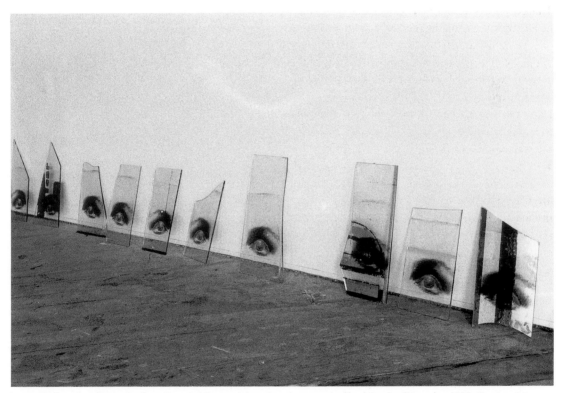

Jeremy Graham, installation shot from Occupied Zone artist's project, Artspace, Auckland October/November 1989. Courtesy Artspace and the artist.

Notes

1 Michel Foucault, *The Order of Things: An Archaeology of the Human Sciences*. London: Tavistock Publications, 1970, p. 382.

2 Foucault, p. 383.

3 Foucault, p. 383.

4 For a discussion of the relationship between titles and art-works see Stephen Bann, 'The Mythical Conception is the Name: Titles and Names in Modern and Post-Modern Painting', *Word & Image* Vol. 1 No. 2, April-June 1985, pp. 176-90, and E. H. Gombrich, 'Image and Word in Twentieth-Century Art', *Word & Image* Vol. 1 No. 3, July-Sept 1985, pp. 213-41.

5 Foucault, p. 381.

6 The irruption of language into art as 'visual sign' rather than as a subsumed part of a representational system is matched by the

Barbara Kruger interviewed by Jeanne Siegel in 'Barbara Kruger: Pictures and Words', *Arts Magazine*, Vol. 61 10, Summer 1987, p. 21.

11 Gombrich, p. 213.

12 Inez Hedges, *Languages of Revolt*. Durham N.C.: Duke University Press, 1983, p. xviii.

13 Jerome Rothenberg and George Quasha, *America a Prophecy*. New York: Vintage Books, 1974, pp. xxix - xxx.

14 Thomas Weiskel, *The Romantic Sublime: Studies in the Structure and Psychology of Transcendence*. Baltimore: Johns Hopkins University Press, 1976, p. 18.

15 Edmund Burke, 'Of the Sublime and Beautiful', Weiskel, p. 18.

16 For discussions of Marinetti's *'parole in libertà'* see Christine Poggi, 'Marinetti's *Parole in Libertà* and the Futurist Collage

ELIZABETH WILSON

Aesthetic', and Antonella Ansani, 'Words-in-Freedom and Cangiullo's Dancing Letters', *The Futurist Imagination: Word + Image in Italian Futurist Painting, Drawing, Collage and Free-Word Poetry*. New Haven: Yale University Art Gallery, 1983.

17 Poggi, p. 4.

18 Dada Manifesto 1918, *DADA-Constructivism: The Janus Face of the Twenties*. London: Annely Juda Fine Art, 1984, p. 87.

19 Marcel Duchamp, speaking of *Fountain* (1917) in Anne d'Harnoncourt and Kynaston McShine, *Marcel Duchamp*. New York: The Museum of Modern Art, 1973, p. 283. Malevich's contemporary Kruchenykh, in his manifesto, said 'The artist is free to express himself not only in a common language . . . but also in a private one . . . as well as in a language that does not have a definite meaning . . . that is transrational', Marjorie Perloff, *The Futurist Moment: Avant-Garde, Avant Guerre, and the Language of Rupture*. Chicago: Chicago University Press, 1986, p. 121.

20 Weiskel, p. 19.

21 Duchamp to Arturo Schwarz in d'Harnoncourt and McShine, p. 278.

22 Gillian Brown and George Yule, *Discourse Analysis*. Cambridge: Cambridge University Press, 1983, p. 66. The comic possibilities of the urge to relevance are explored in the film *The Man with One Red Shoe* where a way of reading, the spy movie genre, is imposed on to a series of 'meaningless' events which then become re-transcribed to farcical effect, underlined by the persistent literalising of metaphors — 'taking the place apart', and the refusal to read anything at all outside of the conventions being utilised — 'there's gotta be a reason why he's flushing the toilet'. The film comically exemplifies both the effects of a thwarted discourse and the impossibility of anything ever being 'freed' from processes of signification.

23 Alexander, p. 45.

24 Robert L. Delevoy, *Dimensions of the 20th Century*. Geneva: Skira, 1965, p. 116.

25 A reductive simplicity which is present in Nicholas Wade's *Homage to Magritte* (Nicholas Wade, 'Literal Pictures', *Words & Image*, Vol.1. No.3, July-Sept. 1985, pp.242-272) — a pipe shaped from the words 'this is a pipe' — which tends effectively to terminate the discourse on *Ceci n'est pas une pipe*. See Suzi Gablik, *Magritte*. London: Thames and Hudson, 1985, and Foucault's *Ceci n'est pas une pipe*.

26 Malevich, 'And they fashioned jubilant faces on the screen', A.R.K. Kino Moscow No. 10 1925, *DADA-Constructivism* 53, n. 1. In its French translation the relationship of servant to master, itself loaded with sexual overtones, is changed, and Malevich's implication becomes even clearer. '*Il a servi sa maitresse ideologique pendant de nombreux siecles . . .*' V. and J. Marcade, *Le Miroir Suprematiste L'Age d'Homme*,1977, *DADA-Constructivism* 53.

27 Fredric Jameson, *The Prison-House of Language: A Critical Account of Structuralism and Russian Formalism*. Princeton: Princeton University Press, p. 113.

28 Barbara Kruger interviewed by Jeanne Siegel, p. 21.

29 See Jameson, p. 20-1.

30 'Observe: he has just compared the sponge to the orange, two things in *ge*, two ob-ges, along with their two respective relationships to the processes of impressionable aspiration and expression. "As in the sponge, there is, in the orange, an aspiration to recover its countenance after enduring the ordeal of expression. But where the sponge always succeeds, the orange never does: for its cells have burst, its tissues are torn. (. . .) Do we have to take sides between these two ways of tolerating oppression badly?"' Jacques Derrida, *Signéponge/ Signsponge* (trans. Richard Rand). New York: Columbia University Press, 1984, pp. 64-5.

31 Joseph Chiari on Mallarmé '. . . the words are used as much as possible like musical notes or signs; they have been deprived by various syntactical distortions of their logical meaning so they never produce a static picture in the Parnassan style; . . .

Language is used . . . as a kind of magic aimed at creating a state of trance whence will rise the unheard music, the vision of the absolute . . . Yet such an ideal is condemned to failure, for the words . . . can never be rid completely of the contingent, and therefore they cannot destroy *le hasard*.', in 'Ronald Bush: Modern Postmodern: Eliot, Perse, Mallarmé, and the Future of the Barbarian'. In Kiely and Hildebidle. Cambridge, *Modernism Reconsidered*. Cambridge, Mass.: Harvard University Press, 1983.

32 Francis Picabia, *Portrait of André Breton* in *DADA-Constructivism* 86.

33 André Breton, *Poem-Object* 1941. See William S. Rubin, *Dada and Surrealist Art*. New York: Harry N. Abrams, nd, p. 287.

34 'these empty lands — where I wander — vanquished by shadow — and the moon — caught in the house of my heart'

35 Weiskel, p. 17.

36 Weiskel, p. 19.

37 Cf Daniel O'Hara's definition of irony: 'the power to entertain widely divergent possible interpretations — to provoke the reader into seeing that there is a radical uncertainty surrounding the processes by which meanings get determined in texts and interpreted by readers.' See Alan Wilde, *Horizons of Assent: Modernism, Postmodernism, and the Ironic Imagination*. Baltimore: Johns Hopkins University Press, 1981, p. 6ff.

38 Weiskel, p. 20.

39 Weiskel, p. 21.

40 See Foucault: '. . . of course these are not affirmations . . .', p. 386.

41 Duchamp in d'Harnoncourt and Kynaston, p. 303.

42 Richard Dale, 'Archaeologist of the Human Spirit', *N.Z. Herald*, 18 Jan 1990, Sec.2: 2.

43 Dale.

44 Man Ray to Marcel Jean in *The History of Surrealist Painting*, 1960, p. 60. Quoted in Arturo Schwarz, *Man Ray: The Rigour of the Imagination*. London: Thames and Hudson, 1977, p. 34.

Cover Versions

The Album Sleeve in the Era of Musical Reproduction

Lawrence McDonald

. . . even today, we speak of 'auditing', that is, 'hearing' account books, though what an accountant actually does today is examine them by sight. Earlier, residually oral folk could understand even figures better by listening than by looking.

Walter Ong, *Orality and Literacy*, 1982.

I think in people's senses there is a hierarchy, and the visual side is a lot more spontaneous — people react a lot more immediately to a visual image than an audio image . . . I'm not saying it's longer lasting. There's a lot more crossover if you see and hear something together — it seems to be a more complete experience.

Stephen Mallinder, *Industrial Culture Handbook*, 1982.

COVER 1 (noun) The cardboard jacket in which records are packaged, usually printed with information, graphics, or photos. 2 (verb) to re-record another version of a popular song, either to revive its popularity (if the song is an oldie) or to stylize the song differently for a different market.

Wayne Wadhams, *Dictionary of Music Production and Engineering Terminology*, 1988.

The album sleeve. From *The White Album* (1968) to the *Black Album* (1988), a wide spectrum of design possibilities. The former is, of course, one of the most widely disseminated LP records of the last 25 years. To this day, Richard Hamilton's cover design stands as one of the boldest minimal statements yet made within popular culture: the exterior of this gatefold sleeve comprises a completely white surface, unrelieved except for the embossed title *The Beatles* on the front, and small black lettering on the spine. The degree zero of the record cover. The 'white writing' that followed the show biz excesses of *Sgt Pepper*. The effect is to throw all attention on to the Beatles as songwriters and musicians, free of any extraneous, overarching concepts. The visual simplicity of this statement is not matched until the advent of Prince's unreleased/privately circulated *Black Album*[1] (also a double), a self-consciously obverse homage to the Beatles and Hamilton. During the same period as the *Black Album*, Prince issued the 12" single of *Glam Slam* in a clear plastic jacket; its only identification marks are an external, arrow shaped sticker and the exposed label at the centre of the vinyl. The disc's transparent 'clothing' fully reveals its vinyl 'body' to the gaze of the audiophile poised over the megastore bins. Without the arrow and the centrally placed sticker, this piece of vinyl would be visually mute, an anonymous pattern of grooves. It had to be imprinted with a set of classifying sign-images in order to be immediately readable with the eye. In this regard, it is only the most elemental example of what is required of all LP (album, cassette, CD) packaging: a base line of product identification from which more seductive visual strategies may take off.

The album sleeve is at once all of the following:

1. The outer surface or skin of a sign/commodity/object within popular or mass culture.
2. A container that provides protection from dust and scratching for the vinyl disc's vulnerable surface.

3 A form of clothing that covers the nakedness of the vinyl with its adornment.

4 An overlaid form of visual writing that covers an indistinguishable sheet of vinyl with a set of signs that differentiate it and the other members of its batch from other batches.

5 A cataloguing device that supplies contextualising information to connect a piece of vinyl, a cassette tape, a compact disc to frames of authorship (another Van Morrison album), genre (another 'jazz' or 'classical' album), and industry (another Warner Bros or Stiff record).

6 A travelling art work that will assume a history of social use and accumulate a cultural biography.[2]

From the period of its initial display in a city record store to its incorporation (short or long term) into an individual's record collection, it may pass through many hands. It may even be separated from its vinyl contents and be placed upon a bed or living room wall.

It's often said we are fast approaching the end of vinyl and therefore of the square cardboard surface of LP design. And it's true in terms of world sales where vinyl has been eclipsed except in the case of 7 and 12 inch singles. But the regnant formats of cassette and compact disc offer drastically reduced possibilities to the designer. Indeed the miniature card of the cassette and the CD 'library case's' thin paper insert are closer to the cover of the paperback novel than the vinyl LP's 'canvas'. The British photographer Brian Griffin who has contributed to many successful album sleeves makes an eloquent case for the importance of the vinyl LP cover: 'It is *the* vehicle, because it gets into the living room, as opposed to some art sanctum. It's on the streets, it's in the shops, it's in the home, and it stays around for a very long time. The most important aspect of it is the psychological one. The twelve-inch square is just right when you hold it at arm's length: it's an absolutely perfect viewing space, in feel, shape and size'.[3]

The discussion will continue in the form of a review of some past glories of large format album design.

Exhibit One: Cecil Taylor, *Unit Structures* (Blue Note (A) BST 84237) Recorded 19.5.66.

16 cecils

On the square white surface of this album's recto face we find the following: 16 small coloured squares, each of them — except for a blank in the top right hand corner — containing an identical photographic image of the upper half of Cecil Taylor's body; identical except for a limited variation in the colour range of each image. Taylor, enigmatic behind dark glasses, has his name and the title of the album superimposed over the third square from the left on the top row. The square in the top right hand corner, dark pink in hue, carries Blue Note's characteristic logo (a rectangle, an oval and the legend 'the finest in jazz since 1939'). Another numbered commodity

from the house of Blue Note; a small specialist company whose fine products nonetheless are issued in unlimited editions.

The cover design by Reid Miles (incorporating photography by Francis Wolff), Blue Note's house designer, is clearly an ironic homage to Andy Warhol's early 60s (1962-4) cycle of serial silkscreened portraits. The irony resides in the fact that Taylor, unlike Marilyn Monroe, Jackie Kennedy etc, is very far from being an icon of the mass media. Quite the reverse. Even now, 24 years after the release of this record, Taylor is little known outside the jazz world; indeed he is still numbered amongst the most uncompromising and difficult of 'avant-garde' jazz musicians. As in Warhol, Reid's presentation of Taylor in multiple image draws attention on the album jacket itself to both the manifold reproductive nature of

identical copies (without an original) in the production of recorded music (Unit Structures indeed!) and to the structure of Taylor's own music with its strong affinities to modern, serial composition. Significantly enough, Warhol himself had already contributed design and illustration to two Kenny Burrell albums (*Kenny Burrell* [1957] and *Blue Lights* [1958], both Blue Note) before the arrival of *Unit Structures*. Yet the cover of this album is without doubt the most 'Warholian' statement made within the history of Blue Note records.

Turn the album over and its verso face is covered with printed language in dark/light, large/small, contrasting typefaces. To the right of a boldface column of information on musical personnel, track listings etc, is a lengthy piece of writing (two wide columns) by Taylor himself, titled 'sound structure of subculture becoming major breath/naked fire gesture'. I say piece of writing because it does not conform to the usual kind of liner note — it is neither essay nor poem — but is virtually unique in forging an amalgam of discursive and poetic modes. A representative extract: 'Western notation blocks total absorption in the 'action' playing. The eye looks, mind deciphers, hands attack, ear informs. The pupil mirrors only the inner light, an ear having heard identifies. Hearing is sight face away academy's superfluity. There are not separate parts: one body and the mind enclosed. We procede inventing. The interpretation has occurred . . . the root of rhythm is its central unit of change eye acting upon motor responses directing motions internal movement (wave)'.

Inside the album sleeve we find a paper, plastic-lined dust-jacket literally covered with blue notes — the company's distinctive blue quavers; while the label at the centre of the vinyl disc is, of course, blue. And the music? Well, that can't be seen or heard without the intervention of technical means whether analog (needle and pickup) or digital (laser scanning).

Exhibit Two: Patti Smith, *Horses* (Arista vpli 7536, 1975). Design: Bob Heimall; Photography: Robert Mapplethorpe.

A significantly large number of LP records, cassettes and compact discs have covers or inserts almost entirely dominated by photographs of the featured musician(s). This applies to both 'serious' (i.e. high cultural) music — overburdened with staid, unimaginative artwork — and all forms of popular music. Within the latter field it would seem that it's mostly the extremes of commercial visibility (both the very famous and the very obscure) that license the freedom to dispense with standard artist or group shots in favour of adventuresome design; the Beatles and Prince are examples of commercially high profile musicians whose work has appeared in striking packages; while Cabaret Voltaire and Suicide are just two groups that fit the second category. Perhaps only the wanna-bes and the almost-theres are those most required to push the cover mug shots in order to

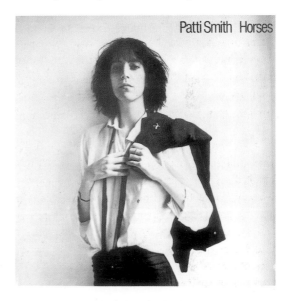

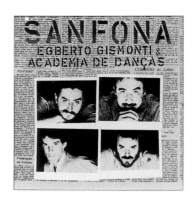

advance their careers. 'Record companies', as Eric Watson has noted, 'go to great pains to sell their recording artists. Music is fleshed out with a calculated visual image, usually a photographic portrait . . . the photographic medium . . . "isolates" the recording artist and enforces the rhetoric of the "star" system. The record buyer possesses a photograph of the artist. The cover raised itself from mere packaging to the status of a personal keepsake'.[4]

Amidst the avalanche of bland photo-portraits routinely seen on album covers, there is an occasional stand-out. The cover portrait for Patti Smith's *Horses* is one. Released in later 1975, *Horses* was Smith's first recorded LP as well as being the first album from the New York 'punk' wave that built on the legacy of the Velvet Underground.

Robert Mapplethorpe's black and white portrait is a strong, direct, frontal statement: Smith, simply attired in plain white shirt and dark trousers, stands defiantly in front of a white background; her gaze is cool, steady, almost arrogant;[5] her name and the title of the record appear in plain black letters in the top right-hand corner. Smith as androgyne; Smith as poet metamorphosised into rocker; Smith as 'homage to Keith Richards'.[6]

At the top of the back cover, Mapplethorpe's mini-portraits of the Patti Smith group give them the visual uniformity we associate with a 'true' band. They are made to look like 'Patti Smith' musicians just as the Rolling Stones look like Rolling Stones, the Beatles like Beatles, etc. Beneath these portraits is a prose poem, signed off with Patti's signature. And finally, the new beginning connotations of the cover are borne out by the opening song, a cover version of Van Morrison's *Gloria* which Smith prefaces with the immortal line: 'Jesus died for somebody's sins but not mine'.

Exhibit Three: *ECM* records, Munich. Design: Barbara Wojirsch, Dieter Rehm et al.

With ECM records, the tendency of the record label to aspire to the condition of a dealer gallery without walls reaches a peak of self-consciousness. The accent throughout has been on a version of spare, modernist 'good taste' in an attempt to match visually the cool sounds of a roster largely populated with European jazz musicians and American neo-impressionist stylists. Typographic information is kept to an absolute minimum, conveying only production details, track listings and the personnel involved. The overall visual design is paramount. The label's motto is 'a movement next to no movement' and it applies to the design as much as the music. Yet the impression gained from viewing several hundred ECM albums is of a tasteful blandness, relieved by the occasional striking cover. What began as a healthy reaction against the garishness of some early 70s cover art has ended in predictability.

Exhibit Four: Malcolm McLaren, *Duck Rock* (Charisma 810 432-1, 1983). Design: Nick Egan; Illustration: Keith Haring; Graffiti : Dondi White.

The album cover as graffiti surface

The extreme global eclecticism of the music on *Duck Rock* (see p. 173) is matched by the visual design of its enveloping cover. Both the front and back face have as their background a work by Keith Haring in his trademark graffito 'wild style'. Superimposed upon Haring's front face, dark pink patterns, is McLaren's famous customised ghetto-blaster, a striking example of post-modern bricolage. A plethora of aerials rise from its body, signalling a desire to tune into as many radio frequencies as possible. Amongst the other 'raw' and 'cooked' attachments are: a microphone, a hooter, a pair of headphones, a rear

The new electronic interdependence
recreates the world
in the image of a global village.

cepts without benefit of formal training. But the 'truth' of *Duck Rock*, although composed of certain relatively 'raw' ingredients is a richly 'cooked' concoction, appropriate to an age of scrambled cultural menus.

Notes

1. But strictly speaking, Prince's album was preceded by the Damned's 1982 release, *The Black Album* (Chiswick), a much less well-known record despite its commercial distribution.
2. The phrase 'cultural biography' is taken from Igor Kopytoff's essay 'The cultural biography of things: commoditization as process', in Arjun Appadurai (ed.), *The social life of things: commodities in cultural perspective*. Cambridge: Cambridge University Press, 1986.
3. Brian Griffin quoted in Bob Fisher and Colin Greenland, 'Introduction' to *Album cover album 3*, in *The ultimate album cover album*, compiled by Roger Dean and David Howells. New York: Prentice Hall, 1987, p. 110. Compare Griffin's comments with those of Neville Brody: 'Record covers really were the boom industry in design at the time (late 70s/early 80s). There was a supportive network to enable an interesting sleeve to reach anything from 10,000 to 50,000 people. I thought the record shop was just as valid a showcase as the framed environment of art galleries, or, better still, that your living room was a place to look at and think about visual expression, without any of the dogma of a gallery'. Neville Brody in *The Graphic Language of Neville Brody*, text and captions by Jon Wozencroft. München: Bucher, 1988, p. 9.
4. Eric Watson, 'Portrait of the artist as a saleable commodity', *Camerawork*, 12, January 1979, p. 12. Cited in John A. Walker, 'larger than life: representing pop music stars', *Studio International*, 196, 1003, (1983), p. 19.
5. Kim Gordon's lines in 'The Sprawl' might now serve as an appropriate caption: 'Does this sound simple?/fuck you/are you for sale?does fuck you sound simple enough?/this was the only part that turned me on'. Sonic Youth, *Daydream Nation* (Blast first records, 1988).
6. This phrase appears in Simon Frith and Howard Horne, *Art into Pop*. London : Methuen, 1987, p. 155. In an interview conducted in Wellington, Barbara Kruger spoke about the influence of Patti Smith in the early 1970's: '. . . She was totally male-identified. Patti was self-revulsed by her femaleness. But she was also a force. She could stand up there and recite and the whole male New York poetry scene couldn't stand it. But the rock and roll scene liked it.
 Barrie: So what was it that you were responding to — the power in her work?
 Kruger: To her very forthright wallowing in sexuality and the of the group. She introduced my first poetry reading in 1973, in Artist's Space. So I started writing more and more and the more I wrote I knew I couldn't continue making the painted work. Because when I was writing I was right on the edge of my intelligence, everything was accelerated and with the painting — ten weeks . . . slow.' Barbara Kruger, conversation with Lita Barrie, 7.3.88 (unpublished).
7. From an appendix to Richard Gehr, 'Malcolm McLaren', *Artscribe*, No. 73, Jan/Feb 1989, p. 73.
8. John A. Walker has compared the cover of Go 2 to Joseph Kosuth's 'Thought' in *Cross-overs: art into pop/pop into art*. London : Comedia/Methuen, 1987, p. 92.

vision mirror, two orange plastic lights, a fur lined carry handle, a protruding feather and, at both ends, protruding horns. Grafted on to the inset speakers are the distorted and multi-coloured letters that make up the album's title — *Duck Rock*; and an allusion to the record's radio formatting device — 105.9 FM. Graphic words (electric boogaloo, break) are broken up and distributed on each face of the sleeve. McLaren's proper name, boldly centred in irregularly sized/coloured, giant size type, is preceded by the first three letters of his christian name — MAL — to let us know that this is a 'bad', funky record.

The back cover repeats Haring's wall painting in a blue shade and places a large variety of figures, graphic titles and photographics upon it. McLaren makes a minor, 'Hitchcockian' appearance as back cover star, dressed 'buffalo style', knob-twiddling his ghetto-blaster. Inset within thick black square painted borders that frame it like a television image, is a photograph of a group of Zulus sitting around the ghetto-blaster. All at once, this image makes a nod to McLuhan's global village and simulates those 'first contact' scenes so beloved of the popular media (colour supplement magazines, *The gods must be crazy*, etc). To the left of the painted tele-frame is that truly stunning image of a Zulu woman balancing McLaren's ghetto-blaster on the top of her head. Overall this array of word-images, lines and photographics brilliantly encodes the juxtapositions contained on the vinyl.

The lyric sheet within continues this design pattern in black and white. Mock ethnographic photographs with extended field notes sit beside Haring drawings, movie stills (Marilyn Monroe, Brigitte Bardot (?)) and the words of the songs.

McLaren likes to quote Rousseau's line: 'Craft must have clothes, but truth likes to go naked'; he is referring to his successful pursuit of musical con-

This is a RECORD COVER. This writing is the DESIGN upon the record cover. The DESIGN is to help SELL the record. We hope to draw your attention to it and encourage you to pick it up. When you have done that maybe you'll be persuaded to listen to the music - in this case XTC's Go 2 album. Then we want you to BUY it. The idea being that the more of you that buy this record the more money Virgin Records, the manager Ian Reid and XTC themselves will make. To the aforementioned this is known as PLEASURE. A good cover DESIGN is one that attracts more buyers and gives more pleasure. This writing is trying to pull you in much like an eye-catching picture. It is designed to get you to READ IT. This is called luring the VICTIM, and you are the VICTIM. But if you have a free mind you should STOP READING NOW! because all we are attempting to do is to get you to read on. Yet this is a DOUBLE BIND because if you indeed stop you'll be doing what we tell you, and if you read on you'll be doing what we've wanted all along. And the more you read on the more you're falling for this simple device of telling you exactly how a good commercial design works. They're TRICKS and this is the worst TRICK of all since it's describing the TRICK whilst trying to TRICK you, and if you've read this far then you're TRICKED but you wouldn't have known this unless you'd read this far. At least we're telling you directly instead of seducing you with a beautiful or haunting visual that may never tell you. We're letting you know that you ought to buy this record because in essence it's a PRODUCT and PRODUCTS are to be consumed and you are a consumer and this is a good PRODUCT. We could have written the band's name in special lettering so that it stood out and you'd see it before you'd read any of this writing and possibly have bought it anyway. What we are really suggesting is that you are FOOLISH to buy an album merely as a consequence of the design on its cover. This is a con because if you agree then you'll probably like this writing - which is the cover design - and hence the album inside. But we've just warned you against that. The con is a con. A good cover design could be considered as one that gets you to buy the record, but that never actually happens to YOU because YOU know it's just a design for the cover. And this is the RECORD COVER.

XTC GO 2 (Virgin, 1978, Design: Hipgnosis)

meaning, n. 1, = that which exists in the mind (e.g. yes, that is my —, *mihi vero sic placet, sic hoc mihi viditur*; see INTENTION, WISH, OPINION; 2, see PURPOSE, AIM; 3, = signification, *significatio* (of a word), *vis* (= force of an expression), *sententia* (= the idea which the person speaking attaches to a certain word), *notio* (= original idea of a word; see IDEA), *intellectus*, *-ūs* (how a word is to be understood, post Aug. t.t., Quint.); it is necessary to fix the — of the verb "to be in want of," *illud excutiendum est, quid sit* CARERE; to give a — to a word, *verbo vim, sententiam, notionem sub(j)icēre*; well· —, see BENEVOLENT.

Art–Language *Art as idea as idea* (1967, photostat)

"The presence of the text in the figural space can appear surprising. How can a linguistic space whose property is to be oriented toward a left-to-right reading – a space with strict and apparently inviolable internal rules – "inhabit" the same space as the figure without bothering the eye and the ear?"
–Jean-Francois Lyotard
'Plastic Space and Political Space' (1973)

Cover of an anti-catalogue, written, designed and produced by Sarah Charlesworth, Joseph Kosuth et al, the Catalog Committee of artists meeting for cultural change, New York, 1977.

an *anti*-catalog

Because it calls the neutrality of art into question, this Anti-Catalog will be seen as a political statement. It is, in reality, no more political than the viewpoint of official culture. The singularity of that viewpoint—the way it advances the interests of a class—is difficult to see because in our society that viewpoint is so pervasive. In this Anti-Catalog, we have attempted to elucidate some of the underlying mechanisms and assumptions. Our effort is not intended simply as a critical exercise. Culture has the power to shape not only our view of the past but also the way we see ourselves today. Official culture can only diminish our ability to understand the world and to act upon that understanding. The critical examination of culture is thus a necessary step in gaining control over the meaning we give our lives.

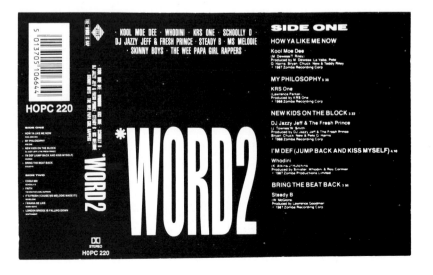

Card insert of cassette, *WORD 2*, (Jive records 1989)

Pet Shop Boys Domino Dancing (12" disco mix, Parlophone, 1988)

LAWRENCE McDONALD

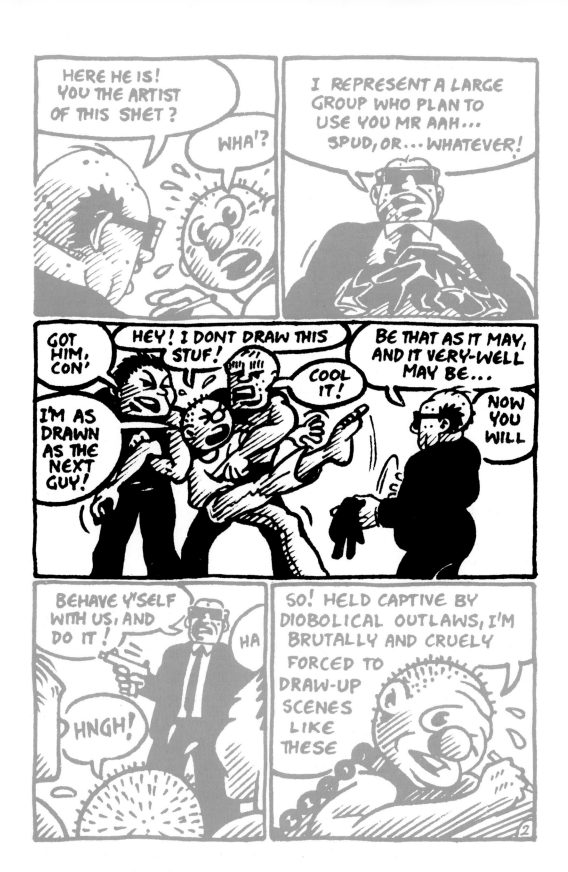

Barry Linton, from *Brainwash* 1981. Strips No. 17 1981. Courtesy
Barry Linton.

Paint by Numbers

The Mediation of McCahon

Sara Knox

I

Te Tangi o te Pipiwhararua [The song of the shining cuckoo] (see pages 174-5) has outlived its maker. It has counted itself out of the years allowed the artist, and although numbered finite (1-14: the stations of the cross) it keeps counting, for that is the paradox of numbers: procession into infinity. For the viewer, *Shining cuckoo* and McCahon's other works have immortalised him — inscribing his name, and the notion of his intended genius, on and beyond the canvas. The size of the work defies reproduction, its bulk alone deems it irreplaceable, without issue, an *original*. As an *original* it carries the message of its genesis within it, the artist for whom it is prodigal. People peer into the work to find him. The work is a gate to the land of the dead where everything is remembered and nothing dies, and the living believe the gate will open to them and all they ever loved, if they wait — well-behaved and patient — for entrance. The artist, always already dead, is martyred: *Jesus is condemned to death.*

This is what the painting *says*.

II

If I look at *Shining cuckoo* determined to ignore the artist, what, if anything, do I find? Five panels — one cannot look at the whole of the original, except from a distance. Numerals in orderly progression, seven and ten privileged: the former as a holy number (what the angels would always choose for Lotto) and the latter a fallen cross. The canvas counts on me to see these things. But my view has a horizon wider than this one work, I see McCahon's other numeral paintings (particularly *Walk with me 1*, 1974, with the corner bitten off by darkness above the artist's name), I see the teleology of the works without numerals: *Mary and Jesus (there is only one direction)* (1952). There is only one direction: from zero to infinity, from the flawed and mortal Madonna to the holy child, from sin to redemption, *from the lesser female to the more perfect male*. The painting holds out the lying promise of centuries of liberal humanism: progress and refinement.

Jesus receives his cross.

III

But, for a minute, look back into the picture for the artist — do not doubt that he is there. Is it not a matter of catching a glimpse from an angle where the light falls just right, and the work surrenders its true meaning to us; when we attain the innocence of the viewer who refuses to hear the strident voice of interpretation and criticism that veils the work? Whom do we believe: there is the work, and then there is the story of the work.

But no, there is only the story of the work — with all its varied storytellers, of whom I am one and you another.

Jesus falls the first time under his cross.

IV

Much has been made of the fact that McCahon's paintings *talk* to us, they instruct us, the words carved into the acrylic as indelible as if into stone (like epitaphs, to mark the very fact of absence). We need the orientation of signs, as the orientation of speech — there is a certain reassuring quality about signs because they suggest we might all be *getting somewhere*, and that we might be *understood*. McCahon's work has volume, has an almost canonical authority, but most importantly (though less comfortingly) it has the authority assigned to it by 'its history of having an effect'.[1] It effects because it is effective, it is said to have an effect, we are affected.

V

In both *Walk with me 1* and *The song of the shining cuckoo* McCahon frames the numeral IV. At that part of the Stations, Christ meets his afflicted mother

for the second to last time. For some reason in the New Testament the disciples decline to mention this, providing instead much detail (even lineage) for Simon of Cyrene, first burdened by the cross (the fifth Station). McCahon then tells me (I hear) this story another way: his Mary eclipses Simon, the sign of her Station joined by the cuckoo's flight to the sacred numeral VII.

(But don't forget — I'm the one telling this story, not the artist.)

VI

History, says the postmodern historian, is a conversation with the dead about the things we love.[2] It is neither a searching out of facts, nor an attempt to situate one privileged voice in the web of discourse: it is story-telling, it is the construction of multivalent truths.

Yet I read this painting as if it were an intellectual reliquary. Here the numbers brook no opposition; Hotere's poem retreats before the orderly advance. The past paradigms of knowledge are also present: McCahon is teaching us evolution in the 'natural history' of art.

VII

Current (and, admittedly, past) critical practice within literary theory suggests there is debate as to the 'source' of meaning in texts, and the processes that construct meaning/s. To simplify a complex theoretical debate let us posit a continuum from *production* (including stress on authorial intention, and contextualism) to *reception* (with its own permutations: text centred and structurally based, or reader 'process' orientated). Proponents of the latter, in the search for new paradigms, have come to question the means by which works (and their creators) enter the canon; and the concomitant failings of traditional critical approaches to the canonised text. Thus I am faced with a double epistemological problem: why the artist (McCahon) and why this canvas (*Te tangi o te Pipiwhararua*)?

'... that which wins through will thereafter be regarded as good.'[3]

Jesus falls the second time.

VIII

Let us consider the context of the meeting of viewer and artwork. Any 'conversation' between the two is dictated by the environment in which it occurs and the subject's point of vision, a vision socially and psychologically constructed. Unlike the reader of the printed word, who 'possesses' the text physically (as an object: the book), the viewer's relationship to an artwork is mediated by the circumstances of the meeting and its context. The meeting occurs under certain conditions that qualify the response of the viewer to the work: it is physically framed by the gallery wall, and by the building itself. It is further juxtaposed with other works (one hardly has the chance to rendezvous with it alone by night, but for the unlikely example of the art thief). Most importantly the work is framed *within* the subject by the prejudices and preconditions that dispose the subject to 'understanding' — understanding tempered, when viewing a supposed 'masterwork', by the intervention of the *ideal biography* of the artist, and by the physical presence of the *original* artefact that connects viewer to artist, and present to past.

IX

So let us get the prophesying done with: *Jesus falls the third time*. This is the last fall and, the weight of our knowledge being retrospection, we know that he shall rise, and die, and finally ascend, and that's all we need to know of the story, even though the story has not done with us yet — not for these last 2000 years.

But you might say: Isn't this all rather literal and distracting? To which I reply: Yes, but isn't it impossible to be truly literal?

X

What of an attempt to lay bare the painting? What can we strip it of? Nothing. All criticism is addition, all interpretation addition: reading extends the possible futures of the text. Deconstruction is a reconstruction of meaning into a particular present that contains past meanings. Thus what I write about this painting is already full of other meanings: all that has been said before.

(Thus when the Roman guards stripped Jesus of one set of clothes he donned another: *dressing up the text*.)

Let me return, however, to the idea of the canon.

Might we not suppose that when a work is just completed it is free for that brief moment before it begins to gather a history, that then it signals clearly both the artist's unmediated intention and the discourse of which it forms a part? If so, the task of the art historian is to return us to just such a point of vision, so that we may see the work, renewed, in the fullness of its possible meanings. This task, if possible at all, has been embarked upon with vigour and intuition by Gordon Brown, a dedicated 'reader' of McCahon. But I would say that what he has done (and I am doing) is overlaying the 'text' with another inter/intra-textually related 'text'. Brown warns against a too literal reading of *Shining cuckoo* and turns the canvas into a beach beneath our feet to hold our footprints: proof that we, like the cuckoo itself, passed here.[4]

XI

Mary and Jesus (There is only one direction). In this early painting (1952) we see curves: mother and child are framed, cameo style; the child's hair is a crescent of shadow joined to the shadow beneath the full face of the Madonna. Her breasts sit upon his shoulders; her shoulders curve. But we are told by the inscription that sits outside the cameo frame: *there is only one direction*. Perhaps the curves suggest a loop backwards to meet the beginning. Yet this painting precedes the discovery of Red Shift, that great metaphysical problematisation of distance. Here the 'one direction' is unilinear, but not of indeterminable distance: sure as mortality there is a 'getting there' and, (apologies to Newton), there must only be one direction: Up.

XII

Writing this I am trying to suppose two very different things: what is happening inside the frame and what is happening outside of it. I've already suggested the latter provides the conditions for the former. But is there perhaps something autonomous, something already made inside the frame that remains ungiving, inalterable: that which speaks from the gallery wall to the other parts of the installation when the last viewer has gone and the lights have been extinguished? If such autonomous meaning were so constituted its presence could only be a mockery to the viewer who is always still in the process of translation, always only 'getting there'.

(Perhaps this is the lure of the canvas: it appears finished whilst we are not.) What happens inside the frame can overwhelm the external action, mocking the viewer's power to determine the text. Baudrillard observed how the canned laughter on American television takes over the viewer's prerogative to respond: 'It is the screen that is laughing and having a good time. You are simply left alone with your consternation'.[5] The text, then, wrests meaning from its audience, and not the reverse.

XIII

The work of McCahon has both canonical authority and the authority that inclusion in the canon imparts. His work has become the plenipotentiary representative of that most erroneous New Zealand cultural 'coming of age' (whatever that might be). But the sheer fact of his work's success should problematise it for us as audience. We should interrogate our response to the 'volume' of the canvas, questioning what it is we hear, and why we hear it. I would argue that McCahon's 'volume' derives from the amplification of the cry of centuries of authoritarian humanism. His is the voice of the Patriarch offering lessons of mortality in the form of scripture. I remind myself: this is not scripture, but text: it is and will be changed. And is that not one meaning of 'resurrection'?

XIV

and Jesus was laid in the sepulchre . . .
 (Not the work, but the story of the work.)

Notes

1 Robert C. Holub, *Reception theory: a critical introduction*. New York: Methuen, 1984, p. 49.
2 David Harlen, 'The Return of Literature', *American Historical Review*, June 1989.
3 Levin L. Shucking (1913), Holub, p. 51.
4 Gordon Brown, *Colin McCahon: Artist*. Wellington: Reed, 1984, p. 178.
5 Jean Baudrillard (trans. Chris Turner), *America*. London: Verso, 1989, p. 49.
 Hans Robert Jauss (trans. Timothy Bahti), *Toward an aesthetic of reception*. Brighton: Harvester Press, 1982.

SARA KNOX

I Will Need Words

Wystan Curnow

I WILL NEED WORDS . . . Words can be terrible but a solution can be given. In spite of a message which can burn I intend a painting in no way Expressionistic but with a slowly emerging order . . .
Colin McCahon to John Caselberg, A Survey Exhibition, Auckland City Art Gallery, 1972.

In this present time it is very difficult to paint for other people — to paint beyond your own ends and point directions as painters once did. Once the painter was making signs and symbols for people to live by: now he makes things to hang on walls at exhibitions.
Colin McCahon, A Survey Exhibition, 1972.

•

I could have put together a Colin McCahon retrospective consisting of figurative, mostly landscape, works, or one of abstractions. Or, as here,[1] one featuring works representing words and numbers. McCahon's career has not been marked by crises precipitating conversions to this or that style, this or that theory of art. It hasn't followed the trajectory of a Philip Guston. Nor has it displayed the elegant vacillations of a Richard Diebenkorn. McCahon seems not to have felt obliged to choose whether or not he is an abstract or a figurative painter or, come to that, what in contemporary literature is known as a concrete poet. On the contrary. Many of his paintings would fit happily into two or all three of our retrospectives, a fact which reminds us how much our viewing is governed by convention and context. Indeed, it is the acknowledgement of contextuality in all his work which makes a number and word retrospective the most attractive choice.

Death has been this artist's overriding subject. His passionate agnosticism persists in bringing him face to face with the death of God — most often that of Christ on the cross. McCahon shares the tragic imagination of painters like Mark Rothko, Clyfford Still and Barnett Newman, but his art differs radically from theirs. Accepting the codes and conven-

tions they jettisoned and sought to transcend, he looks for order in the coincidences and contingencies resulting from his displacement and disruption of these very codes and conventions. The introduction of word and number into his work was, of course, a major instance of this displacement.

Colin McCahon was born in 1919. He belongs to a generation of artists whose careers begin in the immediate post-war years, and whose 'moment' in contemporary art history is an interlude in the later 1950s between Abstract Expressionism and Pop/Post-Painterly Abstraction. If McCahon took part at all in that moment it was as a spectator — he spent three months in the United States in 1958. What he made of that visit was to be seen in two extraordinary exhibitions of his work held the following year in Christchurch, a small New Zealand city not recognised internationally as a site for the making of art history. It was not too bad a moment to miss. The painterly abstract works of Pierre Soulages, Cornelis Corneille, K.R.H. Sonderborg and the like were soon made to look timid (and European) by the older Abstract Expressionists from New York. McCahon's contemporaries in that city were 'second generation', 'gestural realists' like Elaine de Kooning, Grace Hartigan, and Larry Rivers who lacked real originality. In the near provinces they were gestural landscapists like Richard Diebenkorn from San Francisco, or Peter Lanyon from Cornwall. As is clear from his Northland Panels (1958), McCahon was impressed by Diebenkorn's Berkeley series. These compromises with Abstract Expressionism, which to many was more abstract than it was expressive, cut no ice with McCahon's contemporaries of the far province of Melbourne, however. The Antipodeans, as they called themselves, included Arthur Boyd, John Perceval, Clifton Pugh and Bernard Smith. They issued a manifesto in 1959 which loudly proclaimed that 'the great Tachiste Emperor has no clothes — . . .' Against this background McCahon's

developing interest in word and number in the 1950s really does look like an opening, an addition to the limited range of possibilities then being canvassed by his contemporaries.

Many twentieth century painters have of course made occasional use of words and numbers in their work. Words appear frequently and naturally in much 'Pop' art, and even more frequently in late 1960s and early 1970s 'Conceptual' art where they occupy a more than casual relationship to the thinking that underpins the 'movement'. The work of Lawrence Weiner, Ed Ruscha, Hanne Darboven and Joseph Kosuth comes immediately to mind. But none use number and word the way McCahon does. His usage has to be seen in the context of the art of his own generation and of the issues that were uppermost for them. Seen thus it surely marks him out as the most compelling and original of them all.

•

It is interesting to observe that contemporary art in its boldest researches seems to be anxious to attain everything which characterises primitive art (i.e. pre-Raphaelite and Medieval Christian art) in the construction of the work in the simplicity, candour, and rationality of the means, in the ideographical schematisation of expression . . . In that sense, although from other points of view it is diametrically opposed to Christianity, contemporary art is far closer to a Christian art than academic art.
Jacques Maritain, *Art and Scholasticism*, 1946.

Words come into McCahon's art as inscriptions and speech bubbles in the 1940s via his interest in the Italian primitives, the Sienese quattrocento painters and Fra Angelico in particular. McCahon picked up on their use of words on scrolls, in the sky, issuing from the mouths of angels, not because those usages were unique to those artists, but because they were features of their ingenuous style. He was after an ingenuous primitive style of his own so the fact that those usages were shared by the low art of the comic only increased their interest. (In the days before rock and roll, video games etc., comics were regarded as the major threat to youthful innocence.) High art and low, past art and present, turning both ends against the middle — this was part and parcel of a cultural strategy. Commenting on *King of the Jews* (1947), McCahon reckoned that the yellow was from Byzantium and the lettering in the speech balloon he got

from a Rinso soap packet. Good taste was going to have a hard time from this painter.

The other convention McCahon took over from the Italians was that of relocating Biblical events in the painters' own time and place. Not that it was recognised as such; for many viewers his setting of the crucifixion in the Nelson area was in poor taste, while for others it was an assertion that the extreme of suffering represented by the crucifixion 'cannot but be part of our experience too'. McCahon's representation has a sharper edge when we recall that it was a product of the immediate post-war period — the artist had spent the war years and those following in the rural Nelson area where a number of artists regularly sought seasonal agricultural work. He was putting the war in Nelson, where surely it was in everyone's minds. And he was putting European history and culture in Nelson, where surely it was in the minds of McCahon and his fellow painters and, willy-nilly, in those of all its inhabitants.

There's the implication at the back of these paintings that New Zealanders are not yet at home in this place. Perhaps not surprisingly there were painters in Australia making a similar use of the relocation convention. Arthur Boyd's best known work of this period is the crucifixion diptych *The Mockers/The Mourners* (1945) which has sources in Breugel and Bosch. As with the series of his paintings with Old Testament themes which followed, the setting is the Australian bush. In 1951 Sidney Nolan exhibited a number of paintings with biblical themes set in the Australian landscape which had been directly inspired by contact with the work of the Italian primitives. As the earlier Ned Kelly paintings make clear, Nolan developed an ingenuous primitive style of his own at the same time as McCahon. Finally, it ought to be noted that the appeal to some form of primitivism was a widespread Modernist manoeuvre which took many forms. In general it has to do with a returning to sources on the assumption that something is radically wrong with our institutions, our values and rituals, and that such a return offers us the critical distance we need in order to make a new start.

•

McCahon's first attempts at 'all-word' paintings date from around 1945. The earliest to survive are *I Am*, and, *I and Thou* from 1954. These are small works in which the words, the same as the titles, gain

WYSTAN CURNOW

a certain monumentality from the way the letters are painted as three-dimensional objects. But the space they define and occupy is Cubist — full of contradictions and ambiguity. There have been several *I Am*s since then, the most remarkable being *Gate III* and *Victory over Death 2*, both painted in 1970. In them the monumentality of the two words is now literal: in the first they are ten feet tall, in the second, seven. The text is from *Exodus* (3:4):

Then Moses said to God, 'If I go the Israelites and tell them that the God of their forefathers has sent me to them, and they ask me his name, what shall I say?' God answered, 'I AM, that is who I am. Tell them I AM has sent you to them.'

God's name is his being, his identity. In *Victory over Death 2* the ambiguity is the result of an 'am' preceding as well as following the 'I', so

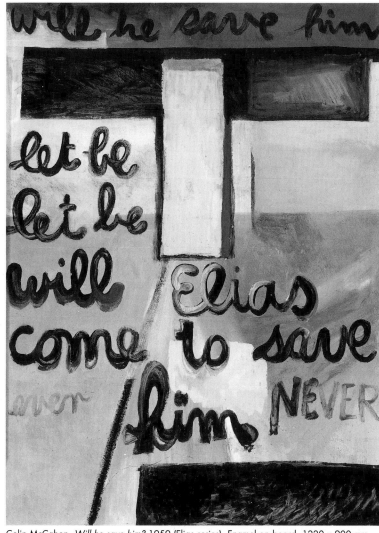

Colin McCahon, *Will he save him?* 1959 (Elias series). Enamel on board, 1220 x 900 mm. Auckland City Art Gallery. Presented by the artist, 1982. Courtesy Auckland City Art Gallery and the Colin McCahon Estate.

that the painting's major text reads: 'Am I [?]/I Am'. As if a question has been asked, then answered by the questioner him/herself. Or, as if there is some real uncertainty; it could be either. Since the first 'am' is somewhat obscured and the second in light and of a piece with the New Testament text with which it is combined, it is the first reading which is to be preferred. But only preferred, the doubt is not altogether erased. This painting is at once God's assertion of his being, Jesus's of his and (inescapably) McCahon's assertion of his. 'I talk all my paintings to myself . . . ' he writes. If God does *not* exist, if belief is not warranted — this possibility is before us — then this painting is surely a piece of monumental arrogance. *Victory over Death 2* is an instance of McCahon testing his nerve.

The next [*Victory over Death 2*] also belongs to the *Practical Religion* series — a simple I AM at first. But not so simple really as doubts do come in here too. I believe, but don't believe. *Let be, let be, let us see whether Elias will come to save him.*

The 1959 *Elias* series were all painted at Titirangi and all come out of the story of the Crucifixion (which should now be read in the *New Oxford* translation) and I became interested in men's doubts. (This theme appears here and appears later — I could never call myself a Christian, therefore these same doubts constantly assail me too.)
Colin McCahon, *A Survey Exhibition*, 1972.

Are you Roman Catholic?
 No, I'm nothing. But I have a great affinity for Catholic symbolism . . . as I have for symbolism of any kind . . . I

don't connect myself with any religious organisation. Not since the Quakers in Dunedin, many years ago.

From a talk at Outreach, Auckland, 1979.

As dramatisations of the crises of belief, the *I Am* paintings relate to the *Elias* series of 1959. The words of these are those uttered by the onlookers at Christ's crucifixion following his cry: 'My God, my god, why hast thou forsaken me?' and the action of one of their number who puts a sponge soaked in wine on the end of a stick and tries to wipe Jesus's mouth:
WILL HE SAVE HIM/LET BE/LET BE/WILL ELIAS/COME TO SAVE HIM/EVER/NEVER/
and
WAS IT/WORTHWHILE/WILL/COULD/ELIAS/ SAVE HIM/SAVE HIM/
and
ELIAS/WHY/CANNOT/CAN'T HE/SAVE/SAVE/ HIM/HIMSELF/
Alternate readings occupy alternate lines or form lists either side of the canvas. As with *Let us possess one world* (1955) and, more pointedly, with *Will He Save Him?* (1959) this latter use has the reader describing the sign of the cross with the movement of his eyes.

. . . it is language which provides the possibility of subjectivity because it is language which enables the speaker to posit himself or herself as 'I', as the subject of a sentence. It is through language that people constitute themselves as subjects. Consciousness of self is possible only through contrast, differentiation. 'I' cannot be conceived without the conception 'non-I', 'you', and dialogue, the fundamental condition of language implies a reversible polarity between 'I' and 'you'. Language is possible only because each speaker sets himself up as a subject by referring to himself as 'I' in his discourse.
Catherine Belsey, *Critical Practice*, 1980.

I, One, One is contemporaneous with the *Elias* series in time and style. What appears to be the right-hand side of a cross with the word 'one' written on the beam, reads also as a close-up of part of the letter 'I'. It hovers over both the cross and the second word 'one' which has been written in the area above the cross but below the 'I'. Here the question of individual identity is linked with the crucified Christ; self is a cross. The self is the impersonal 'one', and it is associated with individuation: 'one' not 'two'. The letter in the sky is the 'I' of God; Jesus and God are one and the same, that is to say they have different names, signifiers, but the same signified. With the resurrection 'one' ascends, from the cross (or is it from the tomb?) to the 'I'. In 1965, McCahon painted *One* — a reworking of this idea in the manner of the concurrent *Numerals* (1965) which dispenses with the Christian references.

The difference between words and images is that words as signifiers (i.e. as aural and visual signs) make no pretence to resemble their signifieds (i.e. the concepts to which they refer). The word 'cross' does not in any way resemble what we mean by the word either as a group of sounds or a set of graphic symbols. The connection between the two is therefore purely arbitrary, a matter of convention. The two paintings I have been describing trade on the arbitrariness of sign systems. In *I, One, One* the *image* and sign are brought together in a marriage of coincidence, and convenience. Both works are puns.

They [the 'Necessary Protection' drawings] have to do with the days and nights in the wilderness and our constant need for help and protection. The symbols are very simple. The I of the sky, falling light and enlightened land, is also ONE. The T of the sky and light falling into a dark landscape is also the T of the Tau of Old Testament, or Egyptian cross.
Colin McCahon, *Necessary Protection*, Barry Lett Galleries, 1971.

McCahon's remarks also relate to *The days and nights in the wilderness showing the constant flow of light passing through the wall of death*, a canvas which is included in this exhibition, and a companion piece, *The days and nights in the wilderness showing the constant flow of light passing into a dark landscape*. Painted together in 1971, they are identical in size and very similar in colour and image. The first is a large ochre/brown 'I', and the second a large ochre/brown 'T' — as if the 'I' had dropped and we had lost sight of its bottom horizontal stroke. The connection we made in *I, One, One* between the 'I' and the 'T' is here a connection between two separate works, with the one providing the context in which to read the other. This is a kind of cross-referencing (pun intended) with which McCahon's work is riddled. Each of these works links a sign, be it the arbitrary sign 'I' or the conventional sign/symbol of the cross, with an image of a landscape. We make the connection by reversing the figure/ground relationship.

WYSTAN CURNOW

Colin McCahon,(left) *The days and nights in the wilderness...* 1971. Acrylic on unstretched canvas 2378 x 1840 mm. Colin McCahon Estate; (right) *The days and nights in the wilderness...* 1971. Acrylic on unstretched canvas 2360 x 1840 mm. Govett Brewster Art Gallery, New Plymouth. Installation shot from *Gates and Journeys,* Auckland City Art Gallery, 1989. Courtesy Govett Brewster Art Gallery and Colin McCahon Estate.

The ochre reinforces the landscape reading but it also relates these two works to the more yellow figure 'I' of *Through the Wall of Death* (1972) whose ground is also a night sky, and to the orange-grounded *One* (1965). We are reminded of further characteristics of language: words do not name things, only categories, and they only come clear as meaning because they are locked into contexts which allow us to distinguish differences.

McCahon can yoke (joke) together the first person singular and the number one in the way that he does, only because in English there is a coincidental identity between the graphic sign for the capital 'I' and the roman numeral 'I'. In French, for instance, you have quite different signs: 'Je' and 'I'. Similarly, the ambiguous sign 'one', meaning both the number one and the impersonal first person singular, doesn't occur in French, where again you have two forms, a difference: 'un' and 'on'. French, of course, offers opportunities of its own for this kind of punning. Further, the coincidental identity of the aural sign for 'I' and 'eye', which supports McCahon's association of 'I' with sky (the process of seeing requiring light to pass through the eye, the connecting of I with God

by light), is restricted to English. These punning connections do provide us with 'a slowly emerging order' but it is one which is built on the arbitrariness of language, on the conventions of human communication.

•

McCahon's number works fall into three distinct periods: 1958-59, the middle of 1965, and 1973-76. As to the first period, the artist has written:

The watercolours of *Two* and *Three* were developed from a whole series of numbers I designed as tail-pieces for the magazine *Landfall* . . . Like the tail-pieces they were designed so that they could be shown any way round . . . I did a major series of numbers on much larger sheets of paper not long after these. All were done about the time of the *Northland Panels* and drawings.
Auckland City Art Gallery Quarterly, 44, (1969).

Late in 1959 he exhibited two sets (they were on slightly different sized paper) of numerals: *Numerals One to Ten* (1958), and *Numerals One to Five* (1959). The earlier set was to be sold as one but was in fact later broken up. McCahon also notes in the

Quarterly that the paper he used for these and the Northland drawings 'was a kind of young cardboard of a somewhat yellowish colour and the combination of that yellowish colour and black and somewhat gritty chinese "writing" ink was about as visually splendid as road signs'.

There is a change of interest to be noted: from *Two* (1958) and *Three* (1958) to *Two* (1958) from the set 1-10 and *Two* (1959) from the set 1-5, there is a shift of focus from structure to process and gesture which is typical of the change that was taking place in his work following his 1958 American visit. Since the whereabouts of all the works in these two series has not yet been established, it is not possible to comment on the relationship in them between process and sequence. But it is clear from the ones known about that McCahon's interest in number as sign begins with these series. What begins as an arbitrary sign on which to base a composition which 'could be shown any way round', becomes an exercise in combining the different signs for the number concerned and giving them the 'signature' of the sign-maker. These drawings multiply the number of visual signifiers for a single signified. Word and number sign are juxtaposed. In *Four* (1958) 4 and 4 occur

as well as the word. In *Three* (1958), there are also three dots, and the first three letters of the word 'three' have been painted over several times more than the last two. Three times maybe?

Numerals (1965) extends McCahon's exploration of number signs by presenting them in their essential linguistic context: the base ten sequence. As is the case with grammatical sequence, the position of an item in a series is itself a sign. Panel number one is unnumbered — its conventional sign is to be found on the following panel — but it can be called the zero-before-the-one, nothing, or, if you like: position. The panel which signifies only because it has a sequel. It establishes the framed panel as the sign for position.

Position either stabilises or destablises, reinforces or complicates, the meaning of the other signs. There are thirteen panels but the signified of the set as a whole is the base ten sequence. The odd number of panels in the work, as opposed to the even ten, taken together with the unprecedented whiteness of the last panel, reads as a sign of opening, continuance, renewal, rather than one of ending, closure. Thus the difference between one and ten as first and last begins to take on significance. The central position in

Colin McCahon, *Numerals* 1965. Acrylic on hardboard (13 panels), installation shot. Auckland City Art Gallery. Presented by the McCahon family 1988. Courtesy Auckland City Art Gallery and the Colin McCahon Estate.

WYSTAN CURNOW

the set is occupied by panel number seven, the subject of which is the number four. The downstroke of the figure four is strong and directly above the 'O' of the word 'four'; because this 'I' over 'O' is a permutation of the 'O' over 'I' of panel two and the 'I' before 'O' of panel thirteen, we have a reinforcement of the centrality of the seventh panel.

It takes seven panels to get to the number four, partly because the concept of sequence is largely established by the numbers one to three and is richly developed in this work. As with panels one and two, the signified of the third panel is the two preceding panels. It is itself subdivided, vertically, and thus is also its own signified. It also generates a substitute, Arabic, figure 2 which subsequently takes over as the type of number used. The Roman numbers return in the final two — a further reinforcement of the first and last panels as the beginning and end. The Arabic 2 takes over in another way: it undermines its own arbitrariness as a sign by dividing the right side of the panel into two, horizontally so as to signify the sky and the earth. At least that can be inferred from the extending of its base to the frame edge and thence across the subsequent (fourth) panel. Perhaps because McCahon's 2s have a Maori look, and because *Numerals* is a contemporary of *One, two, three* with its number signs based on the Maori *koru* motif (representing 'growth'), I suspect a creation story. Certainly 'I' and 'O' spell the name I0, the Polynesian Supreme Being. Perhaps that is Rangi (sky father) lying on Papa (earth mother) in the darkness of panel four. And the light top half of five may be read as the result of their separation which was to give light and space for their offspring. After four it's another story, with five, six and seven leading an underground or night time existence which precedes the dawning day of panel thirteen. *Numerals* has little to do with mathematics and much to do with the syntax of narrative.

•

The series, or sequence, is an alternative to the pile up of signs overlaid upon signs we have found in individual works. This crowding, cramming in of meaning has a basis in McCahon's dualism. The numbers you can't get away from, 1 + 1, the binary opposition. Night and day, black and white, life and death, belief and unbelief. All his painting life McCahon has been making his art out of these contradictions, unable to

avoid or resolve them. Sequence and its narrative expression, the journey, are structures of hope in so far as they are open-ended, a source of relief in so far as they stretch out, provide for movement ahead.

These [*Numerals*] took months to paint and developed very slowly. They work as a painting and as an environment. They are where we are in one way; and, in another way, if we could walk on from 10 where we would get to.
Colin McCahon, *A Survey Exhibition*, 1972.

I'm finished with frames and all that they imply. I want paintings to pin up or nail up or tie up with string. I think it gives them more freedom to act.
Colin McCahon, *Centenary Collection*, Manawatu Art Gallery, 1971.

People should know perhaps that I don't regard these canvases as 'paintings'. They shouldn't be enclosed in frames, they are just bits of a place I love and painted in memory of a friend (James Baxter) who now — in spirit — has walked this same beach. The intention is not realist but an abstraction of the final walk up the beach. The Christian 'walk' and the Maori 'walk' have a lot in common.
Colin McCahon, announcement note for *C and D Series, Mourning for Baxter*, Peter McLeavey Gallery, September 1973.

Right after *Numerals*, McCahon began work on a commission for the Convent Chapel of the Sisters of Our Lady of the Missions, Auckland. As part of this he painted a long undivided landscape Stations of the Cross sequence, his first. Specific stations were represented in *Drawing for Charles Brasch* (1952), but not the full sequence, which is as follows: (1) Jesus is condemned to death. (2) The Cross is laid upon him. (3) Jesus falls the first time. (4) Jesus is met by his blessed Mother. (5) The Cross is laid upon Simon of Cyrene. (6) Veronica wipes the face of Jesus. (7) Jesus falls the second time. (8) The women of Jerusalem mourn for Our Lord. (9) Jesus falls the third time. (10) Jesus is stripped of his garments. (11) Jesus is nailed to the Cross. (12) Jesus dies on the Cross. (13) Jesus is taken down from the Cross. (14) Jesus is lain in the sepulchre.

It wasn't until 1973 that McCahon began to combine stations with numerals. All number works of this, the third, period are of the 1-14, stations kind, and they occupied much of his attention for the next three years or so. The use of numbers as signifiers for the stations provides the narrative structure of the numerical sequence with a specific and religious narrative signified, or content. Roman numerals are

now more frequent in the paintings and in this context signify the authority of Empire, of temporal power. Time which is inherent in the concept of number sequence gains an historical dimension and number a specific mnemonic function. For 'position' read 'station'; for the viewing-reading act read devotional exercise and for movement from number to number read the taking of steps on a ritual journey.

'Position is where you/put it . . .' (Robert Creeley, The Window, *Words*, 1967). McCahon puts it in an art gallery, it being first of all a landscape. As early as the *Northland Panels* and *The Wake*, he gave his paintings the freedom to act frameless on the gallery space. (A related 'letting loose' does, of course,

and the fictional are not protected from each other as otherwise they would be. The gallery is put into an unaccustomed position, that of being a church. Or, as with *Teaching Aids 2* (1975), that of being a school. Such places are invited to coincide. Remove one set of frames and you put pressure on another.

This is not to say McCahon doesn't use boundaries, margins divisions, enclosures. Far from it; as with the title which he long ago displaced from a plaque on the frame onto the canvas, now the frame itself seems to have moved inwards. McCahon has appropriated the sign of the frame and converted it to the sign of the 'station'. *Teaching Aids 2* consists of ten panels arranged in rows of five numbered 1-5, 6-

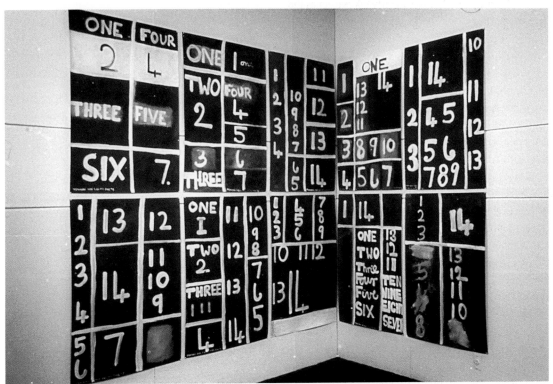

Colin McCahon, *Teaching Aids 2* 1975. Acrylic on paper (10 sheets), 1092 x 728 mm. (each sheet). Colin McCahon Estate. Courtesy Colin McCahon Estate.

occur even earlier when McCahon gives the crucifixion its freedom to act in the Nelson landscape.) He extended this in *Landscape Series A and B* (1963) which were hung as an environment. In *Walk* (1973), which is some forty feet long, and a 'stations' work, he lays place (the actual Way of the Cross) over place (the church re-presentation) over place (Muriwai Beach, the artist's presentation) over place (the actual art gallery). *Walk* has a new literalism which depends upon the removal of the frame: the actual

10. All are covered with station numbers; the first two going up to seven, the rest to the full fourteen. The numbers are framed either singly or in groups representing various structurings or interpretations of the story of the Passion. Each sequence is not horizontal; rather, starting in the top left-hand corner each reads down the left edge and then takes various vertical and horizontal routes to the last number, which is often positioned in the top or bottom right-hand corner. In panel six it is actually enclosed in the

middle, reinforcing its reference to Christ's entombment. Each panel is like a blackboard on which someone is obsessively rehearsing the Passion, each line coming up with a different understanding. With its many erasures, mistakes, corrections, *Teaching Aids 2* is evidence of this effort: to get the sums right, to see if it all adds up.

Te Tangi O Te Pipiwhararua (The song of the shining cuckoo . . .) (1974) (see pages 174-5) is a landscape and stations work and it too uses framing devices in a most complex way. The five panels, which are in fact blind canvases (the pun here is one McCahon himself has used), have borders sewn at the top and bottom and marked by a red thread down each side. These borders are for the most part painted in, although gaps are left to provide 'gates' for the cuckoo's flight. Internal framing lines double as station dividers and horizon lines. Each panel is either a view out a window, a tombstone, or both. McCahon sets the movement of the number sequence and the freer movement of the bird's flight, off against the concentrated ambiguities of image and sign generated by his playing with the conventions of the frame.

The text of this painting is a Maori lament which Ralph Hotere, a painter friend, had from his father and passed on to McCahon who translated it thus: The Song of the Shining Cuckoo/Glow and tell us, glow/Pierce us and join us together, /Bird, alight on the beach,/Alight, my friend, alight/Alight there and rest. This combination of Maori and European imaginative structures is one of several McCahon has made. The two drawings from the *Jet out from Muriwai* series relate to the Maori account of how the spirits of the dead travel to the tip of the North Island, Te Reinga. Here they leap to the Three Kings Islands (their Pakeha name) and take their last look at the land of life. Both the jet and the cuckoo are on this spirit path to the North.

It wasn't in any significant way a question of staging a Holy Communion service or a Sun Dance but of re-establishing the conditions of 'Communion' as a most general proposition about all our work. The problem, after all, is largely western, because in the west there was this historical consignment of great areas of human experience to the domain of something called the secular — like dance, like comedy, like the natural world itself to take a really major instance.
Jerome Rothenberg interviewed by Dick Higgins, O.ARS 1, 1977.

In the early months of 1962 McCahon painted a set of four paintings called *Koru*; later that year, a set of three landscapes with inscriptions in Maori. In 1965, besides *One, two, three* there were attempts at Maori letter forms. *The Tail of the Fish: Maori Memories of the Far North*, 1968, by Matiere Kereama, an eighty year old elder of the Aupouri tribe, was the source for some word paintings from the summer of 1968-69 and drawings of August and September 1969. Three years later he exhibited a number of works painted in homage to the great nineteenth century Maori prophet and rebel Te Whiti O Rongomai. Te Whiti preached non-violent resistance for nearly forty years and led Maori opposition to the wholesale plunder of Maori lands in the Taranaki region late last century. *The Parihaka triptych* (1973) was painted at the request of James Mack for an historical tribute to Te Whiti at the Waikato Museum. In all these works it is clear that McCahon values the absence of the secular in Maori culture. Te Whiti:

When I speak of the land, the survey, the ploughman, and such small matters, the pencils of the reporters fly with the speed of the wind, but when I speak of the words of the spirit, they say this is the dream of a madman.
Cited in Dick Scott, *Ask that Mountain*, 1975, p. 57.

•

The Canoe Tainui (1969) has a special position in this exhibition. Like *One*, it's a kind of nexus of number and word, but unlike *One* it's to do with family rather than individual identity — a contrast which points up some of the values at issue between European and Maori. The naming, the counting out of the generations concerns the articulation and preservation of a narrative on which the sense of Maori social structure depends. The source is *The Tail of the Fish*, which has this note on the title page:

Genealogies linking the different historical personalities usually include the narrator, establishing her right to tell the stories. We are proud of the way in which our ancestors preserved these tales, originally by word of mouth and more recently by writing them down. I tell the stories of my Aupouri ancestors as they were told to me.

McCahon, too, tells stories of ancestors by writing them down. In two exhibitions of 1969 which included many word paintings, he meticulously acknowledged the sources of his texts. It is important to stress that

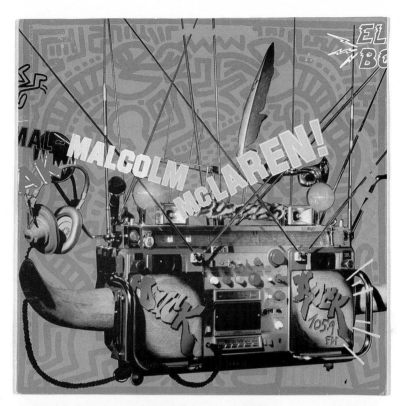

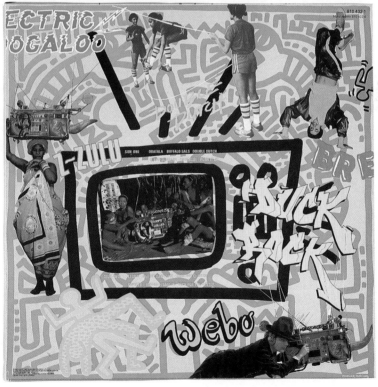

Malcolm McLaren, *Duck Rock*, Charisma 1983. Design: Nick
Egan. Illustration: Keith Haring. Graffiti: Dondi White.

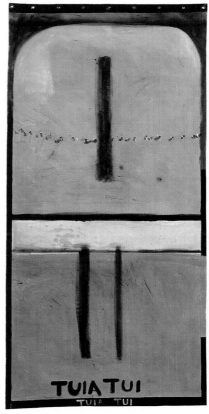

Colin McCahon, *Te Tangi o te Pipiwhararua* (The song of the
shining cuckoo; a poem by Tangirau Hotere) 1974. Oil on
unstretched canvas (5 panels). Hocken Library, Dunedin.
Presented by the artist 1977. Courtesy the Hocken Library and the
Colin McCahon Estate.

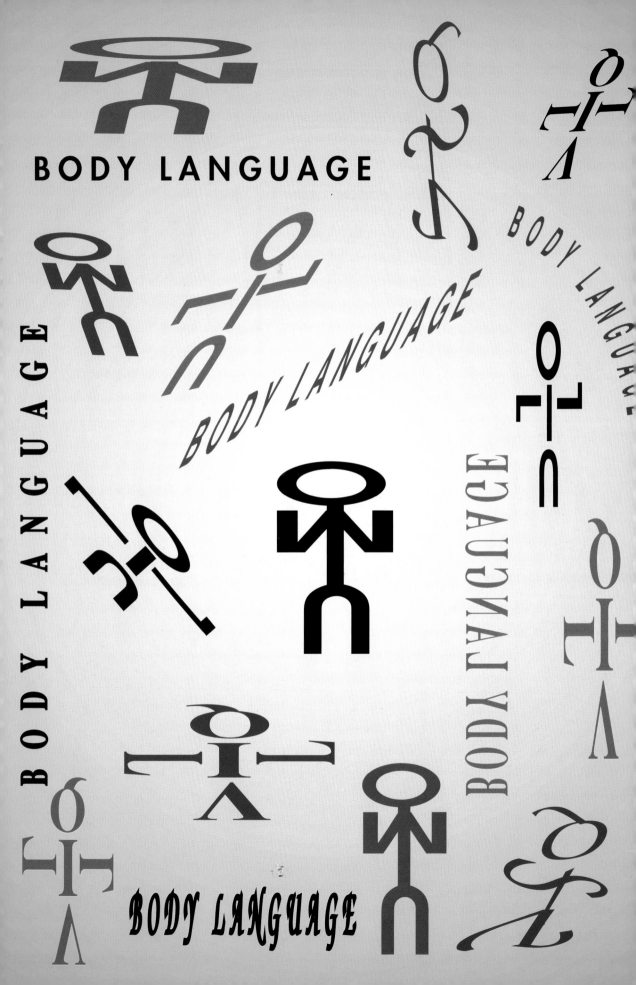

he is *not* the author of the texts he uses. For all that he approves of them, identifies with them, talks them to himself, he did not write them. He tells us how he came by them: he asked his poet friend, John Caselberg, for the text of the *Second Gate Series*, his daughter found *The Tail of the Fish*, Ralph Hotere sent him a poem. He presents himself as a recipient of the language — as he is the recipient of all the signs, symbols, conventions that form the content of his work. McCahon's attraction to the prophetic and apocalyptic voice notwithstanding, he never takes up words out of some expressionistic desire to remove all obstacles in the path of self-proclamation. Rather he enters the language as a reader who would share his reading with us. And of course, he is a passionate reader.

Reading is not, however, an entirely passive act. My 'reading' of a McCahon painting is my 'interpretation'. I like to think of the painter as an anthologist of sorts, a collector, and a translator. In his choices, McCahon is careful not to quote 'out of context'. He is a scrupulous editor as the text of the Lazarus story in *Practical Religion* shows. In the same way, he is mindful of the book of his own work, as year by year his collection of quotations grows. How does the addition of this or that text reinforce or complicate

the story so far? Of course we are here returning to the process with which we have been concerned throughout, that of extracting signs from one context and transferring them into another. To 'translate' means to (1) bear away, convey or remove from one person, place or condition to another; to transfer, transport (2) to turn from one language into another (3) to interpret, explain, to express one thing in terms of another (4) to change in form, appearance or substance, to transmute, to transform.

In translating words from books to painting, McCahon changes their form from that of the printed word to that of the handwritten. While in the 1950s this was an opportunity to shape, touch up, colour the words, to interfere with their visual arbitrariness as signs, since the late sixties he has been more content to let his hand take its normal course. McCahon has not got 'a fine hand'. His is not the italic script of the architectural draughtsman, nor the neat hand on the restaurant menu blackboard. It is unaffected, more or less anonymous, and its significance lies less in its character than in its being public and on a relatively large scale. McCahon's paintings look like (preaerosol) graffiti, protest placards and banners and blackboards outside fruit and vege shops because those are the only other 'sites' for handwriting writ large and in public.

Colin McCahon, *The Second Gate Series* (detail) 1962. Enamel on 16 panels, National Art Gallery, Welington, purchased 1984. Courtesy National Art Gallery and Colin McCahon Estate.

Gas Station, Makoia Rd., Birkenhead. Courtesy Wyston Curnow.

You've all seen those number paintings without realising it. For example fruit stalls with white lettering. The best in New Zealand are on the Bombay Hills.

From a talk at Outreach, Auckland, 1979.

The translation of black on white to white on black goes back to McCahon's work of the mid-sixties and is a significant feature of his reading. Recollections of road markings — see *On the Road* (1976) — AA signs, of scoreboards, and totalisator boards, are not out of keeping. More importantly, however, the reversal means that the art of writing is to be seen as making visible, a bringing of light. In *Practical Religion* the light of approaching dawn over Mount Martha (North Otago) illuminates, or at any rate gives vital reinforcement to the artist's hand which writes out the word of God in the night sky. The lovely assurance of the handwriting in *Are there not twelve hours . . .* (1970) has the same kind of support, and yet the text raises the question as to whether the light of this world is enough. God is the only source of true light.

All eyes on Nazareth please. For years I've tried to break the chain of light of dark of light again. Now knowing that it can't be done I humbly thank you God the Son.

Text of 'Scroll' drawing, 20 September 1969.

Since the mid-sixties McCahon's feel for black and white has become increasingly and extraordinarily sensitive. This exhibition cannot show how completely those two non-colours have come to dominate his work, nor the great range of possibility for colour their use has opened up. The handwritten text is like a gate or the beginning of a sequence. The word shines again with each replenishment of the brush. The text instances the freedom to be found in language, as the gate that in imagery, as the sequence that in number.

Note

1 This exhibition was organised by the National Art Gallery on behalf of the Queen Elizabeth II Arts Council for the 1984 Sydney Biennale, 'Private Symbol: Social Metaphor'. Commissioned by the Biennale Director, Leon Paroissien, it was originally intended to be one of three satellite exhibitions; those featuring Frida Kahlo and Anselm Kiefer did not eventuate. *I Will Need Words* was subsequently seen at the Talbot-Rice Art Gallery as part of ANZART-in-Edinburgh, a festival of Australian and New Zealand art organised by Richard Demarco for the 1984 International Festival of the Arts. the first overseas exhibition of McCahon's painting, *I Will Need Words* was also seen at the National Art Gallery on its return in November.

This essay was first published in *I Will Need Words*. Wellington: National Art Gallery, 1984.

The Enunciation of the Annunciation

Discourses of Painting

Laurence Simmons

Commentary exorcises the chance element of discourse by giving it its due; it allows us to say something other than the text itself, but on the condition that it is the text itself which is said, and in a sense completed.
Michel Foucault, *The Order of Things*

So painting is articulated upon the very thing that is missing in a painting.[1]
Jean-Louis Schefer

Painting a text

You are standing in front of Colin McCahon's *The Angel of the Annunciation*. As well as the painted surface and its content — Is this a New Zealand scene you wonder? Could the central figures be the Archangel Gabriel and the Virgin Mary? . . . — you also note the gold frame which encircles the image, the inscribed title (?) and the brushstroked signature of the painter in the lower left corner. Attached to the wall to the lower right of the picture there is a white card containing the following information: *Colin McCahon, THE ANGEL OF THE ANNUNCIATION, 1947, oil on cardboard, 647 x 521 mm., (Collection National Gallery of New Zealand)*. All these things and more around you seem part of the visual field under your gaze.

There is, of course, a necessary fiction in such an opening: you are not immediately gazing at this painting by Colin McCahon, you are reading a written text: this text. One can't both look *and* read you might wish to object. But as we have already noticed with signature, title, and information label simply looking, too, is already a kind of reading. So what is the relationship between *this* writing and *that* painting, between writing as such and painting, between reading and painting, and reading writing on painting? The commonsense, and often the painter's, point of view is that painting has no need of writing, 'would be better off without it, or might even come to harm as a result of it.'[2] The opposite, and, not suprisingly, often the critic's or writer's position is that a painting does not fully exist without the writing on it. It lacks in some essential way, so that painting of necessity entails some form of writing to complete it. You can see that both these views imply that writing and painting are distinct practices, and whether they differ from each other or entail each other they are different and so remain discontinuous. In contrast to this widely accepted dichotomy, there is in much recent critical theory, perhaps through its insistence upon the figural nature of language, a notion of the textual that successfully exceeds the limits of the representational level of written language to encompass pictorial representation as well, a notion that seeks to make the verbal or the written and the pictorial continuous. You are now more readily coming to 'read' a painting much as you 'read' a written text, a practice which

Colin McCahon, *The Angel of the Annunciation* 1947. Oil on hardboard, 647 x 521mm. National Art Gallery, Wellington. Courtesy National Art Gallery and the Colin McCahon Estate.

you were pointed in the direction of some ten years ago by Roland Barthes:

. . . if literature and painting are no longer held in a hierarchical reflection, one being the *rear-view mirror* for the other, why maintain them any longer as objects at once united and separate, in short, classed together? Why not wipe out the difference between them (purely one of substance)? Why not forego the plurality of the 'arts' in order to affirm more powerfully the plurality of 'texts'?[3]

The difference between painting and writing is, as Barthes suggests, a material one — 'of substance' — not one of critical analytics. Yet curiously, and perhaps paradoxically you note, it is the very material nature of the painted image contrasted with the abstract immateriality of language that is inscribed in the central drama of the production of painting. You know that figurative painting, from the Italian Quattrocento and the invention of perspective on, tended to define itself as *iconic*, that is, founded upon a communicative contract which presupposed adherence between objects represented and objects in the world. Yet this *iconicity* of painting, its attempt at objectivity and realism, depends paradoxically upon techniques of maximum abstractness (difficult geometrical theory and grids, colour theory, etc.). In other words, the more painters researched and achieved a 'realistic' effect, the more they turned to the techniques of artifice. You insist, for the notion of a painting as 'text' the domination of Renaissance perspectivism has important corollaries: in figurative painting the theories of representation are of necessity hidden in the realistic effects desired; at the same time, there is, in figurative painting, a presupposed 'theoretical space' that is physically expressed in painterly terms. In terms of the relationship between the modalities of production of the text and the text itself, every painting contains within it the traces of its own 'communicative machine', references to abstract theories (revealed or implicit) on its own generation and interpretation, its own 'deep structure' to adapt a term from Chomskyian linguistics. Thus you feel authorised to accept the notion that painting is a form of knowledge whose practise conceals its own fabrication and is marked by a perpetual curving back upon itself, a questioning of its own limits. As Louis Marin suggests, it is a notion of pictorial practice 'based upon the assumption that direct experimentation with the theoretical problems of painting can in fact become "the subject of painting".'[4]

This definition of art, in fact of all cultural productions, through an analogy with language is, you understand, one of the fundamental tenets of the field of semiotics. It also touches a problem at the nerve endings of all art criticism, that of the relationship of the language of the critic, and language in general, to the figural properties of the work of art. That the pictorial moment would not be effective if not framed by the linguistic moment that preceded it, or that follows it, is the unsettling paradox known to all critics of painting and the one resisted by most painters: One can only see what one can say.

'Painting can be a potent way of talking'[5]

It is this very coupling of saying with seeing, how the discourses around painting legitimise the interweaving of a linguistic moment with a perceptual one when in fact the opposition between the perceptual and the linguistic is manifest within the general textual situation of painting, that you wish to examine here in a group of early paintings by Colin McCahon: *The Angel of the Annunciation* (April 1947), *Hail Mary* (May 1948), *Annunciation* (July-November 1949). You feel, at first sight, that vectors of connection exist between these three paintings that are not solely nominal (they *are* by the same hand), or temporal (their production was separated by intervals of approximately one year), or thematic (their subject matter is a traditional religious one — the Annunciation).[6] A connection, you feel, that resists all effort to break it apart with stylistic or formal argument for it is not formed solely of those elements.

This hypothesis, which you find particularly seductive, has the singular merit of imposing the condition of seeing these paintings as an ensemble, of drawing you into the game of genre which they refer back to, of discovering how one painting replies (the etymological link with *replica* is not to be discounted) to another in assuming its individuality, what it transforms and what it chooses to represent. So in the first instance you are talking of three paintings talking to each other.

There is more. Every painting is the articulation of the relations between paintings, a weaving together of what has been produced elsewhere in discontinuous form; every subject, every painter,

every self is the articulation of an intersubjectivity structured within and around the discourses available to it at any moment in time:

Any text is a new tissue of past citations. Bits of codes, formulae, rhythmic models, fragments of social languages etc. all pass into the text and are redistributed within it, for there is always language before or around the text. Intertextuality, the condition of any text whatsoever, cannot of course be reduced to a problem of sources or influences; the intertext is a general field of anonymous formulae whose origin can scarcely ever be located: of unconscious or automatic quotation, given without quotation marks.'[7]

Intertextuality, you feel certain, is not merely a network of sources alluded to in the text: the connections are not always single ones, but may also constitute the architectural principle of the text, the typological mechanisms of transfer between texts, even the codes of genre.[8] And it is here that you will be tempted to play the role of the erudite. You know from many and varied sources that Colin McCahon, while painting this first series of religious paintings of the late 1940s, became familiar with features of Italian Quattrocento and early Cinquecento painting. McCahon himself in the survey exhibition catalogue speaks of 'the wonderful gift of the Phaidon Press in revealing Titian.'[9] Hamish Keith states that 'a flying angel in one version of the entombment was taken over almost intact from Signorelli's *Martyrdom of St Catherine*.'[10] Gordon H. Brown is even more forthright: 'the decisive influence upon these works came from McCahon's interest in the Italian primitives, particularly the Sienese Quattrocento painters and Fra Angelico';[11] and he notes in a bibliographical reference that 'McCahon acquired John Pope-Hennessy *Sienese Quattrocento Painting*, Phaidon 1947, shortly after it was published.'[12] So McCahon's texts/paintings are already readings of earlier texts/paintings themselves in turn readings of Biblical texts. Hence you feel authorised, for the moment, to further draw attention to the systematic variation in the presentation of this historical progression.

Among the extreme variety of representations of the Annunciation in Italian Quattrocento painting several recurrent figures may be observed:
— the considerable importance given to the archi-
tectural framework of the scene. Where in fact the *domuncula* (the house of Mary), with its contrast of exterior open loggia or portico and enclosed interior space, progressively becomes an object of architectural and decorative elaboration and an important structural element of each composition as a whole;
— the placing of the figures within the dramatic action. The Archangel Gabriel and the Virgin Mary are placed perpendicular to the linear axis of perspective, Gabriel on the spectator's left, Mary to the right, and both often on the same horizontal plane.[13] (A notable *late* shifting of these otherwise statically repeated elements is to be found in Titian's *Annunciation* (Treviso, Duomo) and Paolo Veronese's *Annunciation* (Venice, Basilica di San Giovanni e Paolo));
— the direction of the gaze of the participants. While the face of the Virgin may be presented from different angles (though rarely frontally), the face of the Archangel is nearly always in profile and his gaze directed at Mary's face;
— the precise moment of the dramatic action portrayed. Although the selection of the actual moment in the temporal sequence of events may vary, each Annunciation portrays the very moment of enunciation and the tension between the figures is a tension brought about by the spoken message;[14]
— a phylactery: the presence of the annunciation spoken by the Archangel and the reply of the Virgin as words written in rays or ribbons stretching horizontally across the composition. The words of the Angelic greeting come from heaven and may be read from the spectator's point of view, while the reply of the Virgin is directed to God and its writing is turned upside-down.[15]

You can now examine some of the ramifications of this list of figures. The Biblical text (*Luke* 1: 26-38) says nothing of the place where the Archangel Gabriel encounters Mary. Without any textual precedent, the progression from the architectural simplicity of the early Annunciations — for example, that of the Maestro del San Pietro (Siena, Pinacoteca) or Fra Angelico's in one of the cells of the Convent of San Marco in Florence — to the sophisticated complexity of the geometric grid of Leonardo da Vinci's *Annunciation* (Florence, Uffizi), exemplifies the dominant role of perspective in the construction of pictorial space in fifteenth century Italian painting. You see, don't you, that Leonardo's *Annunciation* in

LAURENCE SIMMONS

fact seems almost a schoolbook illustration of it. The articulation of depth of space allowed for by the use of perspective permits the multiplication of spaces within the composition (for example, the scene of the expulsion of Adam and Eve from the Garden of Eden in the background of Fra Angelico's *Annunciation* (Cortona, Museo Diocesano), the disappearing corridors of the Gardner *Annunciation* (Boston, Isabella Gardner Museum), and that of the Master of the Barbarini Panels (Washington, National Gallery of Art)). Perspective, too, introduces other elements which point to the very centre of the drama of the painting: the low wall that separates the naturalistic elements of the background in Leonardo's panel functions as a barrier, a means of attracting the gaze and directing it to what lies beyond which is, of course, the vanishing point, infinity. Directing the gaze, also, to the walled garden of Mary's virginity — the *hortus conclusus* — the wall is there to lead the eye to what stands beyond, the apparently invisible, that which monocular vision does not allow one to see but which, and here is the leap, is there as a spiritual presence at the very centre of the composition. A silent centre, since like the doctrinal mystery of the Incarnation, the content of the Archangel's message is non-figurable. The painter through the figures must propose the non-figurable, the vision make apparent the invisible, the painting enunciate the unsayable.

Handing over, giving up

But you are becoming impatient. Enough of theoretical consideration and words around other works. You are now in a position to see how McCahon has incorporated these intertextual elements into the dynamics of the ensemble of these paintings — the play of inclusion, transposition and omission. You feel naturally drawn to Harold Bloom's explanation and exposition of tradition as '*traditio*: a handing over, a giving up . . . and so even a surrender or a betrayal.'[16] In *The Angel of the Annunciation* (**AA**) the structuring and structural element of the architectural framework persists under a different and less dominant form: the farmhouse[17] on the low hills at the foot of the mountain ranges echoes in a modernised form the *domuncula* of the Quattrocento Annunciations and the superimposition of the figure of Mary upon the building serves to emphasise the association. McCahon, you are sure, is appropriating

another Quattrocento convention here: the relocation of Biblical events in the painter's contemporary reality. In McCahon's painting the natural background of the surrounding hills has become the dominant structural principle of the composition, with a complex interplay of diagonals within the wide central band of interlocking hills. Nature here is no longer urban nor the domesticated garden of the Quattrocento versions. The 'scene' of the painting *Hail Mary* (**HM**) is, on the contrary, on two levels: a foreground of figures of the Archangel and Virgin with an inset, like a small blow-up (or, perhaps given its thick-edged frame, a painted panel within the painting?) of three arum lilies; in the background of these elements a field with a low horizon on which

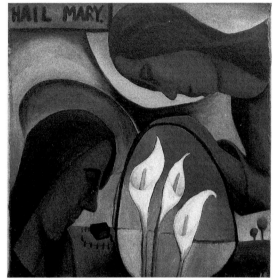

Colin McCahon *Hail Mary* 1948. Oil on canvas, remounted on wax linen, 935 x 890mm. Govett-Brewster Art Gallery. Courtesy Govett-Brewster Art Gallery and the Colin McCahon Estate.

you can discern two trees on the right (perhaps an evocation of the human term of Christ's life posterior to the events of the painting in its referral to the *lignum vitae*, the wood of the cross). The continuation of the line of the horizon through the lily inset helps to further obliterate the effects of distance and perspective, and the picket fence around a rudimentary building echo in a more discrete fashion than *The Angel of the Annunciation* the *domuncula* and *hortus conclusus* of Quattrocento Annunciations. In *Annunciation* (**A**) the total absence of background, buildings, or any natural or symbolic references makes this painting more tellingly stark.

What is the exact development and dialectic of the

AA	HM	A
Three 'levels' or stages of depth: aforeground of figures; mid-ground of low hills; background of mountains.	Two levels: foreground of figures and inset of lilies. Background of field with horizon.	Only a foreground of two figures given against a uniform backdrop of red brown tonings.
No specific details of nature.	Two trees and lilies.	No natural attributes at all.
Building (*domuncula*).	Building with fence (*hortus conclusus*).	No buildings.

Fronting up

As you have already suggested, an important element of the Quattrocento Annunciations is the direction and dynamics of the gaze of the figures of both Gabriel and Mary. In these paintings a system of gazes recognisable through positions of heads and orientations of eyes underlies the communicational exchange of the text where the profile face dominates for the figure of the Archangel, and often a slight three-quarters turn towards the spectator's right is the direction for the figure of Mary. Meyer Schapiro in a revealing comment stresses the connection of the profile face with the grammatical person:

The profile face is detached from the viewer and belongs with the body in action (or in an intransitive state) in a space shared with other profiles on the surface of the image. It is, broadly speaking, like the grammatical form of the third person, the impersonal 'he' or 'she' with its concordantly inflected verb; while the face turned outward is credited with intentness, a latent or potential glance directed to the observer, and corresponds to the role of 'I' in speech, with its complimentary 'you'. It seems to exist both for us and for itself in a space virtually continuous with our own, and is therefore appropriate to the figure as symbol or as carrier of a message . . .'[18]

relationship here? The domination of Albertian perspective — so fundamentally characteristic of the earlier Quattrocento Annunciations — is being progressively dissipated. In fact, as if to deliberately counter the notion of a vanishing point, elements of the foreground are deliberately made to merge with those of the background. In *Annunciation* no background/foreground delineation is to be observed, as if this painting objects in a resolute fashion, you feel, in its reply to the earlier canvases.

Colin McCahon, *Annunciation* 1949. Oil on board, 620 x 520 mm. Courtesy Colin McCahon Estate.

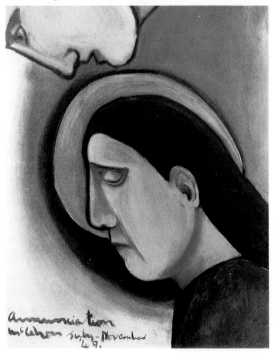

In the case of the frontal figure an extratextual term, the spectator, is written into the text through the very position of the figure observed. Someone is looking at us and we can only identify that fact while we in turn look at him or her. We have, that is, someone who 'fronts up' and someone 'fronted up to', thus reproducing the very dramatic situation of the Annunciation. The profile on the other hand, as Schapiro notes, does not demand our presence as observer. The profile looks at a gaze which is not our gaze as spectator.[19] The pose, gestures and gaze often seem to have a direction that points outside the painting but not because of this do they necessarily encounter their spectator. You will forgive me if I seem to have made yet another detour.

LAURENCE SIMMONS

In *The Angel of the Annunciation* the figures retain similar facial orientations found in the Quattrocento versions: a rather awkward profile in the case of the Archangel and a three-quarters turn for the Virgin's face. McCahon's Archangel has a hand raised in salutation but the more overt symbolism of the Italian paintings — for example, the lily, the religious text, etc.— is not to be found. The disposition of the figures on

AA	HM	A
Full figure of Archangel with with hand raised in salutation. Half figure of Virgin Mary.	Two quarter figures.	Quarter figure and portion of face of other figure.
Archangel in profile. Mary turned on three-quarter angle.	Not perfect profiles. Heads turned slightly.	Profiles only.
Figures cover only one quarter of composition's surface.	Figures invade more than a third of composition.	Figures over half of total composition.
Archangel's gaze directed down on Mary. Mary's gaze to spectator's right.	Gaze directed down in both figures.	Eyes closed.
Emphasis on the sexual/ maternal body of the	Facial similarity stressed	Mary's face and ear: *conceptio per aurem*.

both the horizontal and the vertical planes is radically divergent however. No longer are the figures in some semblance of a horizontal line, the Archangel appears to direct her gaze from above down on to the head of the Virgin who, in turn, appears displaced towards the spectator in more of a foreground position. In fact, as if to deliberately counter the notion of a vanishing point, elements of the foreground are made to merge with those of the background. The Archangel's wing seems at first glance an extension of the background hills, the heavily emphasised folds of clothing repeat the dark gashes of shadow in the background hills, as does the strong outlining around the formless legs. Immediately striking is the angular simplicity of McCahon's faces where the undefined facial features contrast, too, with the emphatic sexuality of the Archangel: heavily outlined rounded breasts and the gash in the centre of the dress leading to and echoing in its form a vagina.[20] In *Hail Mary* the figures are reduced to quarter-size and their exchange appears mediated through the inset of lillies. Both heads are turned slightly outwards to the spectator so that the full anonymity of the third person effect of the profile is not achieved, and the stylised facial similarity makes one face seem the mirror image of the other. In *Annunciation* the figure of Mary is centralised in the composition and becomes dominant. With the eye closed, it is the ear protruding from the straight hairline, which also effectively slices the composition on a diagonal, that becomes a focal point. Together with a progressive incompleteness and relinquishing of portions of the human body from *The Angel of the Annunciation* to *Annunciation*, we have a transferal of the implied bodily sexual processes of the Incarnation to the mystery of a message of fecundation which is linked to the air — the *conceptio per aurem* mentioned in many of the original sources and commentaries.[21] In the shifting from the frontal to the profile there is also an exploration of the dynamics of the possible positions of the gaze and persons, a shifting of those linguistic elements Roman Jakobson called shifters from the I/you to the impersonal he/she.

What links the figures in these compositions, you now understand, is the non-figurable, the paradoxical presence of a necessary absence, the spoken words of the Annunciation. Let us now discover how 'this tourniquet of seeing' tightens.[22]

Seeing through words

What to make of the insistence of the letter in the inscription at the lower left-hand corner of *The Angel of the Annunciation*? To what do the words written into the painting relate? Are they written or are they painted? Is there a difference? Are the words inscribed part of the pictorial representation?[23] Where is the boundary between language and painting being drawn here? Are the words a title? A title may predicate or prejudge a specific type of interpretation. Why do the words place emphasis on what apparently is only half the story, half the composition: the *Angel* of the Annunciation — and Mary? You are confused.

What misleads is the inevitabilty of connecting the text to the painting. The words we read near the image are themselves painted by the same hand:

from the act of painting to the image, from the image to the text, from the text to the unheard voice, which is at the centre of the painting's image. This web of interconnections introduces an inescapable linguistic element into the space from which it had supposedly been ejected. A useful way to examine the complexities of this relationship between text and painting is in terms of what Jacques Derrida calls the *supplement*.[24]

Discussing the predominance of speech over writing he deploys the term to describe how writing has been constructed and construed as an addition to speech. Two important senses of the word are developed by Derrida. In the first, 'the supplement adds itself, it is a surplus, a plenitude enriching another plenitude, the fullest measure of presence'; in the second, 'it adds only to replace. It intervenes or insinuates itself *in-the-place-of*; it fills, it is as if one fills a void'.[25] So the supplement is not a simple addition, it also supplants, it is an increment and a substitute, it also compensates for an absence. As well as meaning an 'extra' added to something already complete it can also mean something whose addition reveals that what was supposed to be complete is, in fact, not. The supplement, that is, uncovers a lack.

for the fact that it becomes an address and, as it is situated in a zone that is neither inside nor outside, exhibits a lack of compositional import. After such a playing out of titling dynamics, the descriptive labelling of title, date and signature in *Annunciation* can only be read as a meditation on what lies outside the work.

The idea of the supplement making the image is apt since, just as writing supplements speech, so do images supplement writing. Another term employed by Derrida — *différance*[26] — is also useful to describe how meaning in these paintings may be activated by differing or deferring. The written text in these Annunciations refers forward to the image and refers back to the spoken — the transcendental signifier of the Biblical moment in the enunciation of God's message. The irruption of the *logos* into history coincides with the irruption of the word into painting itself, and in this case the title is no longer a replica or a repetition, no longer the mere label of the work:

The title can be read as a faithful indicator not only of the meaning of the individual work, but of the relationship which the artist has established (or tried to establish) with the ideal spectator.[27]

AA	HM	A
Title as inscription. Signature and date lower left.	Signature and date lower right.	Title, signature and date lower left.
Title by nature of its size, angle and position is an integral part of composition.	Inscription of HAIL MARY is a statement in its own right as well as title.	
Delineation of title within corner.	HAIL MARY demarcated in upper left.	Title directly superimposed on image. No internal value.

In *The Angel of the Annunciation* the critical zone which the title occupies is integrated into the composition as precisely that of a middle term between figure and ground, and the written title itself by virtue of its angle and size is not merely a support for interpretation. In *Hail Mary* the separation of title from signature and date in the lower right provides

An aspect of the Biblical account of the Annunciation that is generally overlooked is that it is concerned with the act of naming. The angel Gabriel says to the Virgin: 'You shall conceive and bear a son, and you shall give him the name Jesus'. A significant feature of McCahon's Annunciations is that they name themselves and in so doing point to the epistemological implications of both the practice of titling and the relationship of supplement between written language and figural image.

Débordement: 'the question of the frame is already framed'.[28]

You now feel authorised to draw attention to another subgroup of transformations that have a systematic

relationship with the supplementary nature of image and writing you have just analysed. McCahon was long aware, both in practice and in metacommentary, of the problematical nature of the frame and the act of framing painting:

'No mounts, no frames, a bit curly at the edges.'[29]

'I'm finished with frames and all that they imply. I want paintings to pin up or nail up or tie up with string. I think it gives them more freedom to act.'[30]

'The emotion from a painting should fill a room, should not exist on the painted surface but in front of it.'[31]

Wystan Curnow writing on McCahon's Gate series described those works as paintings that 'deny the frame'.[32] Looking at *The Angel of the Annunciation*, you notice the pictorial features that lead us out of the painting, or make us run over its boundaries (a case of what Derrida calls *débordement*): Mary's gaze leading out over or through the inscription; the Archangel's leg protruding out of the composition; the cramped, restricted appearance of the inscription itself, as if it had been squashed forcibly inside its triangular space; the tiny filled-in corner in the lower left (you take a special delight in this small precursor of a major Mrkusich series and a feature that is retained in many of McCahon's later landscapes); the strong contrast of the horizontal band of natural landscape and the vertical organisation of figures tending to 'fill out' the square composition. In *Hail Mary* it is the extension of the figures which lean into the composition that gives the effect of *débordement*. In *Annunciation* the outside is strongly hinted at through the partial representation of the angel's face with the gaze directed vertically down and the strong diagonal, lower right to upper left, which gives a more formal weight to the balancing of the two faces.

There exists a crucial and critical difference between *débordement* in which the frame is violated or

AA	HM	A
Image 'runs over' the frame in the figure of Archangel.	Image 'runs over' frame through extension of figures.	Outside included through partial representation of faces.
Gaze leads out of frame.	Gaze leads to a 'frame within the frame'.	Angel's gaze leads directly down and out of frame.
Title expresses containing forces of frame.	Title is autonomous from composition and framed itself.	Title within frame and super-imposed on composition.

'transgressed', and where it is denied or simply abandoned. In order to further clarify this critical difference, you feel it is necessary here to deal with what Derrida, following from his examination of Kant's *Critique of Judgment*, has engaged as the workings of the *parergon*: 'when we ask "What is a frame?" Kant responds, it is a parergon, a composite of inside and outside, but a composite which is not an amalgam or half-and-half, but an inside which is called inside the inside to constitute it as inside.'[33] The logic of the parergon is akin to that of the supplement, in which the marginal becomes central by virtue of its very marginality and through which each framing may be thought of as a frame-up, an interpretative imposition that restricts by establishing boundaries:

Actually the frame warps as it works. As a locus of a work, an origin structurally bordered with surplus value, that is exceeded on both sides by that which it exceeds, in effect it warps. Like wood. It splits, breaks down, breaks up, at the same time that it cooperates in the production of the product, it exceeds and deducts itself. It never simply exposes itself.[34]

You are only too aware here of the act of critical framing involved in interposing a critical margin or barrier between the external metalanguage and the work it describes and comments on. Critical discourse on painting has, defined by its exclusion, traditionally spoken from above and outside and it is clear that, in the light of this, the notion of the 'organic unity' of a single painting is an effect of framing and thus part of the critical act. A shifting of

critical interest on your part is signified here, you feel, by your own dialogue of self-questioning. You wish to view these paintings deconstructively as grafts and intertextual constructs by examining the logic of signification and self-deconstruction, the questioning of interpretative discourses, the uncanny relationships between one textual level and another, the way each painting disrupts its own account of itself. It is your text that is placed between and among these three paintings, that violates their frames, and sustains dialogue between them. It is your dialogue that makes dialogue between them possible.

'A slowly emerging order' [35]

It is time to bring the separate threads of your discussion together. You feel the need to pause here, not to justify the accumulation of traits that are in appearance heteroclitic, but to savour the lack, an absence that is simply given as the force of an enigma in these paintings, an enigma you find echoed in the very difficulty of saying the title of your essay.

That works of art reply to each other to the point of making a system is not a new idea, as Panofsky has shown: for example, the great Gothic cathedrals are articulated according to the principles of scholastic *disputatio*.[36] It appears to you that such a to-ing and fro-ing is behind the systematic variation that proceeds from the calculated questioning of *The Angel of the Annunciation* to the effacement of *Annunciation* through the new dynamics of forces in *Hail Mary*. The dialogue of these three paintings has a geometric structure produced by a series of diagonals that intersect and traverse and at the centre of which is the Word, the object of the dialogue within the paintings themselves; but it is a centre which is absent, a diagonal line which must be discontinuous.

The Annunciation constitutes one of the deeper mysteries of the Christian faith. As well as being incomprehensible in its content, the pictorial problematic of the Annunciation is precisely that its content is non-figurable, non-representable. We could say of these paintings of McCahon, as Louis Marin says of Crivelli's remarkable *Annunciation* (London, National Gallery) of 1486, that:

... all the sacred mystery of the Incarnation is achieved, not only as the subject matter of the painting, but as in modern painting itself, by exceeding its rules and its laws, by turning them against themselves, through their own means.[37]

The pictorial enunciation that is in play here — the enunciation of the Annunciation — announces at the same time the enunciative capacity of painting. McCahon's ensemble of Annunciations is fundamentally a critical text in that it contains fragments of a discourse on the discourse of painting, and a reflection upon the possibility of a discourse on religion in painting in the twentieth century. But it is not merely the retelling of a moment of history. For here all the sacred mystery of the Incarnation is achieved not only as the subject of representation but also by announcing its Annunciation, by its construction at the very moment where it deconstructs itself; just as every sign, at the same moment it makes present an absent, reflects upon the operation of representation. To find an adequate analogy you feel that you could do no better than to turn to another portrayal of the moment of the Annunciation. Upon reaching the first level of Purgatory, Dante is attracted by the various reliefs sculpted around the banks of his pathway, the first of which represents the Annunciation of the Archangel Gabriel to Mary. The power and beauty of the sculpted relief make the poet observe not only the actions ('atti'), disposition and gestures of the figures represented, but also their speech ('favella') and conversation. The image, although it cannot speak, makes the memory of its spectator speak, for its representation is so strong:

'*che non sembiava imagine che tace.*'
that it seemed not a silent image.[38]

Notes

1 Jean-Louis Schefer, 'Thanatography, skiagraphy', translated, with an afterword, by Paul Smith, *Word & Image* , Vol. 1 Number 2, April-June 1985, p. 193.

2 Stephen Bann, 'Writing on Giorgione' in *Literary Theory Today*, edited by M.A. Abbas and Tak Wai Wong. Hong Kong: Hong Kong University Press, 1981, pp. 43-69. For recent discussions of the relationships between word and image see: Norman Bryson, *Word and Image. French Painting of the Ancien Regime.* Cambridge: Cambridge University Press, 1981; and Louis Marin, 'On Reading Pictures: Poussin's Letter on *Manna*' in *Comparative Criticism. A Yearbook*, volume 4, edited by E.S. Schaffer. Cambridge: Cambridge University Press, 1982, pp. 3-18.

3 Roland Barthes, *S/Z*, translated Richard Miller. New York: Hill and Wang, 1974, p. 56. The earliest outline of the problematical relationship between word and image in semiotic terms is to be found in a somewhat obscure footnote to a 1969 article by Emile Benveniste: 'The real semiotic problem which, for all we know, has not yet been posed will be that of discovering *how* one makes this transposition from a verbal enunciation to an iconic representation, what are the possible correspondences between one system and another, and in what way does such

LAURENCE SIMMONS

an opposition allow one to proceed to the determination of correspondences between differing signs.' 'Sémiologie de la langue' in *Problèmes de linguistique générale II*, Paris: Gallimard, 1971, n. 1 p. 59 (my translation).

4 Louis Marin, 'Interview with Viana Conti', *Flash Art*, no. 127 April 1986, p. 53.

5 Colin McCahon, *Colin McCahon: A Survey Exhibition*, R. N. O'Reilly introduction. Auckland: The Auckland City Art Gallery, March/April 1972, p. 38.

6 Gordon H. Brown refers to 'the three major interpretations of the Annunciation', linking these three paintings through similarity of figurative and symbolic elements as well as stylistic givens rather than as an interaction of exchanges. Cf. his *Colin McCahon: Artist*. Wellington: A.H. and A.W. Reed, 1984, p. 42.

7 Roland Barthes, 'Text, Discourse, Ideology' in R. Young (ed.) *Untying the Text*. London: Routledge, 1981, p. 39. Jacques Derrida reiterates the point when he says that a text 'is henceforth no longer a finished corpus of writing, some content enclosed in a book or its margins, but a differential network, a fabric of traces referring endlessly to something other than itself, to other differential traces.' Cf. 'Living On: Borderlines' in Harold Bloom et al, *Deconstruction and Criticism*. New York: Seabury Press, 1979, pp. 83-4.

8 See my '"after Titian": Intertextuality and Deconstruction in an Early Painting by Colin McCahon', forthcoming in *Interstice*. School of Architecture, University of Auckland, for a discussion of the issues of intertextuality.

9 Colin McCahon, *Colin McCahon: A Survey Exhibition*, p. 18.

10 Hamish Keith, 'Colin McCahon', *Art and Australia*, 6 June 1968, p. 63.

11 Gordon H. Brown, 'With my left hand, I write: A Consideration of Colin McCahon's Word Paintings', *Ascent*, 1 November 1969, p. 19. These arguments have been reaffirmed more recently: cf. Gordon H. Brown, *Colin McCahon: Artist*, p. 32 ff.

12 *Colin McCahon: Artist*, p. 28.

13 It is even possible to specify constant elements in Florentine Annunciations: the Archangel placed on the left, usually kneeling, with a lily in one hand and the other raised in a sign of salutation, the Virgin on the right, seated or kneeling in front of a *prie dieu* on which there lies an open text (according to St Bernard open on the prophesy of Isaiah).

14 Perhaps it is because in the original Biblical text(s) the scene of the Annunciation is presented as only an act of enunciation without visual or gestural elements that later commentators have felt the need to enrich the event from a dramatic point of view by proposing a series of 'moments' of the scene. Michael Baxandall, basing himself on one such commentary, a fifteenth-century sermon of Fra Caracciolo da Lecce, attributes five successive spiritual and mental conditions or states to Mary during portrayals of the Annunciation: *Conturbatio* (Disquiet); *Cogitatio* (Reflection); *Interrogatio* (Inquiry); *Humiliatio* (Submission); *Meritatio* (Merit). However, his attribution of these individual states to different paintings does not seem altogether convincing, especially where more than one may be read from signs in the painting, for example, Botticelli's *Annunciation* (Florence, Uffizi). Cf. his *Painting and Experience in Fifteenth Century Italy*. Oxford: Oxford University Press, 1976, p. 49 ff.

15 Notable examples are Annunciations by Simone Martini, Jan van Ecyk and Fra Angelico.

16 Harold Bloom, *A Map of Misreading*. New York: Oxford University Press, 1975, p. 32.

17 Gordon H. Brown declares that this is in fact the Nelson Golf Club Building, *Colin McCahon: Artist*, p. 39. It could also be seen as having some of the features of a church with its high peaked roof.

18 Meyer Schapiro, *Words and Pictures: On the Literal and the Symbolic in the Illustration of a Text*. The Hague: Mouton, 1973, p. 38.

19 On the importance of the gaze between figures in a painting see Louis Marin on Poussin's *Les Bergères d'Arcadie* in his *détruire la peinture*. Paris: Editions Galilee, 1977. An English version of parts of the argument is to be found in 'Toward a Theory of Reading in the Visual Arts: Poussin's *The Arcadian Shepherds*' in *The Reader in the Text. Essays on Audience and Interpretation*, edited by Susan R. Suleiman and Inge Crosman. Princeton: Princeton University Press, 1980 pp. 293-324.

20 Gordon H. Brown comments unrevealingly as follows on McCahon's choice of a female figure for the Archangel: 'McCahon in depicting the angel of the Annunciation as female, follows a very common preference in this respect.', *Colin McCahon: Artist*, fn 2, p. 42.

21 In both Gaudentius and St Augustine for example.

22 The expression belongs to Jean-Louis Schefer, 'Thanatography, skiagraphy', op. cit., p. 193.

23 Luit Bieringa would appear to think so as he speaks of: 'a large triangular shape which forms an integral part in the composition by emphasising the downward movement of the angel': *McCahon 'Religious' Works*. Palmerston North: Manawatu Art Gallery, 1975 , pp. 10-11.

24 Gordon H. Brown writing on another contemporary painting, *The Virgin and Child Compared* (1948), presages such a choice: '[the words] have become a statement that supplements the other images, extends them and makes their meaning explicit'. Cf his 'With my left hand, I write: A Consideration of Colin McCahon's Word Paintings', p. 20.

25 Jacques Derrida, *Of Grammatology*, translated by Gayatri Spivak. Baltimore and London: Johns Hopkins University Press, 1974, pp. 144-5. For a discussion of painting see also pp. 292-3.

26 'Differance' in Jacques Derrida, *Speech and Phenomena and Other Essays on Husserl's Theory of Signs*, translated, and with an introduction, by David B. Allison. Evanston: Northwestern University Press, 1973, pp. 129-60. For a complete account, see Irene E. Harvey, *Derrida and the Economy of Différance*. Bloomington: Indiana University Press, 1986.

27 Stephen Bann, 'The Mythical Conception is the Name: Titles and Names in Modern and Post-Modern Painting, *Word & Image*, Vol. 1 No. 2, April-June 1985, p. 185.

28 Jacques Derrida, 'The Parergon', translated by Craig Owens, *October* , 9 (1979) p. 29. The complete text is to be found in the French original collected in *La vérité en peinture*. Paris: Flammarion, 1978.

29 Colin McCahon, *Colin McCahon: A Survey Exhibition*, p. 30.

30 Colin McCahon, *Centenary Collection*, Manawatu Art Gallery, 1971, quoted in Wystan Curnow, *I WILL NEED WORDS. Colin McCahon's Word and Number Paintings*. Wellington: National Art Gallery of New Zealand, 1984.

31 Quoted in Hamish Keith, 'Colin McCahon', *Art and Australia*, vol.6 no. 1, June 1968, p. 63.

32 Quoted by Ron O'Reilly in the introductory essay to *Colin McCahon: A Survey Exhibition*, p.13.

33 Jacques Derrida, 'The Parergon' *op. cit.*, p. 26.

34 Ibid, pp. 34-5.

35 Colin McCahon in *Colin McCahon: A Survey Exhibition* , p. 17.

36 Erwin Panofsky, *Gothic Architecture and Scholasticism*. London: Thames and Hudson, 1957. Hubert Damisch has also examined the 'dialogue' between three Renaissance urban perspectives in an article, 'Les voir, dis-tu; et les decrire', *Versus 29. Quaderni di studi semiotici*, May-August 1981, pp. 33-57, to which I am heavily indebted for the form of the present essay. I also remain indebted to Mark Wigley for his perceptive and helpful comments.

37 Louis Marin, 'Les combles et les marges de la representation', *Rivista d'estetica*, 17 (1984), p. 29 (my translation).

38 Dante Alighieri, *Purgatorio*, X, 39. The entire incident is covered in verses 34-45. Cf *The Divine Comedy, Purgatorio*, translated, with a commentary, by Charles S. Singleton. Princeton: Princeton University Press, 1973.

Beyond The Looking Glass

Your Truths Are Illusions

Lita Barrie

How can I be distinguished from her? Only if I keep on pushing through to the other side, if I'm always beyond, because on this side of the screen of their projections, on this plane of their representations, I can't live. I'm stuck, paralysed, by all those images, words, fantasies. FROZEN. Luce Irigaray, 'The Looking Glass, from the Other Side'[1]

her given name — the 'proper' name, which assigns her a position within an economy of proprietal relations under the name-of-the-father. And so she renames herself: 'L, I know it begins with L.' Thus Alice's journey through the 'other side' of the mirror of masculine language, begins with a redefinition of

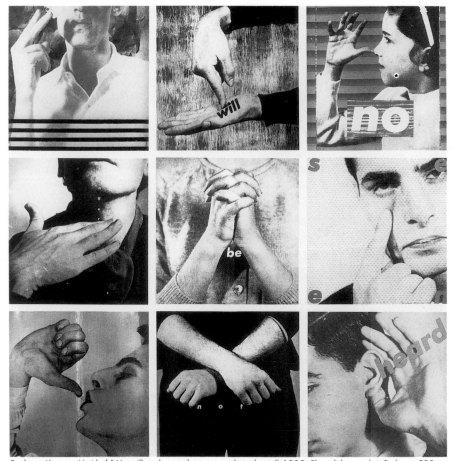

Barbara Kruger, *Untitled* (We will no longer be seen and not heard) 1985. Photo-lithographs, 9 sheets 520 x 520 mm. Courtesy private collection, on loan to the National Art Gallery, Wellington.

When Lewis Carroll's Alice found herself in a wood where things have no name, she began to question her own identity. 'And now who am I? I will remember if I can. I'm determined to do it,' she said.[2] But on the 'other side' of the looking glass, she cannot remember

her identity without reference to patrimony. 'L' is, of course, reminiscent of the French 'elle' — the third person singular, feminine pronoun. Alice inscribes herself into a feminine text in which she both is and is not 'one'. Beyond the mirror of masculine language,

LITA BARRIE

the illusion of a unified self is forgotten. In this symbolic act of renaming, Alice assumes a speaking position from the puzzling perspective of a multiple self within a different psychic economy.

Having stepped outside paternal authority, Alice feels lost. 'And now, which of these finger posts ought I to follow, I wonder?' she asks herself. But on the 'other side' of the lens of masculine language, the rules of logic are inverted. Alice has entered a different environment in which she must choose her own path. 'I'll settle it,' said Alice to herself, 'when the road divides and they point in different directions.' By rejecting the path of linear logic, Alice enters a different discourse in which she can say where she wants to go. The old Freudian problem, 'what does woman want?', evades the logic underpinning masculine language (or so Lacan said). But beyond the mirror of linear masculine logic, words have no 'proper' meanings, Alice learns to say what she wants by speaking in riddles. Alice feels confused. 'The question is,' said Alice, 'whether you can make words mean different things.' 'The question is,' said Humpty Dumpty, 'which is to be master — that's all.'

The fable of Alice's journey might be read as a proto-feminist fiction of a dissident daughter who steps outside the codes of patriarchal authority — defying the self-consciousness reflected through the mirror of masculine logic — to discover what she wants. As we know, in most fictions little girls who take the forbidden journey into the wood alone, choosing their own path, fall into the clutches of the Big Bad Wolf. These fictions were invented to ensure that every little girl learns 'proper' behaviour. Which means she must stay at home, away from public affairs, lying in bed asleep, until she wakes up to find herself reflected through the gaze of a man — or rather, a 'prince'. After all, his missionary position in this fiction has always been his to invent. He will then make a respectable woman of her through an exchange of the name-of-the-father for the name-of-the-husband, which will place her in another bed, according to the laws of a masculine libidinal economy. The moral of these stories is that girls must learn to see themselves through the eyes of a beholder or be sentenced to death.

In recent feminist theory, the 'mirror' has become a metaphor for the illusory recognition woman receives through the controlling masculine gaze.

Trapped within the cycle of man's representations, woman exists as a reflection of *his* claims to knowledge, of *his* interpretation of her body and her sexuality. A reproduction, merely, reflecting back to *him* a vision of *his* masculine privilege, she is relegated to the 'other side' of masculine desire to serve as a cipher for *his* heroic psycho-dramas of virility.

The appropriation of woman within a series of metaphors supporting masculine desire, is based on the privilege man bestows upon *his* own visible sexual organ. Minus phallus, woman is designated as 'lack'. Thus *he* takes upon himself the privileged status of 'oneness' and she becomes merely *his* 'other' — the negative of all that *he* is.

But if her sex offers the horror of nothing to see, then she also serves as a reflection of his fear of castration. She becomes the embodiment of the repressed within his unconscious. She is forced to inhabit an absence within the language he invented on an identity principle based on his visible single organ. Her unseen multiple sex is indefinable within the Cyclopean lens of masculine logic. Thus she is made to inhabit silence and can never tell the 'other side' of the story.

Not content to simply reduce her to a metaphoric status for his ego, man has transformed the imaginary position woman is assigned within his fictions into an *essence*. Through the repetition of his fictions over a millenium of history, she has been persuaded that her repression is a 'natural' condition: that her anatomy is a destiny. This is the illusory nature of man's truth, whose status as fiction, women have only begun to understand.

Recent feminist theory is situated at a critical impasse, attempting to articulate different meanings within a language which embodies the symbolic principles of the phallic ideology it serves. Luce Irigaray uses the fable of Alice's journey to suggest the transitional space occupied by the feminine unconscious as woman attempts to reinvent a position from which to 'speak herself' (parler femme).

Irigaray's Alice reflects: 'So either I don't have any "self" or else I have a multitude of "selves" appropriated by them, for them, according to their desires.'[3] To avoid the fixed identity woman is given through a masculine lens, Irigaray suggests that woman learns to see her 'selves' through the splintered and doubling effect of the concave side of the mirror (rather than the plane side). If, as Irigaray

writes, 'the articulation of the reality of my sex is impossible in discourse,'[4] then women must learn to speak through the cracks in the mirror as Alice did, to riddle the 'proper' meanings of words, in order to suggest the feminine unconscious which language attempts to repress.

Perhaps because the 'seen' is privileged over the 'unseen' in a masculine order, femininity has traditionally been identified as masquerade. Irigaray proposes the use of calculated duplicity in a strategy of 'mimicry' (mimesis). As she writes, 'One must assume the feminine role deliberately . . . to convert a form of subordination into an affirmation, and thus to begin to thwart it.'[5] Through this tactical complicity with the assigned feminine role, women might deconstruct the position assigned to them, in order to re-inscribe it in some way. Irigaray writes, 'To play with mimesis is thus, for a woman, to try to recover the place of her exploitation by discourse, without allowing herself to be simply reduced to it.'[6]

Irigaray uses her speculum[7] to stage a mime within theoretical discourse, travelling 'back through a masculine imaginary, to interpret the way it has reduced us to silence, to muteness or mimicry . . . attempting, from that starting-point and at the same time, to (re)discover a possible space for the feminine imaginary.'[8] Barbara Kruger uses the spectacle to stage a mime within media stereotypes, stepping behind the masculine lens to expose the way woman has been glamorised, eroticised and fetishised for the masculine gaze — attempting to re-create a space for the female viewer. Kruger writes: 'We loiter outside of trade and speech and are obliged to steal language. We are very good mimics. We replicate certain words and pictures and watch them stray from or coincide with your notions of fact or fiction.'[9] Both Irigaray's *speculum* and Kruger's *spectacle* reflect the 'other side' of masculine fictions, and might be read as feminist allegories for the adult Alice.

Kruger appropriates images from the media to expose the consumption of the cultural construction of 'femininity'. She mimics the graphic conventions which produce media stereotypes, but counters the immediate impact of the images with superimposed texts, subverting the underlying codes which dictate the 'proper' reading. Through this disjunction of image and text, she exposes the cracks within the logic of advertising fictions to reveal how ideological factors structure the unconscious mechanisms of viewing, dictating our habitual readings of images.

Like Alice, Kruger steps behind the mirror of masculine language to construct riddles which become *suave entrapments* for the male viewer. Her use of pronouns as linguistic shifters, implicates the viewer in the process through which language assigns speaking positions. In a gender-specific address ('I', 'We') she ensures that the female viewer is invited to share her journey through the transitional space on the 'other side' of the masculine lens, proceeding like Alice, by reading the signs in reverse.

Michel de Certeau once commented that 'theorising always needs a savage.' Kruger has become the 'savage' in the urban jungle of media image implosion, taking an adversarial position by using media conventions against themselves. Adopting the role of a metropolitan street fighter, she mimics the conventions of propaganda posters and the slick paste-up layouts of glossy magazines, to emblazon her message to the widest audience she can reach. Using billboards in the streets, blown-up photographs framed on gallery walls, posters on street lamp-posts, tee-shirts, postcards and matchbooks on shop counters, she expands and shrinks her image-text disjunctions.

Like transmissions from the electronic screens of the techno-science language game we inhabit, her messages assume an astral dimension. They de- and re-materialise like emanations from a computerised communications network. Kruger's messages fragment speaking positions by infiltrating the memory bank of a global consciousness we activate by pressing the electronic buttons that re-enact our own subjection. Who is the subject? What is the object? Which is in control? In the 'divine comedy' which takes place in the universe of astral signs, Kruger short-circuits the currents of this 'high-tech' linguistic labyrinth.

Just as Kruger's work blurs the distinction between art and media, it also blurs the distinction between art and theory. The theory at issue is post-structuralism, based on the premise that the world is experienced as a vast text through which we see ourselves. The aim of feminist theory is to rewrite the text which constructs our psyches. Kruger's work takes its impetus from Jacques Derrida's strategy of 'deconstruction', which aims to displace patriarchal binary oppositions and to re-inscribe them with different meanings. In Kruger's work the displaced

LITA BARRIE

oppositions are: identity/difference, subject/object, surveyor/surveyed, prowess/pose, active/passive, culture/nature, history/fiction, based on the opposition man/woman, which she emphasises with the shifting pronouns, You/I, They/We.

Despite the theoretical complexity underlying Kruger's work, her deconstructions have the immediate accessibility of advertising slogans. Kruger mimics the attention-grabbing techniques of advertising, to upturn the apparent simplicity of the meanings we take from advertising messages. She confronts the seductiveness of advertising on its own territory by providing the same pleasure, which she then undercuts with the accusatory text.

A savage semiologist within the urban jungle of street signs, Kruger refuses to *play nature to your culture*, by exposing the acculturation of woman's body within the phallic ideology of capitalism. In her work, woman's body never appears naturalised or neutralised, but always written upon, inscribed within the system of power relations on which masculine privilege is based.

Kruger exposes the extent to which woman is positioned as the passive object of a controlling masculine gaze, by using images of women posed behind shattered mirrors (*You are not yourself*); dappled glass (*You thrive on mistaken identity*); fractured prisms (*We are your circumstantial evidence*); under water (*I can't look at you and breathe at the same time*); behind veiling devices (*Memory is your image of perfection*); and with covered eyes (*We are unsuitable for framing*). This recurrent use of reflective devices over the female face, emphasises that woman is the site of masculine fictions which prevent her from returning the gaze. However, Kruger uses the superimposed text to declare her refusal to be a reflection of man's ego (*I will not become what I mean to you*).

If man is a Perseus who stole woman's power of vision, to secure his own cultural privilege by hoarding that power to himself, then it was to make woman a silent icon (*Your gaze hits the side of my face*) within his psycho-trajectory. However, Kruger turns the feminine stereotype back upon itself in mimicry of Perseus' act of blinding Medusa, to rob the stereotype of its power.

Kruger plays upon the linguistic nature of images as visual texts which are read (*A picture is worth more than a thousand words*). Advertising and the media use superimposed texts to fix and regulate the reading of an image. This gratuitous relation between text and image, places the viewer in a passive relation as a consumer of meaning determined by dominant ideology. As an adult Alice, Kruger riddles the 'proper' reading of the image with a contradictory text to crack the mirror of the advertising spectacle, creating a multiple perspective for the female spectator.

Kruger also mimes the narrative conventions of Hollywood-style cinema, in which the narrator's authoritative voice creates a controlling masculine perspective. Her texts become a feminine voice which refuses the masculine perspective encoded within the photographic image. In this way, she emphasises that feminine spectatorship has been excluded. She mimics this 'oversight' by using her 'voice-over' to disrupt the ideology which forms the unconscious mechanisms that structure 'looking' as a masculine position (*We will no longer be seen and not heard*).

If woman occupies a paradoxical metaphoric status within man's fictions as both the site of masculine desire and castration neurosis, thenKruger confronts the male viewer with his fear: that woman can look and talk back. Kruger destroys male voyeuristic pleasure by recalling the ever-present castration anxiety woman symbolises. The bold red frames which surround her work, play upon this paradox through a pun on mouth and vulva. The voice-over is placed on the 'lips' of a feminine speaker, but the talking mouth becomes a threatening gesture: the vagina-with-teeth. Kruger mimics Perseus, by reflecting the symbolic violence man has imposed upon woman, back upon the male viewer. Man has transformed *prowess into pose*, turning woman into his *reservoir of poses*, and imprisoning her within a lens which gives *orders not to move*. Kruger retaliates with an image of a mouth as a tooth is extracted and the feminine text, *You are a captive audience*. In this way the voice-over turns the image into a castration threat.

In an era of proliferating media images, in which capitalism has taken over the production of visual signs, photography has become a prime instrument for reinforcing dominant power relations. The photographic use of the single-point perspective lens is based on the *camera obscura*. Advertising photography uses this controlling perspective to reinforce

capitalism, a system based on mastery and control. The use of women's bodies in advertising marks the convergence of the ideology of capitalism with the interests of a controlling masculine gaze. Thus woman becomes an object of exchange within a phallic economy based on masculine egoistic investments (*My face is your fortune*).

Photography's single-point perspective also recalls the theological concept of the 'eye of god' — the invisible presence which controls our world view. Kruger parodies the authority encoded within this pictorial convention with the feminine injunction, *You invest in the divinity of the masterpiece*, inscribed over the Sistine Chapel image of God endowing Adam with his absurd privilege. If man has disembodied himself to speak universally — since men do not speak as men but as authority — it has been to lay down the decree which makes woman's body his property, making her the 'matter' on which his unconscious projections are founded. Ultimately, man transcends himself into the 'voice of god'. Kruger pretends to obey man's law: *God said it, I believe it, and that settles it*.

Her voice-over technique mimics the authoritative tone of this 'voice of god', to expose her irreverence for man's fictions. She depicts man as an automaton son-of-the-father, re-enacting the plan of subjection: *Your assignment is to divide and conquer; You destroy what you think is difference; You substantiate our horror*. Man is portrayed as a usurper, a bully, whose sleuthing is carried out through voyeuristic control: *You molest from afar, Surveillance is your busy work*. His sexuality is depicted as sadistic pleasure, a form of symbolic violation to woman: *You re-enact the dance of insertion and wounding; Your devotion has the look of a lunatic sport; Your moments of joy have the precision of a military strategy*. His technological advances are depicted as a game in which the goal is to win at any cost: *Progress is your most important product; You get away with murder*. Man has become a bedlamite Frankenstein, whose megalomaniac reveries destroy the planet: *Your manias become science; You are an experiment in terror*. If man has invented toys which have become terrorist weapons, Kruger exposes the sham nature of man's self-display with an image of a phallic knife held under water

Barbara Kruger, *Untitled* (You are not yourself) 1983. Photograph, 1829 x 1219 mm. Collection of Ed Donnes, U.S.A.

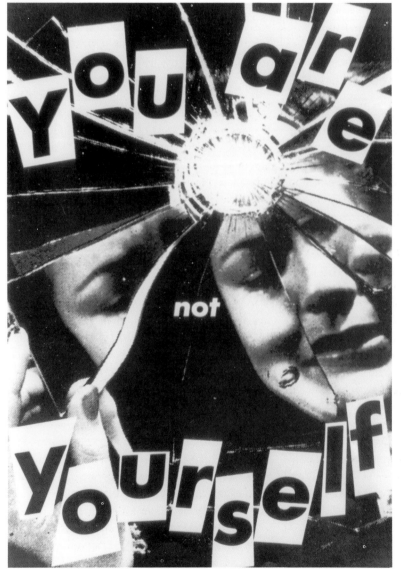

and the feminine text: *You rule by pathetic display.*

Kruger's critique is situated at the interstices of media stereotypes, political economy and the institution of art. She does not separate art as purely visual experience, divorced from the cultural fabric through which we read images. But her appropriations are not simple reiterations of the post-modern dictum on the 'death of the author'. Her deconstructive strategy drives a critical wedge into the culturally-loaded meanings embedded in images, to expose the processes through which we are subjected to ideology which underlies stereotypes. Abandoning the modernist view of the artist working through 'personal' experience under the bogus myth of creating 'original' forms, Kruger manipulates *existing* signs. Her interventions are the form her inventiveness takes.

Kruger stages a critique of the capitalist manipulation of art (particularly her own work) within New York's hard-sell, consumer-orientated Mary Boone Gallery. The notoriety of this gallery is based on the manufacturing of male artists (notably Julian Schnabel and David Salle) into media super-stars, who symbolise the decrepit nineteenth-century myth of the heroic, ruggedly masculine, inspired artist. Their work demonstrates the reactionary side of the great divide in contemporary art practices because they merely revamp old art-referential genres to proclaim the pedigree of their work as collectible art. In contrast, Kruger's work epitomises the resistant side of this divide, which attempts to place art within its cultural context, as social signs existing alongside other social signs in order to disrupt repressive cultural codes.[10]

It is perhaps the final irony of Kruger's interventionist approach that she should enter the predominantly male 'stable' of a gallery which perpetuates the mythical status of artists, whose work is based on humanist fictions of an essential self-hood. Kruger's work deconstructs these fictions by exposing the processes through which subjectivity is shaped, formed and positioned within language and images. She exposes the philosophical corruption of the emotional wallowing and romantic indulgences of her reactionary male peers. Interestingly, these criticisms have been applied to some women's art which explored 'female imagery' based on essentialist views of sexuality.

Unlike the 1970s forms of feminist art, which stayed on the margins of mainstream art institutions,

Kruger accepts the challenge of capitalism, in which there is no outside position from which to be effective. By infiltrating the ranks of the citadel, she adopts the deconstructive strategy of working from 'within' existing structures. The modernist concept of a transgressive avant-garde, making 'alternative' art by adopting marginality, is based on the philosophically defunct view of art's autonomy from wider culture. Kruger's work is complicit with the commodity status of art, but her texts challenge the relations of power within the phallic economy. She uses the bold red frame as an ingratiating device to broadcast the commodity status of her work, but within that frame she upturns the ideology underlying capitalism.

Many of Kruger's recent works quote well-known clichés (*Your money talks; Worth every penny*) to emphasise how economics determines social conventions. In other works, she re-writes famous statements using the shifting references to their authors to accumulate further meanings. *I shop therefore I am*, echoes René Descartes' 'I think therefore I am', on which he attempted to philosophically justify human existence on the basis of deductive logic. Kruger undercuts Descartes' rationalist view of the individual by recalling Jean Baudrillard's view that the individual is 'nothing but the subject thought in economic terms, rethought, simplified, and abstracted by the economy.'[11] However, the text also recalls a statement attributed to man's god: 'I am that I am.' In this way, Kruger exposes the confluence of money, god and phallic privilege within patriarchal ideology.[12]

Kruger uses Jean-Luc Godard's update of Hermann Goering's statement, 'When I hear the word culture, I reach for my revolver,' in *When I hear the word culture I take out my checkbook.*[13] While Godard disrupted linear narrative conventions in film, Kruger creates a disjunction between image and text based on the same strategy of fragmenting a controlling perspective. Kruger imposes the quotation over an image of a ventriloquist's dummy, suggesting that the dummy mouths the words of another speaker, which recalls her own mimicing strategies. The more obvious reading of the work is that capitalism pulls the strings behind culture.

Within the phallic economy, women's affections are bought and sold. Kruger uses an image of a tray of chocolates inside a pink frame to mime a conven-

tional ploy of male sexual propositioning. According to the codes of 'proper' sexual etiquette, women are supposed to 'fake' pleasure in this exchange. Kruger reverses the positions in this power relationship by quoting the cliché associated with an armed robbery — *Give me all you've got* — in a feminine demand for money and sexual pleasure. The phallic-shaped chocolates positioned on an angle in the tray suggest the beginning of an erection, exaggerated by the rose buds on the tips. Inside the pink frame — suggesting a woman's mouth — this becomes an image of oral sex. But the mouth threatens to become the vagina-with-teeth, and with the assaultive text becomes a castration threat.

If the feminine libido has been theorised as passive (by Freud), as inarticulate (by Lacan) and as a form of impersonation (by Nietzsche), in which woman 'fakes' an orgasm she does not experience, then Kruger reverses these masculine fictions with the unlawful demand for what woman wants. But if the 'dark continent' discovers her voice, it is to unearth a masculine libido which relies on woman's silence for its stability.

Hélène Cixous has suggested that man's castration anxiety is displaced onto woman as a decapitation threat — should women refuse to march in time to the 'drumbeats' of a masculine economy.[14] As she writes, 'If they don't actually lose their heads to the sword, they only keep them on condition that they lose them — lose them that is, to complete silence, turned into automatons.'[15] Kruger, Perseus-like, reflects this condition back upon the male viewer in a form of mimicry which recalls the praying-mantis, which can 'fake' her own death to avoid actual death. And, of course, the praying-mantis devours her suitor upon sexual satisfaction. If she does so after mimicing prayer, it is not in obeisance to the god man invented

The enormous size of Kruger's work, recalls Alice's journey through *Wonderland*, since the viewer is diminished within the scale of *Krugerland*. The enlarged scale ensures that the spectator experiences, through her or his own body, the mechanisms through which ideology takes the body into its custody. But in *Krugerland* the female spectator enters a different environment in which it becomes possible to see the joke that man's fictions have played upon us. But to see a joke which is both funny and sad, is to enter the different psychic economy of an adult Alice.

Having entered *Wonderland*, Alice felt her body expand and shrink in proportion to the objects around her. She met animals with bodies that disappeared into space. Alice felt puzzled. 'Oh, you can't help that,' said the Cat. 'We're all mad here. I'm mad. You're mad.' 'How do you know I'm mad?' said Alice. 'You must be,' said the Cat, 'or you wouldn't have come here.'

But on the 'other side' of the mirror of masculine logic, Alice enters a different economy of language, in which words have value according to the multiplicity of their (im)proper meanings. 'When I make a word do a lot of work, like that,' said Humpty Dumpty, 'I always pay it extra.'

Notes

1 Luce Irigaray, *This Sex Which Is Not One*, trans. C. Porter. New York: Cornell University Press, 1985, p. 17.

2 Lewis Carroll, *Alice in Wonderland and Alice through the Looking Glass*. New York: Julian Messner, 1982, p. 163. All Carroll citations are from this edition.

3 Irigaray, op. cit., p. 17.

4 Op. cit., p. 149.

5 Op. cit., p. 76.

6 Ibid.

7 Luce Irigaray's *Speculum Of The Other Woman*, trans. G.C. Gill. New York: Cornell University Press, 1985, plays on the pun of 'speculum' as both a mirror and a surgical instrument, used for cervical examinations. As a mirror, the speculum reflects the illusory nature of man's definitions of woman, the distorting 'optics of truth' in his philosophic and psychoanalytic discourse. As a surgical instrument, Irigaray uses the speculum to scrape beneath the rhetorical surface of Western discourse to expose the hidden gaps in its logic. Beginning with Freud's lecture addressing the 'riddle of the nature of femininity', Irigaray mimics the 'riddle' woman represents to man, to expose 'the Blind Spot in an old dream of symmetry'. Moving 'backwards' through the history of Western philosophy, she ends with a revision of Plato's myth of 'The Cave' as the womb of patriarchal dualistic thinking.

8 Luce Irigaray, *This Sex Which Is Not One*, p. 164.

9 Barbara Kruger, artist's statement in *Documenta VII*, exhibition catalogue. Kassel, 1982, p. 286.

10 Hal Foster, *Recodings: Art, Spectacle, Cultural Politics*. Port Townsend, Washington: Bay Press, 1985. Foster provides a complex analysis of this division between 'resistant' and 'reactionary' postmodern practices.

11 Jean Baudrillard, *For a Critique of the Political Economy of the Sign*, trans. C. Levin. St. Louis: Telos Press, 1981, p. 133.

12 Jacques Derrida has rewritten the theocentric 'logic' of the statement, 'I am that I am' as 'signifier of all signifiers', recalling Lacan's concept of the phallus as the 'privileged signifier'. In this way Derrida exposes what he calls the theo-phallo-logo-centrism on which patriarchal discourse is based.

13 Jean-Luc Godard, 'Le Mépris' (Contempt), 1963.

14 Hélène Cixous, 'Castration or decapitation?, *Signs. Journal of Women in Culture and Society*, vol. 17, no. 2, 1981, p. 142.

15 Ibid., p. 143.

This essay was first published in *Barbara Kruger*. Wellington: National Art Gallery, 1988.

LITA BARRIE

Judy Darragh

Blood on the Snow

Relating the Body to its Hypostatic Image

Fran Dyson

What is the body? What is its relationship to technology? Are we talking about the body as it appears, as it is transmitted via the various technologically-aided representations the media so frequently offers; or the electronic ether we now chiefly inhabit? Or does this question assume entirely different dimensions when filtered through a cybernetic grid: the body as the solid matter of an organising network; a nervous system which stamps any container, flesh or otherwise, with the concept of embodiment.

Raising the question of the body *and* technology gives impulse to familiar paradigms circulating in late twentieth century culture. The very conjunction of these terms warns of a possibly fatal distinction between them, a distinction played out firstly in opposition — the body is annihilated by technology; secondly in assimilation — the body becomes technological; thirdly in appropriation — technology is culturally coded as 'organic', body-like; and finally in absurdity — the relationship between the body and technology can never be stated because of the inherent incommensurability of the terms of that equation. And these paradigms have their symptomatic correlates: RSI, opposition, pacemakers: assimilation; AI models and robotics (particularly those of the Japanese insect variety): appropriation;[1] fuzzy sets, particle-waves: the paralogical conumdrums of the absurd. The resonance of these conceptual motifs often triggers sensations like loss (of the body), disregard (for the body), or a complicated prosopopoeial confusion: is the machine best thought in terms of the body or body in terms of the machine, and how would that thought proceed?

Bearing in mind these questions, these threads and enduring laments, I would like to construct a machinic ritual for the exigesis of the title and subject of this essay. In purely provisional terms, I would like to suggest that the synthesis and processing of images and sounds through technological means involves firstly, and as a general theme, the loss of the body as metaphor for the real — that is, a metaphorical loss. Secondly a recoding of audio/visual representations of the body which drifts from mimesis to idealisation. Thirdly, a process of abstraction leaving a residue which initially registers as noise, static, or interference but eventually assumes the conceptual thrust of 'a body'. And finally, a presentation of the *body of technology* under the guise of rendering the splattered organic form more palatable if not palpable. The thread running through this particular paradigm knots at this last suggestion, because what follows could only be a redefinition of the concept of 'body' to include the body of technology, and yet such an enterprise returns us to a second and more deadly round of the ritual: oppositional, assimilative, appropriatory ... absurd. Loss, abstraction, metamorphosis, conceptual vertigo . . . ad nauseam.

Perhaps an example might subdue this queasiness of the stomach gathering as one approaches such a complicated stratum. (The stomach which, it's worth noting, has its audible complaints stretched to fill the already gnawed space of a background drone existing permanently as a 'sample' and deployed with other low level growls in various soundtracks; is constantly turned inside out by the special effects devices of countless melt movies; and, with its moist and membraned surfaces, provides both theory and television with a new kind of exquisitely undecidable, plastic boundary.) Recently, two parents of children involved in what has been dubbed the 'Mr Bubbles' child sexual abuse case, were interviewed on ABC TV. For legal reasons and to protect their anonymity, their televised heads were rearranged and their voices harmonised supposedly beyond recognition. All that remained of the imaged human form was its torso, the head having become a collection of restless squares denoting, interestingly enough, the primary unit of the video screen, the pixel. Similarly, all that remained of the body's

reproduced voice was language. A viewer unaccustomed to television's practise of authenticating an event by disguising its corporeal origin, using extreme examples of media technology's ability to disfigure and distort (which ironically, also present the essence of a transmitted body; a body evacuated of all that signifies corporeal presence, namely the face and the voice) might wonder why such an interview is broadcast in the first place. A matured viewer, on the other hand, would understand that the necessity to create a face of many squares and a voice which is both deep and double, indicates the severity and secrecy of the transmission — these are bodies, *not to be seen*, on television!!

Once the initial impact of circus show special effects has subsided however, once diligent attempts at recovering the face and the voice from their technologically crafted masks are exhausted, a serious study of what's left of the body can proceed. If many-squared faces and doubled voices are technology's answer to the desire for human incognition, then what is this answer made of? Isn't it an answer spoken in some way by the technology: the pixel — unit of videographic appearance, distortion — essence of audiophonic transmission? Because the human desires to be unknown, the knowledge broadcast is a knowledge of technology — it appears via the square, it transmits via distortion. To some extent, the body and action of technology make their presence felt.

The Mr Bubbles case interview is a ponderous instance of the process by which the transmitted body is abstracted, leaving a residue which assumes at the same time the conceptual thrust of 'a body', insofar as technology now has a look and a sound. Yet this development is possible and comprehensible only because a prior abstraction has taken place. Vocal and facial metamorphosis of the Mr. Bubbles variety (not that the face doesn't splatter, it squares, the voice doesn't change tempo, it becomes electronic) lies somewhere between the idealisation of the human body, and its hypostatisation, although this serialisation is not necessarily chronological. An example of the former would be the close-up: the face becomes larger than life, the voice so intimate it seems almost within the listening ear. Technology is not concerned with presenting actuality but with representing potential — of course, this potential can only ever be realised vicariously, no human ear or eye could greet such largesse and remain organic. An example of the latter could easily be found in the genres of audio and video art, where images and sounds of the body (that is, the *materiality* of those generic forms) are processed through instruments such as the Fairlight, to deliver new ideas, new essences of what the body might be.[2] To use a well-worn phrase, the Fairlighted body is a 'hyper-body'; however, unlike the close-up, the technology, normally perceived as the vague grumblings of static, is overwhelminly apparent. The body becomes a kind of body-effect; colourised, stretched, morrored, fragmented, stenciled, overdubbed, cut and multipled — anaesthetised in order to be aestheticised by the instrument which is responsible for its generation. And the instrument, with an air of self-presence, claims this responsibility as it leaves its signature.[3]

What is occurring here is a re-definition of the concept of the body as such. For the human body, it becomes the body-effect, synthesised and congealed finally to the digitally processed a/v/image. It cannot appear in this form without displaying also its means of production: the body becomes technology, as technology becomes (in the sense of flatters) and indeed creates, the hyper-body. For technology, the body serves a similar paradigmatic function. The processing instrument begins to assume the conceptual status of 'a body', having an organisational apparatus not dissimilar to the idea of a nervous system, having a 'main brain' for its various MIDI limb-like attachments, and even attributes such as a 'humaniser', which reinsert 'errors' into the too perfect production. Thought of as a body, the technology is also flattered — having both a form and sense of coherence previously characteristic only of the single skinned and vital organism. Functionally, the audio or video sampler progresses from holding and relaying an image or sound, 'found' somewhere in the orginial world, to organising and processing that material in ways peculiar to its own method of operation. In classical techno-speak this organisation would ideally produce images and sounds having a certain fidelity to the original, the noise or interference of reproduction and transmission being considered an unfortunate by-product. But with the instrument I have been describing the by-product is *organised*, the noise and interference transmuting the original is signal as well as static, having its own cultural information to impart.

Returning to the paradigms that began this exfoliation, there is, in the developing concept of a technological body, and in the technologisation of both the organic and transmitted body, a reciprocal loss of the real that the simple, unadorned concept of 'the body' once stood for. I have suggested already that this is a metaphorical loss, but now begin to realise that this loss is also a loss, or necessary jettisoning, of a primary metaphor: the body and its related system. A far more painful predicament: not only is the real savagely annihilated, but also the network which constitutes the real; all its indications, all its favourite nesting places, all its cries and calls, noises and objects, must also evaporate as the body represented and transmitted fuses with the electronic signal.[4] However, while the attempt to maintain the body-like amidst the twilight of the technosphere flounders upon a heavy nostalgia and heaving absurdity, the reality of the body is still a thing to be lived with. Perhaps, for the sake of sanity, or at least of discursive survival, it might be worth theorising two bodies, the one lived in and the one transmitted, and severing the ontological link cultural consensus has installed between them. The body represented would then be a distant relative and its affrontery unimportant. But what would this mean?

Writing for *Art and Text*, Douglas Kahn refers to the sampler both as a potentially 'new instrument', containing within itself the impulse towards new arts of sound free from musical domestication; and as 'a better parasite', invoking the sense of appropriation; plundered images and sounds on the one hand and static or interference on the other.[5] The new instrument, the better parasite, is elsewhere defined:

The sampler, in whatever performative configuration, is not the instrument, instead the instrument is the class of sounds the sampler organises, and the way that it organises them.[6]

This suggests an entirely abstract definition of an instrument, focusing on its relational rather than material or embodied conditions. The sampler itself becomes a kind of central nervous system, storing and distributing the various instruments, themselves composed of various sounds coming from some externality or another, all within a meek and mundanely material container. The sampler could almost be considered as a programme or code were it not for the presence of this container: the problem of the 'body'. But there is another sense in which the sampler, skin and system for the new instrument, is almost a programme or code, and this is in its role as parasite.

The parasite, as Michel Serres explains, transforms through theft or loss. The uninvited guest brings nothing to the host's table, but maintains a certain integrity by exchanging food for words. The noise, static or interference situated in information theory as necessary conjuncts to communication (translated as *parasite* in French) allow the system, be it communicational or biological, to develop in complexity. An absence of noise makes the message entirely redundant, too much noise impedes information flow. Noise, or interference, is the necessary third term. Serres calls it 'the third man':

To hold a dialogue is to suppose a third man and to seek to exclude him ... The most profound dialectical problem is not the problem of the Other, who is only a variety — or a variation — of the Same, it is the problem of the third man. We might call this third man the demon, the prosopopoeia of noise.[7]

An indication of the profundity of noise is given in 'The Origin of Geometry'. '... it is well known: *two irreducibly different entities are reduced to similarity through an exterior point of view.*' The synthesis which this entails creates a parasite in the form of a sample, a plundered and dislocated image, an immediate scission between the phenomenal and the represented; but also, in the form a new instrument, a third man, a different kind of 'body'; attached, but barely, to an original event, interfering but no longer in the background, noisy but humming its own little tune.

In the presence of this tune and gaze of the 'exterior point of view' — the third eye of the third man — those recalcitrant incommensurables, the body . . . and . . . technology, are momentarily reconciled. But I doubt that this tune, motif, paradigm could be heard for very long. Our cultural decorum would not permit two bodies, the living and the transmitted, to cross the same mythological and ontological space indefinitely, nor would it be likely to admit squared heads and doubled voices or the organised and meaningful static of the sampler,

FRAN DYSON

beyond the parameters of arbitrary convention. The increasing presence of the body-effect is regarded as an aberration, a pragmatic and inconsequential outcome of certian needs and desires (informational, representational and aesthetic). But there is something of a deilmma to this exchange; for the body to be transmitted, abstracted, globalised, hypostatised through static, it must, to some extent, lose itself. The price for this loss is great: more than the horror of RSI, bionic implants and Bach-playing robots; more than the confusion concepts of 'body-like' technology perpetuate; more than the vertigo of trying to think body and technology together; the body-effect, signal-static, third man of the Fairlight demands the loss of a metaphor, *the* metaphor: the body.

Notes

1 'Appropriation' may be the wrong term here. However, the process of coding technology as organic does assume that metaphor in a manner which is almost stylish. From the model of the human as machine, one of the first being that of the musical instrument, in particular the organ which had the advantage of being wind driven through a series of pipes which could easily be imagined as veins pumping the life-giving humour through the instrument's 'body', the machine has become, in this holistic and democratic age, likened to the body. Computers are now 'like brains' rather than the other way round, and recently there has been talk of the 'technology of nature'.

2 Elsewhere I have referred to this hypostatisation as 'pneumatic' a term which refers to the theology of 'pneuma' as combining or synthesising both breath and spirit. Breath links this concept to the vital force animating the body, spirit to an abstract, disembodied, etherial force which, in the late twentieth century is very much like the teleology of a technology bent on disembodiment (see 'Pneumatic Video', *Scan* + Vol.1, ed. John Conomos, Australian Video Festival, 1989)

3 Toying with the Fairlight CVI, it's impossible not to experience the cascading images it produces with such gusto from entirely mundane material as a frenetic show of signals more than anything else. Similarly, the astounding instrumentation provided by the Fairlight audio synthesiser (and others) always seems 'breathy' — diluted by a kind of soft and airy electronicity.

4 Mary Ann Doanne's suggestion that the body acts as a model for the unity of the film (specifically, its heterogenous sound and image tracks) is valuable here. While film theory, with its two-way, reflective, mirrored conceptual economy cannot support the metamorphic stress of a/v processing, transmission and broadcast, the notion of the loss of the body as model for a phantasmatic unity implies the loss of that unity in the phenomenal world. In other words, if the body falls to pieces, all other bodies: chairs, trees, bird calls, live to air interviews etc., disintegrate as well. See Mary Ann Doanne, 'The Voice in the Cinema: The Articulation of Body and Space', J. Belton and E. Weiss (eds.), *Film Sound*. New York: Columbia, 1985.

5 Douglas Kahn, 'A Better Parasite', *Art and Text*, 31, February 1989.

6 Douglas Kahn, 'Sound by Artists'. Toronto: Art Metropole, 1989.

7 Michel Serres, 'Platonic Dialogue', Josue, H. and Bell, D. (eds.), *Hermes*. Baltimore: Johns Hopkins University Press, 1982.

Teach Yourself Comix

Chris Knox

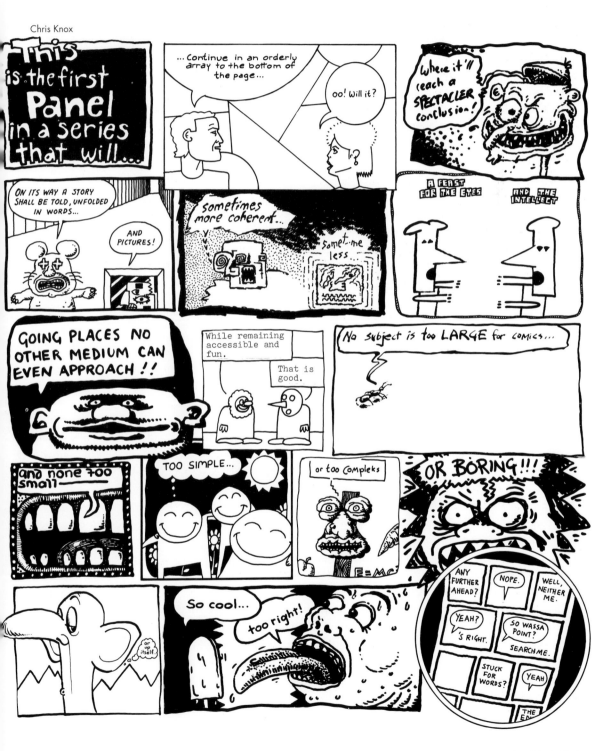

It's one of the last remaining creative areas that is yet to be defoliated by ART.

Sure, there's a handful of Comix that are self-conscious and self-referential/reverential enough to call themselves Art but it hasn't really caught on in a big way, thank whatever.

Arty comix are generally, at this early stage, pretentious and unfathomable. Good comix by artists with a real feel for and (perhaps) knowledge of the form *are* Art. Of course. What the fuck else could they be?

Telling stories, describing emotions, plotting the banalities of late twentieth century living, screeching didactically, subverting slyly, just being there, everywhere, as ubiquitous (almost) as TV, made by skilled men and women for their own kind.

As limitless in possibilities as film but far superior in several respects:

1 You can stop a comic, go back, make a connection, clarify a relationship.
2 You can use a comic in private, at your leisure and convenience, safe in the knowledge that its effect has not been watered down by a process of diminution as with film to video or tv presentation.
3 You know that the work is of one person (or a small, like-minded team) who has not had to accommodate the desires and fears of countless grey moneylenders.
4 *You* can make one, with no more equipment than pen and paper. You can publish it with the help of a photocopier. It's as democratic a medium as you could hope to find.

EXCEPT

In the West (including its South-Eastern archipelago) we have been taught that comix equals Multinational Superheroes. FORGET THAT. Superhero comix are self-evidently as shitty as yer average teen flick. But the fact remains that, as with all the other creative media, the shit gets to the top and the worthwhile .05% gets a raw deal. BUT IT'S THERE.

And it has a power of expression that has to be seen to be believed. Art Spiegleman's 'Maus' is the most visible, Robert Crumb's the most fondly remembered (he's still going, notably in the pages of 'Weirdo' and is better than ever), but there's a million more out there. Aline Kominsky-Crumb, Peter Bagge, Chester Brown, Sue Coe, Krystine Kryttre, The Hernandez Bros., Joe Sacco, Jim

Woodring, Will Eisner, Lynda Barry, and hundreds more from the Americas. Hunt Emerson, Phil Elliot, Alan Moore, Glenn Dakin, Ed Pinsent, Savage Pencil and others from the rather more male-oriented British market. And hordes of talented Europeans, Africans, Asians and Australians with graphic clout and ideas to match.

EVEN IN NEW ZEALAND

Lisa Noble, Peter Rees, The Langridge Bros., Jac Dwyer, Trace Hodgson, Joe Wyllie, Fane Flaws, Siobhan Ryan etc. etc.

You may even have heard of some of them.

They all exploit the infinite capability of word wedded to image. Some choose to accentuate one or the other, some tell one story with words and another with the pictures. Others shatter the senses with combinations of the two factors that never quite gell but obviously belong together. Some explode the page out of its left to right, top to bottom panel progression, giving you a space-time continuum that has much more valid simultaneity than may be achieved in any other medium.

THE ONLY TRUE SPECULATIVE, EXPERIMENTAL PRINTED LITERATURE IS IN COMIC FORM.

And, quid to a pinch of shit, you're missing out on it. And it's hardly your fault, even Unity Books doesn't stock *Yummy Fur* or the odd bit of Carol Moiseiwitsch. At least not until they're anthologised into handy Trade Paperback format, Graphic Novels (Ha!) rather than Comix.

So why are we here in this self-satisfied little tome? Lumped in with other Art Trends of the moment in some attempt to give the Seal of Approval of the WISE AND CONDESCENDING to our pathetic, sub-fine pretensions?

Why is this rough craft under the aesthetic microscope like some newly dead specimen of a once thriving species?

Because Comix have a power that 'fine' art lost when the camera appeared. A link with the 'ordinary person' that ART is jealous as all hell of. ART wants to suck the essence of Comix out, appropriate it, use it till it's limp and throw it on the rubbish pile in time for the next trend. So does LITERATURE. So does FILM. (Need I mention Batman?)

But it doesn't work.

Lichenstein, Haring, Scharf, Fahlström have all had a go and it hasn't worked. (Picasso came close

but he was as good a cartoonist as the ART World has seen.)

Producers are having their turn and it's pulling the crowds but it's not working. They can pull those crowds any old way, just give 'em enough money, but they can't achieve the Comic effect.

Hey, ARTYUPPIE intellectual tightarse, wanna look cool? Throw away yer Semiotic Analysis of West Coast AnarchoPunk Skateboard SpeedMetal and grab a handful of xeroxed mini comix. Hey, even the rappers'll love ya!

A Cursory Glance at a Comic Panel

A small but perky looking man, or maybe a boy, with a long sausage-like nose, short-back-and-sides parted scruffily in the middle and with a mass of large, protuberant pimples on his naked chest is holding an inverted black bowler hat in his unusually large, gnarled hand. His name is Weed and a human head sized toad, wriggling and obviously rather nonplussed by the turn of events, is being lowered into the hat by a second character.

Another male, this one is older, larger and hairier, having a huge white beard that stretches uninterrupted from nose to groin. This upper extremity is extremely large and roughly oval, the size of Weed's entire head but the tiny eyes that surmount it are but black dots so close they touch. On top of the skinny head is perched a cricket cap with an absurdly long peak. The man is handling the frog rather gingerly with his right index finger and thumb while his left hand is poised primly at elbow height, a dainty gesture designed to let him remain totally upperclass dignified while having contact with such a foul, repellent creature.

Weed is saying, with a look of muted delight, 'I shall take 'un home with me . . . ', referring to the toad. The older man replies, 'Indeed Mr Weed, 'tis not right that such a creature be loose!'

In front of Weed, looking at the bearded gent is a bespectacled, top-hatted, bristly bearded man with a nose almost as long and somewhat fatter than Weed's. His expression is neutral and he is silent.

To his left is a haughty looking creature in standup collar and tie. He has heavily lidded eyes, absolutely no forehead and the faint suggestion of a beard. He is the caricatured personification of the English Butler as he would look while announcing a guest at a County Ball. Rather than the guest's name, however, the words, 'Amphibian Stopped Play' (in the appropriately distancing quotation marks) issue from his vertically vast mouth.

Above and behind him is the decidedly goofy face of an inattentive village idiot. He has a huge upper lip that strains to cover a haphazard row of tombstone teeth. His eyes look in different directions and his expression is bemused and smug. His nose is small, his hair receding and he has his back to the toad transaction.

Above and behind him again is a bulky gentleman whose collar and tie struggle to contain a huge fleshy neck that imperceptibly becomes chin and mouth before disappearing under a walrus moustache twice the width of his head. A broken nose perches on top of this luxuriant growth and two protuberant eyes look impatiently and irritatedly at the troublesome toad. 'What of the match?' inquires this squirrel-like figure whose priorities are too in-bred to be shaken so easily.

Outside our field of view, to his right, someone exclaims, 'Most amazing!', while to his left an obviously Cornish farmer in traditional smock and sidewhiskers stands, mouth agape and eyes boggling under a soft-brimmed hat. He is flanked by a neanderthal jawed and browed, balding fellow who seems to be gazing at him with some fondness.

To their left an ordinary looking chap, boasting sideboards as his only head hair quietly mutters 'Singular!'. Below him a tousled-haired man whose nose is large and eyes minute says importantly, 'I shall write to the Times!'.

Below him may be glimpsed an insignificant set of silent facial features to whose left is a scruffy, hairy, ill-tempered, lower-class type who is heard to mutter through clenched teeth that,' . . .'tez they STEAM H'ENGINES . . .'. Obviously a long held and oft-expressed Luddite viewpoint.

This is the information contained in the fifth panel (out of 11) on the first page of Hunt Emerson's 79/80 two-page comic *Phenomenomix*. I have not attempted to interpret anything that is not obviously there in the panel as printed. That there was a cricket game in progress may be inferred, but as to the rest of the story, it may be found in *Big Book of Everything* published by Knockabout Comics.

Looking through a piece of glass

Some early conceptual concerns

Ian Burn

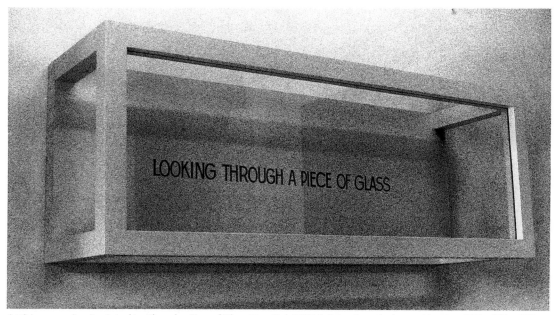

Art & Language (Ian Burn), *Looking Through a Piece of Glass*, New York 1967-8. Painted wood, glass and lettering, 280 x 760 x 220 mm. Version in possession of the artist. Courtesy Ian Burn.

A board with projecting structure framing a sheet of glass. The spectator looks through the glass in order to read the lettering on the board which states: 'looking through a piece of glass'.

•

The inclusion of language, or bits of language, is a familiar strategy in the art of much of the past century, especially Cubist collages and some of the Futurist, Dada and Surrealist pictures. In such work, the visual field of art becomes a site for the letter, word or text. The word and image compete for the same idea, or compete with incongruous ideas, often to produce visual *non sequiturs*. In the earlier sixties we'd briefly explored some of those devices. But the cubist-referenced space absorbed the bits of language into its contemplative reading, conveying almost poetic intent and restricting the role of language. The possibilities inherent in such approaches seemed exclusive of the concerns with different kinds of space evolving in the sixties. Consequently, our involvement with language drew little on that history and was instead provoked by problems more directly associated with objects, with a different kind of art object.

One change during the sixties was that language no longer was collaged or 'composed' into the visual image but claimed its own status, its own 'space', for meaning. No longer simply a rhetorical intervention in the reading of the art object, language took a (literal) place alongside the object, equal, and implying different notions of art and of the spectator, as well as a different self-conception of the artist.

•

The early sixties (even late fifties) witnessed a profound reappraisal of many attitudes in the arts. It was as if nothing could be taken for granted and a reformative spirit was invoked, almost moralistically. The idea of a linear history was already collapsing

into an experience of the simultaneity of Modernism. Artists rediscovered, reassessed and reworked aspects of early Modernism, the Russian avant-garde, constructivism, de Stigl, Bauhaus, the formal gestures of Dada. Rare early texts on Modernism were translated and published, or republished; the experimental writing of Roussel and music of Satie, Schoenberg, Varèse found new audiences.

The post-war existential depressions of Europe had by then been recast within projects of phenomenology and a conservative 'liberalism' had ascended in Cold War America, creating a climate for the market expansion of American art. A countercurrent to the restrictive character of Greenberg's 'mainstream' began to identify itself and the arts became a site of diverse experiments, reaffirming a critical capacity of art. Barriers between disparate practices and categories dissolved; writings in philosophy, linguistics, computer technology, anthropology etc. found ready-made audiences. Artists 'discovered' Wittgenstein, logical positivism, Marx, historical materialism, Hume and the tradition of British empiricism, Saussure's linguistics, Husserl, Merleau-Ponty, Barthes and semiotics, the music of Cage, Feldman, Riley, Young, Glass, Boulez and Stockhausen, Merce Cunningham's dance, the new novels of Robbe-Grillet and Pinget, films by Truffaut and Godard and much more. It was a time when, as John Cage remarked, painting had to get another idea rather than painting. Across art forms a surprising convergence of attitudes and interests emerged, frequently making it difficult to identify sources or even categories of ideas.

•

Jasper Johns said that by working with things the mind already knows it gave him room to work on other levels. Motifs like targets, flags and numbers, he said, 'are seen and not looked at, not examined'. Those 'other levels' opened the way for visual paradoxes and linguistic anomalies, absurdities and conceptual ironies. Ad Reinhardt, developing his own standardised motif, proclaimed: 'The forms of art are always preformed and premeditated. The creative process is always an academic routine and sacred procedure. Everything is prescribed and proscribed. Only in this way is there no grasping or clinging to anything. Only a standard form can be imageless, only a stereotyped image can be formless,

only a formularised art can be formulaless.' Warhol simply said, perversely: 'If you look at something long enough, I've discovered the meaning goes away.'

Barthes wrote enthusiastically about the seventeenth century Dutch painter of empty church interiors, Saenredam: 'Never has nothingness been so bland, so self-confident, so bland in its self-confidence . . . Saenredam is in effect a painter of the absurd: the subject, in his painting, empties itself more thoroughly and more insidiously of sense than in the most tortuous canvases of our time. Lovingly — and exclusively — to paint surfaces that mean nothing at all amounts to a very up-to-date aesthetic of silence.'

But in the sixties this aestheticised silence came to depend on aggressively bland art objects, which invariably led to affirmations of the role of language. Not a new kind of paint, language was more like an extra palette, a tool for different conceptualisations. Traditionally, the art image had provided a field of possible (competing) readings, from anecdotal to formal across the surface of the art work. In contrast, the spectator now brought another complexity, with one reading opening up into the next and so on, each building on the self-consciousness of the spectator.

•

A different kind of object. Reconstituting the relation between spectator and art object produced a curious kind of equivalence between spectator and object. Talking about Robbe-Grillet's treatment of objects in his novels and writings, Barthes said: 'the object had no being beyond phenomenon; it is not ambiguous, not allegorical, not even opaque, for opacity somehow implies a corresponding transparency, a dualism in nature. For him the object is no longer a common-room of correspondences, a welter of sensations and symbols, but merely the occasion of a certain optical resistance.'

Creating an art object which was simply 'the occasion of a certain optical resistance' was in many ways an ideal. Or for that matter any object capable of posing the problematic status of perception, so that how you saw something was at least as important as what you saw. As the act of perception became more critical and reflexive, further incursions between perception and language seemed inevitable, unraveling the 'theory-ladenness' of perception and

IAN BURN

ultimately exposing the institutional dependence on privileged modes of perception and the management of language.

The art objects made in the mid sixties presupposed particular ways of perceiving. For Robert Morris it was a case that 'the object itself has not become less important, it has merely become less self-important'. In other words, other elements in the field had assumed an equal importance. Existing emphatically in a 'real' or physical space entailed that the art object resisted any contemplative reading: 'every internal relationship, whether it be set up by a structural division, a rich surface, or what have you, reduces the public, external quality of the object and tends to eliminate the viewer to the degree that these details pull him into an intimate relation with the work and out of the space in which the object exists.'

Existence was a potential value in itself, sug-gested Judd hopefully: 'Things that exist exist, and everything is on their side . . . Nothing can be said of things which don't exist. Things exist in the same way if that is all that is considered — which may be because we feel that or because that is what the word means or both. Everything is equal, just existing and the values and interests they have are only adventitious.'

•

In the new relation between spectator and art object, both were being reinscribed within 'real' time/space/light, with the human body becoming the measure of 'scale' and 'distance', forcing a heightened awareness of physical attributes of the art object and the space in which it existed. New phenomenology collided with old empiricism. 'No object implies the existence of any other,' David Hume had declared several centuries earlier. If the object was less self-

Art & Language (Mel Ramsden), *Black Book*, 1967. Indexed book with dictionary definitions, 160 x 230 mm. Courtesy John Weber Gallery, New York.

important, then the spectator became more self-important and how an art object was encountered became a more consciously pragmatic experience. Questioning how you perceive something forces questions about the way you perceive your own awareness, consciousness, questioning even the extent to which a notion of self is invented through such processes.

The ordinariness of the object became paramount, its 'art content' seemingly diminished and its distance from everyday life (and language) reduced. The object so limited was being delimited by the word. The spectator adopted a direct mode of address, without deferring to the object in the third person. The object assumed a rhetorical position in relation to the spectator — and all the while much of the determination of its language was inspired by technocratic ideals, masked perhaps within philosophical ideals.

•

Language, it had been realised by the early sixties, was not merely supportive of traditional media like painting but had become constitutive of such practices. In other words, the productive mechanisms of modern art were no longer identified with the practices of artists *simpliciter*. The languages of criticism, of academic institutions and other agencies of art commerce and exchange, had become managerial, like a hidden agenda for the object.

About the mid sixties, strategies began to be proposed by artists intent on disrupting the bases of conventional consumership, destabilising the 'languaged' relation between spectator and object. Other ways of relating to the art object presupposed different ways of conceiving of the object, which in turn prefigured the possibility of manipulating the constitutive role of language. Objects and bits of text were deliberately collided, undermining each other, proposing an art determined to absorb its own textual critique, a critique of itself as an institutional token.

Language seemed to inhabit objects, while objects seemed possessed by language. Competing rhetorics appeared for and in the same objects. How then was the visual point of view formed? Was it immanent in the space or fixed in language? What might a 'visual point of view' now mean?

•

Working in London during 1965-66, Mel Ramsden and I were making paintings which 'withdrew' any conventional interest in order to allow the work to function on other (i.e. conceptual) levels. In 1966 we produced an installation work called *Soft-Tape* which used a tape-recorder playing a spoken text, continuously and very softly. The sound was balanced between noise and speech: one hears the sound of speaking but not the sound of words, or sense. Translating the noise into English sentences remained no more than a possibility. Our paintings to that point had been working around the 'edges' of perception, tracing boundaries between what might be perceived and what was imperceivable. These demanded increasing amounts of 'talking about', as an integral part of the work. The problem we began to realise was — given conventional expectations, how could we make the spectator accept the importance of the 'talking about' part of the work? How could it be made obvious that the conceptual framework was much more than an invisible support for a physical object?

The strategy adopted in *Soft-Tape* was to create awareness of the 'talking about' part by forcing awareness of its inaccessibility. But the semantic uncertainty was inseparable from spatial considerations, so that the spectator became not only the translator but also the measurement of the physical space in which the tape played. The work pointed to a problematic of translation between contexts — whether between a context of production and the context of reception, whether between culturally separated contexts, or whatever.

Subsequent work developed other strategies, with the 'talking about' part put directly up on the wall, which became a feature of the 'style' of conceptual art. Language and object played 'musical chairs' and substitution became a significant player in semantic resolve.

•

A moment passed briefly during which Wittgenstein's duck/rabbit device seemed almost to characterise a language/object relation. The cube had become a popular (endlessly repeated) format for sculpture, especially in the minimalist condition. The cube was a known form (in Johns' sense) and any visual interest which was attached to it — e.g. lighting, scale, environment — had little to do with its 'cube-

Map to not indicate: CANADA, JAMES BAY, ONTARIO, QUEBEC, ST. LAWRENCE RIVER, NEW BRUNSWICK, MANITOBA, AKIMISKI ISLAND, LAKE WINNIPEG, LAKE OF THE WOODS, LAKE NIPIGON, LAKE SUPERIOR, LAKE HURON, LAKE MICHIGAN, LAKE ONTARIO, LAKE ERIE, MAINE, NEW HAMPSHIRE, MASSACHUSETTS, VERMONT, CONNECTICUT, RHODE ISLAND, NEW YORK, NEW JERSEY, PENNSYLVANIA, DELAWARE, MARYLAND, WEST VIRGINIA, VIRGINIA, OHIO, MICHIGAN, WISCONSIN, MINNESOTA, EASTERN BORDERS OF NORTH DAKOTA, SOUTH DAKOTA, NEBRASKA, KANSAS, OKLAHOMA, TEXAS, MISSOURI, ILLINOIS, INDIANA, TENNESSEE, ARKANSAS, LOUISIANA, MISSISSIPPI, ALABAMA, GEORGIA, NORTH CAROLINA, SOUTH CAROL-INA, FLORIDA, CUBA, BAHAMAS, ATLANTIC OCEAN, ANDROS ISLANDS, GULF OF MEXICO, STRAITS OF FLORIDA.

Art & Language (Terry Atkinson and Michael Baldwin), *Map to Not Indicate...*, 1967. Letterpress print, 500 x 620 mm., edition of 50. Courtesy Ian Burn.

ness'. It emerged then as a topic of some debate as to what extent the word 'cube' might satisfy as a substitute for the object. An ideal form? An ultimate abstraction, beyond existence? Sartre philosophised: 'A circle is not absurd, it is clearly explained by the rotation of a straight line around one of its extremities. But neither does it exist.'

For a short time also in the later sixties the Wittgensteinian idea that the limits of language were the limits of our world seemed indisputable and was obsessively pursued. About things in the world, A.J. Ayer declared: 'There is nothing more to things than what can be discovered by listing the totality of the descriptions which they satisfy.' About things in literature, Robbe-Grillet wrote of Raymond Roussel's writing, saying approvingly that Roussel 'describes,

and beyond what he describes there is nothing'. Objects, which so recently had seemed replete, began to crumble on a conceptual level, fragmenting into diagrams, maps, photos, specifications, hypotheses, etc, more frequently utopian than practical.

One kind of strategy for manipulating the 'languaged' relation between spectator and object is proposed by Mel Ramsden's *Black Book* (1967). Choosing a then popular dictionary of art terms, Mel randomly ripped pages out of the book, 'editing' the concepts available. The remaining concepts were then glued into an index book and, ideally, the spectator used this impaired dictionary as a tool for interpretation of works of art. This violation to the 'totality' of the language causes ruptures and discontinuities between concepts and categories, disclos-

ing the constitutive role of the language. Alternatively, Terry Atkinson and Michael Baldwin's *Map to not indicate* (1967) uses different kinds of visual language to represent both a mapped space and an unmapped space. The map points to the explicit connection between the selected and the excluded. Yet, importantly, to point to what is not indicated is not to exclude, in contrast to that which is schematically concealed. We are then forced to ask what might be the purpose or function of a map drawn 'to not indicate'? The strategy seems to dismantle the constructed 'meaning' and power of the map.

•

In the work *Looking through a piece of glass* (1967-68), the apparent 'coincidence' of perception and language is used to expose the lack of coincidence, creating a self-conscious confusion of reading and perceiving (not-reading) for the spectator. The seeing/reading processes identify themselves separately with the systems to which they belong. The bi-focal effect of reading and seeing thus creates not order but disorder, a disorder of conceptual categories, a disorder in the experience of the spectator.

As a physical object, the work evokes ideas about repetition and redundancy, even the illusion of self-reference. But there can be no equivalence between reading and seeing. One process does not substitute for the other, despite the realisation that we may 'see' the meaning rather than read it. The words do not invoke the seeing, nor does seeing invoke the words. The perception occurs within a range of accepted ways of seeing accorded to works of art, thus the 'meaning' implied in the perception is formed within an institutional frame which includes ideological determinants as much as practical factors (e.g. sheets of glass are associated with the protection and framing of works of art). On the other hand, the meaning of the words (which appear to describe the seeing) occurs in an extensive system of language, such that 'glass' evokes something which is not 'wood' or 'steel'; 'looking through' is different to 'looking at'; and so on. In the text it becomes significant that the word 'glass' is used in the context of something that we can 'look through'. As well, the lettering has a visual character associated with public notices or signs that direct or instruct us. And so on. So that the more perception and language are 'combined', the further they seem to drift apart.

•

The role which language assumed in the sixties went beyond just shaping responses to the object. It provided a substitute for much that was seen to have been 'eliminated' — the intimacy, the contemplative and the private, was now achieved in (relation to) language, textually. Language disarmed the spectator, 'aestheticised' the spectator rather than the object. The work of art had become the allegory through which the text might be realised . . . objects which seemed to offer to explain their own meaning in fact merely problematised the possibility of explanation.

Note

For the record, I take issue with much of Terry Smith's account (published elsewhere in this book) of the 1960s and 70s which he offers as a background to the Art & Language 'exhibitions' in Australia in 1975 and New Zealand in 1976.

The interest (by artists) in notions of translation was not invented suddenly in the 1970s. There is a considerable history of such interest, to which Terry fails to refer. When a work like *Soft-Tape*, produced by Mel Ramsden and myself in London in 1966, raised questions about translation, we were drawing on ideas from a wide range of sources, from John Cage and Jasper Johns to Wittgenstein, Barthes and further. Concerns relating to translation manifest in many forms, as complex processes working between ideas, artforms, disciplines and traditions. In particular, it was the transformations and 'spaces' between different modes of perception and language which provided the grounds for much Conceptual Art and its intervention in traditional practices. In the later 1960s and early 70s, issues of translation were an explicit subject for artists in Art & Language, both in England and New York. It was a focus, for example, of several of Dave Bainbridge's early 'sculptures' or models, of various theoretical speculations of Michael Balwin and Terry Atkinson, and informed a range of work by Mel and myself, including *Dithering Device* and *Comparative Models* (1971-72). Thus there's plenty of evidence to contradict Terry's claim that translation was treated as 'a non-issue...as if it were transparent'. Moreover, this line of enquiry connected directly to the overt 'political' concerns, which began to be asserted during 1972-73, and framed the concept of the 1975 Art & Language show in Australia. Today such questions still inform work by artists associated with Art & Language.

Yet, in Terry's essay, the concerns of Art & Language are represented as narrow and singular, involved in 'obsessive self-examination'. This he 'proves' by suppressing reference to the disparate range of work being done. Violent disagreements and conflicts abounded about the priorities of various kinds of work and, at any one time, there were always competing streams of activity. Terry's sweeping comments also ignore the implications of work to which he contributed during periods of 1973-74, missing the relationship between intersubjectivity and praxis which was crucial to the form of the 1975 Art & Language 'exhibition' in Australia. Regarding that show, the point - as Mel and I saw it then - was never that a new role 'of translator' was being proposed for artists. Rather it was to create circumstances in which people ('the audience') could realise their own processes of translation. As the exhibition poster said: 'there isn't, between you and me, a "clear channel". Making the "noise" explicit or accessible is making ordinarily habitual processes self-conscious...'. Terry's role was to help make that noise explicit, to be part of the noise. This we saw as a way of extending the changed circumstances (already secured in the sixties) of the artist-object relationship which aimed at creating a more active and participaroty role for the spectator.

IAN BURN

I've fed the baby and put him down it's eleven ten
winds like trades sweep the phoenixes high airs for highchairs
a story of palimpsest and simulacra a house of replicas
writing over its fictions sticking them on the machine hitting PRINT
and away it goes
over the rooftops the thrashing pompadours the stunt kites that whistle and hum
their lines in contemplation of the image
templum a shape to bite with they are very close
pleasure they share genetic material they could be coeval
 they speak together they've travelled from the same place
 so when one slides back to the power station she is pleased
finessed a by the return THAT'S MY SLIDE she says
projector a good one I'll loan you details help yourself
 the real thing THE SIGNIFICANT OTHER is up at the gallery
 Julian's hung the tiles sideways STET but Alexa has my letter
 as if I

put the baby slides through as well TENDERNESS
reading one face in the other
dear Flossie Teacake Posy Fossil Sugarplum phantoms
a fall ARE ALWAYS INTERESTING they warm by association
of raw sugar in the demerara jar is always a space
December filling up again he's turning one marked out
sweet darling one standing by the peg basket by himself a
waves of applause steady piece of ground set apart a shape
as she goes cut out for travel through a number of worlds

happens what I can do where I can go what they can give
here and what they keep me from
 ESTABLISHES FOCAL LENGTH sitting in the dark five years old
 optician's glasses testing testing cold hit precision and footnotes
 m a g n i f i c a t i o n sharp edges bright lights in the dark
 I can feed him change him put him down feel my way back
can it be done? to sleep thinking
who by? SUBVERT OR OBSCURE EXISTENCE OF THE NARRATIVE
who? POSITION
she gave me *cut lunch* a blank cheque also volumes of information
he heard me get out the cutting board and say LET'S EAT
 THE WOMAN OUTSIDE THE ART GALLERY SELLING AVOCADOS
 muscle carapace flesh position action —
push your fingers in
the secret folds of semi-soft sculpture BLUSHING SHAPE
CREAMED TONGUE PUFFS THE ROSE AND STAR a world of wonder
high fidelity sweeping with the phoenix feather palms thrashing
taking eating having layering icing on the CAKE
when he gets back lemon angel surprises
oh the hell out of tartan touring with Betty
petit from the deck of the Earnslaw binoculars in hand REMARKABLE
berceau what is to be seen once the soft interiorities
marlin boats at Whitianga of the voice strike out instruction
identifying the Douglas Fir at Lac Maligne bye sunshines
CHANGED HER TACK went horseback riding left them squinting at a sail

sobriety sobriquet, girls
MERYLYN TWEEDIE OPENED HER FIRST ONE-MAN EXHIBITION
AT THE LABYRINTH GALLERY the old question (the cake stalls) (ack)
can history do more than amuse? replies A MUSE does it better
rewrites replays returns TIMES OF OUR SOCIALIZATION see it now
 underfoot together on the kitchen floor crawling over diamonds
 and squares (Mondrian a cinch later on) cross-eyed with the effort of
NO ESTABLISHING FOCAL LENGTH and tearing up yes newsprint
clouds laid down against the flood the bin the cooker the cat's plate
 the epic defrost the highchair detritus three times a day
 or just grubby rage for activity a bit of fun SOME
flooral tile on the wall wall ELEMENTARY GAME accountability
paper on the tiles SLIPPERY humming with xerox
and saving the text and blowing it up and staging repeats
MERYLYN SLIDES critical vocals ACCREDITED AS A POET was a
does that person in a pointy hat
square simpering it's the way you hold your mouth
like BARE around the word PO-
FACED lies there on the page HEY ROSEBUD little
bottom your mom's goodlooking a sundried nappy straight off the line
folds one through four two pins and away sweep
she'd sooner be doing this of the printer left to right right
critical fiction to left pull on the line when interpolation breaks
in into the digit count cursor hauling you over a landscape
florescence whose every window fluoresces at a touch

where's Nicola? where's Betty? under the resin tear
folding napkins with Mrs B studying the butter finger the power away
a transitive verb has to EAT everything in its way s
she bosses it (vanishes) BUT IF NOTHING HAS BEEN TAKEN
AWAY VERY MUCH HAS BEEN ADDED the baby in his berceaunette
SHOWING CLEARLY HOW EVERY FOLD IS MADE in terms of pink creases
a body of knowledge Bella Merylyn meet Janet
 she's wrapping the folks remarks in flimsy tissue WE SET THE STALL UP
 ON THE LIBRARY STEPS BESIDE A TRESTLE GROANING WITH
 DONATED FAIRY CAKE dispensed vital signs
 NO NO NO NO NO NO
 steaming wringing scrubbing operas AMALGAMATION
 the glue that holds it together
many soft interiorities musculature a growing body carefully
happy as the boy Ambrosius and will
hours when he's covered his new school books with yes wallpaper
 a fight about pattern competence (pigheadedness) WELL YOU DO IT
pinning THEN she stays up late ruling cutting pasting
pattern at the end there's a little pile of damp books to be pressed
pieces under THE BOOKS OF KNOWLEDGE volumes one through six
 dry and wrinkle-free
she's filling handbags in the morning
with plaster IT TOOK THREE OR FOUR MINUTES BUT I MADE IT
to go on the wall IT TOOK A LONG TIME but the family is full
next of December babies tenor and vehicle they all resist

Select Notes

1 Phoenix canariensis.
2 Janet Frame, *Living in the Maniototo*. New York: Braziller, 1979.
3 Kites, 103 Victoria Rd, Devonport.
4 Prunus domestica.
5 Merylyn Tweedie, *Nicola* or *Floral Tile* or *Betty*, floor tiles, photocopies on fibreglass cloth on vinyl wallpaper, coated with epoxy resin, 459 x 428 cm, 1989.
6 Merylyn Tweedie, *Happy Hour* or *Profile Tile* or *Acapulco*, floor tiles, photocopies on fibreglass cloth on vinyl wallpaper, coated with epoxy resin, 459 x 428 cm, 1989.
7 Julian Dashper, Artist's Choice at the Auckland City Art Gallery, 8 December 1989-21 January 1990.
8 *The Century Dictionary: An Encyclopedic Lexicon of the English Language*, ed. William Dwight Whitney, 6 vols. New York: Century, 1891.

1 Newspaper review of 'Merylyn Tweedie photographs'. Christchurch, 1975.
2 Robert Leonard, 'A New Acquisition', *NAG News-letter* #4, 1988.
3 Alexa Johnston, senior curator of NZ contemporary art at ACAG, talking, November 1989.
4 Kaypro 2X.
5 Ian Wedde, 'Merylyn Tweedie: Subtracting Art'. *Evening Post*, 10 December 1986.
6 Walker Percy, *The Moviegoer*. New York: Knopf, 1961.
7 Medium Curity Stretch.
8 Ian Wedde, 'Comfort Stop Waltz', *A Fly-by-Night Broadside*. Vancouver: Slug Press, 1983.

1 Roland Rees, Palmerston North 1962. Repeats.
2 Susan Ash, 'Mirror-Writing: Subjective Perception in the Work of Katherine Mansfield, Robin Hyde, Janet Frame, and Keri Hulme'. Ph. D thesis, University of Otago, 1990.
3 *Mrs Beeton's Book of Household Management: A Guide to Cookery in All Branches*, rev. ed. London: Ward, Lock, 1909.
4 Robert Leonard, 'Merylyn Tweedie,' Limited Sedition. Wellington: QE II Arts Council, 1987.

1 Robin Hyde, *Wednesday's Children*, 1937. Reprint: Auckland: New Women's Press, 1989.
2 *Virtue's Household Physician: A Twentieth Century Medica*. London: Virtue, n.d. Specimen book.
3 Janet Charman, 'the print kiss', *Untold* 9/10, 1988.
4 E. H. Ruddick (ed.), *Vitalogy: An Encyclopedia of Health and Home*. Chicago: Vitalogy Association, 1930.
5 *Charlie-boy*. Repeats.
6 Pam Memory on the terrace writing New Year cards.

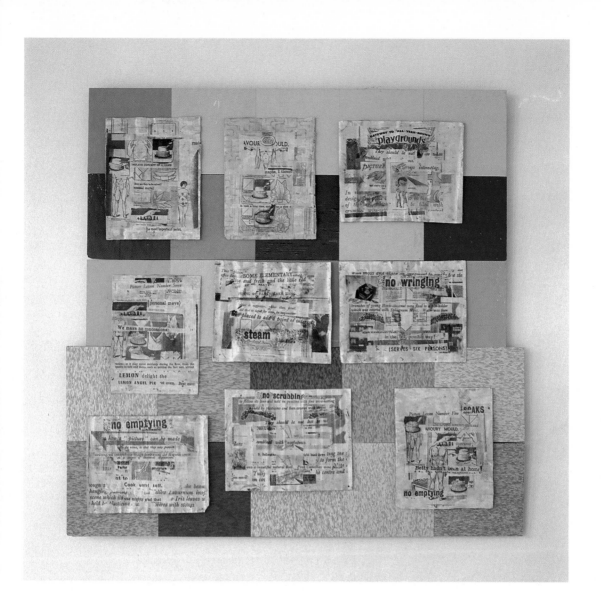

Merylyn Tweedie, *Nicola or Floral Tile or Betty* 1989. Sheet of photocopies on fibreglass cloth on vinyl wallpaper, coated with epoxy resin, on floortiles, 1680 x 1590 mm. Courtesy Gregory Flint Gallery, Wellington, and the artist.

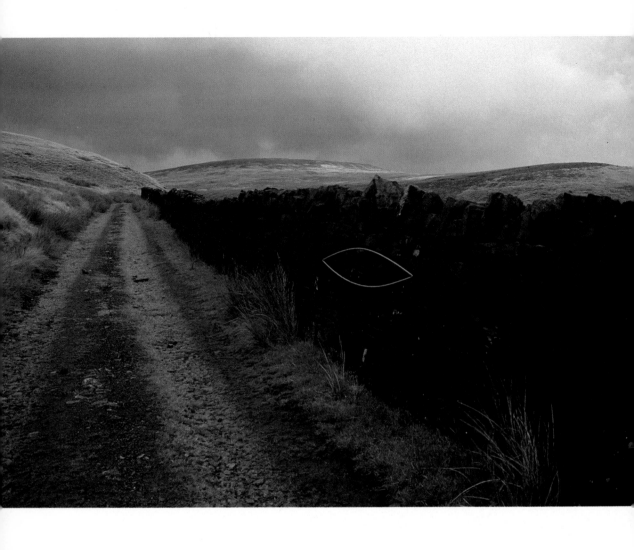

Pauline Rhodes, photodocumentation from *The Rossendale Project*
1989. Courtesy the artist.

Entries

Christina Barton

The diary embodies and articulates the tracing of a 'self' through time. It is a private place where fragments of a life are hoarded, where the quotidian rubs shoulders with the portentous, where the mundane is given free rein and the intimate full voice. As an alternative to both literature and history, the diary has been reclaimed and promoted by women as a site for the careful germination of a woman's 'voice'.[1] What follows is a fragmentary attempt to identify, in the contemporary visual art practices of women, the displaced traces of a diaristic form and impulse.

The diary is not-writing

A divine morning. At breakfast William wrote part of an ode.[2]

Compared to her brother's poetry, Dorothy Wordsworth's Grasmere journal (1800-03) does not carry much weight in the grand scheme of literary history. Her words inhabit the spaces around her brother's verse, signifying in her absence their status as not-poetry. *His* poetry is made to nestle comfortably amongst the quotidian details of the morning and of the hardly remarkable fact of his writing there, at breakfast. Yet *her* effacement cannot completely eradicate our sense of her pleasure in the fine morning.

It is a pleasure conceived not as a sentence but as a phrase. It is at once a statement of fact, a description, an exclamation, a sigh; its incompleteness a mark of its potential to signify, a measure of both a plenitude and a lack.

If one writes for one's own pleasure I don't know what it is that happens. I suppose the convention of writing is destroyed.[3]

The conventions of writing are indeed flouted, both from within: the very structure of the sentence is decomposed, rendered fragmentary; and from with-out, for the diary fails to transform language into literature, refuses to impose anything more than the most cursory of narratives on events.

The Journal cannot achieve the status of the Book . . . it is only an Album.[4]

And what is an album but a quantity of interchangeable leaves, a scrap-book where all kinds of fragments can be collected, stored, arranged and re-arranged? It is, as Barthes would have it, a nascent Text outside the 'serene heaven of Logic', a literature in its immature, unconstituted form.[5]

If this is the case, then the diary poses an alternative: to the Logos, to History and to linear time. Its function is archival rather than archaeological. For in the archive information is randomly and obsessively acquired without reference to use or value, it is stored as a non-discursive texture of equivalence, rather than formulated hypothetically into a narrative about living, a history in its raw unformulated state.

If the diary is an interwoven texture of equivalence, an archive of sorts, its visual analogue might be the collage.

[Collage lifts] a certain number of elements from works, objects, pre-existing messages, and [integrates] them in a new creation in order to produce an original totality manifesting ruptures of diverse sorts.[6]

The collage fragment is polyvocal and unstable, remaining representational 'while breaking completely with the trompe-l'oeil illusionism of traditional realism'.[7] As the diary is to Literature so collage is to Art. By rupturing perspectival space, collage undermines the hegemony of the visual, thus disrupting the unitary relation of author/viewer to work. Where the traditional author/artist has been conceived as phallic (Irigaray/Cixous),[8] the collagist has been characterised as bisexual (Derrida),[9]

involved in the dual process of 'castration' (the severing of the fragment from its original source) and 'invagination' (the fragment folding-in on itself in its new location).

The collage is marked by seams and sutures. It is a complex lamina on which dismembered images combine and disintegrate. Think, then, of Merylyn Tweedie's resined text-pieces, where bits of recipe jostle fragments of fiction, where dislocated lines from theoretical texts dislodge handy hints from housekeeping manuals, where what image there is, is torn and decomposed. More like ambient noise than coherent speech, Tweedie's work eschews a 'writing' of self for a deferral to the myriad texts that make *her*. A collage is a commonplace book: a site for quotation and for borrowing, where the self not so much speaks but is spoken for, where the writer is no author.

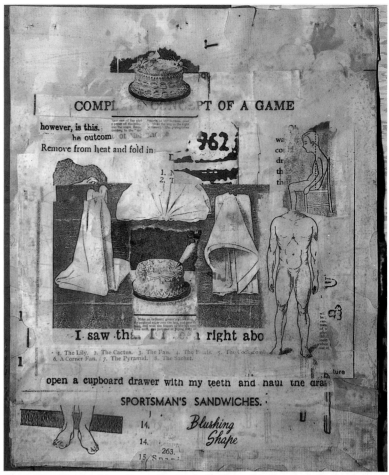

Merylyn Tweedie, detail from *Happy Hour or Profile Tile or Acaculco*. Sheet of photocopies on fibreglass cloth on vinyl wallpaper, coated with epoxy resin, on floortiles, 1680 x 1590 mm. Auckland City Art Gallery.

Writing is not-autobiography

Language is the history that gave me shape and hypochondria.[10]

Writing my Journal, I am, by status, doomed to simulation . . . What a paradox! By choosing the most 'direct', the most 'spontaneous' form of writing, I find myself to be the clumsiest of ham actors.[11]

Writing in 1981, Leonard Bell seemed somewhat disappointed in Claire Fergusson's *Date Day*, a performance piece in which 365 slides of the artist in the clothes she wore each day for a year, were projected chronologically on to her naked body, to the accompaniment of her impromptu remarks about what she could recall of the events and feelings asociated with each day. He found that:

The random diaristic excerpts, whether intentionally or not, were most often banal and unmemorable, revealing little about the personality and relationships of the person.[12]

Furthermore, he felt the 'preoccupation with dress and surfaces assumed an almost fetishistic dimension — even though the dress was ordinary.'[13] Perhaps Bell was right to feel deflated by failing to locate an authentic self behind the patina of changing costumes Fergusson adopted, but today we are resigned to the fact that it is these very surfaces that define us.

When I rummage through my wardrobe in the morning I am not merely faced with a choice what to wear. I am faced with a choice of images: the difference between a smart suit and a pair of overalls . . . is not one of fabric and style, but one of identity.[14]

If identity is situated in codes of dressing, then 'self' can be invented by words chosen, by language used. The opacity of language renders problematic the diary's relation to autobiography, just as the coded nature of painting throws into doubt both the mimetic and self-expressive potentialities of the self-portrait.

I like to paint with the seasons . . . I usually work by blocking in my general ideas, then leaving the painting for some months, or years, and with notes, the ideas grow to a further stage.[15]

For a prolific and committed self-portraitist like Rita Angus then, the act of painting was inextricably tied to the evolution of her thinking; as Laurence Simmons suggests, she is *embodied* in the very 'process of

applying paint to canvas',[16] no doubt in the same way that a writer is aware that she is *writing*, as much as of what it *is* she writes. But Rita Angus's self-portraits are coded in other ways. For one, she 'almost always relied on the montage of distinct subject assemblages to engender emotional response'.[17] Here then, the viewer may find clues to her identity in both the attributes of the persona she adopts (goddess, bodhisattva, madonna) and in the objects with which she surrounds herself. These associational clusters are collage fragments re-presented within the paint surface itself. Thus 'she' resides not only in the texture of brushstrokes, not only in the physiognomy of the human figure before us, but also in the emblems and symbols that are but partially concealed as the things about her: at once costumed and in disguise.

For another, and meta-discursively, her unconscious acknowledgement of image *as* image, of self as other, is played out through the projection of self as a mirror displacement reflected onto the surface of the painting.[18]

I, as subject and 'author' of these works, am located in *Tifereth* (Grace) the fifth *sefirah*. The understanding of the self's own constructed being, through the processes of metamorphosis, evanescence and substantiation, is symbolised by reflective surfaces . . . and photographic emulsion . . . These materials are pseudo-matter in the sense that their properties have more to do with light than substance. Like 'transparency' used in the highest *sefirah* (the Crown) they mock matter.[19]

Julia Morison's recognition of herself in the 'I' of the *Tifereth* is mirrored in *Quiddities I-X*, her recent self-portrait series, by her use of the photocollage as a medium

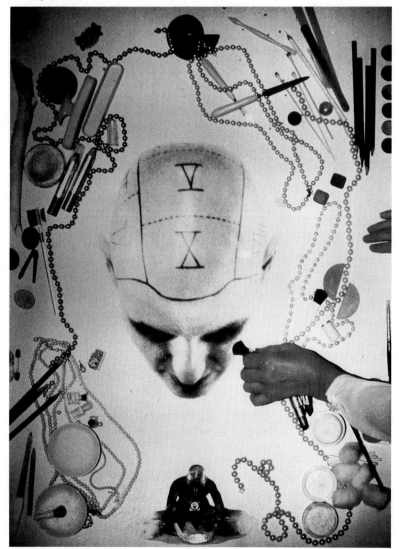

Julia Morison, *Quiddities V*, 1989. Cibatrans in lightbox, 920 x 660 x 175 mm. Courtesy the artist.

CHRISTINA BARTON

Grace Cochrane, *Christmas Morning 1950/1982*, from *Pages from an Album*, 1984. Hand-coloured photocollage, 400 x 530 mm. Courtesy the artist.

for the tranformation of real objects into a polyvalent system of signs. These signs operate as ancient and contemporary symbols for the Kabbalist *Sefiroth*; and simultaneously for an investigation of the subject/self as both manipulator of, and coded by, the very system Morison articulates.

Implicated in the processes of naming, Morison carries with her a 'vademecum',[20] a manual to code and decode her experiences. Undoubtedly, it is significant that the hermetical knowledge to which she holds the key belongs to a pre-Christian era. For Morison is attracted to a polyglot body of knowledge that is largely tangential to the dominating discourse of Western metaphysics, yet which, at many junctures, provides that metaphysics' subtexts. Perhaps it is more than coincidental, then, that Rita Angus, too, was attracted to an historical period that was distant from her own, one which was largely suppressed in her time: the medieval.[21] Rather than identify her preference as an unproblematical nostalgia for a 'bygone age',[22] it could be seen to recall a time which was not only bound to the cycles of nature, deeply susceptible to the magical, but which was, most

importantly, iconoclastic in its attitude to the written remains of inherited knowledge. For:

The Middle Ages ... performed a heedless destruction and a disordered preservation: it lost essential manuscripts and saved others that were quite negligible; it scratched away marvellous poems to write riddles and prayers in their place, it falsified sacred texts, interpolating other passages, and, in so doing, wrote 'its own' books.[23]

In tracing itself, the self emerges, then, as a palimpsest, as a tracing of a tracing. The 'self' fills and is filled by not one book, but many. And she is expert at disguise.

Past imperfect / Present tense

As for time, female subjectivity would seem to provide a specific measure that essentially retains *repetition* and *eternity* from among the multiple modalities of time known . . .[24]

. . . the sequence through past, present and future is not necessarily linear . . .[25]

She told me she had the idea of a little temple of art: a rotunda with spokes radiating and dividing areas to display different aspects of an individual artist's life.[26]

'Women's time' is cyclical and monumental, non-linear and a-historical.[27] It is a dual recognition of the daily and the eternal, the repetitive both micro- and macroscopically intuited. It is, in essence, mundane.[28] The diary is a writing of this time, the snap-shot its record and the album its home. Everyone's family albums look the same: the weddings, birthdays and Christmasses that make it onto film, blurred photographs of half-forgotten relatives, shaky snaps of children and pets. Additively they reveal a private, familiar world in its fleetingly public moments, a world which, far from being coherently or conclusively portrayed, is marked instead by gaps and omissions, by absences and caesuras: the realm of memory not history.

If 'women generally write in order to tell their own family story',[29] then it is unremarkable that Grace Cochrane should use her own family albums to tell hers. What is significant, though, is the way in which she combines images, placing herself — as she is now — back into the photographs; photographs not only of her childhood and adolescence, but even of a time before she was born. In a process which inevitably confounds the linear progression of time, Cochrane maps the intricate traceries of her family history, exploring the dual notions of lineage and kinship, re-visiting the occasions and locations of her childhood.

. . . to scatter like dust, from day to day, the traces of a period, mixing all dimensions and proportions . . .[30]

Photocollage, with its interpolative, combinatory capabilities, is an ideal tool for Cochrane's re-formulations. For she has in it a medium which is itself a version of the very processes she is intent on exploring. Furthermore, by retaining the album format she refuses any singular reading, deferring to the series in order to chart her own history, both through the images she presents and, in absentia, in the interstices between the serial collages she creates.

. . . the series promotes transmission rather than representation as such, it is . . . possible to cultivate void space (or silence), to reduce representation to traces and intimations.[31]

And as the series unfolds, the circle turns; leaves are added, the album rearranged.

Journal / Journey

Journal (n.)2. a book in which a daily record of happenings etc. is kept
(from L. diurnalis = daily, see: diurnal)

Journey (n.)1. a travelling from one place to another; trip or voyage 2.a. the distance travelled in a journey b. the time taken to make a journey
(from L. diurnum = day's portion, see: diurnal)

If the literal proximity of 'journal' to 'journey' renders writing a movement through time and space, then movement must surely be a writing of sorts, through space and time.

I have just re-read my year's diary & am much struck by the rapid, haphazard gallop at which it swings along . . . Still if it were not written rather faster than the fastest typewriting, if I stopped and took thought, it would never be written at all . . .[32]

Daily runs
sculptural/scriptural
 activity
the flow of —
idea/matter/body
 of the sensuous
 NOW[33]

Rhythms emerge as the daily record unravels. Less a sequence than a routine, the journal is marked by repetition, unfolding through time not in any regular, inevitable progression, but by fits and starts. A single incident will take a page to describe, two days will pass and a sentence will suffice. On a particular day memories will be recorded, promises made.

From here each day seems like a little boat and all the days are swept and tilted back and forth across an immense and distant bay of blue, grey, green. We were like plump birds along the shore, caught by the mortal breaks. Dimension, longevity, colour and pleasure.[34]

Word and sentence, page and volume, moment and duration, point and line. Such rhythms recall the play and replay of Pauline Rhodes's ongoing sculptural 'interventions' that briefly mark out a certain place *in* the landscape, *on* the land over which she runs,

CHRISTINA BARTON

through which she moves. Her luminous green rods and red marker-flags are pointers to her passage, reminders of her reactions to a particular site. They locate her and, momentarily, bring the landscape into line. But only for a moment. The photographs that document the work-in-situ, while remaining as the only record of her actions, serve as no more than *aides-de-memoire*, her writing is elsewhere and already complete.

The difference, then, between the photographs of the work and the work itself is the difference between history and memory, between the official record and the intimate journal. In sculpture the monument stands for History:

. . . a sculpture is a commemorative representation. It sits in a particular place and speaks in a symbolical tongue about the meaning or use of that place.[35]

Immobile, vertical, the monument is a permanent fixture. In contrast, Rhodes's ephemeral markers are anti-monumental. Dispersed almost casually in their various locations, they lie, nestle, lean. Rather than declare their un-natural other-ness, they seem to gently prod the land into disclosing its secrets, to reveal the way in which nature is already inscribed by culture. And if the monument serves to fix time by immortalising it, her work, devolving as it does from her fascination with the cyclical processes of degeneration and renewal, growth and decay; draws on time: recycling materials, repeating operations, responding to the rhythms of locating, placing, removing.

What remains is a set of tracks. Not the single broken line of the traveller making progress on a map; but a double line, an exploration of reversibility, the trace of a movement on a strange still place in which everybody looks at elsewhere, and somebody looked at here.[36]

Wot was here.[37]

The journey is embarked on, the journal entry made; as it was yesterday, and will be, again, tomorrow . . .

Notes

1 The diary, as a literary form with visual potential, was reclaimed by women and feminist artists in the 1970s and early 1980s as a strategy which embodied the notion of the 'personal as political', that vital precept on which the reclamation and validation of women's experience in art was based. The work of a large number of artists is important here, amongst them: Carole Shepheard, Claudia Pond-Eyley, Joanna Paul and many more.

2 Dorothy Wordsworth, Grasmere Journal (1800 — 1803), quoted in Thomas Mallon, *A Book of One's Own: People and their Diaries*. London: Picador, 1984, p. 127.

3 Virginia Woolf, diary entry dated 7 November, 1928, quoted in Mallon, op. cit., p. 33.

4 Roland Barthes, 'Deliberation' in Susan Sontag (ed.) *Barthes: Selected Writings*. Oxford: Fontana, 1983, p. 492.

5 Ibid, p. 495.

6 Andre Bazin quoted in Gregory Ulmer, 'The object of post-criticism' in Hal Foster (ed.) *The Anti-Aesthetic: Essays in Postmodern Culture*. Seattle: Bay Press, 1983, p. 84.

7 Ibid, p. 84.

8 See Toril Moi, *Sexual/Textual Politics: Feminist Literary Theory*. London: Methuen, 1985, p. 8.

9 Ulmer, op. cit., p. 90.

10 Lyn Hejinian, *My Life*. Los Angeles: Sun and Moon Press, 1987, p. 47.

11 Barthes, op. cit., p. 493.

12 Leonard Bell, 'Self paint trait', *New Zealand Listener*, 5 September 1981, p. 36.

13 Ibid, pp. 36-7.

14 Judith Williamson quoted in Susan Butler, 'How do I look? Women before and behind the mirror', in *Staging the Self: Self-Portrait Photography 1840s-1980s*. London: National Portrait Gallery, 1987, p. 56.

15 Rita Angus, artist's statement in *Yearbook of the Arts in New Zealand*, n.3, 1947, p. 67.

16 Laurence Simmons, 'Tracing the self: the self-portraits of Rita Angus', *Antic* 4, October 1988, p. 49.

17 Ronald Brownson, 'Symbolism and the generation of meaning in Rita Angus's paintings', *Rita Angus*. Wellington: National Art Gallery, 1982, p. 82.

18 I am indebted for this insight to Laurence Simmons' extended account of Lacan's 'mirror-stage' as it is enacted in Rita Angus's self-portraits, op. cit.

19 Julia Morison, 'My repugnance for antithesis is certain', *Julia Morison: Vademecum and Golem*. Wellington & Auckland: Louise Beale Gallery/Artis Gallery, 1987.

20 This term was used as the title of her 1986 work, *Vademecum*, which was her first major work to systematically address the sign-system of the *Sefiroth*.

21 Rita Angus's oft-quoted statement, 'New Zealand is, in essence, Medieval', can be found in *Yearbook of the Arts in New Zealand*, op. cit., p.67.

22 This view is exemplified by Anne Kirker in her essay, 'The later years 1959-1970', *Rita Angus*, op. cit., p. 61.

23 Umberto Eco, 'The return of the Middle Ages' in *Travels in Hyperreality*. London: Picador, 1987, p. 84.

24 Julia Kristeva, 'Women's time' in Toril Moi (ed.), *A Kristeva Reader*. London: Basil Blackwell, 1986, p. 191.

25 Grace Cochrane, artist's statement in *Grace Cochrane: Re-marking Time*. Palmerston North: Manawatu Art Gallery, 1988.

26 John Money on Rita Angus to Janet Paul, 'Biographical essay', *Rita Angus*, op. cit., p. 33.

27 Kristeva, op. cit., p. 191.

28 N.B. the Collins Dictionary definition of *mundane* (adj.): 1. everyday, ordinary or banal 2. relating to the world or worldly matters (from L. *mundus* = world).

29 Julia Kristeva, 'Oscillation between power and denial' in Elaine Marks & Isabelle de Courtivron (eds.), *New French Feminisms: An Anthology*. Sussex: Harvester Press, 1981, p. 166.

30 Barthes, op. cit., p. 481.

31 Ian Wedde, 'Resisting Foreclosure', catalogue essay for *Joanna Paul: Wanganui Works*. Wanganui: Sarjeant Gallery, 1989, p. 6.

32 Virginia Woolf, diary entry, 20 January 1919.

33 Pauline Rhodes, 'Daily runs', *Splash* 4, April 1986, p. 91.

34 Hejinian, op. cit., p. 27.

35 Rosalind Krauss, 'Sculpture in the expanded field' in *The Anti-Aesthetic: Essays in Postmodern Culture*, op. cit., p. 33.

36 Meaghan Morris, 'Two types of photography criticism located in relation to Lynn Silverman's series' in *The Pirate's Fiancée: Feminism Reading Postmodernism*. London: Verso, 1988, p. 149. Morris is here describing Australian artist Lyn Silverman's work which documents her journeys into the Australian outback by presenting a series of paired images: each one juxtaposing a view of the horizon and a shot of the ground on which she stands. While Rhodes does not separate the 'prospect' from her placements in it, I nevertheless believe that Morris's remarks are evocatively applicable to Rhodes's work.

37 Pauline Rhodes, artist's notebook entry, 23 October 1984.

The author would like to thank Elizabeth Wilson and Bridget Sutherland for their help and advice in the preparation of this essay.

Ed Ruscha, *Flipping* 1963. Pencil drawing, 355 x 432 mm.
Courtesy Andrew Bogle.

CHRISTINA BARTON

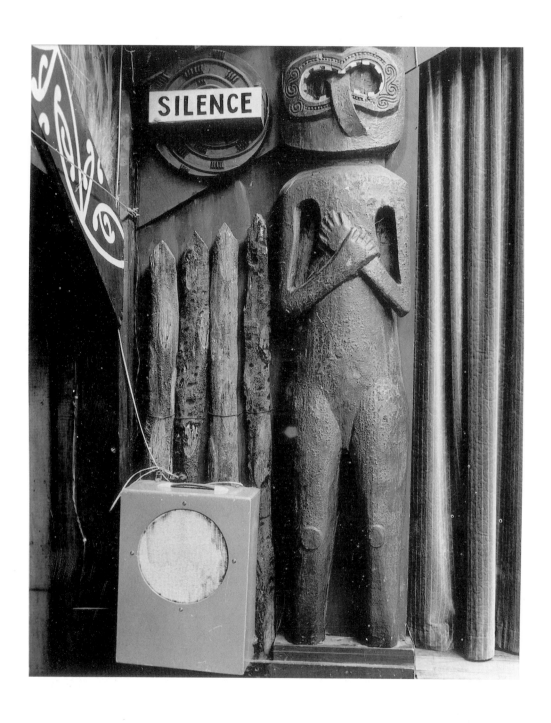

Laurence Aberhart, *Nature Morte (Silence)*, Wanganui, 10
February 1986. Silver contact print, gold and selenium toned,
245 x 195 mm. Courtesy the artist and Aberhart North Gallery,
Auckland.

Architecture & Translation

Rewi Thompson (Ngati Raukawa: Ngati Ngarongo Ngaiterangi; Ngati Porou: Te Aitanga o Hauiti, Ngai Tamanuhiri)

Maori Architecture has been little theorised yet its presence and language have existed in New Zealand for hundreds of years, and its translation may be understood by only a few. Maori have strong ties to their ancestral land. This is not only portrayed in Maori mythology but is more significantly expressed in their daily lives. The meanings of Marae, Tangata Whenua, Turangawaewae, are fundamental to Maori life and are expressed both physically and spiritually.

Often the physical aspect is misread or misunderstood. For example, the Whare nui (meeting house) (fig.1) is often visualised as a facade and labelled as a 'traditional form', with a door to the left and window to the right. The Whare nui however, is more symbolic and more expansive in its meaning. Basically it represents the Tipuna (ancestor) of that particular house.

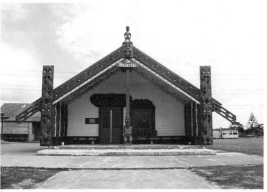

fig. 1 All slides and drawings courtesy Rewi Thompson.

The building components represent the body parts; for instance: The tekoteko (gable apex) represents the head, the Maihi (barge board) represents the arms, the Taahuhu (ridge) represents the backbone, the Heke (rafters) represent the ribs, etc. Traditionally, all the building components were carved, painted or woven to reinforce and complete the whakapapa (genealogy). (fig.2)

Today we see our meeting houses not so much as '*translations* of the origina!' but more as *interpretations* based on tradition.

The structural integrity of our modern houses no longer relates to the traditional house. However, Maori it seems have accepted this, so long as the spiritual meaning and symbolism remain, and this is usually in the form of tekoteko, kowhaiwhai and carving, applied as elements independent from structure and construction. (fig.3) This acceptance, in my view, separates the essence of the symbolism from the structure. If this is the case, then the symbolism should decide the structure. However, the common practice is to build the house shell, then design the symbolism within the space.

fig. 2

There have been cases where carvings have been inappropriately sized for the space. How relevant does symbolism become then? What seems to have happened is that the master carver's role has changed.

This may suggest that as long as significance and symbolism are understood, the physical form or translation may be more a matter of interpretation and not fixed.

The spiritual and symbolic dimensions allow our interpretation or translation to be flexible and to accommodate compromised situations without losing the 'bare bones' or 'essence'.

This Whare nui is for Ngati Otara Marae Society and breaks from the traditional door and window order. The door and window are conceived as one element. This acceptance illustrates the changing view of the Maori, and that tradition may only be a matter of interpretation.(fig.4)

This design for a 'Hometown Museum' for Wellington, was based on the Marae. The Marae is symbolised in the form of a futuristic canoe beached within the harbour. (fig.5) The spiritual significance and protocol of the Marae still exist, but the architecture has been 'translated' in a contemporary form.

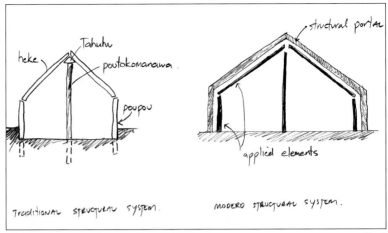

fig. 3

Pā & Mana

While the pa was primarily seen as a defense device, it also became an identity and therefore carried mana (prestige). Tribes associated themselves with their respective pa and these became symbolic landmarks. (fig.6)

The symbolism attached to our 'landmarks' and pa sites is less obvious today, yet the translation of these places can suggest architecture which is more significant and relevant than is normally achieved.

This design is for a prestigious office block development for Auckland. The form is dramatised by the volcanic cones of Auckland which also became pā sites for the Maori inhabitants. (fig.7)(fig.8)

The Debating Chambers for the Auckland Regional Authority's new buildings (fig. 9) have been articulated to reflect the numerous volcanic cones and headlands. (fig. 10) The association of the various areas is expressed as a city. This expression is

fig. 4

fig. 5

fig. 6

fig. 7

fig. 8

fig. 9

sometimes difficult to visualise in architecture. The sketches and design illustrate that the various parts of the city are architecturally connected - connected physically, spatially, historically and spiritually. (fig.11)

fig. 10

fig. 11

Marae & Space

The Marae is a place for 'rituals of encounter', whether it be for tangi, hui etc. The welcome process is formal and follows protocol and tradition. The architecture is interpreted not so much as building, but in spatial terms. (fig.12)

1st Space — Entrance
2nd Space — Marae atea
3rd Space — Whare nui

fig. 12

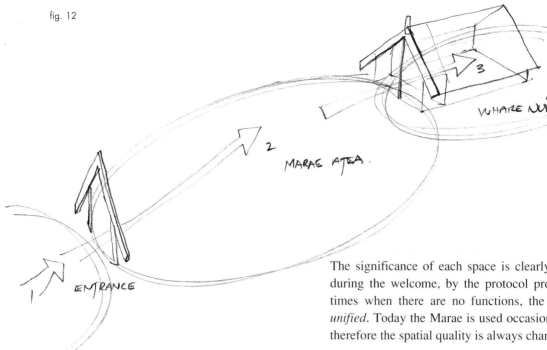

The significance of each space is clearly defined during the welcome, by the protocol process. At times when there are no functions, the space is *unified*. Today the Marae is used occasionally and therefore the spatial quality is always changing.

(fig.13) This diagram illustrates the change in spatial quality and relevance, dictated by formal occasions on the Marae. Space is more dynamic and related to time. If space is three dimensional, this may suggest that space can be defined in a vertical direction, and related to the welcome process.

If the 'Marae' can be translated into architectural space, then 'time' becomes a 4th dimension of (Marae) architectural space. (fig.14)

This house in Kohimarama, Auckland (fig.15) has interpreted the Marae as an architectural space in a vertical direction. (fig.16) A four storey void unifies the whole house as a space. (fig.17)

As one ascends, the mezzanine levels define each

fig. 13

fig. 14

fig. 15

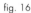
fig. 16

TIME

VOID.

LIVING.

SLEEP

ENTRANCE

fig. 17

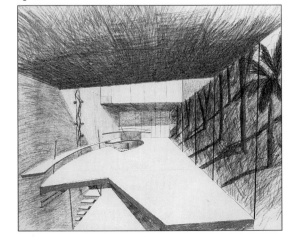

space relative to the position of the person ascending. The experience should be no different, whether moving vertically or horizontally.

Different Viewpoints

The arrival of the pakeha resulted in architecture being seen as more absolute, more defined. Maori and pakeha translations of architecture can be conflicting. However, architectural conflict can only be resolved in architectural terms. That is to say, in terms of the relationship between different viewpoints, or rather the spatial relationship between each viewpoint. This architecural conflict may not produce answers but will at least define differences.

Augustus Earle's painting *Meeting of the Artist with the Wounded Chief* allows us to translate this historic event in architectural terms.

Hongi's relationship with site - the land.

Hongi is looking out.

Augustus's relationship with site is not clear but we can assume that it is with his way out - the sea.

Earle is looking in.

The different relationships can be defined as outlined in the matrix. (fig.18)

However, the relationships should be defined three-dimensionally, if we are to see things in architectural terms. (fig.19)

fig. 18

fig. 19

REWI THOMPSON

Both Augustus and Hongi have clearly defined space relationships. The transitional space between them is more difficult to define but exists nevertheless. To illustrate this more physically, we can look at a house design for the Hokianga Harbour, Northland. (fig.20)

The individual elements and their spaces respond to various aspects of the Harbour and surrounding hills. They 'come together' at a particular point. Each element is a segment of the larger site and is represented by its shape and orientation. (fig.21) (fig.22)

The space created by the elements is undefined and transitional. Similar to the space created between Augustus and Hongi. This space could be informal, friendly, unpretentious etc.

In creating architecture in New Zealand, the spiritual dimension is virtually untried. Yet it has existed here for hundreds of years. In my view it would be difficult to call New Zealand Architecture authentic without coming to grips with the spiritual dimension. How one decides to translate this is a matter of interpretation. The architectural space created by Augustus and Hongi defined their relationship. It is not always necessary to see architecture as formal elements. As architects, we need to get used to this idea.

All designs by Rewi Thompson

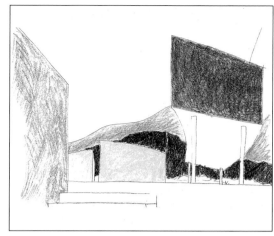

fig. 21

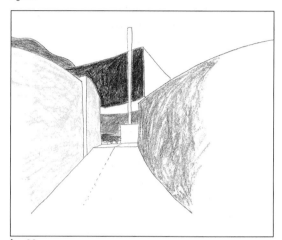

fig. 22

fig. 20

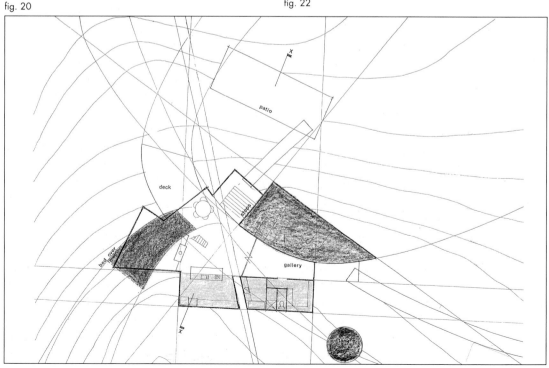

Listening to the Stones

(DEAF DEAL DELL DULL MULL MULE MUTE)

Mary Paul

When I first looked at Mary-Louise Browne's installations I was impressed and amused by their eschewing of associative qualities — apart from those clear associations which arise from lettering on stone. Particularly amusing is the large distance between the initial idea and the completed product. The absence of immediate clues to the meaning of a piece (even when there are accompanying notes) seems to be very much part of the tone of her work.

For example in her *Milestones* series commissioned for the *Putting the Land on the Map* exhibition (1989) she has engraved on each white carrara marble milestone the motto of a city; and underneath the motto, a number of miles. That number, separated from the accompanying notes, has no immediate significance. But in fact behind the number lies a systematic and detailed enquiry and calculation. The number of miles is the sum of the distance covered by the streets named after women in each particular city. The numbers are thus for the most part small ones.

In his notes to the *Putting the Land on the Map* exhibition its curator Wystan Curnow comments of the *Milestones* project that it is Mary-Louise Browne's adopting of 'the role of the dandy with superior manners and taste that enables her to take liberties' and 'gives her the right to ask difficult and timely questions' about the kind of social history that has been inscribed on our maps and which has kept women off them. While he may perceive Browne's politeness and elegance as a strategy to be simultaneously political and acceptable, for me what is more interesting is the passionate opaqueness in the work and the humour of the fact that it is so careful not to reveal its questions directly.

Mary-Louise Browne's texts on paper (loose leaf and in book form) are also characterised by their absences and gaps. A horror of the obvious, a desire to avoid easy or sentimental associations and an interest in controlling the act of creating something in an extremely systematic way: these factors are all present in her earliest text work some of which was executed while she was still at art school (Elam, 1976-82). In her loose leaf work with its punning title *De-Composition* (1981) the text indicates on its first page that it intends to deconstruct itself. The same text appears on the following pages making the same claim but becoming less and less intelligible as systematically one and two letter words and then longer ones disappear. This playful text is a metaphor for memory failure and for the possibility of a frightening disintegration of language. But it also undermines our expectations that a text will construct a narrative and remain firmly in the fictional or descriptive sphere, when we read a page that gives instructions for its own dismantling. Another work from this period (1982), *Black and/or White*, similarly undermines what we expect from a text. For a start, though like *De-Composition* it is a sequence of pages where we would expect text and sense to be continuous, it turns out not to be; each page is complete in itself in the way that each page of a folio of drawings would be. This technique turns writing into image. Then, to further confuse expectations, each page ends in three footnotes which prove to be three alternative endings to the narrative. Thus we have a kind of mocking comment on the academic text as well as the echoing of a technique we would expect to find in a board game or in a Dungeons and Dragons manual. This amusing strategy is complemented by the fact that the narratives are all concerned with an artist's anxiety about her work and the responses it may elicit — a multiple of anxieties, in fact, about interpretation.

The self-consciousness and indecision humorously presented in these early works has perhaps been answered by Browne settling on narrower systematic strategies in the production of her 'transmutations', as she calls them. In these 'transmutations' Browne creates, on paper or on stone, a sequence of words running from a significant beginning word to

a significant ending one — the rule being that each word may only vary by one letter from the previous one. There is choice operating here but in a tightly controlled system. A system which throws up seemingly arbitrary connections on the road from one word to another but which allows ample room for the viewer/reader to find significant relationships between those words.

For instance in the text used in a plaque made for the Katherine Mansfield *Hearts and Minds* exhibition (1988) Browne takes the journey from 'Have' to 'Hold', 'Care' to 'Worn' and 'Home' to 'Work'. (These twosomes relate to Browne's interest in the theme of masochism and oppression as it exists between servant and mistress in Mansfield's stories.) Other times she collapses opposites into each other as in *pneuma* where the sequence runs from 'Body' to 'Soul'.

Browne's work depends on the re-contextualising, often in a humorous way, of the use of signs. Her installations comment on traditional uses of stone in plaques, gravestones, doorplates, foundation stones and even milestones. I've already mentioned the punning milestone (a milestone for women!) but there is also the reference to the habit of hanging biblical and celebratory texts on the wall of the family home in her *Nominate, Dominate, Domesticate* wall plaques done for the Katherine Mansfield exhibition. And her *Truly Rural* environmental installation in Dunedin churchyards subverts our expectations of what words we will read on stones in such places. (The inscription was suggested by a phrase that is apparently used as a test of sobriety — if you can say 'truly rural' you're not drunk.) Browne is ironically juxtaposing her uses of 'signs' to the usual ones, much as Barbara Kruger has done with the advertising billboard. And of course this becomes more confusing when as in Kruger's case her billboard is erected alongside the real advertisement or, as in Browne's installation the stone is laid in the Knox Church graveyard.

Browne's cool, minimalist and systematic approach can also be seen as a reaction to the feminist aesthetic of the late 70s and 80s. Her approach, even when her concerns are with gender and power, is oblique and possibly one could say clinical. Her *Nominate/Dominate/Domesticate* work hints at the intimate relationship between entrenched power and the pleasure of yielding to that power, as something of interest rather than something to be judged. From this perspective it's interesting to compare Mary-Louise Browne's work with the writing of Ann Kennedy who has also worked in reaction to a fashion for personal documentation in women's writing, foregrounding instead the playfulness of storytelling, and assailing clichés by exaggerating and delighting in them.

That Browne's work is conceptual is obvious from this discussion — and it is the fact that it is primarily conceptual that allows me to make some comment on the exhibited work which in fact I have never been able to see 'in the stone'. *Deaf/Mute* (see colour page 231) is an as yet untitled work but maybe in itself it provides a comment on Browne's name for her method: 'trans*mut*ations'. Travelling the journey between Deaf and Mute (DEAF DEAL DELL DULL MULL MULE MUTE) we ponder the relationship between the words via a kind of story. DULL sits exactly between DEAF and MUTE. DEAF is indicated in the physical privacy of DELL. DEAF is a DEAL — something you are DEALt. To be DEAF is to be alone, to MULL over, but also to be obstinate (MULE) and to refuse speech, to be MUTE. Here we have an exploration of the violence in the label 'deafmute'. And because all labels are nominated by someone about someone or something else, we find ourselves feeling for the lost, leftout particles of grammar, especially the pronouns which tell us who was mute, who dealt, who was deaf and to what. The language makes us reach for the instances of the speech act.

Browne's 'transmutations' foreground the activities of reading and interpreting but I think there is another desire in this curious method. The desire to rediscover an essential relationship between the shape of the word and its meaning, an inspired magic project hidden in the elegant clothing of the dandy. And a project always very sensitive to comic possibilities.

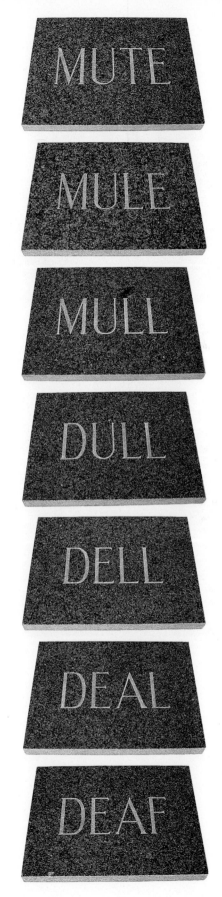

Mary–Louise Brown, *Untitled* (Deaf/Mute) 1990. Black Granite,
7 sections, each section 300 x 400 mm. Courtesy the artist.

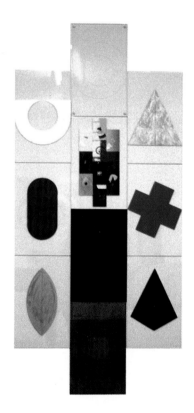

Julia Morison, *Golem* (detail) 1987. Mixed media on aluminium.
2000 x 12910 mm (100 plates 500 x 310 mm). Courtesy the
artist.

A word on dumbness in the thick of speech

Stuart McKenzie

From: *The Golem: the Thing that Walks like a Man!* Strange Tales, Marvel Comics Group, 1974.

When God created the world He first created the Torah. Black fire on white fire, wrote Rabbi Isaac the Blind. Understanding the Torah, God created the world.

The creation of the Torah is the process by which the divine name emanates from the Unnameable and settles as the visible and invisible. The Torah is the full name of the Father, and gathers all His names together. The letters of the Torah are the fabric of God. The name of God is a veil, and so allows a glimpse of Him.

Kabbalistic speculation is mostly concerned with the conduits of divine emanation, the *sefiroth*, through which the creative urgency of God devolves, and evolves back into Himself. Each *sefirah* is understood as an attribute of God. Refractory to direct or final comprehension, these attributes must be translated into symbols.[1]

Julia Morison has refined her own set of symbols for the *sefiroth* in the 'pared down style', as she remarks, 'of modern advertising logos'.[2] It is appropriate that these symbols be called 'logos'.[3] The unfolding of the Ineffable into light is, after all,

characterised by the kabbalist as the effulgence of the divine *language*. Moreover, in the same way that a corporate logo visually signifies and expounds the quality of a particular industry, Morison's graphic devices attest, but do not exhaust, the industry of a particular quality or *sefirah*. Indeed, the sefirothic logo preaches the *inexhaustible* nature of sefirothic content: the appreciation that divinity can never be divined.

Just as language is a metonymic career from signifier to signifier, through which defile desire is negotiated; and just as commerce is a dizzy transaction of values rather than goods, but again with real effect; so God exists in the currency of signs, the circulation and calling of names. It is through words that God is recycled. Not surprisingly, the circle is Morison's 'highest' sefirothic logo: the shape of things to come; the ring around divinity; a garter, a

 finitude which shrinks into infinity.

God is a circle whose circumference is nowhere and centre everywhere. Following the torsion of language, He also condenses at every

233 STUART McKENZIE

point.[4] The meaning of a word, defined by other words (by what it is not), is finally and definitively itself — 'I Am what I Am'. Likewise, a graphic signifier properly testifies to itself. We might imagine, therefore, that a corporate logo is not only an element of the identity of a particular industry but, in its sheer effrontery, that identity itself. And, in the case of the sefirothic logo, the content which it exercises is worked out within the horizon of its form. Paradoxically, the style of the sefirothic logo *is* the attribute of divinity. In fact, this absurdity is not foreign to certain kabbalistic ideas in which the *name* of God is understood as coterminous with His *identity*; just as, analogously, the surface of a Moebius strip convolutes into its own lining.

The appellation, then, the appurtenance, the tacked on, secondary, or supposedly unreal, is not only compossible with but also inalienable from the so-called real. The advertisement is the commodity. The precession of simulacra is an event of authenticity. The surface is profound: the deep is built of shallows. Invisibles in visibility.

This procession of visibles — of the things whose reserve dehisces into shape — is, as it were, loud with its own traffic. This pandemonium of visibles — of the things made and unmade in the forge of their names — has a density and is a 'flesh' which, as Merleau-Ponty abridges, has the structure of a 'chiasmus': the shape of a wound, an interlacing, decussation, crossing, double-crossing.[5]

 In *Vademecum* (1986) Morison attempts to cheat the mundane logic which encourages antagonisms of word and world, deep and superficial, flesh and soul, sacred and profane. Instead, the industry of God — the ten *sefirah* ranging from the Kingdom (*Malkuth*) to the Crown (*Kether*) — is expanded through the successive merger of logos culminating in the amalgamation of circle and square. But this big business should not be regarded as the simple and monotonous upgrading of the degraded, or the annihilation of difference in identity. Rather, it is the disintegration of crude difference into exiguous and subtle difference. The joining together or articulation of difference. The escalating sentience of language in a curd of silence. (The flesh succumbing to the word: bespoken. The word made flesh: dumbfounded.)

T.S. Eliot also saw through the Word to its opacity, listened to its quiet. Eliot, however, rued the pitiless and heedless commerce of the world, its busy talking: 'The endless cycle of idea and action', he said, 'Endless invention, endless experiment, Brings knowledge of motion, but not of stillness; Knowledge of speech, but not of silence; Knowledge of words, and ignorance of the Word'.[6] Several times in the same work — regretting the gag and spew of language which is a perversion of the orginal, authorial silence of the Word — the Christian poet laments the hectic printing of books, and chides their authors for being 'too vain and distracted for silence'. Oppositely, the Jew, recognising that the Torah is the word and flesh of God, celebrates the endless publication of commentaries, summaries, dissertations, refutations, marginalia, glosses. He attends religiously to the sacrifice of the Word in language. (Which is why God is always a dismembered God, and the crucifixion an obsessively Jewish event. And why it is through language that God is remembered.) Silence is built in a din.

 The industry of Jewish confabulation has been impressively brought to bear on the Hebrew word *golem* This *hapax legomena*, or word which appears once only, has its scriptural source in Psalm 139:16. The author — regarded by Jewish tradition as Adam — relates how God saw his golem, unformed matter, and proceeded to bring it into line. From this passage, occult exegesis elaborated the possibility of engineering a man, a Golem,[7] by imitating the divine order and applying it to dumb earth.

A tradition communicated by Rabbi Eleazar who lived in the third century holds that the Torah is not revealed in its proper order. If it were, anyone who read it might create a world. Anyone might make a man, raise the dead, or defy the Father's version. God only knows the grammar of creation. The cryptic *Sefir Yetzirah*, however, argues that man is a transcription of the cosmos, a microcosmos attuned to the Word, image of the Father, and so *can* realise through himself the genius of origination.

 The final chapter of the *Sefir Yetzirah* (The Book of Creation) attributes to the patriarch Abraham an expedience in the silent word of the world, and suggests that he exploited this command by creating a man.[8]

Accordingly, Abraham became the image of all those magicians, rabbis, scholars who kneaded the earth into the image of flesh and inspired it with the Word of Truth.

The fact that Abraham, the very progenitor of Israel, was conscripted by legend to dignify the manufacture of Golems might, oppositely, betray in the literature a sense of its own sacrilege. In some legends the notion of trespass is explicit. One fearful story tells how Ben Sira and Jeremiah studied the *Sefir Yetzirah* and, after three years of labour, gave birth to a man whose forehead was twisted into the caption 'YHWH Elohim Emeth' (God the Lord is Truth). With a sharp knife, however, the Golem cut a letter from his flesh to leave the epitaph 'YHWH Elohim meth' (God the Lord is dead). Jeremiah ripped his clothes and taxed the creature for an explanation of its blasphemy. But the Golem's answer returned the guilt of sacrilege to his accusers. Having conjured a man into the world, he rebuked, they have challenged the unique authority of God. Dazzled by simulation, people will recognise no God previous to these magicians!

Ben Sira's Golem is exceptional in that it can speak. Disavowing such a possibility, Eleazar of Worms argues in his influential commentary on the *Sefir Yetzirah* that the Golem is necessarily dumb. The piety of its maker is tarnished — his craftmanship impaired — by his very effort to ape God's art.[9]

The Golem legends seem both to encourage and prohibit imitation of the Father. According to Freud, the aetiology of such a tension is to be discovered in the Oedipus complex and its normalisation. In this scenario, the child is removed from the body of the mother and instructed in its identity by the duplex Law of the Father. The subject must obey the precept to emulate the Father ('You *ought to be* like this'), *and* the prohibition against em(asc)ulating Him ('You *may not be* like this').[10] Certain things are the Father's prerogative. (And the wise men, kneading and putting the hard word to mother earth, exercising the cruel spell of their naive magic until she crawls with flesh, transgress this ordinance.)

 Primarily, the Father's interdiction has been understood as applying to the boy child — 'I only may possess your mother'. In fact, this restriction permits the son to establish attachments elsewhere, and initiates him

accordingly into the Word or Symbolic Order. On the other hand, the female child's apparent exemption from the Father's directive guarantees her increased subjection. The incarceration of the male within language is the gift of authoritative speech. The female, however, is sentenced by the Symbolic Order to be its Other and, supposedly, without a word to stand on.

 The legs which stand awkwardly in the *Tifereth* section of Julia Morison's *Golem* — the *sefirah* of the Self, the dream, and language[11] — may well bespeak the female subject's historical loss of voice and face. Of these two female feet — which raise their hands, perhaps for help, perhaps to be allowed to speak — one is bound to a lead plate, while the other is equally strapped in fetishising apparel.[12] These handled legs are also unmistakably phallic. This is not surprising given that the fetish (the shoe, the bound foot) has been instituted in theory as standing in for the phallus. Rather than a form or a fantasy, the phallus has come to be deployed as a symbolic object, 'the signifier of desire'.[13] The phallus is called 'transcendent'. And like God, who circles the extent of language and occupies each point, the phallus is the irrecusable authority of each signifier, allowing it to advertise 'I Am what I Am'. Cut off from the phallus, the so-called 'primary signifier' — and consequently disqualified from an effective relation with desire, which mediates all intercourse — the female is effectively kicked out of language.

 But it is not a simple exclusion which gags the subject. It is not simply against language that there is dumbness. The voice is lost in speech, removing the tongue by moving the lips. And like the Golem who is brought to life and fitted out with an identity through the incantation and imposition of words and yet is mute, we are made fluent in a language which speaks us if not talks us down. And like the engineer of Golems, it is the individual's impossible piety to create herself but not to. To be, as it were, two faced.

Duplicity is precisely the strategy Morison uses to rewrite the body into language. In this she follows the programme of kabbalistic ritual in general, and the

STUART McKENZIE

sefiroth in particular. The sefirothic tree, conceived also as a body, comprises three female and three male aspects mediated and finally resolved through the four neuter *sefirah*.[14] The ten sections of Morison's *Golem*, then, perform the overall androgyny of the sefirothic body. Moreover, rehearsing the play of micro- and macrocosm, each section is itself divided into ten panels; and so the androgyny of the sefirothic system as a whole is potentialised at every stage.[15] *Golem*, proceeding from this simple standpoint of hermetic conjecture, propounds the value of duplicity through the expropriation of logos from *Vademecum*. By compounding these loaded words with mum flesh, *Golem* forecloses the business of the Father which the words previously transacted.

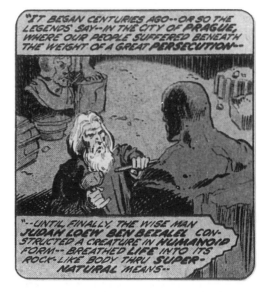

 Morison's ambition to get around the Father — pressure signification to a radiance of crisis and of fission — is most explicitly announced in the section *Hod* (Praise), whose sefirothic relation to 'knowledge' is that of 'signification'. By developing the vesica-piscus logo as a vaginal opening, complicated by the surround of bulbous shapes reminiscent of buttocks, breasts, and the swollen heads of penises, Morison outlines a metaphor for the bankruptcy of phallic claims to original or primary signification.[16]

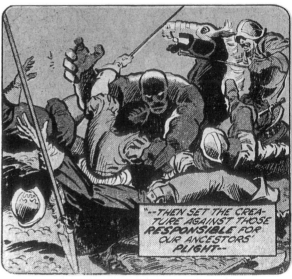

The Word marks off a silence. A word is a silence precisely because it must resort to itself as its own explanation, return to itself as its own point, body of oblivion, but brute fact or flesh: the very matter of the immaterial. Between the word and flesh — between order and silence, violence made to order — there is a relentless vacillation. In *Vademecum* the logos mine God into light. There is conjugation, convolution, and a bursting into view. There is also repression: the visible achieves a certain mass, a weight, a ritual, certainty or dogma. On the contrary, the logos in *Golem*, whipped into flesh, strain to say, beyond the Father, otherwise than what has always been already said. To speak the cast shadow of the hard light of the said, which, in turn, will harden into light and cast a darker and more burning need needing to be spoken. (And the gagged will surely speak — it is necessary, after all, only to gag those who can — and be silent. And while the word construes the body, invents the flesh, the flesh may have the final word.)

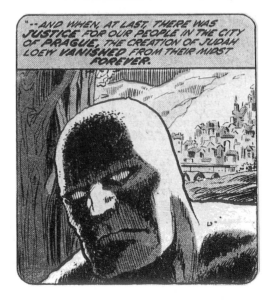

Notes

1. Much of my information on the Kabbalah has been culled from Gershom Scholem's important book *On the Kabbalah and its Symbolism*. London: Routledge and Kegan Paul, 1965.

2. Julia Morison, 'My repugnance for antitheses is certain', *Vademecum & Golem*. Christchurch: self published, 1987, n.p. On this point, it is probably worth noting Robert Leonard's intriguing comment that 'Morison's re-styling of esoteric signs suggests a cosmological content at work in contemporary capitalism.' Priscilla Pitts and Robert Leonard, *Exhibits: the museum display and the encyclopedia plate*. Wellington: National Art Gallery, 1988, p. 28. See also, Buzz Spector's exhibition and catalogue essay, *Objects and Logotypes: Relationships Between Minimalist Art and Corporate Design*. Chicago: The Renaissance Society at the University of Chicago, 1980. Both minimalist art and corporate logos, argues Spector, 'reflect a common faith in the efficacy of form as a means of restructuring society through public exposure to works executed within particular systems of use' (p.3). Likewise, Morison's reference to the style of commercial logos communicates her sensitivity to the expediency or politics of form. In developing her logos, Morison relies on the ideas and meanings which have come to be associated with various shapes. In a letter to the author she recognises that her logos are not 'idiosyncratic' but 'clichés permeating language — text & image — insidiously'.

3. Morison's logos are the product of a certain shape executed in a complementary material — e.g., lead for the square, 'transparency' (glass, or some other appropriate medium) for the circle. Like the eloquence of form, different materials have learned to speak different ideas. Thus, the materials that Morison uses — ash, clay, excrement, 'reflection', blood, mercuric salts, silver, gold — consolidate the particular shapes, nuancing and enhancing the rhetoric of the final logo.

4. In Chapter 11:17 of *De quantitate animae* (*The Greatness of the Soul*), Saint Augustine, after an extended discussion of various geometric forms, decides that the circle is the highest form because its symmetry is most complete. He designates the central 'point' of the circle a *signum*, a 'sign'. Like God, who Is what He Is, the point or sign is simple, indivisible, caught up totally in itself. Doctor Faustroll paraphrases the Saint with his definition: 'GOD IS THE TANGENTIAL POINT BETWEEN ZERO AND INFINITY'. (Alfred Jarry, *Exploits and Opinions of Doctor Faustroll, Pataphysician*)

5. Many of Morison's logos explicitly recall the idea of convolution. For example, the 'vesica-piscis'; 'spiral'; 'twist'; 'crossroads'.

6. *Choruses from 'The Rock'*

7. (The cabalist who officiated as divinity
 Called his farfetched creature 'Golem':
 These truths are related by Scholem
 In a learned passage of his volume.)
 (Borges, *The Golem*)

8. Conjecture defended its thesis by esoteric interpretation of the first Book of the Pentateuch which describes Abraham and Sara as taking with them to Canaan 'the souls they had made in Haran' (Genesis 12:5).

9. It is no doubt due to its divorce from language that the Golem is such a ready agent of violence. In the versions of the legend which began to circulate in Central Europe from the seventeenth century onwards (and in their cross-cultural derivatives: Frankenstein, for example), the trauma and chaos that is speechlessness rapidly burns through external constraints and the creature runs amok. Curiously, in a Marvel comic entitled 'The Golem: The Thing that Walks Like a Man!', the Golem is described as being created by Rabbi Judah Ben Bezalel to defeat the persecutors of the Jews in seventeenth century Prague; that is, to use its dumb violence to give a voice to the articulate but oppressed.

10. See, for example, Sigmund Freud, *The Ego and the Id*, trans. James Strachey, Standard Edition, Volume XIX. London: Hogarth Press, 1961, p. 34.

11. Each *sefirah* is to be understood through its unique relation to, amongst other things, a particular part of the body, an aspect of alchemy, of temperament, of consciousness, and of knowledge. *Tifereth* thus relates to perceptual capacities, to the Self, to involution, to dream, to language.

12. Each of these two feet, developing into an arm and hand — similarly written over, up, and off — form the kind of deformed body which populates dreams and the universe of horror. A mutant body which has not learnt to attribute coherence and symbolic order to itself; a body in bits (Lacan's 'corps morcelé' prefiguring the 'mirror stage').

13. Jacques Lacan, quoted by Anthony Wilden, 'Lacan and the Discourse of the Other', *Speech and Language in Psychoanalysis*. London and Baltimore: Johns Hopkins University Press, 1968, p. 187.

14. See, Morison, op cit, fig 3.

15. For example, the 'lowest' panel (*Malkuth*) of the *Tifereth* section anticipates the entire system — the final cosmic order and the integrated Self — by illustrating an androgynous figure drawn from an ancient medical diagram of the body divided into *sefirah*.

16. A similar disruption is suggested in the section elaborating on *Netsah* (Victory), which relates to aggression. Here, Morison develops the 'arrow' logo into a hermaphroditic body with breasts which lactate razor blades. Again, her desire to frustrate the trade in gender constructions is expressed in *Gevurah* (Strength). This *sefirah*, whose given logo is the 'twist', relates to the breast. Morison quotes such images of proliferating breasts as the *Diana at Ephesus* or Hans Bellmer's surrealist sculpture *The Top* (1938), but gives a twist to these obsessive essentializations by presenting them as swollen glans, condoms inflated with milk.

Sefirothic logos by Julia Morison

Opposite page: From: *The Golem: the Thing that Walks like a Man!* Strange Tales, Marvel Comics Group, 1974.

STUART McKENZIE

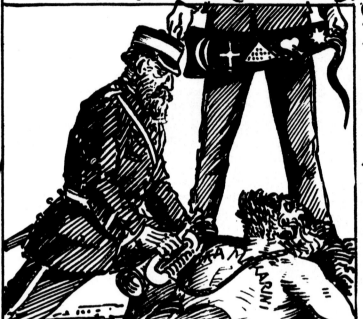

② THERE WAS NO DOUBT AS TO THE IDENTITY OF THE DEAD MAN. HE WAS FAIR-SKINNED, ALMOST WHITE, & ACROSS HIS BROAD CHEST WAS TATTOOED HIS MAORI NAME. **MAIR** 'FOUND ON THE BODY **TE KOOTI'S** FAMOUS WAR PENNANT KNOWN AS *TE WEPU* (THE WHIP), WITH ITS QUEER CHARACTERS, & THE BUGLE WHICH **TE KOOTI** HAD TAKEN WITH HIM WHEN HE ESCAPED FROM THE **CHATHAM** ISLANDS IN 1868. **PEKA** WAS KNOWN TO USE THIS BUGLE TO DECEIVE THE **PAKEHA** TROOPS. DURING AN ENGAGEMENT ~

(left margin fragment) ...GST ...EANS HAD ...ELL-VED ...OF ...CHER.

(left margin fragment) TURI EN— ...S WRITES, ...FROM THE ...WAS A ..."

⑤ FROM THE START **BAKER** WAS AN INCORRIGIBLE, CONSTANTLY BREAK-ING BOUNDS & BEING A.W.L. TIME AFTER TIME. WHEN POSTED TO HAWKE'S BAY HE DESERTED &, AFTER NUMEROUS ADVENTURES, JOINED THE **HAU HAU** REB-ELS. HE WAS

(right margin fragment) **⑥** ...M ...T ...E

from *It Happened in New Zealand* by Ross Gore, 1958.

"People are amazed. So am I."

Paratene Matchitt (Whanau a Apanui, Ngati Porou, Whakatohea)

They [Para Matchitt's banners commissioned for the Commonwealth Games opening ceremony] go over 30 metres — 30 metres side by side and they come up with different images. One set of choreography will bring up the Waitangi image, another move will bring up Te Kooti's flag, and another one will bring up a real old weaving pattern — there's four different movements... Well, twenty banners like that, give you an image of Waitangi; twenty banners maybe positioned in different places, would give you Te Kooti; on the other side, the image will relate to the pre-Christian era. But you've got all these other images as well — there are four different trade areas that we looked at — they are very literal . . .

Courtesy Los Angeles County Natural History Museum. Photo: John Deleon 1983.

Just like the big piece [Te Huakina, 1986] that you did for the NAG . . .

Yeah, but you imagine that with overlays of other images on it — and you wonder what is going on. . .

I don't do too many drawings — a lot of leading up drawings but they don't mean anything . . . [Goes through the drawings.] As I say, a lot of these things are quite literal. You see they gave me this brief — they wanted four banners to represent different ideas. One to represent the trading of kauri forests; trade with vegetables, like potatoes, flax, kumara — but most of those ideas have gone out. I think the flax has remained much the same, but that's the general idea. And there are six banners to make that shape and on top of that, there are other things, and it'll probably come out like this. So you can see the shape coming

through here and if we follow that choreographically, then we are liable to get all this black shape coming through to make sense. And another time, all those orange shapes would get together and the black wouldn't make any sense at all. A lot of those, we don't know what they are about. Some of them we do, but some of the things they've come up with are not only complicated to look at but equally ambiguous . . .

A lot of logos work like that — even the Batman one. A lot of people when they first looked at that didn't see the bat — they saw the yellow, it's like a confusion between the figure and the ground of it . . .

The most outstanding one is the Waitangi — just letters, people relate to that, but they can't relate . . .

In a way, those letters are the most ambiguous of all ...

Well, we'll have to see if they are going to work first. It worries me just a little bit having to make them in a short space of time and the Aotea Centre thing [Mural Commission for Auckland's Aotea Centre] also screaming to be finished. We've lost a lot of sleep over this. And since we started on the project, they've decided to drill some holes in the wall on two levels for cables — TV cables and so on — a massive change of design in one particular section. Instead of timbers going that way on the wall, they are now going that way to compensate for this little hole. Even though they are little holes in the wall, it'll

make a difference. I'm not prepared to compromise the mural for a little hole in the wall but if the hole can be cut to the size where I've actually got a hole in the timber—and they're not too far off it . . . Sorry, we're getting away from your thing.

The main question was this business of translation. You were talking about the 'old guard', as you put it, who got things moving — yourself and Ralph [Hotere] and Sandy Adsett and so on—How would you describe the process of making the signs of one culture move across into the art practice of another? It seems to me that Maori art, if you want to put a label on it, has been extremely adaptable from way back. Do you think this is a process that is an easy one and a natural one?

I don't think it is easy from a people's point of view, because people have their own ideology, and their own tradition, and their own inhibition too, related to images that are historical. If I can talk about some historical aspects of the design factors related to ancient art and traditional work. A lot of those have been set in store by the manipulation of materials and equipment. There's a lot to say for the mark of the adze on timber, not only in terms of how the thing was made and the scoring on the surface of the timbers and stone, but the mark of the tool. So that things like V-shapes and notches in timber for instance were quite natural to come by with straight cutting into timber, and the forms had to be strong. First of all, they had to be simple, to be cut out with a stone tool; but that, in itself, made the forms much stronger — made the wood like stone in a way.

All the factors were together, including the human-being factor, the person manipulating the tool, creating it, and getting the materials. And so there's a natural penchant for people to think that is the way to do things. It's like breathing, I suppose, you only breathe one way and that is how your body lets you breathe. So what are we doing when we introduce other kinds of material — steel, concrete — the equipment and the technology that we have — they become unnatural in the eyes of the naturalists, the traditionalists. They are inhibited by the naturalness of where those things came from. And people like that 'old guard', for instance, they recognise all those angles but in their day they decided that perhaps other images can be made, totally different from those ones. Or they can create from the strengths of

those designs, new strengths that they can relate to. Arnold [Wilson] made those pallisade images of his way back — you know made out of tanalised timbers, fence posts . . . So today, we have a whole lot of fence posts around the countryside. You know Arnold had a huge influence on that particular aspect of freedom — freedom from actually making the pallisade look like a pallisade. And then you got — you've already had Gordon Walters — and then you've got people like Sandy Adsett who has taken the kowhaiwhai — the painted image — and re-created that in a different way. But going back again further — you have a person like Dittmer with his illustrations of the myths and legends of New Zealand — and that still is a huge influence on lots of Maori artists today. They like the idea of a flowing kowhaiwhai. Well Sandy has taken that and turned it around, a bit like the Gordon Walters action. And although some of his work is starting to refer back to the Dittmer type thing, people like Cliff Whiting have pushed that idea too — and so a lot of his work is kowhaiwhai-related even though it might be into three dimensional or at least relief work. He relies a lot on that.

Did Dittmer understand the narrative function of that kowhaiwhai?

I don't think so. Over the years, that kowhaiwhai, we have seen it as the play of the intense lighting factor we have here in New Zealand, we have seen it come out in terms of op art . . . And it's been here all the time. And so it keeps reminding us of certain factors and certain things in our lives — not just Maori lives but anybody's life. People like Dittmer and now the Sandys and the Whitings and many other people are using those same things to express themselves in their way, just the same way with Arnold's fence posts.

But now there seems to be another question that is being asked. Those kowhaiwhai motifs were not just formal—that tended to have been the interpretation put on them by European observers who had a belief in the decorative arts. And the power of those motifs to carry another meaning — that aspect seems to be coming into hearing again more and more, and I wondered how you felt about that. About the use of those patterns. Are they beginning to talk again, as it were?

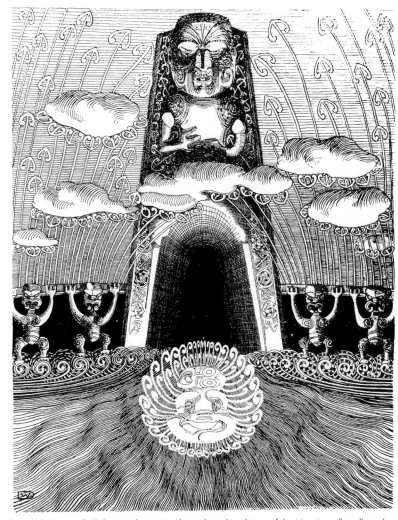

From W. Dittmer, *Te Tohunga: the ancient legends and traditions of the Maori, orally collected and pictured by W. Dittmer*. London: George Routledge and Sons, Ltd., 1907.

different things came out — they started to make positives out of the negative. Some people like Cliff, for instance, had no hesitation in using kowhaiwhai and making a bold statement that he's able to put in his own work. And Sandy coming up with his rendition of the form to say something for himself, new. Those are derivations. And my own feeling is that those shapes are not unique to New Zealand.

What I am trying to say is that the sources of energy are not just in one place. The spirals for kowhaiwhai are all over the world as we know. What I am trying to say is that the art thing, the visual thing, is quite universal and it doesn't depend on a spoken language to start. But what has happened of course is that people have verbalised the images, they have given word meanings to visual statements. And sometimes those statements have been made by the tool

I think I've tried to avoid the issue. You know, some years back, I think nearly every one of us looked at those ideas and they became different things to different people. Some people avoided them — like Ralph's gone right away from them and yet he might be the closest person to them, in actual fact, because he's not using those images per se but maybe the spiritual thing is still there. For instance, somebody said, in the kowhaiwhai painting, Ralph was concentrating on the black ends . . . and I thought there was a little bit of a play upon words there . . .

Yeah — so let's examine those areas more intimately. What do those shapes say? And for some time people concentrated on the negatives of the kowhaiwhai and said, 'There's some hidden thing here, see if we can find out what it is.' So you had a spate of activity on the negative side and lots of

used and now we have to decide what that thing is. So that notch has now taken on a different connotation . . . Because it was struck with a stone and the shape stays and it's amazing how people can build into those sorts of things.

With that in mind, the things I am doing now are just statements made by tools and sometimes they work out on their own and I'll say, we'll cut it here and we'll cut it there and it starts to reverberate all over the work and so it's an orchestrated thing. That piece way down at the far end, it's also part of this thing right up close to us here but it's miles apart but that doesn't matter — well, it matters. In actual fact on a mural like the one I'm working on now, you have to roam all over it. You have to go down there and come back to this scene. You can't just stand there and take in a total view of it.

PARATENE MATCHITT

•

I asked John Ford whether his use of certain motifs, especially taaniko-type motifs, was a kind of language. And he said that is a fairly modern development of the large decorated house. Had one important effect on the way the images were made, and what they did. Because a lot of information had to be correctly presented in a wharewhakairo. So before the art was made, there was a large amount of talk and a large amount especially of whakapapa. And then afterwards, when people came to the place, there would be a subsequent amount of talk where they wanted to know why this, why this. So that the art itself became saturated with language and with the histories that it was involved with. Is this still a factor in the contemporary making of images? Is it still something that you are aware of? This silent presence of language?

There is a very silent moment. There is less talk around the meeting house about the meeting house. Maybe the intention has not ever been to talk about the meeting house, but to talk about the subject on the date. But all *that* talk has been enhanced by the presence of the meeting house, and the presence of the images and the work inside it. They give it substance. You can relate anything you say to these images, or to the meeting house. Then you have some substance because, you know, people are number one. There is that meeting house, and that is the baseline. If things are not related back there, speakers have a hard time making themselves heard, let alone understood. And if people are speaking in English on a marae base, then that is a massive turn-off. No matter what you have to say, no matter if it is real important, it is a massive turn-off. It's got a linguistic link, related directly to those images. Somewhere along the line, to my way of thinking, the images came first, and people started to relate to them linguistically. And then after a while it became the norm, to link the two together. But with the work that is being done today, there is a whole lot of silence around it. Nobody knows how to linguistically make the connection between the visual . . . and how to put words . . .

Ralph seems to have been especially careful to make his work silent, except that he includes text.

But even with the other people like Arnold Wilson . . . well Cliff not so bad because he has got a linguistic link with the work, and Maori people find that very easy to get along with. I find that pakehas don't always have the same sort of connotation. But to Maoridom it feels just right. Same with Sandy — people can communicate with Sandy quite readily. But with Ralph they don't make that connection. My work they don't — they have a hard time, too. Especially the works that I am on now. Even the work that Selwyn [Muru] is doing, there isn't that Maori language connection. And if they can't make that connection, you might as well leave the work outside or something. In a sense. And the people that are now making connections with that work are other artists, not necessarily the people.

Was that always at least a possibility, that the community for whom the art was made in the old days, would have included an expert sector, as well as the community as a whole?

It had to be specialist, like orators were specialists. The tohunga didn't become a tohunga unless he or she could communicate with those people. And when you are talking about the voice that artwork makes in terms of being understood and felt, it is very easy to take the step into the traditional area and come up with a winner, every time. If you observe all those kinds of things then you become the tohunga. But it is almost impossible in the contemporary area. In the contemporary area they might relate to me because I have worked on restoring houses, that is my name in Maoridom. I have taken people for solid traditional carving, and paintings, and weaving. So the name is there. But when it comes into the work that I am doing myself . . .

What about the use of words in your work? The use of symbols and signs that are in their way quite secret?

Well, you see, that's funny. Because those same people who knock it out if you present the same work without any symbolism related to themselves, because you present a symbol that they recognise, all of a sudden your work becomes acceptable. Because they've made the language, they've made a historical link, you know, all those kinds of linkages. But,

I feel art is not just that sort of thing. We are in a day and age where — I am not looking for accolades for the work I am doing. How many viewers are you going to please? This is the work that I can do. This is the way I want to do it. This is how I am going to do it. And to a lot of Maori people, that is just not on. You can't do things like that. The system is there for the survival of all, not just for the survival of one. What you are doing is totally out of context with all of that. Right? So you are criticised for that.

But I would have though too that one of the things art shows us, especially in the way of adapting new materials, new techniques, new tools, is also a kind of translation. Because Maori have always been adaptable, and quick to pick up whatever new technique was available. So that you find wool being used in weaving, very early. I remember looking under the Museum in New Plymouth, there's a beautiful collection of whaariki there, and there's lurex wool being used in the 1920s. Surely, the art practice of people like yourself is a continuation of this process.

We have a prime example in a carver who carved the meeting house here in the Museum — in Raharuhi Rukupo. Now, his work has been the guideline for the Rotorua Carving School. That's been the blueprint for carvers right up until now. It doesn't matter whether they are working a North Auckland image or a southern image, or what, it all comes out in the same style. And the style is related directly to Rukupo and how master-carvers of the day have been able to maintain that. Up until now — really, right now, that carving school is taking on another whare. All carving is related to some school, somewhere along the line. The images have been set, they have been set in concrete so that people want to relate to that, until a new artistic element comes into it. That changes it.

Rukupo was one of those people, because before his time carvings were of a different nature. Because his skill in manipulating the iron tools, and adapting to those iron tools and making them work and influencing the people around him to be able to make cuts sharper and deeper and more finite, captured the imagination of the people as well. So his innovation became paramount and that's flowing right in to where the carvers are today. Out of that whole bunch probably will emerge some people with very keen

artistic statements to make. I think, say, the things that are happening with the 'old brigade' people. They have made those movements. People haven't recognised it yet. But those movements have been spotted by up-and-coming artists. They are following very closely on the heels of the people who initiated those new moves. I suppose one of the reasons why we are organising an exhibition for next year is to try and bring out those factors so that people can see where movement began. It became a group event, I reckon it did. Amongst ourselves there was a great sort of dialogue.

With the advent of metal tools and the skills of carvers like Rukupo, that freed up the possibility of the large carved house. And maybe now with the vanguard of artists of your generation, the next step is a similar one. That now the work is making its way into the art space in the way that once it made its way into the wharewhakairo. There is a way of making that work present to a public, but in a different space now, in a different economy if you like, as well. So in effect, the Museum will become the meeting house. It will involve renegotiating the gap between these two figures.

Funny you should mention that. Those two figures. I have been working with some architects in Christchurch on this as well. I have been the silent person, a lot of the time. But there came a time when we talked very hard. Because the brief asked for certain things to be done in a Maori sense, or to project a Maori image, and what we found ourselves doing was of course relating to the linguistic, to the language side. And unless you do that, Maoris are not going to get anything out of this, except maybe one hundred years from now when everybody is on a different tack. But we are not planning this for one hundred years down the track. We are planning it for now. Because this is the important time. One hundred years from now let them decide what they want to do. I think what I see happening in the Maori field, is that people are picking up their own voice. A new voice. But still very much either relating to themselves as personalities in the Maori world, or hovering like Ralph, and saying 'Well I'm a painter', and distancing yourself. Most people don't feel that confident about themselves as human beings, for a start off. But to me Ralph, he might have distanced himself, but he

PARATENE MATCHITT

Paratene Matchitt, *Te Wepu* (the Whip) 1986 (detail of *Huakina* 1986). Mixed media construction in 9 wooden sections. Courtesy National Art Gallery and the artist.

has actually got closer to people. And very quickly. He makes a communication link very fast. Makes himself understood very quickly with very few words.

I've often thought that too, about the way he makes images. Like the big Aramoana corrugated iron pieces, very dark, a very formal given structure like the vertical corrugation of it, a material that was common to most people's experience—and then just shifted into another context and dignified by being made into something else. That process in a way seems to be a very familiar one. If you look into art-making that uses, for example, the same materials that are used for domestic purposes. Like materials used for decorating parts of the meeting house, the same things are used to make a food basket. They are dignified by use. And this is slightly different from the European tradition of art making. What's stressed there is the exclusiveness of its signature, so that its value becomes determined by the individual who made it, and by the information it carries about its history, and the production of art, and so on.

I am going right back to what I started to say at the beginning, about the use of materials. In those days, the material dictated what that work was largely going to be about, how it was going to be made. For instance, there was the weaving. I'll be shot down in flames for saying it's a simple sort of technology, which it is, but it has taken us a hell of a long time to learn about it. But I have seen people weaving like people knitting, going so fast, this guy makes a kit in half an hour. His fingers flashing around.

I just saw one of the old James McDonald films, the one that was taken up by Pipiriki, up the Wanganui. There was a woman there making a little food kit — three minutes — boom — here it is! Amazing.

People are amazed. So am I. And even though I say that the weaving seems a simple technology I am still amazed by the dexterity of the professional. So I suppose Ralph is not too far removed from that kind of technology. And sometimes when you have got that simple technology going, you can emphasise little points, little off-beat things. You can laugh, you can joke, you can do all sorts of things.

I'll go back to Pine Taiapa. He spent a lot of his evenings in later life designing weaving patterns. He identified all weaving patterns that he could think about, and there were masses of manuscripts that he had hand-made, through his one lens spectacle. But what he was doing, he was scribbling in masses of books, and working out all the designs. You've seen the way people crisscross, well he wasn't satisfied to do that. There are a number of the patterns he was actually identifying, patterns and designs, and creating new ones. And what he would do, is use the whole book. He would start on the top page and draw out a design, and then he would cut part of that page out along certain lines, and then start the pattern again. Almost like doing a tracing on a tracing on a tracing. I don't know where all those books are now, but I know that when he died some of them went with him, and some went to other people. And I have always been, well I was amazed by what he was doing then. Out of his own head he'd devise this system of creating those books. He had patterns, how our weavers used to work, and he said, they can be

made. Yes, they can be made, because these patterns have been made and these ones here follow the same kind of system.

So, in a way, he was also a great innovator. People wouldn't normally think of him as being an innovator, would they?

They don't even think of him as that much of a master carver. Pine was the fashioner of ideas, but not necessarily the polisher of the idea.

John [Bevan Ford] and I were involved in an exhibition in Hamilton a number of years ago now, where we exhibited with some traditional pieces. Pine came up to open that show, did he tell you about that? I asked him to come up and open the show. And he came, and he was in a hell of a state. Anyway, it eventually turned out that he actually didn't like our work. He didn't like what we were doing and he came over to tell us off, or tell me off, anyway, not so much John because John was somewhere else. He was going to come and tell me off. 'After all these bloody years, of me teaching about our history and so on, and then you turn round and do this bloody rubbish!' That's almost word for word what he said. And then he went away and thought about it before the opening of this exhibition, and he came out. 'I came down here to blow these boys up.' But he thought about it a bit more and he said, 'The world is full of art, there is room in it for everyone.' Took that stance because I think he then realised that I wasn't going to go away. I kept saying to him, 'This is what I want to do. I spent time with you, you've come up to my place, yes, that's all right, I acknowledge that, and respect that; but this is what I want to do.' He

said, 'Well, you're the teacher. Maybe you could teach your way to bring people around to accepting the traditional thing.'

Does that mean he saw that your work itself also linked back?

I don't know if he saw that, he may have. Or he may have had another ploy. He may have decided, instead of telling these guys off, to encourage them to do what they are doing, get to their places as fast as they can and get back on the real track.

But in effect what I am saying, and relating to Ralph and simple technology, is what I am trying to do now instead of trying to be clever with tools. I just use the tool for what it can do. But that to me is also a huge step away. It is all right using the tool to make something but you have to make something that people can relate to. I haven't come to terms with wanting to do that, just to make it for people to relate to. Even though it takes in the symbols that are still there in some people's minds.

You mean like your use of Ringatu symbols?

Yes. It maybe leaves the rest up to the people to decide how they are going to relate to it. But I saw in that Ringatu one [*Huakina*] immediate acceptance by some of those Ringatu people. This fellow said to me, we've got to find a place at home for that.

There was one thing happened with that big work. When that was upstairs in the National Gallery, downstairs was Te Maori, *and one of the pieces that really got to me in that, was a huge archaic adze, it*

was a big hand adze, it was beautiful, the whole balance of it, the way the curve corrects for the striking-turn — an extraordinary object just as a combination of technology and aesthetics. And upstairs was your piece, and the conversation that was going on seemed to be between that tool and the piece upstairs which was made with a chainsaw largely. It was like the chainsaw was talking to the adze.

Someone picked up on an idea there related to the adze and the chainsaw — 'from the adze to the chainsaw'. I'm realizing that this technology is what it is and it is what you make of it. And what you were saying before, the technology was always used with a linguistic connection. So that it was easy for people to pick up on the things that were being made. For instance, when I started using all those machine tools I was criticised to hell, 'Fancy using that stuff', but what people I think were more concerned about was that I wasn't making work they could recognise — the language of the work, they weren't making that connection, because at the same time other carvers were using the same kind of machinery.

•

Do you think Huakina *was accepted by some Ringatu people because they recognised certain signs? Like logos in a way: the moment you see them they produce acceptance immediately, they just trigger it? Like the koru shape which appears in half a dozen different company logos? . . .*

But it could have the opposite effect if for some reason or other Maoris were not the flavour of the month. Anything to do with that sign or shape would be a total turn off. But I'll tell you why it has become a hell of an important today: because other people *are* accepting it — other people than Maoris accept it. In other words pakeha accept it and therefore it is important. It is the same way with kiwi feather cloaks — at one time they weren't in favour with Maoris. And now they are important because the bird is rare, because it is protected, because it's got all sorts of connotations put on it outside of its status I suppose — you know it is regarded as the king bird, so Maoris then follow the same sorts of ideology, the kiwi cloak is more important than anything else. I like people to examine those areas and say, 'Well no, it's not'. I've seen a kaitaka cloak which I would prize over a kiwi cloak. Why? Because it's more visually exciting.

So how does value then come to attach itself to things like the Ringatu symbols — how are they valued now given that they also work in one way like logos, if you like. Where is their value now in the art system?

I can't say too much about the logo because that is a very specialised area. But the value of the artwork is still there so the connotation, the meaning of the poutama and mangopare and kowhaiwhai and all those different patterns and stories relating to different patterns — we need to get back to that sort of meaning. Very strong meaning related to ancestry. Those things aren't pictorial in our sense of the word, they are meaningful in another sense — they are the spiritual links with the ancestors. And the whole house has taken on that idea so that kowhaiwhai has come out on the tops of heads of people, they've got to the roof, they have intermixed up there, it's a whakapapa of the whole house. And that's why it's important to have the right genealogical time — if you get somebody else that has no connection, what the hell is this about? You have to have a good story and people need to see the logic of that. So the meeting house really is the logical sequence of events and it depends on how the tohunga can carry that function out, whether he is a good tohunga or not. But people haven't evaluated this in those art terms we use for evaluating paintings and drawings today. Their valuation is different. The mere fact that it's there matters, how it's made doesn't matter too much. Of course amongst the artists themselves it matters.

John Ford made the point that the pressure in Maori art always was, and he thinks should still continue to be, towards abstraction. That it was always being moved in that direction through the legends, through the myths to the origins of them. And that the art was always pressing towards that way of representing; and the slackening of tension may have occurred when pressure began to go on the art to be more pictorial, to tell stories rather than push for the abstract. And I think what he was insisting on was that the 'old guard' if you like, himself and yourself and so on — that the task you had was to turn that pictorial tendency around and get the pressure back on, to move it back towards the abstract, towards the conceptual.

I just like the way that the log sits beside another log — a piece of wood or a piece of material, how it just positions itself with something else. And talking about abstraction, if if means that because you enjoy the fusion of ideas and the positioning of things, well that to me is what it is all about, I can't really even verbalise beyond that — that's how I want it. And other people say, 'What the hell difference does it make, you could put that over there?' I say, 'No, I want it here, right here, beside this one here, and I want that thing to go there.' I have been called fussy because that's how I want it. But that is immaterial to me, the fact is that's how I want it.

A guy came to me, the fellow's a furniture maker, and of course all his joins are very perfect. 'How the hell do you get away with it?' It's not a matter of getting away with anything, that's not the case. The case is that's how I want to make it, and if I want to make that join I'll make it, but *that's* not what I want to do otherwise I'm going to end up with a table or something. He couldn't get over it. The other day he was flashing around with a huge plane, and the bed of the plane was as wide as this, for goodness sake you couldn't see it but that table top had a curve in it, and they wanted to polish one end of it to get the curve out of it. I mean it is so infinitesimal you couldn't see it. And they were going to sell the machine after that because it's easy to sell the machine and get a new one — I said I'll have that one, I'll buy that one.

But the thing is that this machine is too good for me! And the influencing factor there to me — among lots of influences — is my own father. I didn't appreciate the thing at the time. Matter of fact, I was so ashamed of the stuff, because everybody else had turned legs on their chairs, and tables that didn't rock, and he made all the gear that was in our house — chairs and tables — with an axe and a saw. It wasn't until years later that . . . really my old man is the greatest influence in my way of doing things.

Not that he was rough as guts, not that at all, I think he could handle that machine better than anyone else I know. Today people are making adze furniture and the bigger the bumps in the thing the better. Well, he would try and get all those bumps out of it when he was making it so that the thing became quite flat. What mattered is the use of the machine, and what I've put into my life is the care and maintenance of those things. And when you think about it, that adze you were talking about was well cared for and well maintained. Yes, for a long, long time. All the cutting edges have to work, the rest of it can be rough as anything, so long as those cutting edges do the job. Somewhere along in there is some other relationship to how the work is made. Nothing to do with the symbolism or anything, just with the making, so that's become important and I suppose it is what's happening today in terms of training programmes where people are not so much concerned about what's being made but how. Like in carving schools, like in mechanic schools and in welding schools, everybody concerned with the skills of manipulation, the care and the maintenance, which is really important to us as artists, and we tend not to think about that, we just pick it up and do it. Put it back again. I think if you have a look at each artist's studio you will see that the things that matter, they really care about those. It seems to make the work happen, but nobody says anything about it. In some other cases those things are all-important, they become really important and they override any other factor. And when it comes to the symbolism of all that, what I was talking about before, you can make things that people recognise and have a linguistic connection with, and if that's your intention, well that's how it goes. I use words now. I never used to because I thought a word is not an art form, a word is to read, and I'm well away from reading altogether. But it is the communication point.

*I remember them in the Shed 11 piece [*Kaainga, Taki Toru, *1988], for example.*

See, I put those on there and the original thing had been . . . at the Fisher Gallery they weren't on. I felt that it needed something to go around, a band of something. I didn't want to just put a band of saw cuts right round. So I had a bit of time and we thought about the words and the whole thing fitted right around there — every statement — not a board out of place — and I thought, well that's a good sign. That's a good sign, everything fits and the two ideas came together independently and those are the things I don't call accidents.

And it is the same when the weaving was made. The weaving was a convenient platform, or you might say a convenient canvas of the day to express those sorts of ideas, and once again the most abstract

forms. It didn't make picturesque ideas but all abstract, which related to their own understanding of the world around them. They send people up into the hills to study the stars, and they stay there until they come back with whatever it is they have to find out about, what those stars . . . So the recording devices became weaving. Became some of those weaving patterns. I mean they are so abstract in that sense that they start to make those things into stories that people could then relate to, but the tohungas of the time, the ones who are really into it, they could understand all that. They hid all those meanings in the poutama pattern, in all those patterns that are made, the ones that John Ford is now making in his things. All those hidden meanings were in there but for the people they had these meanings which really related to them as well, but the really abstract . . .

Do you think they worked on two levels? People can tell stories to them or from them, but inside there was another band of meaning which was esoteric, hidden, specialised.

Otherwise anybody could become carvers, anybody could become weavers — as they were, they wanted the kit to carry the kumaras in — work flat out, flat tack. But on the other hand if they wanted to unravel the mysteries of life . . . But not everybody could unravel those, which the legends of the kits of knowledge come from. A carver would carve a figure today and try and put all those symbols in there. That's sort of exposing all that.

But because we don't understand too much we can't read those sorts of things either in the kowhaiwhai or in weaving. We create our own images and of course what we are creating today, we've put these tools in the hands of the carver . . . Well, you see, with the Te Kooti thing I haven't heard any Catholics talk about that and yet the original thing belonged to them! Complete silence from the Catholic world about that particular flag, and yet it was made by them in Napier. And here the Ringatu are going flat out and they accept it like anything where nobody else . . . Anyway I like the idea, I like the idea of the whole not just the symbols of it, but the whole idea behind it. And I also get some kind of quaint thing about christianity being turned around the other way by these people, yet they are very christian themselves. Anyway that is only a little quirk.

And the other thing about those symbols, not all of them but say the heart shape, is a manipulation of an idea. A triangle to me is certainly a universal . . . That star shape, well that's a contrived sort of thing okay, whoever made it, it's still the star shape that has been contrived of another culture. But that triangle shape, of all those, is a universal. The moon shape is a contrived — anything that doesn't fit into the abstract of the flax work to me has to be in some other contrived position. I would have to say now that that carving is also a contrivance, but that could be directly related to implements used for one reason or another.

•

Do you think there is a danger of Maori art ghettoising itself?

I see Maori artists looking for excuses to stay Maori within the context of work that is also linked with work outside their cultural sphere. You know we have a great penchant for taking something and calling it our own. Pork and puha, it's really Maori food — well the whole idea of the way it's been cooked is another cultural experience, but we've made it our own so we've actually taken over that ground. I don't see anything wrong with that. But the historical thing has to be there so that people can have a better appreciation of that. You were saying you went to Rotorua and you had all that stuff there intermixed, it's a totally . . .

What seemed to be happening there was that there was something there called 'Maori' but it was like a screen concealing whatever it was that was being supported by this. There was something else — it certainly wasn't in the 'model village', the 'model village' was one of its constructions.

I would like to think that outside of the world we are portraying we are also making advances to the rest of the world in terms of our attitude, in terms of how we manipulate things, in terms of materials and equipment. All those sorts of things should go to say to Maori artists, say that we are part of a greater world of art, not just in our own backyard.

The other thing about art in terms of its viewing and showing and manipulation and what it has to do, is borne out in art galleries. And we've still got our

people who are saying we don't believe in art galleries, but they are still making the kind of work that needs to be seen. They've got to realise that that's where those things are to be seen. They want to try and make the meeting house into the art gallery. The meeting house is full of stuff itself. We've done it and it can happen, you can do all sorts of things anywhere you want, but there's more prime space and place for something that you have to rig up. And it's the recognition of that expertise in the area where it is working. And also into that comes the valuation of the work. With our stuff we think that only Maoris should be evaluating it — I say anybody should be evaluating, if anybody sees it they make their own evaluation of it. There are a lot of Maoris who don't want anybody to do that, they don't even want people to hang their work for goodness sake. You know, they want to hang it themselves. Well, that's okay, we all enjoy doing things like that. But, that's not our job, they've got people who are professionally — that's their profession.

That's what I wanted to say too, about the connection with the rest of the art world: uniqueness because it's here, it has that uniqueness in character as it relates to people in and around here, but then it also has a link the way it's been made with the rest of the world. The fact is that these shapes and forms, designs, what have you, are all over the place, it's like the wind blowing seed.

We concentrate on certain aspects here: we are working in abstract weaving, the same as the Mexicans are weaving over there, the Indians are . . . the Latvians are doing there . . . and the links and the connections that can be made through those activities should be a point of linkage as well as of difference. You see it all the way through Maori art in the traditional area: 'This is Maori, this is New Zealand, this town', when in actual fact even that work is connecting with other parts through the symbolism being used, replacing something else to tell the story.

[*This is an edited transcipt of an interview with Paratene Matchitt by Ian Wedde, Wellington, January 1990.*]

From W. Dittmer, *Te Tohunga: the ancient legends and traditions of the Maori, orally collected and pictured by W. Dittmer.* London: George Routledge and Sons, Ltd., 1907.

PARATENE MATCHITT

The Tasks of Translation

Art & Language in Australia & New Zealand 1975-6

Terry Smith

It is now recognised that the politics of provincialism preoccupied artists everywhere in the mid-1970s. Geographic and, more importantly, cultural distance from the dominant metropolitan centres such as New York, and from the new network emerging in Europe, particularly in Italy and Germany, were acutely experienced. The power to confer recognition and reward, but above all the power to set the agenda of what counted as significant art and criticism, seemed to be sourced forever elsewhere. Deep resentment was felt by those working in the so-called centres yet marginalised by the Modernist orthodoxies prevailing there — felt, that is, by women artists, and by those from racial and ethnic minorities. Just as strong were the feelings of artists living in the cultural peripheries, in the-dependent worlds of the old colonies and the new economies. From these places, and from the dispossessed artists of the First World, came the sharpest critiques of the institutionalisation of the avant-garde, as well as the extremes of formal experimentation, the bizarre hybrids, the insistence on difficult content, the radical searching for new audiences. This anti-Modernism was, in my view, just as strong an impulse of the mid- and later 1970s as were the apolitical ironies which captured (however briefly) the catchy appelation 'postmodernism'. It may, in the long run, turn out to have been the most inventive and effective current. I believe that it was, in our region at least. If this proves to be so, our conceptions of recent art history need much rewriting.

While these larger currents are matters of fre-

Art & Language (P), *Piggy, Cur, Prefect* 1976. Silkscreen poster for Auckland City Art Gallery Project Programme exhibition, August 1976, 570 x 450 mm. Courtesy Auckland City Art Gallery.

quent debate, what tend to be overlooked are the specific ways in which the big issues have their impacts. It was no coincidence that, in the early 1970s, it was conceptual artists, particularly those interested in languages and their operations, who raised the political questions first. Nor was it mere chance that they saw questions of power as issues at all levels, both macro and micro. Questions of meaning preoccupied them, including questions as to the nature and even the possibility of meaning. It is scarcely surprising, then, that the tribulations of trying to translate between languages — especially artistic ones — were where the problems of difference and incommensurability hit home sharply, at the fundamental creative and interpretative drives.

My basic proposition is that the demands of the mid-1970s moment created a new role for certain artists, and for newly empowered art audiences: that of *translator*. Or, more accurately, a fresh inflexion of an old activity became pressing: individual translations between items of other visual cultures took on, for many artists and audiences, a much more activist, public dimension. We became translators between competing contemporary cultures. How some of us fared in these circumstances may have some historical interest. More importantly, the ideas of the artist as translator and of the audience as creative readers are regaining current relevance, as cultures split, splice and splinter again with a rapidity even greater than fifteen years ago.

Of Translatability

Around 1970, the classic text on the theory of translation was Walter Benjamin's 'The Task of the Translator', the introduction to his 1923 translation of Baudelaire's *Tableaux Parisiens*.[1] He argued that translation was not ruled by accuracy, was not usefully understood as a warring between fidelity and licence, and was barbarous when it became a literal rendering from language to language. Translation, rather, made possible the 'afterlife' of original texts, occurring when both languages concerned had evolved beyond the moment of the original writing. It was a mode of releasing the translatability of the orginal, its potentiality for change, for becoming literature — or, in his words, for realising a text's capacity to become 'pure language', transcending that in which it was written. It follows that good translation does not shift a text from one language to another, instead it enriches the translator's language by importing the purity of the text being translated, by enabling that text to echo within the translator's language in ways parallel to its original effects in its own language. Good translation, therefore, is untranslatable.

Benjamin went on to speak of the 'kinship of languages' on this elevated level, one which enabled the 'fulfilment' of languages, thereby 'integrating the tongues'. He cited Mallarmé:

The imperfection of languages consists in their plurality, the supreme one is lacking: thinking is writing without accessories or even whispering, the immortal word still remains silent; the diversity of idioms on earth prevents everybody from uttering the words which otherwise, at a single stroke, would materialise as truth.

Writing of this nature, including translation, was the 'language of truth'. He acknowledged, on the other hand, the 'essential foreignness of languages', and that translation was a mode of 'provisionality' in relation to this incommensurability. But he concluded by stressing the thirst of writing, again including translation, to reach beyond this towards a total unity of signification, content and reality. Thus all language aspires to the condition of Holy Writ, revelation being the only condition under which unity is achievable. This celebration of Scripture as the ultimate writing seemed bizzare to those reading Benjamin for his tangential takes on historical materialism. Like the assumption throughout the essay that it is great art that most calls for translation, such mysticism seemed an eccentric abberation, an echo of his Talmudic past, best edited out, like the odd bits about the 'aura' of original artworks in his 'The Work of Art in the Age of Mechanical Reproduction', read ragged at the time for its proposals about political effectivity in art.[2]

The question of translation was also present at the 'birth' of deconstruction, its emergence from formal semiology. In a 1967 interview Jacques Derrida echoed Benjamin remarkably closely:

Within the limits of its possibility, or its *apparent* possibility, translation practices the difference between signified and signifier. But, if this difference is never pure, translation is even less so, and a notion of *transformation* must be substituted for the notion of translation: a regulated transformation of one language by another, one text by another. We shall not have and never have had to deal with some 'transfer' of pure signifieds that the signifying instrument — or 'vehicle' — would leave virgin and intact, from one language to another, or within one and the same language.[3]

Derrida is, however, attempting something that Benjamin dealt with in other ways: he is beginning to wreak havoc upon the Saussurian concept of the sign as consisting in a signifier (a sensible part, such as a sound, word or image) and a signified (an intelligible part, such as a concept, referent or meaning), particularly the expectation that the former gives systematic access to the latter. Indeed, he sees these two parts as essentially in opposition, just as they are always imbricated in, and contaminated by, each other. His remarks about translation occur within a broader discussion about how metaphysics (to him, most philosophy) imposes on semiology, the science of signs, a never-ending search for a 'transcendental signified', that is, a concept independent of language. God is the most obvious example of such a concept; and it is easy to see how it follows, as Benjamin concluded, that Holy Writ would then be both the beginning and the end of all language-use, existing at a point both before and after translation.

But this opposition between semiology and metaphysics, between language and a transcendent concept, itself has the form of a conflict between signifier and signified. This is, I believe, what Derrida is getting at in the following remarks which immediately precede the passage cited above:

TERRY SMITH

That this opposition cannot be radical or absolute does not prevent it from functioning, and even from being indispensable within certain limits — very wide limits. For example, no translation would be possible without it. And in fact the theme of a transcendental signified was constituted within the horizon of an absolutely pure, transparent and unequivocal translatability.[4]

Benjamin — and Mallarmé — would have recognised, and concurred, with these themes: no conflict between signifer and signified means a closed language world, with no space, need or possibility of translation; whereas conflict between the worlds of the languages provokes the desire for a space beyond them, one where they might all be translated into pure language, into writing itself, *écriture*.

Yet, while Derrida is summarising his predecessors, he is also driving into new readings. Two key words mark out the shifts. He speaks of translation 'practicising' the difference between signifier and signified; that is, the preferred relationship here is one of rehearsal, testing, learning, trying out possibilities rather than a mechanical reproduction of fixed difference. More importantly, he substitutes transformation for translation, recognising the impossibility of clean transposition, of simple 'transfer' from one language to another. Certainly, at this stage, it is a 'regulated' exchange, yet, as Derrida's deconstructive enterprise expanded, regularities became obstacles quickly overcome in the search for the irregular, for traces, marginalities, differences, for *différance* itself.

The problematics of translation pervade Derrida's writings. They provide many typical deconstructive strategies: for example, the re-reading of Plato's *Phaedrus* via its mistranslations.[5] Deconstruction typically presumes the predominance of the signifier, the priority of regimes of signs, their intertextuality. Is not translation a kind of intertextuality — indeed, is it not the writing practice most committed to the interaction of texts? Is not the figure most privileged by deconstruction — the reader who reads against the grain of the text — a translator of the kind celebrated by Benjamin and Derrida, that is, a *transformer?* Finally, is not this translator/transformer one of the most striking personifications of that very same reader whose birth from the ashes of 'the death of the author' was being so eloquently celebrated at the time by Barthes and Foucault?[6] Does it not follow that translation becomes itself a transformatory *practice,* no longer secondary and dependent on 'original' texts, but as primary as other forms of writing, as embedded in the intertextuality of all writing as they are?

Derrida was scarcely known to English-speaking artists in the late 1960s/early 1970s, despite the impact of his work in French intellectual circles. Barthes was known, Foucault becoming so. Yet many of these themes emerge in Conceptual Art of the period, especially that concerned with relations between art and language.

Language and Art: Late 1960s/Early 1970s

Despite the markedly international character of Conceptual Art, and the widespread — at times, dominant — interest in language among most of the artists involved, translation rarely appears as a major concern during the early years. I can find no reference to it in any of the thousands of pieces, projects, texts, actions and publications from the period 1966 to 1972 collated by Lucy Lippard in her anthology *Six Years* (New York: Praeger, 1973). Ian Burn and Mel Ramsden's *Soft Tape* 1966 is an exception: devised in London for an exhibition in Melbourne that did not take place, it consisted of a tape-recorder on a pedestal in an otherwise empty room, playing a spoken text at an audibility level just below the sound of sense. In his notes on the recreation of this piece for the 1990 Sydney Biennale, Ian Burn recalls: 'Communication, we argued, isn't just a semantic or conceptual problem of translation (deducing the 'right' correspondences and so on) but is also crucially a spatial problem . . . If the semantic uncertainty is inseparable from spatial considerations, then the spectator not only is the translator but also becomes the measurement of the space'. This format would appear, in dramatically different circumstances, in the Art & Language exhibitions in Australia in 1975.

Almost all Conceptual Art involves language, most minimally in explanatory notes to documentations of actions, events or processes; most completely when language-use is taken as the paradigm human activity and concern with exploring its structures becomes paramount. How could translation be a non-issue in such contexts? How could such intellectually alert people treat translation as if it were transparent? Three reasons suggest themselves: in-

ternationalism, art's autonomy, and the dominance of formal theories of language.

Internationalism in art is never neutral. With the disintegration of New York as the pace-setting, global art making and marketing centre in the years around 1970, two quite contrary tendencies began to flower in the resultant vacuum. One was a regionalist revaluation of local histories and initiatives — of which more later. The other was the sudden sense that the next avant-garde innovations could come from anywhere: experimental work from Toronto, London, Cologne, Milan, Sarajevo, San Francisco, Sydney and elsewhere began to appear in new magazines, in photocopied catalogues and in exchanges through the mails. The model here was antithetical to the cultural imperialism of the New York-based Modernist Machine, imposing its structures and values on its artistic colonies. It was more that of the

randomising, argumentative celebration of disruptive difference that marked the ex-centricity of the Dadaists, the Surrealists and, most recently, the Fluxus groups. An international community of artists quickly developed, based on direct contact, indirect information and the creation of new forms of publicity, such as Seth Siegelub's *March 1-31, 1969,* the first catalogue-only exhibition. At this stage, much conceptual work existed most significantly in reproduced form. The language of its reproduction tended to be that of its publisher or distributor, that is, English and, to a lesser extent, German. An alternative, but still avant-gardist, internationalism was evolving (one which the gallery system, soon to regroup its forces, would find helpful when it came to picking out the new generation of promotable artists). While issues of translation frequently came up as practical problems in the course of the day-to-day organization of this network (three pieces of mine are still somewhere in Italy), they rarely surfaced as in themselves the source of a creative problematic. The alternative internationalism, at this stage, meant solidarity against the Modernist academy rather than divisiveness based on national or personal differences. A common enemy obviated individual acrimony, as did the desire for collaborative modes of working. In Derrida's terms, you could say that both acted as 'transcendental signifieds', making translation unnecessary.

Assumptions about the autonomy of art also had their impact. As noted before, many artists sought spaces for invention beyond the atrophied history of Modernist orthodoxy, represented above all by hard-edge and colourfield painting, by painted metal sculpture and by formalist art criticism. Formalist artists and critics made claims for art's essential separatedness as totalising as any that had been made before.[7] Some conceptual artists, in the early years, were just as vehement that art should be about art before anything else, and that it be made for artists before all others. Joseph Kosuth's influential essay 'Art After Philosophy' is typical of this mood.[8] But this insistence on autonomy and reflexivity had, in the most innovative work, a quite distinct inflexion. While formalists celebrated art's autonomy as fundamental to conserving its quality and its continuity, conceptual artists, convinced that art as it has evolved was irredeemable, saw reflexivity as the first step towards the possibility of radically reconceiving art

Terry Smith, *Daily Ideology* 1976. Black, white and red photo-panel, 595 x 430 mm. Courtesy National Art Gallery, Wellington.

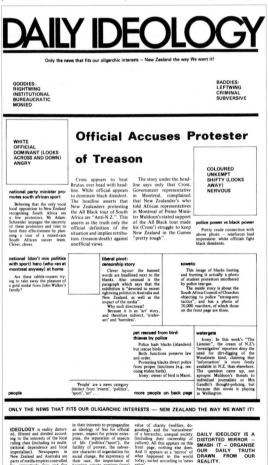

altogether. Painting, sculpture, all the traditional modes of image-making, were exhausted. For a time, mixed media seemed the way to go, but it lacked clarity for many. The creation of objects invited their instant commodification by a vast, voracious and increasingly desperate art marketing system. Even the seemingly neutral presumption that visual art be in some sense visual became subject to extensive controversy. For some artists, each of these problems seemed merely issues within a larger, more terminally threatening dilemma. Art itself was at stake, not just its media, its forms, its secondary languages, its contexts, audiences and institutions. The concept of Art was up for grabs.

The manoeuvre here can again be put in terms of Derrida's earlier distinction. Taking normal art practice as a semiotic one (as a system for the production and reproduction of signifiers), its failure in the years around 1970 to transform the babble of its languages into a viable, continuing art, obliged metaphysics to impose on it the task of re-examining its roots. Given the eternal conflict between signifier and signified, this can only be done through the domination (however temporary) of a signified — in this case, the concept of Art itself; the previous transcendental signifier, Modernism, having so conspicuously collapsed. Left as a domain of simple sign-production (a world of signifiers) art-making is condemned to incessant repetition, to closure, to impossibility, to say nothing of untranslatability. Thus the invasion of a transcendental signified, thus the necessity for reflexivity.

The most radical Conceptual Art was radical because it seized the task of going to these roots. It assumed that the concept of Art existed most fundamentally not in 'the mind', nor in works of art (be they great or the whole class), but in language. There were other influential ideas around: Richard Wollheim, for example, argued that Art was 'the institution of art', that is, all the beliefs, practices, relationships and organisations which surrounded and constituted the production of art objects.[9] Language was relevant, in that Wollheim, like many others including Donald Brook in Australia, held that art objects, practices, etc. were such because they were usually identified as such by the words and the actions of those in the relevant community. Art was what people normally said it was, and borderline cases could be settled in the usual way, by disputa-

tions and the evolution of customary acceptance or rejection. The idea of institution here is an analogy to ordinary language-use.

Wittgenstein's influence also pervades the early interests of English conceptualists such as Art & Language. Terry Atkinson opened the editorial in the first issue of *Art-Language* (May 1969) with the hypothesis that 'this editorial, in itself an attempt to evince some outlines as to what "conceptual art" is, is held out as a "conceptual art" work'. This attracted much more attention — being a striking, avant-gardist ambit claim — than the substantive content of his piece, the proposal for how to go on as artists in the impasse: 'I would suggest that it is not beyond the bounds of sense to maintain that an art form can evolve by taking as a point of initial inquiry the language-use of the art society'. The rest of the article, and others in the same issue, contained commentary on various earlier projected 'artworks', along with notes on their putative viewers, including an alien. In the second issue of *Art-Language* (Feb. 1970), Atkinson's essay 'From an Art & Language point of view' applied this kind of analysis to predecessors such as Duchamp and contemporaries such as Robert Barry. In New York (and, prior to that, London), Ian Burn and Mel Ramsden had independently arrived at a similar set of concerns, and Joseph Kosuth was using information from the investigative sciences in his series of displays entitled *Investigations*. Students at the Coventry School of Art, Philip Pilkington and David Rushton, founded the journal *Analytical Art* (July 1971).

Art & Language writings soon dispensed with physical objects, however conjectural, as beginning-points for inquiry, concentrating on ideas of and about art that were circulating in the international artworld, testing them as statements against the group's growing knowledge of linguistic philosophy, semantics, anthropology, philosophy of science etc. By 1971 Art & Language had moved from a phase where it was, like much other Conceptual Art, analytic of art's making and theorisation, to a more distinctive set of intentions. These pushed beyond anything that the stylistic category 'Conceptual Art' could encompass. They were, as I put it in 1974, 'to construct a complex methodology for nonspecialist critical discourse which would function in the "interstices" between some of the concepts and procedures raised thus far within specialisms such as art, phi-

losophy, sociology, etc'.[10] Typical methodological approaches were relativism, 'theory-trying', recursivity and falsification.

Translation was of interest to the logicians, such as Quine, the philosophers of language, such as Goodman and Hintikka, and the logicians of languages such as Apostel and Fodor and Katz. But the overriding concern of these men was the systematic description of the regular behaviour of language users, and they typically applied formal logic in generating structures for artificial languages and in accounting for the operations of natural languages. Translation tended to become a readily deferrable problem, probably easily solved, especially in the most formal systems, by some kind of direct transfer. These spaces were, however, elusive and unstable, and approaches to them were tentative, disparate.

But it was the extreme, even absurd, implications of such systematisation that attracted artists: a statement about translatability such as Nelson Goodman's 'With suitable principles of correlation, Constable's landscape painting could provide an enormous amount of information about a pink elephant' highlighted a freedom of signification that seemed enormously liberating.[11] It also flagged an edge to the academic discipline of linguistic analysis, an excess requiring the intervention of those working in the 'interstices' between the specialisms. Inspired also by Kuhn's dramatic theories of science's paradigm shifts, and by Feyerabend's anarchistic epistemology, this was just where Art & Language wanted to be.

It was, however, during the next two phases of Art & Language's development that issues around translation became increasingly important. Art & Language had expanded to two 'groups', one based around Banbury and Coventry, the other in New York, with a variable membership of approximately eight each. By 1972-73 communication within and between each group became the overt object of inquiry. Was the constant conversation within Art & Language 'a body of discourse that literally just searches', or could the semantics and the ideologies active in the exchanges be mapped in some ways? English members developed an index, a programme map and began compiling an idiolectic dictionary, while the New York group collected its written and verbal 'blurts', annotating them with comments from other members, then sought ways to make the conversations accessible to others. Both groups were taking themselves as actual language communities, and exploring their imbrication in whatever might be basic about language structures as well as the much more free-wheeling actualities (the pragmatics) of their language use.

Among the 400 'blurts' chosen from the annotating project conducted by New York members of Art & Language between January and June 1973 and collected in a Handbook (Blurting in A&L), there are fourteen collated under the heading 'Translation'.[12] Some were reports on current theories of translation, others commented on the limitations of such theorisation. Some reflected concern about acting in the gaps between disciplines, still others indicated anxiety about communication in a divided artworld; thus no. 366: 'If we (say) want to "talk to painters" we can't abstract a general theory of painting and then set up a comparison theory between that and our own "theories". For the painter (etc.) theoretical implications don't enter a level on which that comparison theory might function. This is the kind of translation problem we can't avoid . . .' Finally, in blurt no. 363, translation was recognised as problematic for the group itself: 'If we don't admit some kind of translation problem then we can only talk at each other. Excluding the 'problematic' of translation we will exclude all anomalies, contradictions, baggage, etc. (that is, all the interesting stuff)'.

Two issues of Art-Language in 1974 were devoted to theorising the group's particular, and peculiar, sociality, as were many exhibitions in Europe and the U.S.[13] In 1975 I characterised this phase as follows:

In contrast to the personal subjectivity ('I speak with my own voice') which prevails in the artworld, and to the impersonal supra-subjectivity of groups and committees ('We speak with one voice'), the Art & Language world of discourse searches for a personal intersubjectivity ('I speak with many voices').[14]

Translation, in all its senses, became more and more an issue as communications within Art & Language, and between the group and others in the art world, became increasingly volatile. Art & Language was achieving its maximal impact, but this coincided with accelerating internal conflict, particularly between the English and New York groups, and with the full-scale disintegration of the Modernist Ma-

TERRY SMITH

Art & Language (P), *Media Massacre* (detail) 1976. Black and white photopanel installation for Auckland City Art Gallery Project Programme exhibition, August 1976. Courtesy Terry Smith.

chine as the dominant regulator of international art practice.

Australia 1975 : It's Time Past

Nixon's moral bankruptcy had seeped through American society and was intolerably fouling South-East Asia: he had breached his Watergate. England's decline as a post-war superpower had passed the point of no return: it had become enslaved by 'the gnomes of Zurich'. And there were the multiplicity of micro-imperialisms which affected artists as much as anyone else: the hard economics of scraping a living for some but not others, the structural repression of women, the near-invisibility of minority viewpoints. To more and more members of Art & Language, especially in New York, it began to seem that the searching conversation, despite its increasingly radical form, was shrivelling into irrelevance. Translation between different language-worlds was still a pressing problematic, even more so, as it was evident that these worlds were co-terminous not only with nations, and with classes and subcultures within them, but also with groupings inside the subcultures, even with individuals. Sociolects became idiolects, ideologies also existed as idiologies.[15]

The same absences mark all the thinking about translation so far discussed: Benjamin's, Derrida's, those of the linguistic philosophers, those in the Art & Language blurts. Social, economic and cultural inequality haunts translation; it is not an abstract transit lounge, an esperanto of artificial possibility, a direct mapping of one grammar onto another, a conflation of dictionaries. As words, concepts and images travel from one language world to another they lose as much baggage as they carry. At stake here is not just the 'natural wastage' of inevitable cultural difference. In a world where international capitalism relentlessly seeks to impose cultural conformity, yet constantly and conspicuously fails to do so, what are really put at risk are all the universalising concepts: world government, the great historical narratives, a global economy, the very figure of Man, humanism and all its derivatives . . . to say nothing of the canonical achievements of art and literature, the avant-garde adventure of Modernism, or even the day-to-day routines of the international art world. If translation between all human languages is, in principle, possible, if works of art are readable by all, then these hopes and presumptions of modernity are at least grounded in some kind of adequate human communication. If not, then they, too, are lost causes, pointless activities. At most, they are partial enactments, shabbily simulating a past that was itself always a sleight of hand.

The systemic inequity of the international art world could no longer be glossed by universals such as art, Modernism, formalism, quality, ambition, achievement, career, etc. Just because the centre was

losing its grip, and the peripheries were rebelling, 'provincialism' became a telling explanation of the structural unfairness of the system, of the ways the dice were always loaded against the artistic colonies, of how artists both at and outside the centre were locked into hierarchies of competition and misinformation while the power to change, or even persist, lay elsewhere.[16] Art & Language publications debated the issue of how best to analyse this system in order to develop equitable alternatives, fairer ways of going on as artists — viz. the first and second issues of *The Fox* (New York, 1975).

Other artists were forming groups with similar goals: in New York, for example, artists' groups, along with many individuals, came together for discussions about feasible political effectivity in a loose umbrella coalition called Artists Meeting for Cultural Change. A frequent target was the galleries, public and private, for their museumisation of avantgardism, their commodifying of inventiveness. When *Some Recent American Art*, a survey of mainly minimal art, toured Australia in 1974, it attracted criticism, particularly in Adelaide, as both incomprehensible and culturally imperialist. When Lucy Lippard accompanied the show on its New Zealand tour, she raised these issues herself.[17]

In such a context, when Art & Language was invited to exhibit in the major state galleries in Australia in 1975, the key issue was obvious. The format had to provide an alternative model of an 'international art show'. It was prefigured in *Soft Tape* 1966. A politicised concept of translation, acutely alert to cultural difference, took centre stage:

We wanted it to be open, translatable, to establish a learning situation around it — so, above all, we needed a structure which would allow the participants to feed in their reflections on what they are engaged in. As well, though every issue would inevitably come up in an art context, we needed a form which would be loaded towards breaking the limitations and question-begging of that context. Finally, we wanted to examine the technical problems involved in the 'cultural noise' which transmitted messages pick up, to see how 'translation' functions in such situations.

So the format became the simple one of Ian Burn, Mel Ramsden and other members of Art & Language New York sending each day for a week telexes of work in progress to a discussion room set up in the exhibiting spaces of the gallery, where I and an invited guest would attempt to embed the text in dialogue with each other and the audience. The 1975 account currently being cited went on to the key issue:

The core problem is the compartmentalisation of our culture(s). A focus for this is the provincialist dependence on metropolitan art models, of which stylistic influences are only the most obvious symptoms. We hoped that by exaggerating the mechanism of sending current New York art information, by sending telexes of work being done at the time by Art & Language New York, the issue would come up in unavoidable ways. And by my presence as 'translator' the implications of the exchange would be rendered available for discussion and change in dialogue with me.[18]

The issue of metropolitan power and provincial dependence certainly came up, and with a vengeance. As it happened, the timing of the Sydney and Melbourne shows coincided with the tour of International Council of the Museum of Modern Art's blockbuster *Modern Masters: From Manet to Matisse*. N.S.W. Liberal politician Peter Coleman objected, and Art Gallery of N.S.W. trustees and director Peter Laverty cancelled the Art & Language show. In Melbourne, visiting MoMA curator William Lieberman threatened to sue the National Gallery of Victoria on the basis of the following paragraph in the Art & Language poster:

This latest form of art imperialism can only be assailed by first assailing our given producer-consumer 'natures'. Are we in good hands with the Museum of Modern Art and the U.S. Information Service, the professionals the specialists the artocrats/bureaucrats who hand us culture, not as something *we* do but as something *they* do, who 'creatively' wrap themselves around the creations of others, not something we do but something *they* do?

NGV director Gordon Thompson also caved in, but was persuaded by staff to allow its staging in the Art School in back of the Gallery. At the Art Gallery of South Australia the exhibition went ahead as planned: Adelaide was not part of the schedule of *Modern Masters*. These acts of censorship reflect the acute senstivity of the Modernist masters to the extreme fragility of their culture.

What shapes did translation take in the 1975 Art & Language discussions? The difficulty of Art &

TERRY SMITH

Language discourse was often remarked. For some, this signalled pretension, for others, confusion: it was, then, either not worth the effort of translation, or untranslatable. Yet is not the drive to the unrepresentable an absolutely essential avant-garde impulse? Art & Language, like many others at the time, searched for meaning beyond the easy meanings of closed knowledges: was not its commitment to systematically rendering its sociolect incomprehensible to even its own its speakers an important strategy to this end? Similarly, the aggressive, even abusive, attacks on everybody else's 'bad language' could be seen as an instance of the totalising negativity essential to any avant-garde breakthough.

But the first impulse blocked access, and the second bred resentment, both effects being contrary to ease of translation. Furthermore, while one sacrificed translatability in favour of insisting on the significance of the untranslatable, the other presumed a degree of translatability — indeed, of common, if essentially contested, ground — otherwise the attacks would seem mere hysterical shouting, incohate mouthings. Art & Language moved its multiple foci from 'intersubjectivity' to 'praxis' during these years. Similar paths were taken by many artists at the time: it has been convincingly argued that it was Conceptual Art's 'failure' to achieve its more abstract goals that led to its more fundamental 'success', that its devastating critique of high Modernism laid the groundwork for the much more socially and politically engaged art that followed.[19]

While a significant element in shaping the 1975 shows was to try to embody some of the contradictions and inequalities of the metropolitan/provincial situation, the aim was less to transmit what was going on in New York, more to provoke local self-knowledge. Thus the poster, after describing my role as being to 'deal with each blurt praxiologically — concerning himself with the question of embeddedness, the problems of re-embedding, the specific contexts of reference', went on to place the obligation to translate firmly in the hands of the discussants. No longer spectators, nor even audience; everybody was a participant, actively translating willy-nilly.

I set out to be a participant in the pandemonium, not a spokesperson for Art & Language in exile, nor a visitor speaking in transit. I opened the first NGV discussion by saying that I found the telex as problematic as the *Modern Masters* exhibition upstairs. I began the second session by claiming that 'one of my roles here is to act as a kind of translator in relation to the blurts sent from NY', then I identified that day's telex as originating from English Art & Language (a surprise to me). This was already an act of translation, which I followed up by a detailed exposition of the key arguments and phrases in the 800-word transmission. Two quite opposite conceptions of the translator's role are manifest. In the latter case, I was the translator as interpreter, an as-neutral-as-possible mediator. In the former (and, in fact, throughout the actual discussions) I sought a critical independence within the process, constantly changing tack in order to keep the dialogue open. In this way I attempted to challenge a further contradiction implicit in the situation, one endemic to provincialist dependence: the expectation that, after two years in New York I would be transmitting the latest ideas, values, trends and gossip, whereas my essential message was that the latest from overseas doesn't matter any more, and that we had to construct our own artistic cultures, here and now, with the fragments available.[20]

Did this amount to a new role for the artist, that of translator, seeking new transformations in the shifting spaces between cultures, spaces shaped by enormous inequities, passionate resistances, subtle compromises, elusive promises? To a degree, yes, but in a more important sense, no. The ambiguities, elisions and naivetes of trying to act as a wide-open middleman are evident through the texts of the 1975 discussions — as are, I hope, some of its rebarbative, and useful, edges. But more significant was the drive towards the obliteration of the artist as privileged generator of meaning: as translator in this open, reflexive, engaged sense I was less an author of the work in progress, more an agent in the practice of its production. But so, crucially, were the participants: all were enabled, even obliged, to become translators of the discourse as it was happening.

Auckland 1976 : 'The Way You Want It'

Much changed between May-July 1975, the dates of the Art & Language shows in Australia, and August 1976, when the (Provisional) Art & Language discussion/displays were held in Auckland. Working relations within and between the New York and English groups had soured to such an extent that who

used the group name when was hotly contested: thus the '(Provisional)' before any work by (certain) members of the New York group, even when showing essentially independently, as I was in Auckland. Of much greater significance was the extraordinarily intense political situation: its impact was felt in all spheres of life and throughout the art world.[21] After the dismissal of the Whitlam Government in November 1975, theoretical modes of working, however semiotically radical, even terroristic, suddenly seemed impossibly esoteric. With many others, I sought much more public spheres — particularly, the mass media — and new, non-art world audiences — in the case of Art & Language in Australia, the labour movement.

I knew (I thought) more about New Zealand politics than I did about New Zealand art. I could call to mind Colin McCahon's and Ralph Hotere's word imagery; it had always seemed to me that the Annandale Imitation Realists' peculiar mixture of wild words and 'primitive' imagery was not unconnected with the fact that two of that group's members — Ross Crothall and Colin Lanceley — were New Zealanders; I had heard that Jim Allen and Bruce Barber built performances around visual/verbal plays; I discovered Nicholas Spill's wild punning. The National Party, having won the 1975 election by a landslide, promptly imposed a wage/price freeze, imposed heavy anti-union legislation, unleashed police squads to send Islanders home, staged a Russian warship scare, and endorsed an All Black tour of South Africa during the Olympic Games. Prime Minister Muldoon governed by contempt, fear and bluff. 'New Zealand — The Way You Want It.' There seemed to be sufficient parallels to the new regime in Australia for me to hope that the format of the 1975 shows would work somehow similarly across the Tasman.

There were, however, some major differences. I introduced these in an attempt to obviate — again by the device of exaggeration — the cultural dependence which, I assumed, followed from Australia's economic dominance of the region. As a setting for the discussions, I installed three displays of newspaper posters, one along each wall of the Gallery. *Medibunk* set out the Sydney newspapers' divisive presentation of the general strike against the dismemberment of the universal health care system, Medibank, by the Liberal Country Party. *Media*

Massacre began with the idea of showing how dimly New Zealand appeared in the Australian press but blew out into a display of the sensationalisation of murderer and escapee Phillip Western. *The Story of Cur, Piggy and Prefect* traced Kerr's coup, Fraser's ascendency and parallels with Muldoon's reign. Each of these, but particularly the latter, was conceived as a *ta tze pao*, a wall newspaper on the model of the Democracy Wall in China, to which anyone could add their views. Some did.

But before the show could get underway, a censorship farce had to be played out. The poster's centrepiece consisted of three words — 'piggy', 'cur' and 'prefect' — above photographs of Prime Minister Muldoon (taken in the makeup room of a television studio, chosen for its evocaton of official portraits of Mussolini), Australian Governor-General Sir John Kerr (taken when drunk at the Melbourne Cup) and Prime Minister Malcolm Fraser (taken when chewing cake during an American Bicentenary Celebration). Disrespectful, critical readings of these men are inevitable when their nickames are set against such images of them. This proved too much for certain members of Council and the Gallery committee: the poster, and the show itself, were banned. After much negotiation, the words in the poster were obliterated, and the show went ahead. My major aim with respect to provoking displays of iron fists within liberal gloves was realized the next day: on the front page of *The Auckland Star* a photograph of the censored poster appeared, alongside a heading which restored the words, and a story about the exhibition being 'devoted to right-wing politics in Australia and New Zealand, as well as the impact of the media'. Just how ideologically embedded in each other these events were is traced in my piece *Daily Ideology*, commissioned by the National Gallery and shown in *The Word in Art* show, January to March 1978.[22]

Jim and Mary Barr, in their exhibition *When Art Hits the Headlines* (National Art Gallery, Wellington 1987), cat. p.13, tell only part of the censorship story, and then inaccurately, ending up with an unnecessarily negative conclusion about the powerlessness of political art in galleries. The poster was pasted up around the city before being censored, the blackening out occurred on only a few posters, the posters on display in the Gallery were blackened out, then stamped with a 'This has been censored' sign.

259 TERRY SMITH

After *The Auckland Star* story the tapes blackening out the words were taken off. Sir Dove Meyer Robinson's remark about anything in the Gallery being 'in quotation marks' was made in the midst of these events. I was more concerned about him banning the show itself a few days before. At the end of his visit during the installation, he said: 'This is an attack on the media, isn't it? I hate the media too. Go right ahead'. So, while I agree that the politics that work best in an art gallery are those that deal with the politics of the gallery itself, with the institutions and practices of art, I do not accept the Barrs' conclusion that these are the *only* politics possible. The gallery can be used as a base for more public politics, for the ideological battles, the struggles for the power to signify, which are part of the currency of 'real/ political life'. The Mayor recognised this, both in his comment to me and his quite contrary remark to the press. In politics, people speak with many voices.

The discussions were not structured around blurts from further away, but around the media displays in the gallery space, and the media event of the failed censorship. Art & Language material was available in part of the space as background reading: my

distance from it was increasing, so I rarely acted as translator/mediator. The language of the newspaper posters is the ultimate in apparent transparency, so they required little in the way of direct translation, a lot in the way of ideological decoding. This was done by the participants in the discussion — journalists, building workers, artists, critics, academics — in a full-blooded, critical fashion. For a moment, translation was transcended. And this, perhaps, is the best thing that can happen to it.[23]

Notes

1 Walter Benjamin, *Illuminations*, ed. Hannah Arendt. New York: Schocken, 1969, pp. 69-82.
2 Ibid., pp. 217-252.
3 Jacques Derrida, 'Semiologie et Grammatologie', *Positions*. Paris: Editions de Minuit, 1972, p. 31, cited Gayatri Chakravorty Spivak, 'Translator's Preface' to Derrida's *Of Grammatology*. Baltimore: Johns Hopkins University Press, 1976, lxxxvii.
4 Cited Alan Bass, 'Translator's Introduction' to Derrida's *Writing and Difference*. London: Routledge & Kegan Paul, 1981, xv.
5 'Plato's Pharmacy', in Jacques Derrida, *Dissemination*. Chicago: University of Chicago Press, 1981.
6 Roland Barthes, 'The Death of the Author', 1968, in Stephen Heath ed., *Image-Music-Text*. Fontana 1977; Michel Foucault, 'What is an author?', 1969, in Donald F. Bouchard ed., *Language, Counter-Memory, Practice*. Ithica: Cornell University Press, 1977.

Art & Language (P), discussion session, Auckland City Art Gallery, August 4 1976. Courtesy Terry Smith.

7 'Modernist Painting' was the key text: Clement Greenberg, *Art and Literature* (Spring 1965), in Gregory Battcock ed., *The New Art*. New York: Dutton, 1966.

8 *Studio International*, October and November 1969, in Gregory Battcock ed., *Idea Art*. New York: Dutton, 1973.

9 Richard Wollheim, *Art and Its Objects*. Harmondsworth: Pelican, 1970.

10 Terry Smith, 'Art and Art & Language', *Artforum* (Feb. 1974), p. 50.

11 Nelson Goodman, 'Review of *Art and Illusion*', *The Journal of Philosophy*, 57 (1960), p. 599.

12 New York: Art & Language Press, and Halifax: Nova Scotia College of Art, 1973, pp. 81-84.

13 Baldwin/Pilkington, 'Handbook(s) for Going-On', *Art-Language*, June 1974, and Burn/Ramsden/Smith, 'Draft for an Anti-Textbook', Sept. 1974.

14 Handbill for *Art & Language* exhibition, National Gallery of Victoria, Melbourne, May-June 1975, cited in Terry Smith ed., *Art & Language: Australia 1975*. Sydney, Banbury, New York: Art & Language Press, 1976, p. 19.

15 A theme in the 'Draft for an Anti-Textbook', *Art-Language*, Sept 1974.

16 See my 'The Provincialism Problem', *Artforum* (Sept. 1974), pp. 54-59. Recent discussions include sthose about regionalist tendencies in Australian art within and beyond the East Coast capitals, and the debate between myself and Bernice Murphy following the 1988 Sydney Biennale, *Art Monthly*, Aug., Oct., Dec. 1988.

17 Lucy Lippard, 'Notes on seeing Some Recent American Art in New Zealand', *Auckland City Art Gallery Quarterly*, 59 (1975), pp. 2-3.

18 Terry Smith, 'Fighting Modern Masters', *The Fox*, 2 (1975), pp.15-21; also in *Art & Language: Australia 1975*, pp. 1-4.

19 Ian Burn, 'The 'Sixties: Crisis and Aftermath', *Art & Text*, 1 (Autumn, 1981), pp. 49-65.

20 Detailed transcripts of the discussions are in *Art & Language: Australia 1975*, op. cit.; a display of this last point is my 'Art Criticism/Self Criticism', introduction to the *6th Mildura Sculpture Exhibition*, Mildura Art Centre, 1975, pp. 1-10.

21 See my 'Art Criticism in Australia: the mid-1970s Moment', in Robyn McKenzie ed., *Art Papers: the present and recent past of Australian art and criticism*, supplement to *Agenda*, 2 (Aug. 1988), pp. 12-13.

22 For a contemporary reaction to the show see Geoff Chapple, *The Independent*, Nov. 6, 1976. My account of these events, plus extracts from the discussions, appears in *The Great Divide*, Charles Merewether and Ann Stephen eds., Melbourne 1977, pp. 48-53, and *Left Curve*, 7 (1978), pp. 66-72. I would like to pay tribute to John Maynard's crucial role throughout, and to Bruce and Pauline Barber for their support.

23 Translation has come up recently as a term more accurate than 'appropriation' in describing recent post-postmodern art strategies: see 'The Life-Motif, Interview with Imants Tillers', *Imants Tillers: Works 1978-1988*. Institute of Contemporary Art, London, 1988. But Tillers still ties it to the old mythologies of the artist as privileged creator, as key author of the discourse, however much it consists of the already-said. On more pertinent thinking about translation, especially in 'post-cultural' situations, where more subtle analyses than those of metropolitan/ provincial, centre/periphery cultural imperialism are necessary, see *Meanjin*, 4 (1989), especially Simon During's essay 'What Was the West?' (also published in a longer version in *Sport 4*, Wellington, 1990) which includes interesting analyses of the complexities of communications between New Zealand cultural groups.

TERRY SMITH

Contributors

Laurence Aberhart: Photographer, lives in Russell
Wayne Barrar: Photographer, teaches at Wanganui Polytechnic
Lita Barrie: Art-writer and journalist
Christina Barton: Assistant Curator of research collections, Auckland City Art Gallery; co-editor *Antic* magazine
Leonard Bell: Teaches Art History, University of Auckland
Miro Bilbrough: Fiction writer and critic, artist, freelance researcher, former Assistant Curator at Wellington City Art Gallery
Gregory Burke: Curator at the Wellington City Art Gallery; video and photographic artist
Ian Burn: Artist, writer, based in Sydney, associated with the English based Art and Language group in the 1960s
Alex Calder: Teaches in the English Department, University of Auckland
City Group: Artists/Writers/Researchers collective
Wystan Curnow: Poet, art critic, curator, teaches English at University of Auckland
Judy Darragh: Artist and teacher based in Auckland
Margaret Dawson: Photographic artist resident in Christchurch
Andrew Drummond: Sculptor, based in Auckland
Fran Dyson: Video artist and writer, teaches media theory at University of Technology, Sydney
Leon van den Eijkel: Dutch artist resident in Wellington, designer for the Wellington City Art Gallery
Fohn Ford: Ngati Raukawa ki Kapiti. Artist, carver, teacher, lives in Ashhurst
Dr Maarire Goodall: Ngai Tahu and Ngati Mamoe tribes. Former Director of National Cancer Research laboratory from 1985 to mid 1989; original research officer for the Waitangi Tribunal; presently involved in publishing and consulting for Aoraki Press
Tony Green: Professor of Art History at the University of Auckland
Ralph Hotere: Artist, lives in Carey's Bay, Otago
John Hurrell: Christchurch based artist and art critic
Robyn Kahukiwa: Ngati Porou and Te Aitanga-a-Hauiti. Artist, lives out of Wellington
Philip Kelly: Artist based in Wellington; graphic designer with Wellington Media Collective
Chris Knox: Comic artist, musician, filmmaker, journalist based in Auckland
Elizabeth Knox: Fiction writer, based in Wellington
Sara Knox: Poet, studies history at Victoria University, Wellington
Michele Leggot: Poet, teaches English at University of Auckland
Barry Linton: Comic artist, based in Auckland
Paratene Matchitt: Whaanau a Apanui, Ngati Porou, Whakatohea. Sculptor, based in Napier; recently commissioned for the 1990 Commonwealth Games in Auckland; and for Auckland's Aotea Centre
Chris McAuliffe: Art historian and critic based in Melbourne
Colin McCahon: NZ artist born 1919, died 1987
Lawrence McDonald: Art writer and teacher of Social Anthropology, based in Wellington
Stuart McKenzie: Student of Religious Studies, writer, based in Wellington
Julia Morison: Artist, based in Christchurch
Fiona Pardington: Photographic artist based in Auckland
Neil Pardington: Artist and graphic designer based in Wellington
Joanna Paul: Artist and poet, lives in Wanganui
Nick Perry: Teaches Sociology at the University of Auckland
Ann Poulsen: Director of Poulsen & Hill Ltd, Marketing and Creative Consultancy, Auckland
Patrick Pound: NZ artist and film-maker currently living in Melbourne
John Reynolds: Artist, based in Auckland
Pauline Rhodes: Sculptor, based in Christchurch
Ed Ruscha: American artist, born 1937. In 1990 and 1991 his major survey exhibition *Some Words and Letters* will be touring in Europe and the U.S.A
Noel Sanders: Composer and writer, teaches in the area of Cultural Studies at the University of Technology, Sydney
Laurence Simmons: Art-writer, teaches at the Department of Romance Languages, University of Auckland
Terry Smith: Associate Professor in the Department of Fine Arts, University of Sydney; associated with the Art & Language group in the 1970s
Rewi Thompson: Ngati Raukawa: Ngati Ngarongo

Ngaiterangi; Ngati Porou: Te Aitanga a Hauiti, Ngai Tamanuhiri. Architect, lives in Auckland
Merylyn Tweedie: Artist, and film-maker, lives in Auckland
Ian Wedde: Writer and editor, based in Wellington
Damien Wilkins: Fiction writer and critic; assistant editor at Victoria University Press; at present taking the Graduate Writing Course at Washington State University, St Louis, Missouri
Elizabeth Wilson: Teaches in the Department of English, University of Auckland
Nicholas Zurbrugg: Artist, writer and curator, teaches at Griffith University, Brisbane

Acknowledgements

Every effort has been made to locate and contact the owners and copyright holders of artworks, images and texts reproduced in this book. The contributors, editors, Wellington City Art Gallery, and Victoria University Press gratefully acknowledge the following individuals and institutions:

Lawrence Aberhart; Artspace, Auckland; Wayne Barrar; Jim and Mary Barr; John Bevan Ford; Peter Black; Andrew Bogle; Mary-Louise Browne; Gregory Burke; Ian Burn; Peter Callas; Carillon Importers Ltd; Lawrence Clark and *Strips*; Grace Cochrane; Colenso, Auckland; Wystan Curnow; Judy Darragh; Margaret Dawson; Leon van den Eijkel; Field Enterprises Ltd; Juliet Frizzell; Gregory Flint Gallery, Wellington; Jeremy Graham; Haikusha Publishing Co Ltd; Hibiscus Films Ltd; Ralph Hotere; John Hurrell; Janne Land Gallery, Wellington; Robyn Kahukiwa; Philip Kelly; Chris Knox; Barry Linton and *Strips*; the Louvre, Paris; Peter McLeavey; Ann and Paul NcNamara; Marvell Comics Group; Metropolitan Museum of Art, New York; Julia Morison; New Zealand 1990 Commission; Ralph Paine; Fiona Pardington; Neil Pardington; Patrick Pound; Mick Prendergast and Coromandel Press; John Reynolds; Pauline Rhodes; Ed Ruscha; Terry Smith; 33 1/3 Gallery, Wellington; Rewi Thompson; Merylyn Tweedie; Gordon Walters; Estate and Foundation of Andy Warhol; John Weber Gallery, New York; Ian Wedde; Adam Wolter; Nicholas Zurbrugg.

The Alexander Turnbull Library, Wellington; Art Gallery of South Australia, Adelaide; Auckland City Art Gallery; Australian National Library, Canberra; The Govett-Brewster Art Gallery, New Plymouth; The National Archives, Wellington; The National Art Gallery, Wellington; The National Museum of New Zealand, Wellington; The Hocken Library, Dunedin.

The Estate of Colin McCahon.

Colourcraft Reprographics, Wellington; Penguin Books (NZ) Ltd, for the quote from David Eggleton on p.17; also for the Allen Curnow quote on p.52; Elizabeth Knox for the text on p.56; AH and AW Reed for the Ross Gore strips on pp.86 and 238.

Ralph Hotere, Robin Dudding and *Islands* magazine, and the Estate of Colin McCahon, for the handwritten letter and notebook pages reproduced from *Islands* Vol 5 No 4 July 1977, on pp. 132 and 133.

W.E.A for Prince, *Glam Slam*, Paisley Park; Polygram for Malcolm McLaren, *Duck Rock*, Charisma 810 432-1; and for Patti Smith, *Horses*, Arista Records, U.S.A; Virgin Records for *GO2* (XTC); E.M.I for Pet Shop Boys, *Domino Dancing*, Parlophone 12R6190; *Word 2*, Jive Records, HOPC 220.

NOW SEE HEAR!